WOMEN IN GERMAN YEARBOOK

Volume Nineteen

2003

EDITORIAL BOARD

Claudia Breger, Indiana University, 2001-2004

Gisela Brinker-Gabler, State University of New York, Binghamton, 1992-2003

Helen L. Cafferty, Bowdoin College, 1992-2003

Jeanette Clausen, Indiana University-Purdue University Fort Wayne, 1995-2004

Susan L. Cocalis, University of Massachusetts, Amherst, 1992-2003

Ruth P. Dawson, University of Hawai'i at Manoa, 2001-2004

Myra Marx Ferree, University of Wisconsin, 2001-2004

Sara Friedrichsmeyer, University of Cincinnati, 1999-2004

Katherine R. Goodman, Brown University, 2001-2004

Atina J. Grossmann, Cooper Union, 2001-2004

Patricia Herminghouse, University of Rochester, 2002-2005

Nancy Kaiser, University of Wisconsin, Madison, 1998-2003

Ruth Klüger, University of California, Irvine, 2001-2004

Barbara K. Kosta, University of Arizona, 2001-2004

Renate Möhrmann, Universität zu Köln, 1998-2003

Georgina Paul, University of Warwick, 2001-2004

PAST EDITORS

Marianne Burkhard, 1984-88
Edith Waldstein, 1984-87
Jeanette Clausen, 1987-94
Helen Cafferty, 1988-90
Sara Friedrichsmeyer, 1990-1998
Susanne Zantop, 1998-2001
Patricia Herminghouse, 1994-2002

WOMEN IN

Feminist Studies in German Literature & Culture

GERMAN

Edited by Ruth-Ellen Boetcher Joeres & Marjorie Gelus

YEARBOOK

Volume Nineteen

2003

University of Nebraska Press, Lincoln and London

© 2004 by the University of
Nebraska Press. All rights
reserved. Manufactured in
the United States of America.
Published by arrangement
with the Coalition of
Women in German. ∞
ISBN 0-8032-4812-1 (Cloth)
ISBN 0-8032-9838-2 (Paper)
ISSN 1058-7446

CONTENTS

Acknowledgments vii
Preface ix

**The Measure of Our Words, or
Taking How We Talk to Each Other Seriously** 1
Angelika Bammer

* * *

Focus: Women and the Holocaust

Departures: New Feminist Perspectives on the Holocaust 9
Lisa Disch and Leslie Morris

**Unspeakable Differences, Obscene Pleasures:
The Holocaust as an Object of Desire** 20
Karyn Ball

**Positionality and Postmemory in Scholarship
on the Holocaust** 50
Pascale Bos

Postmemory Envy? 75
Elizabeth R. Baer and Hester Baer

**Making the Stranger the Enemy:
Gertrud Kolmar's *Eine jüdische Mutter*** 99
Irene Kacandes

* * *

**In the Waiting Room of Literature:
Helen Grund and the Practice of Travel
and Fashion Writing** 117
Mila Ganeva

**A Female Old Shatterhand? Colonial Heroes and Heroines
in Lydia Höpker's Tales of Southwest Africa** 141
Jill Suzanne Smith

**Searching for Missing Pieces around Us:
Christa Wolf's *The Quest for Christa T.* and
Ingeborg Drewitz's *Who Will Defend Katrin Lambert?*** 159
Michelle Mattson

**Pro-Porn Rhetoric and the Cinema
of Monika Treut** 179
Muriel Cormican

**Overcoming Boundaries: Feminist Doctorates and Women's Careers
in Germanics 1980–2002** 200
Patricia Herminghouse and David P. Benseler

About the Contributors 251
Notice to Contributors 255

ACKNOWLEDGMENTS

The coeditors would like to thank the current Editorial Board for their welcome assistance in reviewing manuscripts, their participation in our on-line discussions, and their general support and encouragement. We also gratefully acknowledge the assistance and advice of the following individuals in reviewing manuscripts submitted for publication in the *Women in German Yearbook.*

Brigetta Abel, Macalester College
Susan Anderson, University of Oregon, Eugene
Jeannine Blackwell, University of Kentucky, Lexington
Jane Brown, University of Washington, Seattle
Robert Ellis Dye, Macalester College
Friederike Eigler, Georgetown University
Tamara Evans, City University of New York
Frances Ferguson, Johns Hopkins University
Miriam Frank, New York University
Gerd Gemünden, Dartmouth College
Kiki Gounaridou, Smith College
Julia Hell, University of Michigan, Ann Arbor
Anne Herrmann, University of Michigan, Ann Arbor
Marianne Hirsch, Dartmouth College
Eleanor Kennedy, Queen's University, Kingston, Ontario
Marcia Klotz, Portland State University
Helga Madland, University of Oklahoma, Norman
Biddy Martin, Cornell University
Alexander Mathäs, University of Oregon, Eugene
Margaret McCarthy, Davidson College
Richard McCormick, University of Minnesota
Elizabeth Mittman, Michigan State University
Leslie Morris, University of Minnesota
Helen Morris-Keitel, Bucknell University
Magda Mueller, California State University, Chico
Andrés Nader, University of Rochester
Susan Piepke, Bridgewater College
Julie Prandi, Illinois Wesleyan University
Elizabeth Rudd, University of Michigan, Ann Arbor
Monika Shafi, University of Delaware, Newark

Lorna Jane Sopcak, Ripon College
Jacqueline Vansant, University of Michigan, Dearborn
Valerie Weinstein, University of Nevada, Reno
Lore Wildenthal, Rice University
Sabine Wilke, University of Washington, Seattle
Karin Wurst, Michigan State University

Special thanks to Victoria Hoelzer-Maddox for manuscript preparation.

PREFACE

This volume of the *Women in German Yearbook* is on the cusp of the *Yearbook*'s twentieth year. In most ways, it marks a fairly familiar path in its presentation of current work in feminist German Studies: it begins with what we might call a "creative piece," although we certainly view all contributions to the *Yearbook* as creative; it then presents something not entirely typical but certainly not foreign to *Yearbook* readers, namely, a thematic cluster of articles; it continues with a series of what *Yearbook* editors tend to call the "historical section," that is, a chronologically arranged set of pieces that can be clearly tied to certain historical eras; and it concludes with an extremely helpful piece of a more documentary nature, although its quantitative sections are supplemented by qualitative material.

As always, we intend to examine current scholarly directions in our particular subfield of feminist German Studies and to present you with an interesting cross-section of what we find is going on. There is a certain comfort in the familiarity of what we are offering you, although there is a certain discomfort too, especially when we realize what is missing. In this volume, for instance, we were surprised and unsettled to realize that the pieces that we had accepted for inclusion in the historical section all focus on the twentieth century. As the annual conferences of Women in German have shown especially in recent years, there is interesting, subtle, and important work being done in gender studies on the literature and culture of pre-twentieth-century German-speaking countries. We are hopeful that the *Yearbook* will receive more of the results of such research for review in the coming months. We welcome work that is wide-ranging in its interdisciplinary concerns, its desire to conceptualize broadly and comparatively, and its ability to think imaginatively about gender and other analytical categories of interest to feminist inquiry. And we particularly hope that the upcoming volume marking the twentieth year of the *Yearbook* will attract even more in the way of innovative and interesting scholarship. We urge our readers to contribute. We welcome your work and look forward to reading it.

We begin this volume with "The Measure of Our Words, or Taking How We Talk to Each Other Seriously," an elegant and eloquent

essay by Angelika Bammer that discusses the politics of language as it can be exemplified by Women in German. Her examination focuses specifically on the debates surrounding the use of German at a critical time in the development of the organization, the difficulties, the amazing emotional baggage connected to such debates, and the ways in which we were transformed in the process. An earlier version of her essay was presented at the opening session of the 2002 annual Women in German meeting, and we view it as a convincing example of the ways in which the essay form, that mix of the personal and the objective, can so perfectly articulate feminist thinking.

What follows is a cluster of pieces that were initially presented at a conference in April 2001 at the University of Minnesota on women and the Holocaust. When conference co-organizers Leslie Morris and her political science colleague Lisa Disch, both faculty members at Minnesota, offered revised and expanded versions of these four papers to us—and when we and the external reviewers had a look at them—we were impressed with the wide range of issues presented, but especially with the ways all four papers, and the introduction to them, gave such firm evidence of how scholarship on the Holocaust is benefiting enormously from the increased presence of feminist work. The introduction to these pieces, by Morris and Disch, sets the series of papers up with a contextualizing look at the conference itself, at the questions that were posed at the outset, and at the ways in which the conference met expectations and created even more challenges and questions.

Providing a provocative opening for the cluster of pieces is Karyn Ball's "Unspeakable Differences, Obscene Pleasures: The Holocaust as an Object of Desire," which presents theoretical and thematic focuses that are echoed in the other pieces—issues of postmemory and positionality, for example—while also offering a complex and illuminating investigation of how feminists approach their scholarly work on the Holocaust. She asks difficult and painful questions about the relationship between [feminist] scholar and subject matter. She also offers an extremely rich discussion that ranges from Foucauldian discipline, to compassion and its sensitive relationship to what she calls "cultural fascination," to the fantasy that is inevitable in even the most objective scholarship.

Pascale Bos's "Positionality and Postmemory in Holocaust Scholarship" also deals with the relationship between scholars and their objects of study, focusing on the Holocaust as a particularly poignant and indeed overwhelming topic when it comes to the matter of analysis. She is as interested in the autobiographical nature of the "readings" of the Holocaust by feminist scholars as she is in the issue of postmemory,

with its emphasis on the post-Holocaust generations, as well as in the role of empathy and emotions in such work.

"Postmemory Envy?" by the mother-daughter team of Elizabeth Baer and Hester Baer examines their collaboration on the translation and editing of a relative's memoir concerning her experiences in the Ravensbrück concentration camp. The Baers echo previous themes: the personal and the scholarly and how they are interwoven in this work; the importance of positionality and postmemory as suggestive theoretical signposts in their thinking. At the same time, what is particularly exciting are the very different responses each displays to her relative's memoir—here, positionality becomes both generational and philosophical, and the result is a thoughtful and engaging commentary.

The final piece is "Making the Stranger the Enemy: Gertrud Kolmar's *Eine jüdische Mutter*," Irene Kacandes's close reading of a novel from the early 1930s, which she sees as providing what she calls a "cultural key" to what was to occur in the years that followed. In contributing to the discussion of the complex processes of othering that occupied Germany in the pre-war years, Kacandes's interpretation is startling in the eerie sense a reader feels at seeing so much already present in the language and themes that would become prominent in the resulting catastrophe. It is a fitting conclusion to the cluster in its effort to pull its readers into its examination of the ambivalent processes of assimilation that are so deceptively at work in Kolmar's novel.

That eeriness is echoed in the first of the pieces in the historical section, Mila Ganeva's "In the Waiting Room of Literature: Helen Grund and the Practice of Travel and Fashion Writing," a lively investigation of the fashion journalist/travel writer Helen Grund against the background of the Weimar Republic in all its fascination and menace. It offers not only a genre study of the feuilleton and the travelogue but also intriguing looks at modernity and gender, the German *flâneuse,* and at the modern German woman whose contributions to journalism met gender expectations but also reflected the increasingly chaotic world around her.

Jill Suzanne Smith's "A Female Old Shatterhand? Colonial Heroes and Heroines in Lydia Höpker's Tales of Southwest Africa" offers a useful addition to the growing body of writing by both historians and literary critics on the German women who lived and wrote about their experiences in (post-)colonial Africa. Smith analyzes two novels by Höpker, a German settler woman, by highlighting her use of gossip as a revealing narrative technique in her depiction of colonized African workers, changing gender hierarchies, colonial fantasies, and the omnipresent power of the white Germans.

Michelle Mattson's "Searching for Missing Pieces around Us: Christa Wolf's *The Quest for Christa T* and Ingeborg Drewitz's *Who Will Defend Katrin Lambert?*" presents a study informed by recent feminist scholarship on the ethics of care to examine female characters in these novels and their differing ways of acting in opposition to social participation as it was understood in their respective German states. In its effort to think politically, socially, and culturally about the former east and west Germany, this carefully contextualized analysis addresses issues of conformity and resistance, autobiography, and so-called "audit selves."

Finally in this section we have Muriel Cormican's "Pro-Porn Rhetoric and the Cinema of Monika Treut," a look at issues concerning what she labels pro-porn and anti-porn feminism. Cormican points out how Treut's films as well as her public pronouncements present a complex and often ambiguous response to pornography in what she sees as a simplistic oppositional stance toward the anti-porn feminists. What gets lost in the bargain, she maintains, are the more important and subtle issues in the films that focus on women's "erotic options."

The volume ends with "Overcoming Boundaries: Feminist Doctorates and Women's Careers in Germanics 1980-2002," by Patricia Herminghouse and David P. Benseler. This useful and informative quantitative and qualitative investigation of US doctoral dissertations in Germanics written primarily by women offers evidence of increasing work on gender and the expansion beyond narrow canonical concerns, but sees what we at the *Yearbook* also have noted, namely little change in the racial and ethnic diversity of the field's practitioners—and, we would add, in the race-specific issues that those practitioners examine. The piece presents not only important and revealing data but also supplies welcome qualitative work, the comments and often disheartening experiences of those in the field. It also gives ample evidence of the significance of feminist work in the changing and expanding field of German Studies.

With volume 19, the new coeditor, Marjorie Gelus, is now wholly on board. She and Ruth-Ellen B. Joeres have learned together during this past year. We have missed the steady and experienced hand of Patricia Herminghouse, but we have benefited from the support and encouragement and assistance of others. We want to thank both of our universities, the University of Minnesota and the California State University at Sacramento, for their support. We are especially grateful for the able assistance of the Minnesota editorial assistant for the *Yearbook,* Nicole Grewling. And we are, as always, enormously thankful to have our formatter, Victoria Hoelzer-Maddox, whose skilled,

thoughtful, and expert work on the manuscript preparation is greatly appreciated.

The Coeditors
July 2003

The Measure of Our Words, or Taking How We Talk to Each Other Seriously

Angelika Bammer

This paper argues that at the heart of our work as Women in German has been our work on and with language, including the way we use language among ourselves. Using as a paradigmatic example the way in which we have negotiated the use of German—which has meant coming to terms with the significantly different meanings it holds for us, depending on our historical relationship to German culture—it proposes that our willingness to engage the politics of language within Women in German, in our institutional practices and personal relationships, has constituted a fundamental commitment to a transformative politics of and within language. (AB)

Who are we? Where are we going? These are the questions our panel asked.[1] I shall begin my remarks by responding to the first question and I shall end, rather more speculatively, with my answer to question two.

I begin at the beginning—the question, "Who are we, we Women in German?"—with a framing set of answers. We are many different things: women and men, students and professors, scholars and teachers, lesbians, gays, and heterosexuals; we are people with families, who live with partners, who live alone; we are young and old and in-between. We are Europeans and we are Americans, with myriad ethnic and cultural roots. We are of different races. Some of us are Christians, some are Jews or of other faiths, and many are secular non-believers. We are many different kinds of people. But, these differences notwithstanding, we are people who talk to one another. For we believe in the necessity of our ability to talk across the multiple differences that can divide us: differences of life experience and life choices, of institutional placement and professional standing, of scholarly interests and theoretical emphases, of allegiances and bonds to other communities.

And we are people who, based on our belief in this necessity, have made a commitment to work on language—in our scholarship, our teaching, and our personal interactions—so that our words can be a measure of who we want to be, within ourselves and in relation to one another.

I will focus here on one exemplary aspect of this language process—the "German/English" question—to illustrate some of the ways in which we, as a group and an organization, have responded to this necessity. But before I begin, I would like you, my reader, to imagine yourself doing (or actually do) the following exercise:

1. Get out a sheet of paper (or start a new blank page on your computer), and
2. Write down,
 a) your thoughts on speaking German: How does the thought of speaking German ("jetzt werden wir alle Deutsch miteinander sprechen" ["now we'll all speak German with each other"])[2] make you feel? What feelings do you associate with speaking German? With speaking German in a public forum? Do your feelings come with any particular memories?
 b) Do the same with English.
3. Which of these thoughts would you be willing to share with a group in a conference setting?
4. Now imagine this:
 How would the proposal that we speak German at our conference sessions ("Wir sind doch schließlich eine Fachorganisation für 'Women *in German*'" ["After all, we're a professional organization for 'Women *in German*'"]. "Don't we teach German? Then why are we always speaking English at our conferences?") make you feel?

Years ago, in the early years of Women in German (it must have been in the late seventies), this proposal, or one very much like it, occasioned a crisis in our group. A crisis of language, of identity, of memory, of affiliation. It started with a simple, and seemingly innocent, suggestion (that we ought to speak more German at Women in German meetings), advanced to a proposal (that we have a German-language session at Women in German conferences), and it ended up with tears.[3] Someone had made a proposal; we had agreed with the reasoning. But then our other histories blew in and through us, like storms from our various pasts.

I remember us at one of the early Women in German conferences in Racine, Wisconsin, standing in little clusters of women—in the hallway where our bedrooms were, in a corner of one of the meeting rooms,

outside on the grounds—arguing, yelling, silent, crying. At issue was this question of language and what it meant. To us, then and there, it meant many different things. It meant grief over losses not often acknowledged, certainly not publicly: losses of homelands and mother tongues, families and communities of origin, a cultural sense of place. It meant remembering anxious efforts to unlearn an inherited language and learn a new one, to be validated, to be safe. It meant shame and fear when our language or the accent of our parents "gave us away" or exposed nostalgic longings. And it meant pride in the fact that we were multi-lingual, cosmopolitan, culturally versed, at home in more than one language.

These feelings were powerful, visceral, yet when they surfaced, it came as a shock. For they were surfacing here, in public, at a Women in German conference, in a setting that had presumed commonality, but suddenly did not feel safe. We were women together, committed—we thought—to the vision of a world in common.[4] Yet neither our desire for community as women nor our shared political commitments as feminists had been able to contain the force of these feelings. It was as if, coming from elsewhere, they now broke free. And as we faced, or turned away from, one another in those hallways or on our walks; as we yelled or cried, embraced or avoided one another, we had to realize that this was not a simple, conference-format issue (to have a German-language session or not). We realized that language—how we talked to one another, in what tongue and with what accent, with which psychic shifts of affiliation—was deeply and intimately and historically about who we were. Language, and our positioning within it, *was* who we were. In this respect, the question of language was much like the question of sexuality, which—probably not coincidentally—also became an issue among us around this time. And, like our relationship to sexuality, our relationship to language was more often than not profoundly complicated, "split at the root," unclear.[5]

Some of us, then as now, were Jewish, of German cultural origin; some were Holocaust survivors or children of refugees. Some of us were German or Austrian, not Jewish, but marked by the history of the Holocaust to such an extent that we could not bring ourselves to say the word, "*Jude*," or even, in English, "Jew." Some of us had left home in Europe to make what in time were to become American lives, without looking back to acknowledge or grieve the losses that our initial leaving had entailed. Some of us came from families where German, forever stigmatized by its Nazi history, had become taboo, a *Mördersprache* ("murderers' language")[6]; others from families where German continued to be a source of cultural pride. Some of us had learned English—or

German—out of desire; some out of fear. For some of us the splits ran right through our families. There were silences between and within us, chasms of hurt, distrust, and fear. And there was confusion about how and why all this mattered here and now. We did not know how to respond.

So we did what we, in our profession, have learned to do: we searched for language. In the hallways of the conference site, on walks around the grounds, over meals, and late at night in our rooms, we talked. Yet we talked in ways unfamiliar to those of us who had been trained in the meanings and use of language: with words that we knew but did not really know how to use, with the anxiety of thoughts pulled apart by conflicted feelings, with the awkwardness of ignorance that had learned to avoid questions and was now struggling to learn how to ask. We talked about such things as our places of origin, our families, and our pasts, why we were here and what "here" and "there" meant to us—things that we had never talked about with each other, at least not publicly, until then. Of course, we knew about language intellectually: its defining role in constructing our sense of personal and public identity, its fundamental instability, the splits it exacted within our deepest apprehension of ourselves. We had read Althusser, Lacan, Kristeva, and Adorno on "foreign words." But we had not put together this intellectual knowledge with what we also knew, and often differently, in our emotional and psychic selves, where language is configured by love and longing, as well as grief and shame. The intensity of our response to as simple a suggestion as "let's speak more German at Women in German meetings" clearly had to do with what we did not know how to say, and the resulting disconnections between our heads, our hearts, and our gut. That is why a seemingly procedural matter like a vote on a proposal on the question of which language we would speak with whom, and when and where, was, for us, not simply procedural. It was seismic, producing trembling along the fault lines of the conflicting histories out of which we had forged a group. For what this commonality was, in relation to these histories, had not been worked through yet. No matter how much we understood intellectually, we still had to do our "internal homework."[7]

What I will always remember about Women in German—and what I have always loved about Women in German—is that we did that homework together. Not all of it, of course; there was much that each of us had to do herself. But we took these things—things such as what language we used and what we used it for—seriously. And we worked on them; we worked hard; and we did that work together. We learned—and helped teach one another—how to take risks, emotionally

and intellectually, as we spoke out and asked questions and listened and cried and hugged and shared stories with one another. We organized sessions and workshops and studied theories that offered terms and frameworks for understanding. We experimented with format. We fought the assumptions built into our institutional practices that there are right and wrong ways to speak, legitimate and illegitimate speakers, by experimenting with different ways of organizing a conference, shaping a workshop, or conducting business meetings.[8] We changed the rules of professional discourse so that we could be more fully present to one another in the various persons we actually are.[9]

In the process, we realized that the silences between us measured our passions and our fears. In our search for a liveable language, therefore, we would have to begin to reorient ourselves from there. We would have to reconnect our language to those passions and those fears, or, as Marge Piercy put it in her poem "Unlearning to not speak," we would have to start, again,

> as the infant does
> with her own true hunger
> and pleasure
> and rage.[10]

For, to quote another poet, Olga Broumas, from her collection *Beginning with O*, as feminists and as scholars in the field of language, literature, and culture, we had committed ourselves to

> a politics
> of transliteration, the methodology
>
> of a mind
> stunned at the suddenly
> possible shifts of meaning—for which
> like amnesiacs
>
> in a ward on fire, we must
> find words
> or burn.[11]

So, where did this take us, this search for a different language? Where are we going, as the second panel question asks? My answer is this: We are going to where we have been all along: the places within ourselves and in our work together where language matters. Because it is there that we face our possibilities and find the words that we need.

Notes

For Evi—Evelyn Torton Beck—who taught me much about the living truths of words and how to embrace them, rather than fear them.

[1] This paper was written as a panel presentation for the opening session of the 2002 Women in German conference in Rio Rico, Arizona. Historically, this opening session on Thursday night has been designed to provide a link between the disparate places and experiences from which we come together for a conference and the shared space and experience of the conference itself. The premise of this session, in other words, has been that we bring our differences to the commonality that we create. For this reason, the Thursday evening session has most commonly been framed in terms of one experience of difference that all of us share: the difference between the forms and contingencies of our private lives and those we live publicly in our profession. Correspondingly, the format of this session has been different from other conference sessions also: it has been dialogic, interactive, experimental. Most commonly, we have broken into small-group discussion groups after the panel presentations; however, we have, at different times, also brought and shared photographs, done art projects together, or simply told stories about who we are. In this written version of my presentation for the 2002 Thursday night panel on "Who We Are, Where We're Going," I have chosen to retain the feel of this personal engagement in dialogue with other members of this extended group.

[2] This inversion of the standard rule for the *Women in German Yearbook* that all quotations be in English is deliberate and serves as a small textual instance of the small shocks regularly effected by language rules and their transgressions.

[3] As we reconstructed the history of this proposal in the discussion after the panel, one of us remembered that it was occasioned by the anticipated visit of Margot Schröder at our 1980 conference. Schröder, the Hamburg-based writer with whom we initiated the tradition of inviting a German-language writer or filmmaker to attend our annual conference as a special guest, did not speak English. This circumstance shifted what we had theretofore experienced as a matter of preferences or options to a matter of necessity, of courtesy, and our obligation as hosts.

[4] Adrienne Rich's collection of poems, *The Dream of a Common Language*, and her belief that in the fact of "two women, eye to eye / measuring each other's spirit, each other's / limitless desire" lay the beginning of a whole new language, were emblematic of this vision and, in that respect, symptomatic of this feminist time (Rich, "Transcendental Etude" 76).

[5] "Split at the root" is a term used by Adrienne Rich as a leitmotif of sorts in her long poem "Sources." In this poem she explores the connections, and the breaks, between the various, disparate parts of her present and past identifications, affiliations, and inherited ties: Jewish and Christian; European and American; the South and New England; her identity as a woman and a lesbian, and her unsettled relationships to her father and her former husband.

[6] In "Deutschland" ("Germany"), a poem composed in 1933, Bertolt Brecht imagines Germany as a "pale mother" in a house of murderous sons, a house in which true language is no longer possible: "In deinem Hause / Wird laut gebrüllt, was Lüge ist / Aber die Wahrheit muß schweigen" ("In your house / What's a lie is bellowed loudly / But the truth must remain silent"; Brecht, 487–88; my translation).

[7] "Internal homework" was a term given me by Evelyn Torton Beck in an email exchange as I was preparing for the panel.

[8] For example, we instituted the practice of designating co-organizers and co-chairs for Women in German conference sessions, pairing an experienced or "senior" co-chair with a novice or "junior" (usually, graduate student) co-chair. They shared the work, learned from each other, and—in their public personae as conference session co-chairs—spoke with equal authority.

[9] Nowhere, to my mind, has this changing of the rules of professional discourse and decorum become more manifest at Women in German than in the ritual of concluding the conference with a cabaret on Saturday night. For the cabaret takes the idea of a conference summation—a critically appraising look back at what happened, what we did and what we discovered in the course of the conference—and re-presents, performs, it as cabaret. Anyone can participate, either as actor or as planner; roles, plots, props, and costumes are pieced together out of what we have. Literary references or key terms from conference papers, figures and texts analyzed, slips of the tongue, turns in the discussion, even business meeting votes, as well as aspects of both personal histories of special significance at a given conference or political events in the world at large, all pass review for another look. But this time it is the irreverent look of an audience for whom the meaning of an event is measured by its total effect, not only on our intellectual, but also on our emotional and embodied selves. In this way, the very outrageousness and even deliberate silliness of the cabaret performance continues, indeed focuses, the work of the group overall, as it boldly expands the possibilities of what we can think and say—in public—with one another.

[10] Piercy (38).

[11] Broumas (24).

Works Cited

Brecht, Bertolt. *Gesammelte Werke: Werkausgabe.* Vol. 9. Frankfurt a.M.: Suhrkamp, 1967.

Broumas, Olga. "Artemis." *Beginning with O.* New Haven: Yale UP, 1977. 23–24.

Piercy, Marge. "Unlearning to not speak." *To Be of Use.* New York: Doubleday, 1973. 38.

Rich, Adrienne. "Transcendental Etude." *The Dream of a Common Language, Poems 1974–1979.* New York: W.W. Norton, 1978. 72–77.

———. *Sources.* Woodside: The Heyeck Press, 1983.

Departures: New Feminist Perspectives on the Holocaust

Lisa Disch and Leslie Morris

An introduction to the following cluster of articles, this essay explores a number of "departures," most importantly that within the field of feminist Holocaust studies from an early fascination with women's "different voice," to address far-reaching ethical and theoretical debates about representation. Specifically, this introduction and the essays that follow challenge the commonsense notion of representation as standing for an absent object, event, or experience. Using such concepts as "postmemory," "trauma," and "second-generation survivors," the authors examine the role that the repetition and circulation of images and public narratives play in constituting what gets taken for granted as "the past." (LD and LM)

In April 2001, the Center for Advanced Feminist Studies at the University of Minnesota joined forces with the Center for Holocaust and Genocide Studies to host a conference, "Departures: New Feminist Perspectives on the Holocaust." It was an ambitious undertaking. As this was a featured event in the university's sesquicentennial celebration, we had a varied and—as it turned out—conflicting mandate. We wanted to spark an academic conversation and host a public event that could satisfy the outreach imperative of a land-grant institution. We would be expected to show that humanities scholars have as much to contribute to the world outside academia as scientists and other makers of technology. And winning a few new donors to our two Centers would have been nice, too (a must in times of tight university budgets).

Because questions of identity, memory, identification, and representation lie at the core of this special cluster, it is worth asking why a sprawling research university located in a state known not for its Jewish culture but for its Lake Woebegon Lutheranism should designate such a conference as a featured event in its 150th anniversary celebration. It

was an unlikely choice. At this taxpayer-squeezed research university, the most visible intellectual initiatives of the past decade have had commercial or political applications. The newest buildings on campus house the study of management, biogenetics, law and public policy, and they bear the names of prominent politicians, business leaders, and even automobile companies—Mondale, Carlson, Humphrey, and Toyota. How would our conference, which featured nothing marketable or policy-oriented, sell itself to a non-academic community?

We turned to the arts. We began our first day's offerings not with a plenary address but with an avant-garde theater performance, followed by an art opening and reception, and concluded with a string quartet performance of music composed at the Terezin concentration camp. Over the next two days, we punctuated the conventional academic activities—paper presentations and commentary—with talks by women artists, writers, and filmmakers who engaged with questions of Holocaust representation on their own terms.

This was to be our first point of departure: to stage an academic conference by means of events that solicited the attention of a classic bourgeois public: an arts- and letters-oriented public. To be sure, there was a funding imperative at work here. But we exerted ourselves to meet that call in much more than a perfunctory way because we saw a potential—which ultimately went unrealized—for this conference to challenge received notions that conceive the critical force of Holocaust art and feminist practice to be derived from the sheer facts of history or experience.

This sets the context for how we conceptualized the Holocaust not simply as an ethical problem, but as a more fundamental challenge to the commonsense notion of representation as standing for an absent object, event, or experience. Among academics, the Holocaust has become paradigmatic for the crisis of representation that has taken hold of contemporary political, social, aesthetic, and ethical thought. This crisis prompts a break with ways of knowing that imagine language as a vehicle for self-expression, or construe "fact" as a straightforward basis on which to establish the truth of assertions about the present and past. Among feminist theorists, this crisis has taken shape as a skepticism regarding the notions of sex difference that have made it possible to refer to "women," and to speak on their behalf as subjects of injustice, bearers of ethics, and potential agents of emancipation.

It was precisely this crisis of representation that we wanted to stage at the conference. This was to be our second departure: breaking with those feminist Holocaust scholars who had taken it upon themselves to

recover and represent the lost voices and experiences of the women who survived the camps or perished in them.

Feminist Holocaust scholarship began in the 1980s with just such a recovery mission. Sparked by the field's failure to attend to women's voices—those of both scholars and survivors—feminist scholars set out to document the differences between men's and women's experiences of the ghettos, of deportation, and of the concentration camps (Goldenberg; Goldenberg and Baer; Linden; Ofer and Weitzman; Ringelheim; Rittner and Roth). This work yielded two tropes.

First, scholars emphasized how the Nazi regime put Jewish women under "double jeopardy," subjecting them to physical and emotional violence by virtue of their sexual vulnerability and vulnerability as mothers. Second, they argued that the bonds of womanhood—maternal consciousness and sisterly solidarity—afforded unique strategies of survival. As even these early scholars have come to recognize after the fact, these first studies were limited by assuming the overriding importance of sex difference, a difference they treated as a given (albeit recognizing that its meanings and import are open to social construction). Moreover, even as they aspired to transform the field of Holocaust studies, they reiterated the persecution narrative that infuses aspects of it with a kind of exceptionalism: the claim was that as special victims of history, women have a special ethic to teach us (Ringelheim).

We aimed to shift the emphasis within the field of "women and the Holocaust" away from this fascination with "different voice" and its attendant sex stereotypes. Instead, our hope was to demonstrate what feminists have contributed to the far-reaching ethical and theoretical debates about representation, and to underscore feminist contributions to exploring how the past is produced in art, by memory, and through testimony.

Over the course of the weekend, there emerged a notion of "second-generation" Holocaust survival and scholarship that staged these questions—which we meant to pose in terms of the crisis of representation—as a debate about legacy. The familial metaphor, which was inherited—in part—from the popular and critical reception of Art Spiegelman's *Maus* series, threatened to reduce the problem of Holocaust representation to a problem of time—specifically, of aging. To put it simply, firsthand knowledge of the Nazi genocide is (literally) dying off; thus there is an imperative to get the facts straight before there is no one left to testify to them. Understood in these terms, the metaphor of generations privileges firsthand or original knowledge, playing into conventional notions of representation as recovering the past. Yet, at the same time, it makes an arresting anti-empiricist gesture, as the children

of Holocaust survivors use the generations metaphor to give a name to secondhand trauma. For descendants of Holocaust survivors to style themselves as second-generation "survivors" is to open the possibility that we can suffer traumas for which we were not literally present. Beyond the familial sphere in which trauma becomes re-enacted and in this sense "lived," there is also the role that the repetition and circulation of images and stories in public discourse play in constituting what counts as real. The term "postmemory" has evolved to underscore this second, anti-foundationalist conception of the past. Postmemory, as Marianne Hirsch defines it, is not firsthand knowledge of an event as it actually happened (to borrow the tag line of historical positivism), but rather a secondhand knowledge and affective attachment, produced by images circulating in the public imaginary, that reconstructs and recirculates the past.

These terms—"second-generation" and "postmemory"—mark a potential linkage between the different ways that academics and members of the public might approach the Holocaust. As our discussions proceeded, the artist and survivor participants framed their engagement with the Holocaust explicitly in these terms, claiming to speak for and as survivors and "second-generation" survivors. These themes—daughters who have had to come to terms with losing their mothers to the camps (or even witnessing their deaths), granddaughters following the traces of events that marked their lives before they were born—were echoed in the scholarly papers that engaged this same trope of family legacy, yet aspired to foreclose these conventionally sex-differentiated terms of identification. We were at odds with ourselves. We had aimed both to open a public intellectual space and to withdraw the terms with which nonacademic women would be most likely to identify, as sisters, mothers, and daughters. Despite our efforts at bridging, our conversations fractured along familiar fault lines of generation, disciplinary specialization, public and academy, modernism and poststructuralism, Jew and non-Jew. Instead of bridging this gap, we had choreographed a series of rifts.

The first rift opened after the keynote address. One of the conference participants, a scholar and Holocaust memoirist, was deeply offended by the session. Our keynote speaker, Pascale Bos, had raised provocative questions about scholarship and popular memories of the Holocaust that took women's "different voice" as its conceptual framework. She asked whether claims about women's special survival skills (due to their orientation toward relationships) or their abject victimhood (due to the "double jeopardy" of being both woman and Jew) should be understood to produce gender as an identity rather than to validate that

"real" differences exist between men and women. As the session disbanded, the participant approached in anger: had she understood what we were "up to," she would never have agreed to participate in the conference. Incisively, she explained that she had long remained silent about her camp experience, simply accepting the fact that the iconic survivor narratives were written by men, and that anything a woman might have to say about that experience as a woman would necessarily trivialize the fact that the Nazis had persecuted her as a Jew. The field of Women's Studies had opened up a space within which her story could count for something. And now it seemed that we wanted to close that space again with trendy talk of narrative convention and fallibility. She cut straight to the point: "Now you mean to tell me we are lying?"

On its face, her question called for something we were not prepared to offer: a safe space where women could speak about their experience as women and become empowered. But can one ever speak "as a woman"? Philosopher Elizabeth V. Spelman dispatched this question beautifully when she deemed this phrase "as a woman" to be the "Trojan horse of feminist ethnocentrism" (13). The point here is that to speak "as a woman" is to imagine oneself without any other social markers—a fantasy that masks privilege. Further, to imagine that speaking as a woman could be safe is to imagine an enclave that sets "women's speech acts" outside their larger cultural, historical, and political effects.

But it would be wrong to dismiss this question as naive. For at the same time as it threatened a return to well-worn debates, that question posed—far more effectively than any scholarly address could have done—what is perhaps the most compelling connection between the fields of Holocaust and feminist studies: the fraught connection of authority to experience that is played out in the event of testimony. Testimony cuts to the heart of debates about representation insofar as firsthand accounts are taken not simply to represent the past but also to remember it, to construct it through available narrative frames. This is the paradox of testimony: that speaking neither discloses the self nor reports the past but lays bare, as Leslie Morris states, the "uncertainty of authorship, experience and identity" (294).

To explore this paradox was our third point of departure. It was what we hoped to engage by bringing writers together with artists, with filmmakers, with academics, with survivors at our conference. That this paradox opened the first rift is no wonder. Given all that we invest in testimony, is it any surprise that calling attention to the stories we impose on the past in remembering it would seem to a memoirist to question the integrity of the person?

In retrospect, we learned a great deal more from the awkward silences at this conference than from its heated debates and genial conversations. For these silences redefined our very notion of "departure." We had named the conference in a classically modernist spirit of optimism, imagining a departure from old ways of thinking that we understood and assumed would happen as a break or a rupture with the past. What strikes us now is that to depart is to be *unterwegs* ("underway"), engaged continually in acts of rewriting and rethinking that remain entangled in and engaged with what one aspires to leave behind.

Karyn Ball explores precisely this entanglement in her essay "Unspeakable Differences, Obscene Pleasures: The Holocaust as an Object of Desire." Ball critiques the role that Holocaust testimony plays—as a form of confession—in those technologies of modern power that produce subjectivities who are oriented toward the disclosure of and the search for sexual secrets. Drawing on Foucault's notion of the imbrication between power and knowledge, Ball interrogates the convention that understands testimony to foster moral solidarity—identification "as women" with victims who have suffered a specifically sexualized power. Alongside that call for solidarity, Ball acknowledges that testimony holds the lure of the abject: the clinical fascination with horror that disrupts identification to position the listener as both participating in, and titillated by, sexual violence.

Taking her bearings from Foucault's critique of the repressive hypothesis, Ball questions whether there is really any paradox in "speaking the unspeakable," as a governing trope of testimony would have it. Ball argues that unspeakability does not stop speech, but rather precipitates its ongoing and continuous iteration. Ball argues that speaking—and listening to—the unspeakable renders the spectator/auditor complicit with those atrocities by the very fact that she is fascinated by them, and feels compelled to work through that fascination. With this essay, Ball creates a departure that we did not initially envision during the planning of the conference, but one that strikes us as vital for the ongoing reconsideration of the various layers of meaning that the conference has since accrued.

In her essay, "Positionality and Postmemory in Scholarship on the Holocaust," Pascale Bos interrogates the relationship between "experience" and family inheritance and the role they play in legitimating Holocaust scholarship and in producing a cultural memory of the Holocaust. The problem as she sees it is that when family ties become a prerequisite for entry into a scholarly field, an authenticity game settles what would otherwise be the complex and muddied questions of critical engagement. As a Jewish woman and granddaughter of survivors whose

name and appearance do not signify as such, Bos perceives herself to be caught in a bind. If she does not reveal herself as an "insider," then she loses credibility. If she does so, she both reproduces that "authenticity game" and foregoes an opportunity to acknowledge or call attention to the "autobiographical imperative" that constitutes the objects of Holocaust Studies—what it regards as relevant, its research questions, its iconic figures—and legitimates who gets to speak in the field.

By virtue of the impasse that she sees, Bos has the possibility of making a departure from the authenticity game that enjoins her to claim the Holocaust as legacy. She invokes the concept of "postmemory" to twist free of the insider/outsider binary that this game sets up, yet her reading of that concept throws her back onto a familial (familiar) legacy. As we have noted, postmemory is a term that Marianne Hirsch has proposed as a way to think about how an event such as the Holocaust becomes a figure for traumas and commitments that are taken to define a cultural era. She calls it "a powerful and very particular form of memory precisely because its connection to its object or source is mediated not through recollection but through an imaginative investment and creation" (22). This is a resonant concept, one that has been especially influential in redefining the problems of history in Holocaust studies so as to render them amenable to feminist epistemologies and methodologies. Yet as our contributors' essays show, Hirsch's formulation invites a contradictory reading.

Much as Hirsch aspires to complicate the commonsense notion of memory as merely re-collecting past experience, she nonetheless reproduces a key piece of that notion when she defines postmemory as effecting a "connection to its object or source." This referencing of memory to a prior object or source imports into postmemory a conventional understanding of representation that conceives of memory literally, as coming after the fact. Read this way, postmemory differs from conventional recollection only in kind: the connection to the source is mediated not by a remembering subject but by the repetition and circulation of iconic figures (the visage of Anne Frank, a cattle car, "Auschwitz"). Such a reading of postmemory lends itself to this notion of the Holocaust as family legacy, something that appertains literally and exclusively to the descendants of Holocaust survivors.

At the same time, however, Hirsch's emphasis on "imaginative investment and creation" gestures toward a conception of memory not as a representation that corresponds to an empirical past but as an effect of the repetition of signifiers that refer only to each other. Understood this way, memory is not foundational. It does not invite identification with a (lost) original experience, nor can it establish a legacy by way of

descent from that defining moment. It takes hold instead by a proliferation of sounds, visual images, scripts "as part of an ongoing process of intertextuality, translation, metonymic substitution, and a constant interrogation of the nature of the original" (Morris 293). We are drawn to this second reading of postmemory because it breaks the link between experience and identity and thus interrupts the discourse of authenticity.

Postmemory certainly could serve Bos to disrupt the authenticity game, yet in her response to the photographs in Ann Weiss's *Eyes from the Ashes,* she deploys the concept to defend a fairly literal notion of memory as family inheritance. *Eyes* is a "memory project" that (among other things) composes family photos recovered from Auschwitz deportees into an album-style coffee table volume. It is, as Bos argues, disconcerting to imagine the Holocaust on display in such a format. Yet when she frames her criticism as a concern that the volume enjoins its readers to enter into it as if it were a family album, thereby transforming photos that ought to hold some "personal attachment" into "collective sign," Bos seems to deny the very premise of postmemory—the Holocaust as icon. For Bos, it seems that photos should do no more than document lost lives, functioning exclusively on a literal register that represents an absent original. In this, Bos suggests not an endorsement of postmemory but its critique. In so doing, she restores to authenticity its grounding in both the lived past and the recollecting subject who remembers and is remembered in turn—especially by family. It is precisely for this ambivalence toward authenticity that Bos's essay is valuable: it demonstrates how attachment to loss—for loss is itself a mode of constituting the past—both enables departures and weighs them down.

The essay by mother and daughter Elizabeth Baer and Hester Baer, "Postmemory Envy?" stages this debate about legacy differently: whereas Bos is at odds with herself, Elizabeth Baer and Hester Baer come into a conflict with each other during their collaboration on *The Blessed Abyss* that moves both of them forward. The discovery that they had a relative in a concentration camp gave them—as Catholics—an unexpected family tie to the Holocaust to which each responded quite differently. For Elizabeth Baer, who had felt quite violently positioned by what Bos calls the "authenticity game"—as "a trespasser in the field of Holocaust Studies"—discovering Herbermann came as confirmation of her deep sense of identification with the Holocaust as a defining ethical event. Ironically, this was postmemory as we understand it, an affective identification without a ground in experience. But for Elizabeth Baer, Nanda Herbermann gave her postmemory in the literal sense of a legacy that "gave me a toehold in a field where legacy matters—even if

scholars are reluctant to acknowledge this" (80). For Hester Baer, operating within an equally traditional—if antithetical—set of conventions, a German relative compromised her "critical distance" as a scholar in German studies (85). Their essay charts the course of their collaboration as a calling each other to account, with Hester Baer troubling Elizabeth Baer's desire for authenticity and Elizabeth Baer tempering Hester Baer's disdainful distancing.

Upon the book's publication, Wayne State University Press moved their debate from questions of authenticity and familial legacy to postmemory in its other register. The press included the book as part of its Jewish studies list, and chose to publicize it by running a photograph of young Herbermann in a dirndl on the front cover of the catalogue. The photo, by its reiteration of the iconic shot of Anne Frank, produces a perverse subject—"the survivor in the dirndl"—whose very hybridity testifies to the impotence of family, legacy, and authenticity to define the field of Holocaust scholarship or accredit Holocaust scholars on the strength of family ties. Baer and Baer make a departure from the bonds of legacy when they conclude by affirming the multivocality of Herbermann's text, its status as a document, a translation, and a dialogue between three generations who do not merely transfer a document from one language into another but write a book in that act of translation.

Like the essay by Elizabeth Baer and Hester Baer, Irene Kacandes's essay, "Making the Stranger the Enemy: Gertrud Kolmar's *Eine jüdische Mutter*," focuses on the textual layers and the act of reading in her attempt to understand the historical and cultural underpinnings of the process of marginalization and extermination of the Other during the Weimar era and the Third Reich. Drawing on Primo Levi's idea of the "unspoken dogma" that leads to the *Lager* (camp), Kacandes focuses on Kolmar's 1930–31 text as a "cultural key to the historical moment in Germany when Levi's 'random, disconnected acts' and 'unspoken dogma' start to become the 'major premise'" (99–100). In a reading of the text that uncovers the gaps and the unspoken as much as the narrative thread that does move the story forward, Kacandes presents *Eine jüdische Mutter* as a "blueprint" for the "random, disconnected acts" that led to the Holocaust and as a staging of the attitudes in the 1930s that "every stranger is an enemy." Kacandes speculates about the reasons why Kolmar, already a published poet, did not try to publish *Eine jüdische Mutter*, which she had completed two years before the Nazis' rise to power. Kacandes concludes that the moral complexity that Kolmar establishes in the novel was perhaps Kolmar's way of grappling with Levi's idea of the "random, disconnected acts" that led to the

Lager itself, and yet this moral complexity, which remained in 1931 still unspoken, is what prevented Kolmar from seeking publication.

Kacandes opts not to look at Kolmar's text as an "aesthetic object," but rather as a cultural artifact that enables an investigation of the convergence of debates in Weimar Germany on gender roles (the "New Woman"), sexuality, and racial hygiene. She thus presents a careful close reading of the text in order to draw out precisely the figuration of these debates in the text and the question—drawn from Levi—of how historical events could unfold to the point of the *Lager*. Yet despite her disavowal of the aesthetic status of the novel, Kacandes nonetheless invokes aesthetic questions when she acknowledges the melodramatic and sensationalistic aspects of the narrative. By establishing the affective links between reading and the self, Kacandes proposes new ways of thinking about text and the ever-contested realm of "experience"—including the experience of reading popular fiction.

This special cluster strikes up a conversation that is very much in the spirit of a departure as we have come to understand it. Furthermore, the four essays that we selected represent as well the "departure" from traditional *Germanistik* that marks current work that is being done in the interesting border zones between German Studies, Holocaust Studies, and Jewish Studies. The essays thematize new ways of thinking and the problems that new ways of thinking raise. They also enact the sense of entrapment, the disorientation, and the frustration that grip us because we can never depart in full. This makes them especially valuable: they are working through the process of departure with its attendant problems, without arriving at a resolution.

Works Cited

Goldenberg, Myrna. "Testimony, Narrative, and Nightmare: The Experiences of Jewish Women in the Holocaust." *Active Voices: Women in Jewish Culture.* Ed. Maurice Sacks. Urbana: U of Illinois P, 1995.

Goldenberg, Myrna, and Elizabeth Baer, eds. *Experience and Expression: Women and the Holocaust.* Champaign: U of Illinois P, 2000.

Hirsch, Marianne. *Family Frames: Photography, Narrative and Postmemory.* Cambridge: Harvard UP, 1997.

Linden, Ruth. *Making Stories, Making Selves: Feminist Reflections on the Holocaust.* Columbus: Ohio UP, 1993.

Morris, Leslie. "Postmemory, Postmemoir." *Unlikely History: The Changing German-Jewish Symbiosis, 1945-2000.* Ed. Leslie Morris and Jack Zipes. New York: Palgrave, 2002. 291-306.

Ofer, Dalia, and Lenore J. Weitzman. "The Role of Gender in the Holocaust." Introduction. *Women in the Holocaust*. Ed. Ofer and Weitzman. New Haven: Yale UP, 1998. 1–18.

Ringelheim, Joan. "Women and the Holocaust: A Reconsideration of Research." *Signs* 10.4 (1995): 741–61.

———. "Thoughts about Women and the Holocaust." *Thinking the Unthinkable: Meanings of the Holocaust*. Ed. Roger Gottlieb. New York: Paulist Press, 1990. 141–49.

Rittner, Carol, and John Roth. *Different Voices: Women and the Holocaust*. New York: Paragon House, 1993.

Spelman, Elizabeth V. *Inessential Woman: Problems of Exclusion in Feminist Thought*. Boston: Beacon Press, 1988.

Unspeakable Differences, Obscene Pleasures: The Holocaust as an Object of Desire

Karyn Ball

This essay explores the prospect of a will to power/knowledge in feminist approaches to the Holocaust. My thesis is that a cultural fascination with Nazism over-determines feminist responses to women's testimony as a source of new knowledge about the gendered and sexual differentiation of traumatic historical experience. I therefore analyze the overlap among post-memory, fantasy, and sympathetic introjection as venues of symbolization that are affected by disciplinary structures of identification, professionalization, and self-surveillance. At stake is the ethics of a feminist commitment to progressive politics that forecloses the role of sadomasochistic fantasy in the disciplinary configuration of compassion. (KB)

The "Departures: New Feminist Approaches to the Holocaust" conference in the spring of 2001 brought together scholars who shared an interest in moving away from perspectives on the genocide that relied on falsely neutral or essentialist treatments of gender and sexual differences. Midway through the proceedings, participants were invited to step outside our debates to hear a panel of women survivors of the Final Solution recounting scenes of physical violation, bereavement, and, in the interstices, the sheer luck that allowed them to survive. We sat in rows in a capacious auditorium at the University of Minnesota, our eyes riveted on the platform below. The survivors on the platform had been encouraged to speak specifically about their experiences as women who had been interned in the concentration camps or who, through resistance and flight, had miraculously evaded the sweeping arm of the Final Solution.

Like the other members of the audience, I listened sympathetically to the testimonies of the survivors. In the conversations that took place afterward, I agreed with the conference participants that these women

had courageously confessed incidents that added a new and important dimension to our understanding of the Holocaust. Yet my sympathy for these women could not foreclose an uneasy awareness that the space of our encounter distanced the scholars from the survivors, and elevated us above them for the purposes of observation. Was this auditorium not, in effect, a theater of what Michel Foucault would call the will to power/knowledge?

To visualize this point, it is worth recalling another auditorium scene depicted in Thomas Eakins's *The Agnew Clinic* (1889). The painting portrays a surgery theater closely packed with male medical students keenly observing a surgical operation being performed on a nude woman's breast. Eakins's reflexive depiction of this scene ironically links the viewer's attention with the earnest gaze of the medical students in the background of the painting as they concentrate on the surgical demonstration in the foreground. This gaze is accentuated by the shadowy contours around the men's eyes. In contrast, the prone white female body covered from the waist down on the surgery table is lit up as though it were on stage.[1] Dark hair marks where a head should be, but the woman's face is not shown. One breast is exposed while the other disappears under the surgeon's hands and their ambiguous surgical instrument. Either the missing breast has been mutilated, cut away altogether, or the angle prevents us from viewing it.

Before such a chilling spectacle, a feminist need not be reminded that a nude female body remains, before the "man of science," a nude female body, even under his surgical knife. In its depiction of the scopic drive to penetrate the secrets of a female breast, Eakins's realist painting performs a paradoxically clinical analysis of the crudely masculinist ethos of modern scientific progress. The object of desire is an object of knowledge: the quintessential fetish poised for dismemberment.

I conjure this scene because it illustrates an ominous nexus of corporeal objectification and voyeurism as the conditions of an emerging scientific self-consciousness. The men's putatively clinical gaze is a product of professional training and disciplinary rigor that nevertheless cannot be separated from a lust for mastery that establishes the collective identification of male students in a surgical theater at the end of the nineteenth century as a scientific community. The painting disturbs me because the moral and social sanctioning of this gaze in the name of medical progress does not relieve my suspicion that the scientific observers represented in it nevertheless derive obscene pleasure from the spectacular penetration of naked female flesh.

As a feminist, I could, perhaps, assure myself that I occupied the auditorium in Minneapolis very differently—as a compassionate listener

rather than as a clinical voyeur. Yet to the extent that feminist studies has, in the course of the last three decades, emerged as a disciplinary field in its own right, my attempt at self-assurance seems naïvely self-congratulatory. It takes for granted the institutional trajectory leading up to that moment when women survivors were positioned publicly to confess incidents that shamed them while placing a professionalized me on the observer side of that auditorium (my sympathy notwithstanding) as a vehicle of disciplinary power.

Certainly, the differences between the scenario depicted in *The Agnew Clinic* and the panel of survivors at the "Departures" conference are considerable and will require discussion, but there may also be crucial lessons to be learned from their troubled similarities for feminist scholarship and for progressive agendas as a whole. To bring these lessons to the fore, what follows is a critical speculation on the prospect of a feminist gaze. In keeping with Foucault, I understand the gaze in a disciplinary sense as a locus of external and internal surveillance affected by the confluence of professional training, ethical or scientific protocols, and institutionally shaped scholarly desires. The issue is how I might take responsibility for the ways in which my gaze as a "compassionate feminist" may be inadvertently complicit with what Foucault has critiqued as a will to power/knowledge in his history of the discourse of sexuality: the urge to construct, implant, and locate sexual perversity under the guise of unmasking it; to isolate, map, and codify its secrets as a means of controlling it. Foucault suggests that the promise of "bearing light" on this "latent" or "dark" secret animates a psychoanalytic will to secure its scientific self-understanding. The question I invite readers to consider is whether a feminist scholarly agenda calling for attention to the gendered and sexual differentiation of historical experiences colludes with this will in sexualizing the untold and therefore "secret" horrors of the Holocaust. To answer this question, it will also be important to depart from Foucault in order to consider the unconscious value of women's Holocaust testimony as an object of feminist inquiry. What would it mean to view this testimony not only as a focus of feminist scholarship, but also as a voyeuristic venue of fantasy and repressed desire?

* * *

There is a telling slippage in my introductory remarks when I allude to Holocaust testimony as a form of "confession." Given my references to Foucault, this slippage is obviously not inadvertent. My contention is that the context of giving and hearing testimony in an academic forum mobilizes and reinforces power relations that enter into the disciplinary

formation of subjects by rendering them vulnerable to location, categorization, and judgment. These power relations also affect modes of imaginary identification that include sympathy. I will consider the disciplinary configuration of what I want to call the "compassionate imaginary" at a later point. I want to begin by exploring the differences elided by such a slippage that bear on the status of testimony for firsthand witnesses, historians, and psychoanalysts.

One of the most self-evident differences between my relation to the survivors' testimony at the "Departures" conference panel and the clinical gaze of the surgery students in Eakins's *The Agnew Clinic* is the compassion that I felt for the women seated on the platform. This compassion is genuine, but it is also obligatory on an ethical and professional level. A failure to sympathize with testifying survivors would be deemed morally repugnant by Holocaust scholars and feminists alike. In addition, my willingness to permit myself an explicitly affective relation to my object is historically determined by feminist critiques of the myth of scientific neutrality that affirm the need to retain sympathy in my professional demeanor as a scholar who positions herself precisely against a masculinist and positivistic opposition between "objective" science and feeling. From this perspective, sympathy is no longer simply a "spontaneous," "natural," or "heartfelt" response since it is also already coded on a professional level as "proper" behavior for a secondhand witness and a feminist. In addition, Holocaust scholars who reflect on the processes of giving and hearing testimony foreground the role of compassionate listening in response to Holocaust survivor testimony and, by implication, testimonies about other traumas. What is sometimes missing from these accounts is a willingness to recognize the structural and regulative effects of the testimonial context upon the processes of subjective formation that are, at once, individual and collective.

It is a commonplace that historians see testimony as a prospective source of evidence that they employ to evaluate other details and resolve disparities among varying accounts, though one that must itself be evaluated with and against other sources. In contrast, the most frequently cited psychoanalytic and literary considerations of testimony, among them Lawrence Langer's *Holocaust Testimony: The Ruins of Memory* (1991) and Shoshana Felman and Dori Laub's *Testimony: Crises of Witnessing in Literature, Psychoanalysis, and History* (1992), tend to treat it as a poetic configuration of traumatic history's impact on the witness.[2] This impact is therefore not merely an aspect or result of the facts of persecution and genocide, but is intrinsic to the very configuration of the Holocaust as a traumatic object of scholarly inquiry. What such perspectives share is an investment in the value of testimony as a

"firsthand" description of the genocide that guarantees its abiding significance in the writing of history and in survivors' own personal trajectories. In bearing witness, the survivor thereby serves as an oral "vehicle" for a written confirmation that surpasses the finitude of the event by memorializing the dead and revealing the extremities of the human condition with the attendant lesson never to let genocide happen again.

Laub's analysis of the split between historical and psychoanalytic views of testimony prioritizes the need to treat all events in the survivor's discourse as valuable in contexts wherein analysts and other scholars make up the audience. Such compassionate listening affirms the truth of the survivor's testimony as an imaginary and poetic venue for understanding the impact of events on frames of reference, which takes precedence over and against competing historiographical protocols, including the demand for facticity, consistency, and logic.[3] The problem with Laub's analysis is that it leaves us with a reductive opposition between factual and psychoanalytic definitions of truth and thus ignores the ways in which the discipline of history relies on a narration of events that poetically configures its moral impact.[4]

Ellie Ragland moves beyond this reductive distinction in recognizing that compassion turns on a "transferential relation" to the testifying survivor that inspires the listener's belief in the truth of the testimony within and beyond its imaginary and narrative valences.[5] This recognition suggests that the good intentions motivating a testimonial audience do not negate its potentially disciplinary aspects, but may, in effect, reinforce them. Dominick LaCapra has argued that transferences occur not just between analysts and analysands in the psychoanalytic session, but also between scholars and their objects of inquiry. In his analyses of historical debates, LaCapra defines transference in a nontechnical sense to refer to the ways in which historians are implicated through their affective investments in the objects they study. Their identification with the object becomes charged or "cathected" in a psychoanalytic sense through "processes active in it [that] are repeated with more or less significant variations in the account of a historian" (LaCapra, *Representing the Holocaust* 72).

More recently, LaCapra has warned scholars against the danger of narcissistic identification with the traumatized when he cautions us "not to assume the voice of the victim" in our interpretations.[6] His warning strikes against the myth of scientific neutrality as well as the paradoxical ideal of disinterested or professional sympathy. It suggests that my compassion for the women Holocaust survivors transpires within imaginary structures of individual and collective identification. Such identifications are narcissistic insofar as they shore up a sense of professional integrity

and selfhood that is inextricably bound up with a desire for social acceptance. It is this desire that sustains academic investments in disciplinary protocols that protect the contents and parameters of a field of study. This is to say that my sympathy, no matter how helpful or sincere, might offer the inadvertent "side benefits" of confirming my membership in a professional community while reinforcing the Holocaust's value as an object of inquiry.

There is another structure of imaginary identification that influences my investment in any field, including but not limited to Holocaust studies. When I speak about the Holocaust as an object of desire, I am acknowledging its regulative power. As an internalized ideal, the object of inquiry guides my attempts to do justice to it in my work and thereby affirm my sense of rigor. By virtue of its status as a regulative idea "in the mind's eye," as it were, the internalized image of the object of inquiry is disciplinary in a double sense: it determines the ways that scholars police the boundaries of their fields of study and it thereby reproduces the power of their affective investments and institutional protocols to compose new phenomena.[7]

My conceptualization of the Holocaust as an object of inquiry/desire highlights its configuration as a composite memory-image, or perhaps more precisely, as a "memory-idealization" based on my imaginative recreation of historical narratives and testimonies, as well as trace recollections of photographs and films depicting it. This idealized composite shares a permeable border with what Marianne Hirsch calls "postmemory," to designate secondhand identifications with survivors and victims of the Holocaust through the images that memorialize it.[8] Borrowing from Geoffrey Hartman, Hirsch defines postmemory as "retrospective witnessing by adoption," which involves taking on the experiences of the Holocaust's victims as if they were one's own and "inscribing them into one's own life story" (Hirsch 10). This vicarious inscription is the condition for a link, postulated by Hirsch, between the belatededness of trauma as an aftereffect of a wounding event and the potentially ethical role of postmemory, which involves a work of formulation and "attempted repair." In this respect, Hirsch's analysis echoes Cathy Caruth's standpoint on the traumatic event as an epistemological "missed encounter" (see Caruth, "Unclaimed Experience"). The repetition that reveals the impact of trauma thus represents a paradoxical mode of retrospectively seeking to obtain knowledge of a danger that could not be anticipated. The lag between the event and its affective reactivation structurally divides the prospect of this failed knowledge from its origin, which means that the traumatized may not ever succeed in closing the gap between a bypassed experience of the past and the present where its

impact is relived. For this reason, it may, as Hirsch remarks, be left up to subsequent generations to work through a traumatic encounter that they were never in a position to miss (12).

Hirsch's emphasis on the social and potentially ethical dimensions of postmemory casts a constructive light on the compulsive recycling of certain photographs of the Holocaust that might otherwise suggest the paralysis of traumatic fixation. Yet she is also committed to theorizing the relationship between postmemory and a potentially voyeuristic gaze, which she distinguishes from the look that might interrupt and thus disorient it. Drawing on Jacques Lacan, Hirsch notes that "while the *gaze* is external to human subjects situating them authoritatively in ideology, constituting them in their subjectivity, the *look* is located at a specific point; it is local and contingent, mutual and reversible, traversed by desire and defined by lack." Whereas the look is returned, the gaze turns the subject into a spectacle (23-24). In sum, the look disrupts the gaze's powers of unilateral objectification by aggravating the subject's sense of being split between imaginary and symbolic identifications.

Hirsch's investment in the ethical potential of postmemory will lead her to situate it not with the gaze, but rather with the look, which can be shared between the first- and second-generation witnesses of the Holocaust and therefore counteract the distancing effects of the gaze. Yet in an academic forum such as the one that took place in Minneapolis in an auditorium that elevated the surveyors above the surveyed, the sharing of looks cannot be isolated from the process of mapping the space of the encounter between firsthand and postmemorial witnesses. In this space, the survivor's look might temporarily break the spell of my fascination and unsettle my gaze as a professional listener, but this provisional disruption may actually reinforce disciplinary power rather than dissolve it.

Hirsch's delineation of the gaze underscores its external power over the subject who experiences it as an alienating outside that profoundly determines him/her in the visible realm. Though she relies on Lacan for this definition, it overlaps with Foucault's conception of the gaze from *Discipline and Punish,* as a venue for the intersubjective specularity of surveillance. The Foucauldian gaze renders the subject visible, thereby locating and fixing her in space and time; however, Foucault scrupulously sidesteps the psychoanalytic focus on conscious and unconscious mechanisms. Instead, he foregrounds the internal and structural power of the gaze to exact and reproduce willing subjection. The gaze is the medium and effect of "panopticism," which he identifies as the topos of modern societies: the guard may or may not be watching at any given moment so the prisoners regulate themselves to avoid the punishments

that befall those who are inadvertently caught transgressing the prison rules.[9] The panoptic theory of generalized yet partial surveillance suggests that the external and internal valences of the gaze affect the formation of subjects as docile bodies. The subject's internalization of the surveillant gaze (of the prison guard, the foreman, the teacher, the administrator) is the basis of the "success" of societies that depend upon the self-regulative pliancy of citizens and workers who must be reliably depended upon to oil the machinery of capitalism without overtly repressive interventions by the state.

What is crucial to my understanding of the gaze is precisely Foucault's critical recognition of the ways in which subjectification is a byproduct of disciplinary specularity, or what he calls the "trap" of visibility: the gaze marks out its subjects in a field as objects/specimens of information and of institutional, clinical and/or voyeuristic interest at the same time that the voyeurs in their turn remain sensitive to the prospect that they may also be caught in the act of stooping to peer through the keyhole. This prospect shames them not only in the moment, but also prior to the act to the extent that it compels the subject to anticipate the ever-imminent look that may spell humiliation, punishment, and ostracism. In this manner, the present and future contingency of the look subtly spurs the internalization of the gaze that coerces subjects to behave properly both in public and private. Once re-externalized, however, this gaze functions as a camera lens/weapon to study and to discipline other subjects.

This collusion between the external and internal force of the gaze has significant implications for professional academic behavior. For it suggests that scholarly approaches are a function of an idealized set of behaviors that exert a mimetic and superegoic pull on the social subject and direct her critical and analytical evaluations of others. The subject is, in this respect, temporally fractured between the external and internal gaze, beholden to present and future judgments of her prospective critics and colleagues on the one hand and, on the other, the protocols modeled by her past masters that she assimilated through training and professionalization. The external-internal matrix of the disciplinary gaze is important because it organizes the imaginary relations that constitute my sympathetic connection with survivors. It may therefore determine the effect of giving and hearing survivor testimony in the space of power/knowledge. I want to argue that the structure of such spaces is implicitly coercive insofar as the tacit rules governing them induce the survivor to perform in front of an audience that reciprocally feels authorized and/or obliged to listen.

Jean-François Lyotard and Shoshana Felman have observed that witnesses are sometimes reluctant to speak out of guilt for having survived when so many others have died, out of fear that their speech will not do justice to the events, or that it will not be believed. In such instances, the survivor may not wish to revisit agonizing situations or burden others by bringing them into the light of day. In these cases, the attempts of historians, psychoanalysts, interviewers, or even family members to convince a survivor to testify may be experienced as coercive despite any relief it might bring.

While it cannot be extended to all testimonial contexts, it is instructive to consider what I want to call the "confessional effect" to call attention to the ways that sympathy cannot erase the disciplinary structure of the testimonial transmission of traumatic knowledge—the very fact of a distance at once spatial and empirical that separates the survivor testifying before an analyst or audience. This effect is remarkable in certain scenes of Claude Lanzmann's *Shoah,* and particularly those centering on the barber, Abraham Bomba, who was forced to cut the hair of naked women and children in consecutive groups of 70–140 before they entered the gas chambers. Recalling that he also cut the hair of women who had been neighbors and close friends, and that another barber had been compelled to work on his own wife and sister, Bomba begins to weep and does not want to continue. Lanzmann is unrelenting in his insistence that the survivor not only recount the most excruciating details from this incident, but that Bomba also describe his feelings about it while cutting a customer's hair in a barber shop. Lanzmann's technique hereby confronts the spectator with the monstrosity of a genocidal system that places Bomba in the position of cutting the hair of women, among them relatives, friends, and neighbors, when he knows that it is in preparation for their murders. The director clearly operates on the assumption that the more personally devastating it is for the witness to recall an incident, the more profound the nature of the evil displayed. Learning this unbearable "lesson" firsthand is important, but it comes to us through Lanzmann's deployment of confession as a disciplinary technology to ferret out a "hidden truth" rendered more valuable by virtue of the painful reluctance that surrounds it and the labor of mining it.

It might be objected that Lanzmann is purposefully coercive in contrast to a scholarly conference in which survivors are invited to say what they wish on their own behalf rather than cringe before a camera that eternalizes their spontaneous expressions of anguish as they face an inescapable barrage of questions. The problem with this view is that it fallaciously sets Lanzmann's technique apart from less explicitly coercive

testimonial modes; it consequently leaves no room for a consideration of the nonvoluntary and even involuntary aspects of speaking about mass murder and persecution before an audience in other contexts. In public forums, the Holocaust survivor's status as a firsthand witness places a particular onus on her as a bearer of historical and moral lessons and as the immediate "presence" of an event's truth. The premise that obligates her consent is that offering up her truth will benefit humankind by teaching us "what went wrong" in Germany in the first half of the twentieth century and/or by giving us "important insights into the nature of evil" and the experience of victimization. From this standpoint, a survivor's testimony begins to resemble confession in the Foucauldian sense of a disciplinary technology.

It is in the context of the first volume of *The History of Sexuality* that Foucault introduces the confession as a technology of modern power, which has been crudely deployed with varying degrees of sadism by an array of state-sponsored authorities from the premodern to the early modern and modern periods. According to Foucault, it is when the confession is separated from torture and becomes voluntary that its coercive powers become subtler and therefore more effective. In a voluntary confession, belief and action reciprocally affirm each other while consolidating a subject's identity as an individual and as an accepted member of a collectivity. The voluntary confession thus derives its power by serving a four-fold purpose: it elicits information that may further a particular social, progressive, and/or scientific agenda, it produces the status of the confessing individual as a particular subject, it affirms this subject's compliance with the rules and values of a civil society, and it consolidates the authority and respectability of the interests that enjoin the confession.

Once connected to Foucault's argument about the discursive construction of sex, the disturbing dynamics of this four-fold power become unmistakable. Here, we will do well to remember that his departure point in the introduction to *The History of Sexuality* is a critical challenge to the so-called "repressive hypothesis," which reductively assumes that power functions only negatively as a function of norms, social policy, and laws that systemically impose prohibitions and constraints. If followed through historically, this hypothesis would purport to explain the alleged silencing of sex, treated as the essence and origin of transgression, and a pathological excess as such. Yet Foucault dismisses this narrative, focusing instead on the proliferation throughout the modern period of juridical, institutional, and medical strategies for isolating and regulating sex as an emerging object of knowledge. The evidence for this multiplication reverses the repressive hypothesis in

demonstrating that discourse about sex was hardly suppressed. Indeed, it was becoming omnipresent and omnivalent as the impetus and end of technologies of power aimed at "discovering," which is to say, producing, implanting, and regulating, the "essence" of human life and death. Sex would become this "essence" to the extent that it had been constructed through interweaving discourses as the covert motivation of human activity which, by virtue of its innate impropriety, lies buried "in the depths." Bringing this secret to light thereby becomes the modus operandi of a rational bourgeois science caught in a paradox of its own making: it naturalizes its class-specific norms and anxieties in the same move with which its practitioners hold these self-same norms up to methodical scrutiny as "repressive," "neurotic," or "primitive" superstitions that their own detached public airing of the issue at once contravenes and supersedes.

In short, the first volume of *The History of Sexuality* suggests that sex is the incentive and aim of the confession as a technology of modern subjectification. Within this economy, sex assumes the value of power/knowledge capital as the mystery of mysteries, the shameful secret that must be suppressed beyond (and beneath) all others. Its extrication promises wisdom into the "shadowy recesses of human nature," which bestows still greater authority upon the "surgeon" of souls, the confessor garbed in various professional uniforms. At the same time, the voluntary confession corroborates the commitment of the confessing subject, along with her confessor, to the conventions and ideals of an enlightened civil society. The uniqueness of the disciplined subject is inaugurated in this moment of offering up his essential, personal, and ultimate truth, his hidden perversions, and unspeakable desires. Is it surprising, then, that he would come to enjoy confession as a means of shoring up his individuality, expressing his unique subjectivity, and of guaranteeing the existence of his soul? If hermetic lyric poetry, autobiographical novels, and pseudo-therapeutic talk shows proliferate in the contemporary era, then it is because the pleasures of confession as a technology of subjective constitution have expanded to the domain of public consumption as a whole.

In "Social Bonds and Psychical Order: Testimony," Susannah Radstone highlights the ways in which a narcissistic and confessional culture promotes self-absolution through public acts of self-scrutiny in the interests of historicizing testimony in light of shifting styles and aims of confession. Radstone's reading of the contemporary proliferation of confession suggests that it covers over the nature of postmodern authority, which has become "diffuse, all-pervasive, and unavailable as a point of identification." In such an environment, the public character of

testimonies cannot be entirely extricated from the public confession conceptualized as a "technology of self," which, according to Radstone, serves to restructure confused power relations between civil subjects and the social order.[10]

Radstone notes that "at least since the 1980s, the confessional order has been countermanded by an injunction, not to self-scrutiny and self-implication, but to bear witness, rather, to the sufferings of others" (60). I would add that this counter-injunction is, in part, a product of the recent institutional history of feminism growing out of the early consciousness-raising groups that led up to the women's liberation movement. Once it became coupled with the multiculturalist perspective in the 1980s, academic feminism opened an institutionally sanctioned channel for women of various backgrounds to testify on their own and others' behalf in order to reverse the silences imposed on them by a sexist and racist society and thereby raise critical consciousness among members of dominant groups. It is important to recognize that this agenda instituted subject-positions for survivors of persecution and genocide to the extent that it depended on their willingness to fill certain pre-assigned roles in public forums that were typically organized and attended by white liberal feminists. Because such forums institutionalize a moral inducement to give and to hear testimony, they assume a disciplinary power to constitute the testifying individual as an obedient subject offering up his or her "authentic" firsthand knowledge.

What is paradoxical about this institutional history is that it transpired in tandem with the growing currency of Foucault's work in feminist circles and for cultural critics as a whole. The broader availability of *The History of Sexuality* in English-speaking countries after its translation in 1978 coincided with the rise and entrenchment of feminist perspectives in the North American university where Foucault's emphasis on the discursive construction of bodies and pleasures was initially perceived as useful to feminists. By demonstrating that discourse is not merely written or spoken, but contingently embodied, Foucault offered a non-essentialist view of the ways individuals and groups are inscribed by categories of gender and sexuality that are themselves produced by historical forces. His consideration of the discourse-power-knowledge nexus was thus a boon for feminist scholarship that sought to disarticulate sex and gender while challenging the putative neutrality of male-centered approaches.

Despite his ground-breaking influence, Foucault's analysis of disciplinarity implicates a feminist preoccupation with gender, sex, and the body in a contemporary will to power/knowledge. For if the repressive hypothesis orients the modern search for truth, then it would

compel us to locate the "real" secret of historical existence in its sexual dimensions—those erotic elements that our repressed societies compel subjects to hide or disavow. These are the "secrets" that a feminist emphasis on embodied experience is customized not only to expose and dissect, but also to disavow. The issue is whether a feminist approach to testimony about the Nazi crimes thwarts and/or enables these ambivalent pursuits. What would it mean to "sexualize" the Holocaust?

* * *

In my introduction, I linked the audience of the survivor panel at the "Departures" conference with the specular dynamics of a nineteenth-century surgery theater and the coldness of the male scientific gaze depicted in Eakins's *The Agnew Clinic*. This linkage chafes against the ethos of feminists and Holocaust scholars who prioritize compassion and respect in testimonial contexts. It might be objected that the scholars filling the seats of the auditorium at the University of Minnesota were not ponderous nineteenth-century men in black, but feminists who consciously discipline themselves to avoid a masculinist objectification and penetration of the female body. In addition, while the institutional dimensions of such a forum undeniably propelled both audience members and survivors to fulfill certain prescribed roles, the women on the platform were neither passive nor prone as they spoke about their experiences. Unlike the woman in the Eakins painting, the panelists were not abject: they had survived persecution, genocide, and devastating bereavements—the losses of parents, siblings, children, and spouses who were sometimes murdered right before their eyes.

Indeed, what I learned from their testimony is that these women suffered forms of objectification that surpassed the uncanny and alienating spectacles of early surgical exploration captured in *The Agnew Clinic*. One woman testified that she had not only been forced to strip before being subjected to a vaginal search, but was also compelled to watch as her mother and others endured this humiliation. Mother and daughter were enjoined in turn to undergo and to witness the other's shame at the hands of Nazis who did not recognize Jewish women's humanity. It is, of course, very significant that my memory of the panel lingers on this testimony. What needs to be considered is how this evidence of my own fascination troubles the ethics of my position as a sympathetic postmemorial witness in ways that bear on the very different experiences of giving and hearing this testimony at a scholarly conference.

I will begin by noting that the survivor who recounted this episode seemed both surprised by and grateful for the safe and respectful space

that had been opened for her to articulate what she had never before revealed: the humiliations that she endured in the camps as a woman. The mortification and shame that had prevented her from previously mentioning this situation involving a hostile stranger probing her body against her will doubtlessly returned in the course of her reconstruction. For my part, I could, perhaps, pride myself for belonging to a community of feminist scholars who were opening up this officially sympathetic space in which she might share an anguished moment from an unbearable history by breaking a burdensome silence.

I employ the aggressive word "breaking" here to emphasize the potentially problematic nature of my well-intentioned sympathy in these contexts. Such sympathy is problematic because it entails a fantasy-prone mode of transferential identification with the other whereby I introject myself into a reconstruction of her experience. Radstone (2002) takes up this problem in a recent reflection on September 11th, where she calls us to recognize that there is always a fantasy at stake in the way that we narrate and make sense of the trauma. She observes that an "event may prove traumatic, indeed, not because of its inherently shocking nature but due to the unbearable or forbidden fantasies that it prompts." She consequently argues for the value of a psychoanalytic perspective with its emphasis on the ways in which "the world of fantasy is inextricably connected with sexual difference and with desire."[11]

In "Social Bonds and Psychical Order," Radstone analyzes the prospective staging of such fantasies in the testimonial context. While she reaffirms the distinction between perpetrators and victims, Radstone argues that testimony's audience may cross that line on an imaginative level, thus affecting what she calls a "grey zone" between good and evil.[12] The grey zone is a site of fantasized identifications with victims and perpetrators that symbolize the prospects of omnipotence and coherent control that are lacking on a psychosocial level and must be disavowed on a moral one. In her view, such identifications may serve to override "'an absence of internalised personal authority'" while structuring and thereby compensating for amorphous structures of surveillance and control in contemporary society.[13]

Radstone's observations suggest that what I have referred to as the external gaze cannot be localized. By extension, the internal gaze may respond to a morally masochistic need to invent a unified locus for surveillant judgment through self-regulative and punishing fantasies that symbolize, reproduce, and work through the guilty residues of the gaze.[14] In calling for a recognition of the ways in which fantasy structures the reception of events, Radstone's thesis about the psychosocial

value of traumatic testimony also takes the prospect of these sadomasochistic identifications into consideration. She urges us to abandon a certain "Holocaust piety" that leaves room for an untroubled absolutism of morally proper identifications with the victims, but not the perpetrators. Instead, she asks us to follow Gillian Rose in acknowledging the "hidden *violence* that subtends identification solely with victimhood, since it is only from a position of absolute power that the predatory capacity of others can cease to be a point of identification."[15]

Radstone's argument resonates with Laura Frost's recent study of the cultural fascination with fascism and the eroticized figure of the Nazi as an icon of sadistic violence. Frost's argument in *Sex Drives* follows through on the implications of Foucault's comments in the 1970s about Nazism as the "ultimate symbol of eroticism," a fixation he attributes to a more general desire for power.[16] Frost also extends Susan Sontag's speculations on the "natural link" between sadomasochism and the exotic lure of fascist transgression for a sexually repressive society.[17]

Frost's reading of modernist literature leads to an analysis of the fantasies and foreclosures that haunt feminist constructions of Nazism as the radical embodiment of patriarchal evil. According to Frost, a strategic conflation between patriarchal oppression and Nazi brutality is not as pure as the political and moral conscience of feminism requires. In various references to Nazis, she pinpoints stirrings of transgressive fascination with shiny boots of leather, steel-eyed ruthlessness, and impenetrable indifference coded as phallic potency and strength. The Nazi thus serves as a highly libidinalized venue for the fantasy interplay of sexualized aggression and submission scenarios both in and outside women's writing. The question is whether feminists could extirpate such sadomasochistic fantasies, given a liberatory agenda that is opposed to persecution and forced passivity. For if "every woman loves a fascist," as a literal reading of Sylvia Plath's "Daddy" suggests, then feminists must stop being women by killing their "inner Hitlers" along with their "inner fathers," not to mention the sadomasochistic instinct that resurrects their ghosts.

To take Frost's argument in *Sex Drives* seriously is thus to reconceptualize the feminist gaze as the effect of a constitutive foreclosure that is, at once, moral, libidinal, and potentially traumatic.[18] For if sadomasochistic fantasies about the hard and cruel Nazi master suggest a particularly vexed set of identifications for feminists, then the feminist gaze is over-determined by such a repression. This is to say that feminist sadomasochism may actually be a byproduct of progressive or democratic politics to the extent that the very taboo against morally forbidden

identifications with Nazi violence might unconsciously mobilize the very desire it aims to contain.

Frost observes that feminists have largely bypassed the implications of the cultural fascination with fascism. Consequently, they have not fully considered the erotic allure that transgressive identifications with Nazi perpetrators retain that might commit us to own up to our fantasies and libidinal investments (150). It is a commitment that may seem controversial when we are talking about the postmemorial reception of survivor testimony, but it is essential to any reflection on the ethics of this encounter. For it suggests that the eroticized figure of the Nazi may creep into my memories by means of my mass-culturally permeated fantasy life both despite and because of my ethical commitments. But then, what possible erotic fantasy could be functioning in the instance of the survivor panel at the "Departures" conference and, more crucially, perhaps, how do I take responsibility for it? Must I admit what I fear most morally and politically, which is to say my pleasurable complicity with violence?

Radstone and Frost invite me to take responsibility for my "postmemorial" fantasies as a preliminary step in thinking through what I earlier referred to as the compassionate imaginary to designate the image content and creative operations involved in "adoptive witnessing." My fantasy-building mechanisms were set into play in that moment in which I identified with the testifying survivor by imagining how I would have felt in her place. Obviously, I cannot "screen" her memory images like a film. Instead, I must recreate her memory in my own mind by drawing on stores of personal memory and mass-produced images from movies, television, textbooks, and magazines. Fantasy and sympathy are modes of visual symbolization that borrow from this repertoire of images, which is to say that the compassionate imaginary shares a permeable border with unconscious wishes including aggressive and/or sadomasochistic urges that may be further specified through Nazi iconography.

The sharing of images between fantasy and sympathy conditioned my response to the survivor's testimony at the "Departures" panel in giving rise to my speculation that the men searching stripped women prisoners for hidden valuables may have derived sadistic enjoyment from this otherwise "banal" task. It is crucial to recognize that this sadistic pleasure is imagined. Whether or not the survivor's testimony concretizes it, I attributed this enjoyment to the Nazis who conducted these searches. My moral repugnance thus stems from the idea of this enjoyment, which I subsequently shun as "obscene." For it is in the specter of this sickening enjoyment that my own visceral disgust and unspeakable fascination with Nazi barbarism lurk.

In Holocaust studies, the trope of unspeakability functions as a means of declaring the radical moral otherness of the atrocities committed by the Nazis and the "unrepresentable" enormity of the suffering they caused. Yet such rhetoric is contradicted by the manifold conferences, articles, edited volumes, book-length studies, dramatic films, documentaries, and memorials devoted to the Holocaust, not to mention the debates and scandals over the last quarter century that have frequently punctuated public discussions.[19] The heavy circulation of this trope in the discourse of Holocaust studies therefore suggests a symptomatically verbose silence, an oxymoron that formally connects it to the repressive hypothesis as Foucault has defined it.

On a substantive level, of course, the two logics are very different. The repressive hypothesis would narrate the history of sexuality as a suppression and prohibition of discourse about sex treated as a concealed and potentially "pathological excess" or as an "origin" of personality. Once again, Foucault overturns this hypothesis by revealing that references to sex were not suppressed in authoritative discourse. Rather, the multiplication of such references and their effects raised this hypothesis to the level of a pseudo-epidemiology, the assumption behind it being that to discover a sexual origin for a symptom or a personality trait was to cure a perversion conceived as a disease. In this manner, the constructed ubiquity of sex and perversion as diagnostic targets medically sanctioned efforts to induce submission to the authorities in question.

Foucault's critique of the repressive hypothesis spurs a certain cynicism regarding repeated references to the unspeakability of Nazi torture and genocide that belie an ambivalent motive: to inoculate authoritative discourse against the pathological perversity of the phenomena it investigates. The aim would then be to "root out" this pathology—to expose this evil for all the world to see—and thereby rid ourselves of genocidal xenophobia. Foucault's critique of the repressive hypothesis thus invites a consideration of the perverse pleasure-in-power that motivates such an exposure, whereby a "pathological origin" must first be implanted, which is to say invented in discourse, before it can be properly "discovered" and "extracted."

The unspeakable is a rhetorical shorthand for that which is tacitly acknowledged, but kept under wraps for the sake of propriety. It applies to those phenomena that "cannot" and/or "should not" be made public. Thomas Trezise has recently analyzed the normative assumptions that enter into the logic of the unspeakable in the context of Holocaust Studies. In that context, the unspeakable typically refers to the magnitude of the evil perpetrated by the Nazis, which exposes the limit of the moral imagination and thereby effects an experience of the sublime.

Trezise explains this experience in Kantian terms: "neither a single representation nor even a totality of all possible representations could make of the Holocaust the object of a comprehensive 'view from nowhere'" (Trezise 41).[20] One must not speak of "it" (these crimes, this suffering) because one cannot do so without profaning a morally transcendent event. The genocide thereby assumes a sacred stature, beyond human powers of representation, for which the experience of the sublime is an aesthetic analogue.[21]

Against the backdrop of an increasingly abundant discourse about the Holocaust, the "cannot" and the "must not" upon which the unspeakable turns appear to be gestures of disavowal. What is disavowed is that which "cannot" and "must not" be admitted (for the sake of maintaining the appearance of civil society and its moral order). This speculation leads me to suspect that what is most unspeakable are not the crimes themselves or the pain that they caused, but rather the shameful fascination with transgression that compels us to dwell on them. Such transgression is unspeakable because it violates deeply held bourgeois social codes; it "cannot" be spoken because to speak it is to imagine it and to imagine it is...to share it?

When the survivor testified about vaginal searches, she remarked that she had never mentioned this incident during years of public appearances. Somehow the prospect of speaking at this conference before receptive women scholars eroded the reluctance that had prevented her from recounting these humiliating searches on prior occasions. It is, of course, relevant that a feminist conference elicited precisely this kind of testimony. It is also important that her testimony ostensibly fulfills the feminist desire for new knowledge about the Holocaust as a radical instance of evil that affected men and women in different ways. Nevertheless, given the proliferation of discussions and institutional forums devoted to the Holocaust over the past quarter century, we should ask ourselves what was precisely "new" about this knowledge? What did it "contribute" to our understanding of human suffering?

By communicating this degrading experience, the survivor did not merely open another window on the relentlessness of Nazi brutality. Her testimony also illuminated the ambiguously sexual and thus sinister character of the putatively "medicinal" and instrumental strip searches endured by women prisoners. I insist on this ambiguity because the silence that formerly buried this episode implies a sense of shame, which I connect to the socio-cultural coding of sexual violence with its roots in a disavowed eroticization of power. Because of this coding, my sympathetic visualization of the survivor's testimony confirms and augments a culturally mediated repertoire of erotically charged scenarios involving

Nazis enjoying their crimes against the Jews. In the grand scheme of things, however, it is an abhorrent image that will join the host of similarly abhorrent images that already fill my personal vision of the nauseating mechanics of the Final Solution. Indeed, what Hirsch calls postmemory may also be a posthistorical repository of violent imagery that I have absorbed over the years from movies and televised news reports alongside my studious encounters with historical and documentary depictions of the Final Solution.

As I have noted above, Hirsch suggests that postmemorial repetition is ethical if motivated by a sympathetic identification with the survivors and a vicarious effort to work through their trauma (7). Yet Hirsch also complicates this claim when she cites Barbie Zelizer's anxieties about certain Holocaust photographs that "have become no more than decontextualized memory cues, energized by an already coded memory, no longer the vehicles that can themselves energize memory" (7). For Hirsch, in contrast, the obsessive recirculation of these images reveals their function as charged icons of Holocaust memory that stand in for the postmemorial witness's affective relation to the present by means of the historical past (16).[22]

The perverse fixity of my own memory makes me hesitate to affirm the virtue of my sympathy for the survivors. For when I think about the Final Solution, my mind sifts through historically detached memory traces drawn from images of impending doom and extreme dehumanization: the photographs of human experimentation; the shooting of infants, children, and the elderly at pointblank range; the tracks leading up to the entrance to Auschwitz-Birkenau; the gates emblazoned with *Arbeit macht frei*; the bulldozers clearing bodies following the liberation of Bergen Belsen; the cremation of corpses in stacks. My imagination gags on these images, which seem at once to crystallize and seduce my sense of horror; it is nevertheless driven to return to them again and again. This compulsive repetition speaks against desensitization by betraying a voyeuristic side to my attempts to assimilate the traumatic significance of the Holocaust through its imagery of death and destruction.

These grim images are "scenes of the crime" whose charged aura indicates a different crime scene altogether, one that transpires in the past, present, and future alluded to by the photographic frame and enacted imaginatively off-screen. This off-screen staging memorializes the horror of the Nazi atrocities, but also displaces and defers their impact to the realm of fantasy, in other words, to what Radstone has called a grey zone where scenarios of domination and sadistic bloodlust alternate with images of masochistic abjection before the sublime tortures of authoritarian masters. The easy currency of these scenarios

is a symptom of my capitulation to the scopic drive that spurs me to visualize violent scenes, to appease an urge to see what it should shame me to enjoy, and to take pleasure without admitting it in the transgression of scrutinizing what is ordinarily veiled out of a sense of bourgeois propriety, but also fear (of my own repressed aggression). A sense of moral delicacy makes me inclined to pass over the implications of this drive for feminist scholarship, but I will nevertheless take the risk of broaching it now.

In my introduction, I mentioned that one objective of the conference was to move beyond essentialist understandings of gender and sexual differences in feminist approaches to the Holocaust. Over the last two decades, the feminist critique of essentialism has typically been deployed as a means of unsettling assumptions that gender and sexuality could be conflated or defined as stable determinants of identity that transcend context and elude historical transformation.[23] My claim that perverse fantasies may play a disciplinary role in feminist compassion for women survivors is therefore problematic inasmuch as it indicates that sympathy transpires through a set of identifications that contravene an anti-essentialist disarticulation of gender and sex. For if my feminist gaze could be said to "sexualize" the Holocaust, then it is by virtue of its power to elicit testimony that the witness formerly suppressed not only because it humiliated her as a person and a Jew, but also specifically as a woman. In addition, to the extent that I also sympathize with her as a woman, I become guilty, from the standpoint of my own anti-essentialist gaze, of an acritical rearticulation of sex and gender. Indeed, it is this very rearticulation that propels my compassionate imaginary to fasten onto the obscene prospect of the Nazi official's enjoyment while probing her body: it is an "unspeakable secret" lodged in the traumatic heart of the Holocaust that a feminist gaze focused on sex and gender is critically, professionally, and sympathetically equipped to "draw out" and "lay bare."

The shadow that cuts across my own act of "laying bare" is deepened by the positions that an empathetic "drawing out" inadvertently produces for the first- and secondhand witnesses in the auditorium. In my complicity with an institutional summons to the survivor to serve as an eyewitness to a "different" form of suffering, my compassion as a feminist scholar and as a woman in the space of the auditorium could not dispel her double bind as an informant in a disciplinary society, but rather confirmed it: she bore a secret whose confession would constitute her as a subject, yet would also convert her into an object of the feminist moral imaginary. She thereby serves to further my knowledge by filling out my map of a field. From the standpoint of Foucault's *The*

History of Sexuality, what is still more troubling is the implication that this double bind is accompanied by a double pleasure reflected on either side of the scientific speculum: on the one hand, there is the pleasure of the testifying eyewitness in becoming an individualized subject, fixed in space and time before a gaze that enjoins her confession in the name of progress; on the other, there is the pleasure of the scholarly audience in deploying this gaze that marks out a position of mastery. The scholar who occupies this position by eliciting the secret (not to mention emplotting it in a "new" narrative) will confirm her membership in a scientific community to the extent that she demonstrates a properly feminist approach to her object of inquiry.

From a professional standpoint, then, my sympathetic yet fantastic reconstruction of the Nazis' violation of the survivor inadvertently serves at least two functions: it provisionally reconstitutes the survivor's feminist audience as a moral community with whom I identify through our shared sense of outrage.[24] Second, it affirms my belief that sadistic enjoyment comprises the barbaric essence of the "orgy" of murderous violence that the Third Reich orchestrated and thereby permits me to ponder images of transgression under the rubric of the Holocaust as an officially sanctioned object of inquiry. Hence, beneath and alongside the progressive goal of forestalling future violence by exposing its myriad forms and effects lies an erotic fascination with power and violence. The Nazi persecution and torture of the Jews is hereby renewed as an inexhaustible object of investigation precisely by virtue of its inexpungeable power to shame the very moral imaginary that memorializes it.

The complicity of these positions and their respective pleasures confronts me with an interesting paradox: the survivor on the podium positioned as an "object of inquiry" is active in testifying, while the scholar is, relatively speaking, passive insofar as I look on and listen from the luxurious safety of my empirical distance, from the comfort I take in my ability to scrutinize all phenomena with scientific equanimity and compassion as proof of my fastidious professionalism. The sordid issue that intrudes here stems from the obverse possibility that this scrutiny might itself be sadistic. Does my deployment of a sympathetic feminist gaze not also permit some form of enjoyment in enabling me to capture in my lens an object that is, in fact, a subject, an all too human one, who suffered terribly and, what is worse, consciously?

This question leads me to my ultimate claim. The sympathetic imaginary that establishes professional and moral solidarity among feminist scholars also provides a vehicle for the scopic drive and the perverse compulsion to view the visceral: the inside, the guts, the sex, if you will, of psychic and material existence. A woman testifies to a violation

that both is and is not sexual. Whether or not the Nazis performing vaginal searches on naked Jewish concentration camp prisoners took pleasure in their crimes is a matter of conjecture and, as I have been arguing, fantasy. Certainly, the women prisoners themselves would have suffered these involuntary searches as a kind of rape (violence that leaves no room for erotic pleasure). The sexual dwells, rather, with the graphic imprint left on my imaginary of a hostile invasion of a tender corporeal inside that does not merely arouse a sense of visceral disgust, but an equally visceral fascination with my own disgust, which I then feel compelled to work through.

In officiating the survivor's confession as an addition to our knowledge, the institutional setting that placed me voluntarily in that auditorium also made me a vehicle of a disciplinary sympathy. Such sympathy inadvertently collaborates with a bourgeois hermeneutic that presupposes sexual repression; it therefore targets sex as a "dark secret" and earmarks my horror as a sign of the forbidden—a transgressive and furtive excess that "must," for the sake of scientific progress, be disinterred as a truth. When I surgically probe my symptomatic disgust, a process of sympathetic introjection consequently allows me to "discover" that the truth I seek lies in the possibility that the Nazis sexually enjoyed vaginal searches of Jewish prisoners.

It is therefore no coincidence that I have "chosen" to analyze my response to this testimony in particular. The disciplinary value of such testimony is over-determined as a focus of feminist inquiry in ways that extend beyond the commonplace that feminists are committed to undoing the silences imposed on women as marginalized or forgotten historical agents and victims. The Final Solution demands a measure of moral sensitivity and care, which provokes an attendant sense of anxiety about speaking improperly and thereby adding to the injustice and outrage experienced by those who survived and by the bereaved. This anxiety leads me to check the kinds of claims I might skeptically "entertain" in the spirit of open-ended inquiry.

It has been this very anxiety that I have wanted to explore. I have therefore written this essay in a confessional mode, a genre not geared toward a cathartic message of hope that would allow me to suture my unsettling contradictions and redeem myself as an ethical scholar of the Holocaust, a constructive feminist, and a decent human being. Rather, my aim has been to expose the tracks of a professional and personal unconscious that surely exceeds me and that has paradoxically spurred me to enact the symptoms of the problematic at stake even as I analyze their unspeakable implications. In this respect, it has mirrored the chain of assumptions targeted by Foucault's critique of psychoanalysis as a

technology of disciplinary power that implants the "secret" of sexual perversion into a confessing subject, thereby reproducing her half-willing subjection. This self-scrutiny may be consistent with the rigorous honesty of a properly feminist inquiry, but it cannot be entirely divorced from the clinical male perspective of Eakins's erotically charged painting of demonstrative surgery on a woman's breast: my critical imagination colludes with the medical students' desire to know what lies beneath female flesh (including my own).

Perhaps my frank speculations suggest an explanation for the syndrome whereby scandal has come to be such a predictable feature of Holocaust Studies. I have breached my own deeply held sense of propriety in the hope that the import of my analysis will not be limited to a pedestrian increase in self-awareness, but will instead motivate feminists to take responsibility for the fantasies and foreclosures that propel our compulsive repetitions. The critical commitment to refine our analytical tools cannot be entirely separated from a scientific gaze that objectifies in order to penetrate its object; nor can it be extricated from the narcissistic and erotic dimensions of fantasy that we might otherwise foreclose in the spirit of a crusade to shore up a sense of moral legitimacy. To recognize this blind spot in the feminist speculum is to begin to assume a responsibility for the unconscious aspects of our scholarly fascination with the Holocaust—to break down unacknowledged obsessions and discover a different way of counting ourselves among the accountable, thereby becoming more accountable still. At stake is the future of a feminist approach that allows for a genuine departure from vicious circles of righteous self-selection.

Notes

I am grateful to Lisa Disch, Marjorie Gelus, Ruth-Ellen Joeres, Leslie Morris, and Heather Zwicker for their detailed comments on prior drafts of this essay.

[1] In her discussion of Eakins's realism, Marcia Pointon remarks that *The Agnew Clinic,* which centers on "a performance or demonstration (a public enactment)—parallels the conditions of viewing in Hollywood cinema in which the foreclosed real and the concealed site of production (studio and operating theater) produce the conditions of lack" (51).

[2] See Felman and Laub; and Langer. Caruth's work on trauma is also important in this connection. In "Social Bonds and Psychical Order: Testimony" (2001), Susannah Radstone attributes the extraordinary impact

of Felman's and Laub's *Testimony: Crises of Witnessing in Literature, Psychoanalysis, and History* (1992) along with Caruth's studies of trauma to "the recent ascendancy of Holocaust Studies, as well as to a theoretical consonance between their theoretical concerns with the transmission of the untransmittable, and the themes of postmodernist theory more generally" (61). Her observations are consonant with the trajectory I map in "Trauma and Its Institutional Destinies," where I argue that a desire to reclaim the power of experience while heeding the poststructuralist repudiation of its metaphysical and humanist attachments entailed a terminological shift. Hereafter experience would need to be represented as multi-faceted and contradictory, if not also partial, mediated, and/or belated. Memory consequently entered into this juncture as a more "poststructurally correct" substitute for experience, while traumatic memory in particular became the hinge of identity politics in a post-identitarian milieu that continued to look to individual and collective suffering as its moral fulcrum. Holocaust studies helped to bring about this turning point by rendering explicit the historiographical, hermeneutical, and moral issues that vex victim and perpetrator memories and the ways in which denial, disavowal, and guilt affect the contours of traumatic history. In addition, the extremity of the Nazi persecution and genocide of the Jews and the Sinti rendered testimony about them nearly immune to the perplexities and banalities of post-humanist discourse as well as anti-foundationalist critiques of authenticity and experience.

[3] To this end, Laub suggests that the analyst's ability to grant such lessons their affective weight and intelligibility might be more strategically served by a dearth rather than a wealth of "factual" knowledge about the circumstances surrounding the witness's testimony: "in the process of the testimony to a trauma, as in psychoanalytic practice, in effect, you often do not want to know anything except what the patient tells you, because what is important is the situation of *discovery* of knowledge—its evolution, and its very *happening*. Knowledge in the testimony is, in other words, not simply a factual given that is reproduced and replicated by the testifier, but a genuine advent, an event in its own right" (Felman and Laub 62).

[4] This is a false opposition that Hayden White has convincingly dispatched in his attention to the ways in which historians typically draw on realist conventions to promote an illusion of referential intimacy and neutrality even while their respective "emplotments" of historical phenomena as narratives encode particular moral standpoints. Of particular relevance to my discussion here is his "Historical Emplotment and the Problem of Truth" in *Probing the Limits of Representation: Nazism and the "Final Solution"* and recently repeated in White, *Figural Realism*.

⁵ Ragland claims that by hearing the "traumatic truth" of the survivor's testimony, a sympathetic listener acts on behalf of the Other (the social order) to confirm a traumatized subject's damaged sense of continuity in relation to it (Ragland 83, 89). Paraphrasing Caruth in Lacanian terms, Ragland writes: "the Other—the social order—must *hear* what is actually being said: a transference relation must be engaged such that a representative listener from the social order believes the *truth* that seeps through the imaginary dimensions of a narrative" (79). Ragland also notes that when the Other exposes the visceral underside of fantasy (and the real as such), it traumatizes the split subject by annihilating the power of his/her object *a* to serve its function of suturing appearance and reality. Compassionate listening must then enter into the unbearable void left by a concrete brush with the palpability of this separation—a breach in the possibility of making meaning.

⁶ LaCapra also asks us not to presume that we are therapists "working in intimate contact with survivors or other traumatized people" (LaCapra, *Writing History* 98).

⁷ I develop this conception of "disciplinary mimesis" in my analysis of the Goldhagen debate, "Disciplining Traumatic History: Goldhagen's Impropriety." It is a conception that draws on LaCapra's prior essay collections of 1994 and 1998 on representing the Holocaust and trauma as well as John Mowitt's theory of the master and disciple relationship that drives disciplinary investments. Also useful in theorizing scholarly investments are Friedlander and Hansen and Geyer in Hartman 252-63 and 175-90. See also the Broszat and Friedlander exchange, which brings to the fore the incommensurabilities that arise between Jewish and non-Jewish German historians in representations of the Nazi Period.

⁸ For Hirsch, postmemory "need not be *strictly* an identity position." It is, instead, "an intergenerational space of remembrance, linked specifically to cultural or collective trauma. It is defined through an identification with the victim or witness of trauma, modulated by an unbridgeable distance that separates the participant from one born after" (10).

⁹ Foucault derives this conception from the architectural model provided by Jeremy Bentham's design for a prison featuring a central watchtower with wide windows facing the inner "showcase" side of a ring of prison cells. Foucault characterizes it with this cinematic description: "All that is needed, then, is to place a supervisor in a central tower and to shut up in each cell a madman, a patient, a condemned man, a worker or a schoolboy. By the effect of backlighting, one can observe from the tower, standing out precisely against the light, the small captive shadows in the cells of the periphery. They are like so many cages, so many small theatres, in which each actor is alone, perfectly individualized and constantly visible" (*Discipline and Punish* 200).

[10] Radstone ("Social Bonds" 59). In her words, Radstone's thesis is that "the ungraspability and *unidentifiability* of contemporary authority exacerbates aggressivity while attenuating possibilities for identification. Under these circumstances, the transformation of aggression against an external authority into intro-psychic conflict becomes yet more deeply unmanageable and threatening than in the age of confession. This, I think, is a danger of our times. In these dangerous moments, memories flash up, but they are memories *shaped* by our present dangers, dangers that our testimonies and witnessings can either re-inforce or mitigate" (71).

[11] Radstone ("The War of the Fathers" 457). Radstone is writing against commonplaces of trauma theory suggesting a passive or short-circuited response to the impact of an "unimaginable" event (September 11th). She contests this view because of the theory of trauma that it associates with catastrophe and the claims it makes for the unprecedented impact of recent events.

[12] Radstone's definition of the grey zone borrows from Primo Levi's *The Drowned and the Saved*.

[13] Craib (109; qtd. in Radstone, "Social Bonds" 70).

[14] Freud (159–70). Freud distinguishes among three forms of masochism: "erotogenic," "feminine," and "moral." "Erotogenic" masochism refers to sexual arousal in the course of suffering pain or identifying with the position of suffering. This form is "original" because it underlies both feminine and moral masochism. So-called feminine masochism is Freud's designation for the pleasure of occupying a passive position. "Moral masochism" is characterized by an investment in self-punishing guilt, which is linked to the masochist's sense that he has failed or has committed some ambiguous crime.

Notably, Freud's identification of the "feminine" form of masochism is historically determined by his experiences in a relatively patriarchal society where women were largely restricted to domestic roles and to service positions outside of the family sphere. While it would be interesting to explore the question of how passivity continues to be "feminized" in a "post-feminist" society, on principle, I would like to abandon the designation "feminine" in favor of the more gender-neutral term "passive" masochism, which women and men experience very differently. The question that remains is whether men and women continue to see passivity as feminine. Is it possible for contemporary feminists to experience "liberated" forms of passive masochism?

[15] Radstone ("Social Bonds" 66). Radstone borrows the term "Holocaust piety" from Gillian Rose.

[16] Foucault ("Film and Popular Memory"). Foucault observes that power has an erotic charge that needs to be accounted for in the case of

Nazism as "represented by shabby, pathetic, puritanical characters, laughably Victorian old maids, or at best, smutty individuals." He questions how Nazism in "all pornographic literature throughout the world" could become the "ultimate symbol of eroticism." His contention is that in the porn-shops' obsession with Nazi insignia, we are witnessing a "re-eroticization of power taken to a pathetic, ridiculous extreme" to fill the void effected by insufficiently erotic leaders such as Brezhnev, Pompidou, or Nixon (127).

[17] "Sadomasochism," Sontag claims, "has always been the furthest reach of the sexual experience: when sex becomes most purely sexual, that is, severed from personhood, from relationships, from love." Never before was "the relation of master and slaves so consciously aestheticized" as in the "master scenario" that Nazism offers in which the "color is black, the material is leather, the seduction is beauty, the justification is honesty, the aim is ecstasy, the fantasy is death" (105). Hence: "Sadomasochism is to sex what war is to civil life: the magnificent experience" (103).

[18] Frost employs the term "disavowal" rather than "foreclosure," which is my preference to emphasize the profound and systemic quality of the feminist need to negate erotic fantasies about Nazis. She also acknowledges that this repression is not restricted to feminism as "only one variant of liberal and democratic politics, with the same disavowal of those libidinal impulses that run counter to its ideology" (150).

[19] In her *New York Times* piece "Swastikas for Sweeps," Maureen Dowd comments on the controversy surrounding CBS's plans to air a miniseries based on Ian Kershaw's biography *Hitler, 1899–1936: Hubris* which, as Dowd wryly notes, will cover the crucial years between 18 and 34, the same age span as the network's target demographic. While CBS president Leslie Moonves defends the untapped dramatic potential of a miniseries exploring the early years of this "fascinating character" because it will give us insight into the evolution of contemporary evil-doers, critics see the prospective miniseries as trivializing the figure of Hitler and his crimes for commercial purposes. As Dowd puts it: "It's a stretch to argue that understanding an old evildoer would shed light on the new evildoers. There's a big difference between genocide and terrorism. But there's no denying Hollywood's eternal reliance on two subjects: evil and sex."

[20] Trezise is borrowing the quoted expression from Nagel.

[21] Anton Kaes notes that "[t]he insistence on the impossibility of adequately comprehending and describing the Final Solution has by now become a *topos* of Holocaust research" (207). This topos has steered North American discussions about the Holocaust and traumatic history in recent decades, and shaped the discourse of trauma studies in the 1980s and 1990s.

[22] Writing about the displacement of the historical referent by posthistorical memory, Thomas Elsaesser demonstrates that iconic images may be appropriated to serve the affective interests of one past at the expense of another as when a famous photograph of a Sinti girl caught in the small opening of a cattle car on her way to Auschwitz is circulated as the quintessential image of a Jewish victim (Elsaesser 70).

[23] It is notable that the impact of the critique of essentialism was already observable during the feminist Historians' Debate of 1989, which, as Claudia Koonz notes, exposed conceptual fault-lines between the essentialist tendencies of German feminist historiography of the Nazi Period and their North American counterparts, whose praxis was beginning to be informed by poststructuralist views of identity, gender, sexuality, and agency. See Bock, Koonz, and Grossmann.

[24] This point raises troubling questions about what a Jewish feminist such as myself stands to gain by way of "identity capital." In light of the narcissistic aspects of my relation to any object of inquiry, I cannot help but wonder whether the evidence that I obtain from the cross-pollination between feminism and Holocaust studies does not also redeem my collective identification, not only with other feminists, but also with "my people" by refueling my continuing *ressentiment* as a member of a long-suffering minority. Wendy Brown's observations about the masochistic stake in identity politics are relevant here. She writes: "reliving a certain punishing recognition reassures us not only of our own place (identity) but also of the presence of the order out of which that identity was forged and to which we remain perversely beholden. The repetition gratifies an injured love by reaffirming the existence of the order that carried both the love and the injury" (Brown 56).

Works Cited

Ball, Karyn. "Disciplining Traumatic History: Goldhagen's Impropriety." *Cultural Critique* 46 (Fall 2000): 124–52.

———. Introduction: Trauma and Its Institutional Destinies." *Cultural Critique* 46 (Fall 2000): 3–44.

Belau, Linda, and Petar Ramadanovic. *Topologies of Trauma: Essays on the Limit of Knowledge and Memory.* New York: The Other Press, 2002.

Bock, Gisela. "Die Frauen und der Nationalsozialismus: Bemerkungen zu einem Buch von Claudia Koonz." *Geschichte und Gesellschaft: Zeitschrift für Historische Sozialwissenschaft* 15 (1989): 563–79.

Broszat, Martin, and Saul Friedlander. "A Controversy about the Historicization of National Socialism." *New German Critique* 44 (1988): 85–126.

Brown, Wendy. *Politics Out of History*. Princeton: Princeton UP, 2001.
Caruth, Cathy, ed. "Trauma and Experience: Introduction." *Trauma: Explorations in Memory*. Baltimore: Johns Hopkins UP, 1995. 3-12.
⸻. "Unclaimed Experience: Trauma and the Possibility of History (Freud, *Moses and Monotheism*)." *Unclaimed Experience: Trauma, Narrative, and History*. Baltimore: Johns Hopkins UP, 1996. 10-24.
Cheyette, Bryan, and Laura Marcus, ed. *Modernity, Culture and "the Jew."* Oxford: Polity, 1998.
Craib, Ian. *The Importance of Disappointment*. London: Routledge, 1994.
Dowd, Maureen. "Swastikas for Sweeps." *The New York Times* 17 July 2002.
Elsaesser, Thomas. "One Train May Be Hiding Another: History, Memory, Identity, and the Visual Image." Belau and Ramadanovic 61-71.
Felman, Shoshana, and Dori Laub. *Testimony: Crises of Witnessing in Literature, Psychoanalysis, and History*. New York: Routledge, 1992.
Foucault, Michel. *Discipline and Punish: The Birth of the Prison*. Trans. Alan Sheridan. New York: Vintage Books, 1979.
⸻. "Film and Popular Memory." *Foucault Live: Collected Interviews, 1961-1984*. Ed. Sylvère Lotringer. Brooklyn: Semiotext(e), 1996.
⸻. *The History of Sexuality: An Introduction*. Vol. 1. Trans. Robert Hurley. New York: Vintage Books, 1990.
Freud, Sigmund. "The Economic Problem of Masochism." *The Complete Psychological Works of Sigmund Freud*. Vol. 19. Trans. James Strachey. London: The Hogarth Press and the Institute of Psychoanalysis, 1963: 159-70.
Friedlander, Saul, ed. *Probing the Limits of Representation: Nazism and the "Final Solution."* Cambridge: Harvard UP, 1992.
⸻. "Trauma, Memory, Transference." Hartman 252-63.
Frost, Laura. *Sex Drives: Fantasies of Fascism in Literary Modernism*. Ithaca: Cornell UP, 2002.
Geyer, Michael, and Hansen, Miriam. "German-Jewish Memory and Historical Consciousness." Hartman 175-90.
Grossmann, Atina. "Feminist Debates about Women and National Socialism." *Gender & History* 3 (Autumn 1991): 350-58.
Hartman, Geoffrey, ed. *Holocaust Remembrance: The Shapes of Memory*. Cambridge, MA: Blackwell, 1994.
Hirsch, Marianne. "Surviving Images: Holocaust Photographs and the Work of Postmemory." *The Yale Journal of Criticism* 14:1 (2001): 5-37.
Kaes, Anton. "Holocaust and the End of History: Postmodern Historiography in Cinema." Friedlander 206-22.

Koonz, Claudia. "Erwiderung auf Gisela Bocks Rezension von *Mothers in the Fatherland.*" Trans. Susanne Nitzscke. *Geschichte und Gesellschaft* 18 (1992): 394-99.

———. *Mothers in the Fatherland: Women, the Family and Nazi Politics.* New York: St. Martin's Press, 1987.

LaCapra, Dominick. *History and Memory after Auschwitz.* Ithaca: Cornell UP, 1998.

———. *Representing the Holocaust: History, Theory, Trauma.* Ithaca: Cornell UP, 1994.

———. *Writing History, Writing Trauma.* Baltimore: Johns Hopkins UP, 2001.

Langer, Lawrence. *Holocaust Testimonies: the Ruins of Memory.* New Haven: Yale UP, 1991.

Levi, Primo. *The Drowned and the Saved.* London: Abacus, 1989.

Lyotard, Jean-François. *The* Differend: *Phrases in Dispute.* Trans. Georges Van Den Abbeele. Minneapolis: U of Minnesota P, 1988 (*Les Éditions de Minuit,* 1983).

Mowitt, John. *Text: The Genealogy of an Antidisciplinary Object.* Durham: Duke UP, 1992.

Nagel, Thomas. *The View from Nowhere.* New York: Oxford UP, 1986.

Pointon, Marcia. *Naked Authority: The Body in Western Painting 1830-1908.* Cambridge: Cambridge UP, 1990.

Radstone, Susannah. "Social Bonds and Psychical Order: Testimonies." *Cultural Values* 5:1 (Jan. 2001): 59-78.

———. "The War of the Fathers: Trauma, Fantasy, and September 11." *Signs: Journal of Women in Culture and Society* 28: 1 (2002): 457-59.

Ragland, Ellie. "The Psychical Nature of Trauma: Freud's Dora, the Young Homosexual Woman, and the *Fort! Da!* Paradigm." Belau and Ramadanovic 75-100.

Rose, Gillian. "Beginnings of the Day: Fascism and Representation." Cheyette and Marcus 242-56.

Sontag, Susan. "Fascinating Fascism." *Under the Sign of Saturn.* New York: Anchor, 1974.

Trezise, Thomas. "Unspeakable." *The Yale Journal of Criticism* 14: 1 (2001): 39-66.

White, Hayden. *Figural Realism: Studies in the Mimesis Effect.* Baltimore: Johns Hopkins UP, 1999.

———. "Historical Emplotment and the Problem of Truth." Friedlander 37-53.

Zelizer, Barbie. *Remembering to Forget: Holocaust Memory through the Camera's Eye.* Chicago: U of Chicago P, 1998.

Positionality and Postmemory in Scholarship on the Holocaust

Pascale Bos

For scholars who work within German literature and culture of the twentieth century, the topic of the Holocaust is hard to ignore. The confrontation with this topic is a complex one, however, as the magnitude of its severity and the scale of its brutality make the Holocaust difficult to approach neutrally. Through a discussion of the feminist concept of positionality, the notion of "autobiographical reading," and the concept of "postmemory," this essay examines critically the issue of personal investment in the study of the Holocaust, and the particular role that positionality, personal and cultural memory, and identification and empathy play in this work. (PB)

For students, teachers, and scholars who work within German literature and culture of the twentieth century, the topic of the Holocaust is hard to ignore. Whether one's research or teaching focuses specifically on the period 1933-1945 or not, the historical events and their grave cultural, historical, and moral legacy for Germans, Jews, and European culture (and Western civilization) need somehow to be considered, analyzed, and made sense of. For any of us who are part of this field of twentieth-century German studies, then, we tend to be confronted with the Holocaust on a regular basis, a confrontation that is on a number of levels a very complex one, especially as the Holocaust is impossible to approach neutrally. The magnitude of its severity and the scale of its brutality make it difficult to remain unmoved. And, in fact, no one explicitly suggests that we should, as absolute scholarly neutrality seems oddly incongruent with the severity of the subject. As a result, scholarly encounters with the Holocaust are often implicitly shaped by a host of ethical and personal imperatives. Those of us who do this work read, research, or teach on the Holocaust because of the "need to remember,"

in order to "bear witness," to "carry on the legacy," or so that "it will never happen again."

Confronting the Holocaust, especially within the field of German studies, is thus no easy task: it demands engagement, and often a deep personal involvement. But what kind of involvement is this? What is our role, as scholars, teachers, or students? Are we serving as witnesses to the events, as some argue?[1] If we are indeed (scholarly) witnesses, it would seem that our role is an important one, which requires a sense of moral obligation and selfless effort. But isn't our position in fact much more complex, aren't our investments also self-interested?

As a scholar working within the field of modern German studies, and as someone who also teaches regularly on the Holocaust and the literature and history of European Jewry, I have over the years come to question the kind of personal and scholarly investments with which we approach the subject of the Holocaust. What is it that engages us in the subject? What are we trying to find, or to learn through our research? How do we teach it, what lessons do we attempt to pass on to our students? And how as researchers, teachers, and students do our different positionalities as Americans, Germans, non-Jews, and Jews (with or without a familial connection to the Holocaust) come into play in our engagement with the subject? I believe that these questions are important to investigate, for whereas our emotional investment in this work seems undeniable, the nature of this investment, and the kinds of work to which it leads us, have often been left unexamined.

This essay seeks to examine critically the issue of personal investment in the study of the Holocaust, and the particular role that positionality, personal and cultural memory, and identification and empathy play in this work. I investigate some of these issues through a discussion of the feminist concept of positionality;[2] Susan Rubin Suleiman's notion of "autobiographical reading"; and the concept of what Andrea Liss and Marianne Hirsch have called "postmemory."[3] While positionality addresses the issue of scholars' subject positions in their work, the concept of "autobiographical reading" allows for an analysis of personal investment and the self-seeking nature of the reading of Holocaust narratives. Postmemory provides a framework through which to examine more specifically the individual and cultural memory through which the Holocaust has come to function in the personal and cultural imagination of those who were born after 1945.

My discussion aims to acknowledge personal investment in Holocaust research and teaching, investigate its nature, and analyze the role that positionality and postmemory play in it. Such a discussion could lead, I hope, to a more open scholarly dialogue within this field of

research (whereby different personal and political agendas can be acknowledged and assessed), and to pedagogical approaches that would take into consideration (and account for) the role of personal investment and positionality for ourselves as teachers and for our students.

Positionality, Autobiographical Reading, and Postmemory

The assessment of one's positionality and of one's personal investment and position in relation to one's research has been central to women's studies research for decades, due in part to the work of Linda Alcoff and Teresa de Lauretis.[4] Their work suggests how the questions of who one is as a (gendered) subject, where one is positioned, and how one is constructed, or constructs oneself culturally vis-à-vis the discourses that frame one's field of research, are important. After all, we are not simply rational, disinterested, apolitical agents. "The configurations of each person's subjectivity," as de Lauretis defines subject position, the patterns by which "experiential and emotional contents, feelings, images, and memories are organized to form one's self-image" (de Lauretis, "Feminist Studies" 5) also affect the work we do, as identity and subjectivity create the background, the position, from which we construct meaning in our work. This awareness, or consciousness, of self, the "particular configuration of subjectivity...produced at the intersection of meaning with experience" (8), that is, of subjectivity as positionality, has been essential to feminist research since the 1980s. This feminist work refused the methodological imperative to distinguish between self as actual biographical referent and self as narrator. For if positionality is a location from which we construct meaning, this positional self could not, and therefore should not, be removed from the text. After all, suggesting it was not there or did not play a role simply constituted a cover-up.

In German studies and in Holocaust studies, such an investigation of positionality has seemed less urgent, for unlike women's studies, these disciplines do not explicitly presume any particular political or emancipatory goal. Within these fields, most scholars tend to assume that a scholar's personal agenda is more or less neutral and to a great extent irrelevant. Indeed, within Holocaust studies more specifically, if questions about the role of positional subjectivity are brought up at all, it happens in a fashion that tends to foreclose a meaningful discussion. This happens at times when a scholar is a Holocaust survivor, for instance, or if there is another kind of direct familial link to the Holocaust (for example, in the case of children of survivors). In such cases, positionality comes to function merely as a simplistic identity position

(whereby the notion of identity is no longer taken as problematic, as always in flux, always under construction) that designates a personal link to the Holocaust that functions to foster a certain measure of authority and authenticity.[5] By foreclosing a discussion on the more complex aspects of this particular positionality, however (how are identity and subjectivity constructed for different survivors or children of survivors, and how do the internal characteristics of the person thus identified, as well as the external context in which that person is situated—that together define the "person's relative position" [Alcoff 349]—play a role in how he or she constructs meaning?), this background, as well as the positionality of those without a personal or familial connection, remains unexamined, even though scholars' personal investments seem so obvious and relevant.

My concern about these issues stems in part from my own peculiar experience with the role identity politics plays in my work on the Holocaust. As a female, relatively young scholar with a foreign first and last name that are not recognizable as Jewish, and as a person who does not "look Jewish" (certainly not in a North American context where this means something a bit different from Western Europe), I have often been looked upon as an outsider in public academic forums such as Holocaust conferences. Apparently not personally connected to this history as a survivor or a child of a survivor, nor as a Jew, nor as a contemporary, I find that I often feel as if I have to legitimize my work or my involvement in this field. (Why do I do this work? Why does so much of my research and teaching deal with the Holocaust? What are the lessons I draw from this history?) Sometimes I refuse to do so, while at other times I make use of the powerful status of the "authentic" in this field by revealing publicly who I "really" am, namely, not only a (Dutch) Jew, but also the daughter of a Holocaust survivor.

This revelation, this "autobiographical posturing," comes about in one of two ways, either before my conference presentations in the form of a brief line in my biography, which the moderator of my panel will read out loud ("born and raised in Amsterdam, the Netherlands, she is the daughter of a Dutch-Jewish Holocaust survivor"), or I may disclose this information myself during the discussion afterwards. In either case, the revelation is both powerful and embarrassing. Powerful, for by doing so, I, personally, and therefore the work I do, seem to gain in legitimacy. No longer a complete outsider as I seemed to be before, my opinion now counts, as my perceived proximity to the Holocaust experience, my "authenticity," my personal, familial, connection are seen as an advantage, as a genuine source of knowledge, and as a position from which to assert authority. While I do indeed believe that my knowledge

or investment may differ from that of scholars without a familial connection, how this background might actually play a role in my case, and in general (and inform our work and teaching, for good or for bad), is never questioned. Playing along with this authenticity game, then, is embarrassing, for, on some level, by entertaining it, I seem to suggest that there is some validity to it, and in turn, I forgo an opportunity to question publicly how precisely positionality, mine or anyone else's, might indeed affect this work.

This is an important issue, precisely as the topic of the Holocaust does evoke a strong response for most of us, as well as for our students. In particular, if we do research or teach on the Holocaust from within the field of German studies, shouldn't we assess how we ourselves fit into this history, how we relate to it as historical subjects? Don't we need to decide how we approach this material, as a part of German history, or as a part of Jewish history, and whether we see the Holocaust as inevitable in the context of either history, or as an aberration? In the context of working on the Holocaust we are expected to take sides, to pass judgment. How can we do so without having our personal and professional background play a role? I believe that we cannot make these decisions without drawing our own subjectivity, which is in one way or another implicated in this history, into it. Where, in relation to the events of World War II and the Holocaust, do we place ourselves? It is reasonable to assume that both our different academic affiliations (as literature or history scholars, in German studies, Jewish studies, women's studies, and so forth) and our own family histories in this regard matter, as does the cultural context in which we were raised and were exposed to this history.

An example of the role positionality plays can be seen in a discussion by Atina Grossmann of late 1980s, feminist debates about women and National Socialism. Grossmann shows how a number of the (rather polarized) positions taken on by German and American women historians in relation to this question seem to be clearly affected by personal positionality: "who is doing the writing matters enormously," Grossmann argues (354).[6] A prominent American historian who condemns German women's complacency and collaboration is described as affected in her work by "the anxious burden of memory shared by Jewish colleagues and the elderly German-Jewish refugees and Holocaust survivors she befriended" (354). In contrast, Grossmann suggests that a number of German historians are carrying "another audience in their heads and hearts," as they "stress their mothers' and grandmothers' fortitude....and the[ir] energy" (354).

Aside from certain professional and personal positionalities playing a role in our research and teaching, another, perhaps even more contested, way to understand our personal investment is by acknowledging that we may indeed be "getting something" out of doing this work. In her analysis of what it means to do work on contemporary literature, for instance, Susan Rubin Suleiman suggests that we work on this kind of literature (that is: literature that is of one's time, that deals with events and ideas that one considers in some way "intersected" with one's own) for three reasons: "self recognition, historical awareness, and collective action" (3). While the latter two reasons, historical awareness and collective action, are indeed invoked as rationale for working on Holocaust-related material, self-recognition, the first, equally important reason, generally is not.

If Suleiman's definition of contemporary literature can be applied to Holocaust literature (as I believe it can, as the legacy of the Holocaust affects much of late twentieth-century history and culture, and as such, is "of one's time" even if one is born after 1945 because it has continued to intersect so strongly with many aspects of postwar politics, culture, and literature), this may play an important role in our work on the Holocaust. Holocaust narratives as "contemporary literature" can thus be "exhilarating" to write about, precisely because, as Suleiman comments, "contemporary works can be interesting in the sense of appealing to one's 'self interest'" (6). She calls this mode of reading an "autobiographical reading" that "consists of reading another's story '*as if it were one's own*'" (emphasis added; 8). In reading Holocaust literature as a contemporary's life story, we thus read for those aspects that resonate with our own experiences and sensibilities. In so doing, we are self-seeking readers.

Suleiman's notion of autobiographical reading helps us understand the nature of the personal investment we may have in doing work on the Holocaust, by seeing it as less selfless and "noble" and possibly decidedly more self-interested than is usually the case. This seems at first wholly unthinkable, for who would want to find themselves in this traumatic Holocaust history? Aren't most of us profoundly grateful not to have lived through these experiences, not to have suffered such losses? And on the other hand, isn't it by definition impossible to understand the Holocaust fully, let alone identify with someone who lived through the "concentrationary universe"?[7]

While there may be something inherently incomprehensible about the Holocaust, we cannot deny that we read these histories of the Holocaust, and memoirs in particular, or listen to survivor testimony, precisely because we do believe that we can understand more of this

experience through reading or listening. And perhaps this activity is precisely bearable in part because while we are confronted with the horror, we feel a sense of relief in knowing that we were not there. Furthermore, if we read memoirs written after the war, we know that at least the author whose story we are reading survived (an image often imbued with a strong sense of heroism and victory, within US culture in particular). That is, while the events are deeply tragic, the survivor whose story we encounter lived to tell about it, and we are grateful to come to know it. Even when we work with stories by victims who did not survive, a confrontation with their story can still allow for an odd sense of comfort: their lost life is tragic, the Holocaust was horrible, but in the form of this work their voice survives, and is continued.[8]

Furthermore, many of us read survivor literature for the valuable "lessons" it provides. The Holocaust as a "contemporary" historical event, and the stories of its victims and survivors, have relevance for us now because they engage us morally and on a deep personal, emotional level. Because of this, we assume that they may help us understand more of our own lives and times. Insofar as these stories facilitate the thinking through (and perhaps even a mourning of) our own personal ordeals and losses, engaging in this work may in fact provide moments of personal catharsis. Just as with any other kind of novel, memoir, or film, it is possible to read or view material on the Holocaust, feel a connection, feel moved, and feel in some sense better afterwards.

The desire to find something redeeming or pleasurable in a confrontation with the Holocaust and the people who lived through it is quite strong and not at all uncommon. While this kind of "reading" may seem naïve or even objectionable, students commonly respond to Holocaust work this way, I have found, and it certainly also plays a role in the kind of scholarship that is produced on this subject. For instance, as feminist Holocaust scholar Joan Ringelheim has pointed out in a critical review of her own work, the need to look at the subject of women and the Holocaust while looking for something that would make "the horror less horrible or even negligible" (388), and to see something positive, such as agency, in the lives of these women, came to affect the outcome of her research. Looking back at her earlier work, Ringelheim suggests that her "desire for solace or peace in a disturbed world" (388) changed her respect for the women survivors whom she interviewed into "glorification" (387). This glorification in turn led to what she now argues is the incorrect conclusion that "these women transformed 'a world of death and inhumanity into one more act of human life'" (387).

In this regard, "self-seeking" and the desire to find meaning in the horrors of the Holocaust may affect the work we do. The tendency to

read autobiographically means that in reading about the Holocaust, and especially survivors' accounts (or in observing or engaging in oral testimony), we may insert ourselves: we identify, we imagine, we empathize, and we tend to project our own (usually unconscious) agendas. In fact, what I argue here is that, in general, research and teaching on the Holocaust are so thoroughly fuelled by an autobiographical imperative—that is, they rely so heavily on identification as a tool to come to understand the experience—that an examination of how, from what position, and to what end we identify is of great relevance. We need to consider what the effects of this self-seeking are on our research and our teaching.

In his work on the role of gender in an autobiographical reading of Holocaust memoirs (in which he uses Suleiman's work), Gary Weissman has pointed out that the desire for "self-recognition" influences what we choose to read and write about, "...as we search for those stories and themes which have 'autobiographical resonance' with our lives" ("Gender" 3).[9] Weissman suggests that because male scholars, who have dominated Holocaust studies, identify with male survivors, one important way in which this kind of reading thus plays a role is that their "autobiographical reading" has affected the canon of Holocaust literature, which as a result is predominantly male. The tendency to read in a self-seeking manner comes to influence the field as a whole since it determines which Holocaust texts are read, which survivors are heard or represented ("Gender" 5).[10] As I have argued elsewhere, the significance of this exclusion of female voices is in turn considerable, as gender matters greatly in determining how the Holocaust was experienced, remembered, and narrated (Bos 34–45). Through the decades-long exclusion of stories of female survivors, we have long been unable to consider the full human spectrum of this history.[11] We, in turn, as scholars who represent a variety of backgrounds and disciplines, need to consider carefully which stories we choose to include and exclude in our own research and teaching, and to be aware that our own (and our students') tendency to read autobiographically will probably affect our selection.

Apart from positionality (through the tendency to read autobiographically) affecting the choice of texts we work and teach on, Ringelheim's self-critique suggests that we should also carefully consider how the process of self-seeking, of identification, influences the content of our teaching and the work we produce. For whereas we may see the issue of identification as problematic and as uncomfortable to discuss, it is also unavoidable. How can we make sense of the Holocaust without getting personally involved, without feeling empathy or compassion for those affected? If we teach about the Holocaust, don't we, for instance, choose

to use personal narratives in order to facilitate some form of identification, of a personal connection between this Holocaust survivor or victim's story and ourselves and our students in order to make the experience more understandable? Don't we count on the involvement of our own and our students' emotions to make this confrontation work, and isn't this kind of affect influenced by who we are as individuals and how we are positioned in this history and discourse? How else but through a process of identification do scholars and students in this field, especially those who may not have a familial connection to the Holocaust, relate to it?

One way better to understand both the necessity and the potential pitfalls of identification, and how identification is affected by whether or not one has a familial connection to this history, is through the notion of postmemory. The term postmemory was initially coined by Marianne Hirsch to describe a familial memory of children of Holocaust survivors (the so-called "second generation"). Through their parents' stories and silences, they were the recipients of a second-hand, delayed, and indirect form of memory that "is distinguished from memory by generational distance and from history by deep personal connection" (Hirsch, *Family Frames* 8), and thus postmemory is seen as a "response of the second generation to the trauma of the first" (Hirsch, "Surviving Images" 8). While for Hirsch the term was inspired by the experience of children of survivors (since the Holocaust figures for them as a personal history, as a "family narrative"), she also suggests, as does Andrea Liss, that postmemory need not be defined by this "familial inheritance and transmission of cultural trauma." For even though "familial inheritance offers the clearest model for it, postmemory need not be strictly an identity position" (Hirsch, "Surviving Images" 10).[12] After all, as Leslie Morris argues, "...as the memory of the Holocaust circulates beyond the actual bounds of lived, remembered experience..it seeps into the imaginary of other cultures (and other geographical spaces) as postmemory..." (291). Thus, "outsiders," too, have access to a form of "secondhand" postmemory (Hirsch, *Family Frames* 249).[13]

The notion of postmemory, then, can be used to understand a familial as well as a non-familial relationship to the Holocaust. That does not mean that the two forms of postmemory are the same, however. Hirsch, for instance, suggests that the postmemory of "outsiders" may be understood as an act, as a *"retrospective witnessing by adoption"* (Hirsch, "Surviving Images" 10; emphasis in the original). This process is made "more readily available" through "particular forms of identification, adoption, and projection."[14] This form of identification provides a means of access for those who were not there: "It is a question of adopting the

traumatic experiences—and thus also the memories—of others as one's own, or, more precisely, as experiences one might oneself have had, and of inscribing them into one's own life story" (Hirsch, "Projected Memory" 9).

The difference, then, between familial and non-familial (extra-familial or cultural) postmemory is one of degree: both involve processes of identification and imagination with a history not experienced firsthand, and in both cases one may find instances of over-appropriation and over-identification. Nevertheless, there are more distinctions. Children of survivors grow up with fragmented family narratives characterized by a trauma that, as Cathy Caruth has suggested, is by definition not linear and directly referential (11). The narrative of trauma, as "an overwhelming experience of sudden or catastrophic events in which the response to the event occurs in the often delayed, uncontrolled repetitive appearance of hallucinations and other intrusive phenomena" (11), was most often vague, confusing, distorted, indirect. To be the first (and often only) recipient of these stories, stories that were characterized by absence and indirectness, meant that these children were in fact twice the recipients of the story of an absence—first, because their parents had no real mastery over their traumatic memories, and second, because they as children born "after the fact" were physically absent from the Holocaust experience. To a child of a survivor, the Holocaust may thus be one's familial story, and in this regard it is one's personal story, but at the same time, one is still left to struggle to decipher the trauma at the core of the silence, to connect, to make what was absent present.

The effects of this trauma, these absences, these silences, are complex and varied, but they tend to lead to roughly two different kinds of responses. Children of survivors may deny the existence or the significance of this particular history (this is possible in particular in families where no one speaks of the experience). Or they may instead feel strongly compelled to "fill in the blanks" of the stories, to come to understand better the source of the silence and loss in their families that so thoroughly affected its dynamics (while most families at the same time denied that it did). They have to come to know, have to find out the details of what had happened to those who made it through, as well as those who did not. When they try to do so, however, it often turns out that the confrontation with these stories does not "solve" anything, nor does it provide some kind of emotional or intellectual solace. In fact, the more one knows, the more it becomes clear that nothing of this particular history can ever be truly assimilated into a story or an emotion that makes sense. The severity of the persecution, the scale of the loss, are

so unfathomable and so incomprehensible that they can hardly be articulated. For many children of survivors, the cumulative aspect of this particular trauma is unbearable, it numbs, and ultimately, it traumatizes all those who allow themselves to be truly confronted by it. The confrontation with (and either avoidance or exploration of) the trauma of the parents thus tends to be experienced as fundamentally involuntary and to a certain extent unavoidable, and as something that cannot be assimilated. One may seek identification just as those without a familial connection do, but the results may turn out to be far less manageable. Furthermore, the sense that this quest is never optional (as it to a certain extent is for those growing up without such a clear family connection) gives it a very different dimension and represents a very different investment.

Thus, while the notion of postmemory can be used, I believe, to describe the affective dimension of the constellation of personal and cultural discourses and experiences that make up our positionality, and thus can be seen as part of one's positionality, extra-familial postmemory (in contrast to familial postmemory) is at once also more than and different from this kind of positionality, as it so clearly denotes an aspect of choice. "Witnessing by adoption" suggests a deliberate affective engagement with the Holocaust, in contrast to a familial postmemory, where the confrontation is defined by historical and personal factors over which one seems to have little control.

Extra-familial postmemory is no less real or important than familial postmemory, however, if we understand it as a form of identification that facilitates the crucial bridging of the gap between survivors and those who were not there, since it seems to allow for a connection, a dialogue. This is important, as the Shoah seemed to extinguish the very possibility of address, of appealing to another person outside of the reality of the camps, as Dori Laub points out (81), and this in turn convinced some of the survivors "that their experiences were no longer communicable, even to themselves, and therefore perhaps never took place" (82). Indeed, Laub calls this loss of the capacity to be a witness to oneself "perhaps the true meaning of annihilation" (82). If we do not believe that through postmemory those generations born after the Holocaust can or should still be able to relate to it, what will be left of those stories?

Notwithstanding extra-familial postmemory's significance for enlarging the circle of witnesses, some of this identification, "the imaginative capability of perceiving...what is happening to others in one's own body," can also potentially become problematic if it remains unexamined. Hirsch warns that these "lines of relation and identification" need to be theorized further in order to resist appropriation and incorporation.

It is the kind of identification that leads to "adoption," appropriation, and the erasure of the difference between self and other in our confrontation with the Holocaust (in research and/or teaching) that concerns me, as it allows the viewer or reader to become "a surrogate victim" and allows "context, specificity, responsibility, history" to become blurred (Hirsch, "Projected Memory" 17).

While I have found the notion of (familial) postmemory very useful for me personally, because it allowed me to conceptualize my own profoundly complex relationship as a child of a survivor to this past,[15] my concern is that when postmemory is used in a broader cultural sense as "retrospective witnessing by adoption," the potentially problematic processes of "identification, adoption and projection" that are involved may not be sufficiently analyzed. I wonder whether postmemory risks becoming a vague catch-all term used by academics through which to articulate a broader cultural-historical awareness of and emotional connection to the events of the Holocaust, but which conveniently leaves out one's particular personal investment in this knowledge or connection. I wonder what need it fills, and how it functions in our work. Not only should we investigate more thoroughly how this broad cultural memory of the Holocaust functions in the US and in different European nations,[16] and how it has influenced each of us individually, we should also ask what we gain personally from our choice to engage with this subject, this trauma, this loss. Why does one choose or feel compelled to become a "secondhand" witness?

I want to argue that the notions of familial and cultural or extra-familial postmemory by themselves do not resolve or explain much about our positionality, and that our use of the terms to explain, in shorthand, as it were, what our relationship to the Holocaust consists of, should not keep us from exploring in more depth how this relationship to these events has been (and will continue to be) shaped. Indeed, there is a great need to investigate and theorize further the "lines of relation and identification" involved in the process of postmemory, both for those with and those without familial postmemory, since I believe that not doing so might lead to an appropriation that can become purely personal and sentimental, whereby "context, specificity, responsibility, history" become unclear.

Let me illustrate here how easily this can happen if one does not explore personal investment and positionality, by means of a reading of *Eyes from the Ashes,* a "memory project" by Ann Weiss, that consists of a video, a photo exhibit, and a photo book. At the center of all three, video, book, and exhibit, is a collection of reprints of personal photographs brought along by Jews who were deported to Auschwitz after the

liquidation of the Bendin ghetto in Poland in 1943. Weiss came across the photos by chance during a tour of Auschwitz in 1986, when the photos, which were not exhibited, were shown to her privately by a guide. She then negotiated permission with the Polish authorities to copy the photos.

Weiss has traveled over the past decade with this exhibit of reproduced photos around the United States, showing her video that contains a selection of the photos and telling the story of their discovery. I find her lecture presentation problematic because the story of the photos' (re-)"discovery" and "rescue" by Weiss, the child of survivors, who grew up without any photos of her own murdered relatives, becomes so central. Because of this, I choose here to focus on her recent book. In *The Last Album: Eyes from the Ashes of Auschwitz-Birkenau* (2001), which opens with a foreword by Leon Wieseltier, author and literary editor of the *New Republic* (and himself the son of a Holocaust survivor), and an introduction by Holocaust scholar James Young, several hundred of the photos that Weiss found at Auschwitz have been beautifully reproduced. This book in particular presents an odd disjunction, for not only does one not expect such photographs in the format of a coffee-table book, it is also highly unusual to see such a book introduced by prominent intellectuals, suggesting that the book belongs to a different (scholarly) genre. Most problematic, however, is how it asks to be read.

Educational and artistic projects that use domestic, pre-Holocaust photography often provide an invitation to identify that is difficult to resist, and this project is no different. As both Liss and Hirsch have pointed out, photography plays a central role in postmemory, as it both facilitates and complicates this process of identification. Liss argues, in fact, that postmemories tend in general to be centrally informed by photographs: "Postmemories...constitute the imprints that photographic imagery of the Shoah have [sic] created within the post-Auschwitz generation" (Liss, *Trespassing* 86). Hirsch suggests that, on the one hand, photos seem to evoke the physical reality of the event, the "trace," or "evidence" we so desperately seek, the further removed we are from the events in time. That is, photos have the ability to connect us to the "real." On the other hand, photos hold a central place because certain Holocaust photo images (in particular those from the concentration camps and ghettos) have circulated with such repetitiveness that they have gained a certain sense of familiarity to those of us who were never there (Hirsch, "Surviving Images" 13). In some respects, then, these photos have become iconic in our cultural postmemory.

Hirsch and Liss criticize the repetitive use of certain kinds of photos (in particular Nazi propaganda shots) in contemporary educational material and in academic and artistic work, because they risk the desensitizing of the audience to these images (Hirsch, "Surviving Images" 24; Liss, *Trespassing* xii-xiii).[17] They suggest, however, that the judicious use of certain kinds of photos, namely family snapshots, does work. Liss, for example, argues that domestic images of pre-Holocaust families potentially can "transform the sentiment of singular personal attachment into potent collective signs of irreducible existence and retrospective resistance," as these kinds of photos so explicitly counter the "other" photos, namely, "the legions of horrific photographs picturing people stripped of their humanness, images that have been archived, reproduced, and codified into unaccountably familiar yet blinding post-memories" (Liss, *Trespassing* 93).[18]

Notwithstanding their power, it is the use of these family photos in art and documentary projects that potentially also lends itself most easily to "narcissistic, idiopathic looking," as Hirsch rightly warns, because we as viewers easily identify with the images and project ourselves into them. Thus, she suggests that the challenge for those who use photography (in art, or, as I would argue, in research or teaching) is to "find the balance that allows the spectator to enter the image, to imagine the disaster, but that disallows an overappropriative identification that makes distances disappear" (Hirsch, "Projected Memory" 10).

This is no easy task, however, as becomes clear in Weiss's project. How the photographic images of the Holocaust are read and what kind of identification they invite or elicit depends strongly on what kinds of photos are selected and on the context in which these photos are placed. Weiss's work is an illustration of a photography project in which careful reading becomes essential, but tricky, as the issues of positionality, ownership, and (inappropriate) identification converge.

The first (and by far largest) part of the book contains photos organized by theme, from different schools and orphanages, the Chasidic community, Zionist organizations, and different families. The photos depict ordinary pre-war Jewish community life and activities. We see pictures of families, children, friends, weddings, outings, and club and school life. In fact, little is remarkable about any of these photos, apart from the fact that the spectator knows that the people portrayed were probably killed by the Nazis, and that those who made the effort to bring these photos with them to Auschwitz were murdered as well. This knowledge of their tragic deaths, then, creates a moving disjunction: the contrast between these vibrant, healthy, happy Jewish faces, which give us a glimpse of Jewish life in Eastern Europe before the Nazi invasion,

and their inevitable, senseless deaths in the Nazi camps. In this respect, this book functions a little like the traditional *yisker bicher,* the memorial books created after the war by survivors to commemorate the destroyed Jewish communities of Eastern Europe.[19]

For many readers, the pictures in this book may indeed provide a first glimpse of a thriving, very normal, pre-war Polish Jewish community. They form a stark contrast with the now widely circulated images of camp inmates, emaciated faces staring through barbed wire fences, and piles of corpses. In fact, this contrast forms the strongest rationale for the reproduction of these photographs, as Weiss suggests: "...these photos do not depict the familiar nightmare images of violence and death commonly associated with Hitler's Europe. Instead they resonate with life. In these intimate photos, we witness life as it was supposed to be, life before the horror began" (20). What matters to Weiss is that these are "the very photos they chose for their own remembering," allowing us "the most intimate view of who these people were, who they loved, what mattered most to them" (21). The reproduction of these photos is supposed to return humanity to the victims.

Weiss presents her work as a personal mission, and the act of painstakingly reproducing and archiving these photos may well have served an important personal function for her, a daughter of survivors who grew up with few family pictures. Thus, it perhaps constitutes important "postmemory work," since, for Weiss, the photos can represent the loss of her family and of Eastern European Jewish culture, and allow for a process of mourning and "working through." I believe, however, that for a general audience that may or may not be Jewish, or even American,[20] and that (on the whole) does not have a familial connection to the Holocaust, the photos come to facilitate a different kind of identification. This identification may be far more sentimental, and even nostalgic, and risks retroactively erasing the reality of the horrors of the Holocaust.

My problem with the book is that it seems packaged to do precisely that. The book's layout is beautiful, many of the men, women, and children in the photos are attractive, and the images are presented without much context. All of this invites fetishization. It is a pleasure to look at these pictures, just as it would be if they had been in a regular family album, and this pleasure is possible precisely through a process of identification. "This girl looks just like my aunt," we think, "this baby could be my nephew!" We look, we recognize ourselves, our lives, our families, and then are called back to the reality of these people's deaths.

While Weiss seeks this identification, seeks to undo the abstraction of the Holocaust, and elicit a different form of mourning from her audience, I wonder what kind of mourning this project truly brings forth.

These are compelling photos, but we know nearly nothing about these people as individuals, the lives they lived, we know nothing of the circumstances of their death, either. We are left to project our own image onto them and to wonder who they are. Instead of using such family snapshots and returning humanity to the victims, or, as Liss suggests, transforming "the sentiment of *singular personal attachment* into potent *collective signs* of irreducible existence and retrospective resistance" (93, my emphasis), the sheer size of the project and the anonymity of most photos make me feel as if I am intruding into lives that were never meant to be this public, lives that are made into a spectacle without permission.

Perhaps because of my own personal connection with this history, growing up with identical snapshots of (my own) murdered relatives in which we as a family had a tremendous emotional investment, I tend to resist this transformation from the personal attachment to the collective sign. Despite the kind of profound postmemory these photographs may elicit through our ability to identify with them, we should not lose sight of the fact that the people in these photos are indeed not our family, are not us, and furthermore, that they were indeed someone else's relatives. These photos, taken along to Auschwitz by relatives or friends precisely because they felt an emotional attachment to the people depicted in them, are now displayed as iconic "traces," representing no longer the people in the photographs or their owners, those who loved them, but more symbolically, the losses of the Holocaust, the loss of innocence, of normal lives, of entire communities. I take issue with this kind of symbolic presentation and the "idiopathic, narcissistic" looking it invites (Hirsch, "Projected Memory" 10), and I am asking others to resist it, too.

For the (much shorter) second part of the book, Weiss tracked down and interviewed a number of survivors depicted in these photographs, as well as surviving family members. Through the in-depth interviews the photographs come to life and do justice to the victims, and a more appropriate distance between them, the Holocaust experience, and the viewer/reader is reinforced. We can no longer project ourselves onto the images in these photos as before, as they are no longer anonymous but presented within the context of the story of the survivors themselves. Certainly, these stories, too, can be read autobiographically, but this requires more conscious effort than with the photos in the first part of the book, where identification occurs so effortlessly. A reading of the interviews is less likely to lead to the kind of identification in which the distance between reader and survivor disappears completely.

Weiss's project, then, suggests precisely how difficult it is to read Holocaust-related work (history, memoirs, film, photos) without projecting ourselves into the stories and images. Both the desire to connect, and the imperative to understand (or to have students understand) more fully these unimaginable experiences make us put ourselves into these stories and images. Furthermore, in some cases, doing so may in fact make us feel better. Looking at the photographs in Weiss's book is in an odd way pleasurable. As we are asked only to imagine what happened to the people in these photos but are not confronted with their deaths, we do not have to confront fully the horror of the events. The history of what follows is assumed to be so well known that it is left out of the work. Graphic photos from Auschwitz, for instance, are not included in the book. Some Holocaust works, then, more than others, tend to invite identification explicitly (even though it may become potentially sentimental, nostalgic, and inappropriate), as our own positionality and investment are so explicitly not called into question.

There are a number of different ways in which we can prevent this kind of looking or reading, and prevent our (and our students') engaging in it. One way, as I have suggested throughout this essay, would be to investigate one's positionality toward this history, and to analyze what one's particular postmemory of the Holocaust is fuelled by, and thus consciously question our personal investments in this work. Why do we do it? What do we have personally invested? What do we get out of it? What are we looking for, how are we reading? I am not calling for such personal revelations to become part of every essay or book published in this field, or even of every student paper. I do think that at some point in every research endeavor, however, we should encourage each other and our students to consider these questions of investment.

Another way to counteract a too facile and potentially sentimental identification which erases specificity and history, and which shelters us from the reality of the profound violence and terror of the Holocaust, is to place the kind of work that potentially elicits this kind of response back into a larger context that does provide a confrontation with this traumatic background. An example of such a contextualizing is the "Tower of Faces" in the United State Holocaust Memorial Museum in Washington, DC. The photos that cover the entire length and width of the inside walls of this tower (which conjures up the image of a chimney) are family and community snapshots of Jewish families from the small town of Ejszyszki in Poland, painstakingly collected over a decade by Yaffa Eliach, one of the few survivors of this town, and they are quite similar in genre to the ones used in Weiss's project. While they thus risk producing a potentially similar problematic response in the

viewer, I believe the effects of these photos to be very different, because of the way they are exhibited. The tower is in the middle of the exhibit, and while standing in the tower, on a bridge, one can look up and down at the photos that cover the walls, but one can never see all of them, or even most of them, as many are too high up or too far down to be seen clearly. In fact, this set-up seems to have been deliberate, as a visitor gets to see different parts of this photo collection only when, at different moments throughout the exhibit, s/he crosses again through the tower while descending through the museum, floor by floor (one starts the exhibit on the top floor), and crossing from one room of the exhibit to the next. As the spectator is confined to different bridges each time, suspended in the air between the walls of the photos, the photo collection prevents the satisfying sense of completeness from taking hold that Weiss's collection elicits. In fact, as spectators we seem to "miss" the encounter with many of the people in the portraits because they are too far away for us clearly to see them, and we are thereby confronted both with the fact that we literally "missed" knowing these people while they were alive, and the realization that a complete presentation of the millions of people murdered by the Nazis, or even of the people of just one village, is not possible. We are thus reminded of the massive scale of the murders, as well as of the losses it represents. At the same time, our tendency to view these family photos in an "idiopathic" way is frustrated, complicated, made impossible. We are not offered the chance to see something as comforting and beautifully arranged as a photo album: the architecture of the exhibit itself prevents this from happening. Furthermore, it is important that these photos are only a small part of a much larger exhibit that focuses precisely on the details of the crimes of the Holocaust, its unprecedented brutality and scale, thus not sheltering us from the larger context of this history.

Awareness of context, framing, and presentation, then, in addition to self-awareness, are vitally important in how we encounter (and teach) the Holocaust, as emotions can so easily be manipulated. Certain presentations may (more than others) elicit a tendency to identify uncritically. Knowing that we do tend to read and look in this self-seeking way can thus guide us in choosing representations or texts that instead frustrate or complicate this desire, making a more critical discussion of both text and our own investment possible.[21]

I have suggested in this essay that within scholarship that deals with the Holocaust, taking stock of how positionality plays a role in the work we do (what different shapes our subject positions take and from which position we come to interpret the material we encounter) is important, for not only is the Holocaust difficult to approach neutrally, it is indeed

our affective capacity to identify (and our tendency to be self-seeking readers) that plays a great role in our gaining access to this experience. I introduced postmemory both as a crucial (and quite widely used) term to indicate the particular affective dimension of the connection we feel to this subject (a response to the trauma of the survivors that takes the form of a delayed and indirect form of memory), and as a notion that brings the problematic issue of identification to the center. For whereas postmemory can be defined as familial (whereby it stands for the affective dimension of the experiences and discourses that make up the encounter of a child of survivors with the Holocaust), it can also be understood as extra-familial, as an act, a "retrospective witnessing by adoption" (Hirsch, "Surviving Images" 10). As such, postmemory may bridge the gap between survivors and those who were not there, but it can do so, I have suggested, only if the acts of identification and adoption are sufficiently analyzed and self-monitored. If not, this affective response to the Holocaust can take the form of inappropriate over-identification that erases the difference between one's own subjectivity and experiences and that of those personally affected by the events.

In both cases, familial and non-familial postmemory, I have argued, the lines of relation and identification need to be theorized further. How do we approach the subject, with what kind of background, with what kind of investment? What is it that engages us, what are we looking for, what are we trying to learn or to teach? To illustrate the importance of such questions, I discussed Weiss's *Eyes from the Ashes,* in which the invitation to identify in overappropriative ways is particularly difficult to resist. A critical investigation of one's positionality is essential in countering such a response, I argued, as well as an awareness that certain discourse on the Holocaust invites "narcissistic, idiopathic" looking more easily than others.

My hope is that a call to a return of a more open discussion of these issues of personal investment and positionality, as established within feminist theory, will lead to scholarship in which positionality can indeed be acknowledged and investigated in more complex ways, not just in working on the subject of the Holocaust, but in the field of German Studies more generally. Furthermore, such an investigation could lead to the formulation of innovative pedagogic approaches that take into consideration (and bring into play) the positionality of our students as well, an approach that is not only relevant, but that in the process also educates the next generation of scholars on these issues.

Notes

[1] Des Pres (xiii). See also Felman, who contends that as the reading of survivor literature opens up "the imaginative capability of perceiving history—what is happening to others—in one's own body," it allows readers to become belated witnesses (108).

[2] Linda Alcoff articulated the notion of positionality in the late 1980s as an "alternative theory of the subject," a "third course" to transcend the dilemmas inherent in both cultural feminist and post-structuralist conceptions of female subjectivity (341). This essay was first published in *Signs* 13.3 (1988): 405–36.

[3] Liss and Hirsch seem to have developed this concept simultaneously, independently of each other. For Liss's first and later use of the term, see Liss (*Trespassing*) and Liss ("Trespassing"). For Hirsch, see Hirsch (*Family Frames,* "Projected Memory," and "Surviving Images").

[4] Alcoff bases her work on positionality on that of de Lauretis, who suggests that subjectivity, "for all social beings," is constructed through the process of experience (de Lauretis 157), that is, "by one's personal, subjective, engagement in the practices, discourses, and institutions that lend significance (value, meaning, and affect) to the events of the world" (159). Combined with the notion of "identity politics," the notion that "one's identity is taken (and defined) as a political point of departure, as a motivation of action, and as a delineation of one's politics" (Alcoff 347–48), Alcoff now argues that a woman can "actively utilize" her identity, "the product of her own interpretation and reconstruction of her history, as mediated through the cultural discursive context to which she has access," as a location for the construction of meaning (349). Positionality is the awareness as (female) subjects that we can "take up a position within a moving historical context and...choose what we make of this position and how we alter this context" (350).

[5] Take, for instance, the authority attributed to someone like Elie Wiesel. Having "been there," and having written on his Holocaust experiences, he has become an "expert" with a year-round lecture schedule, serving as an advisor of some kind for innumerable boards, foundations, and organizations related to the Holocaust. In the case of children of survivors, the assumptions made based on this positionality are possibly even more problematic, as I will explain later.

[6] It is important to note that the only forum where these issues have been brought up at all within this field is from within feminist studies.

[7] This is a commonly used English translation of the term first coined by David Rousset, a survivor of Buchenwald, in *L'Univers concentrationnaire.* It denotes the crimes committed by the Nazis and the concentration

camps themselves; while stemming from within (or located in) modern-day Europe, it also represents a wholly "different universe," bearing little resemblance to a "normal" world.

[8] Something of the kind certainly has occurred in the reception of the diary of Anne Frank, for example. Her work is taken to be a most powerful antidote to the Nazi hatred, whereby the fact that her "voice" survived while she did not is taken as a measure of comfort. It is now possible to find a theater poster announcing a youth theater's performance of the Goodrich and Hackett play *The Diary of Anne Frank,* which reads: "All the world's armies couldn't do more damage to the Nazis than the diary of a 14-year-old girl." The fact that Frank did not survive, and that her diary was not published until well after the Nazis were defeated, becomes completely irrelevant. Her story thus functions to make us "come to terms" with the Holocaust, defeating the Nazis, as it were, posthumously.

[9] I am grateful for his astute analysis of the issue of "autobiographical reading" and his reference to Suleiman's work. See also Weissman's critical discussion of positionality in the work of Lawrence Langer (Weissman, "Lawrence Langer").

[10] In this regard, it is interesting to note that so many of the authors in the canon of Holocaust literature are middle-class, assimilated Jewish humanists (for example, Primo Levi, Anne Frank, Jean Amery, Etty Hillesum, while Charlotte Delbo is not Jewish at all), which suggests that in that regard, too, our personal bias as overwhelmingly middle-class and secular scholars leads to the selection of certain texts over others. Of course, this selection is influenced in part by what publishers put out, and their choice is affected by the demand of the marketplace. It is reasonable to assume that market demand in turn is affected by the public's perceived ability to identify, that is, to read such texts autobiographically. Hence, there has never been much of a market in Western Europe and the US for memoirs written in Yiddish by observant Orthodox Jewish survivors (some of these texts have been published in small editions in Israel, and by small local presses in Brooklyn).

[11] I would like to see us remedy this exclusion, however, not by now focusing exclusively on women's stories, but by using our awareness that we read autobiographically (as gendered beings) to analyze how gender matters in narratives by both women and men.

[12] Liss does not define postmemories as familial at all, but uses the term to define all postwar Holocaust memory projects, regardless of whether the creator is a child of survivors (Liss, *Trespassing* 86). It is interesting to note that Suleiman also points out that a personal connection to a certain story is not necessary to identify: "it would be far too restrictive, and wrongheaded,

to suggest that only one who has undergone a certain experience can respond to another's story...autobiographically" (204).

[13] Hirsch suggests, for instance, that it should be the United States Holocaust Memorial Museum's mission to generate postmemory in a general audience: "The museum was created not primarily for survivors and deeply engaged children of survivors...but for an American public with little knowledge of the event. At its best, the museum needs to elicit in its visitors *an imaginary identification*—the desire to know and to feel, the curiosity and passion that shape the postmemory of survivor children. At its best, it would include all of its visitors in the generation of postmemory" (*Family Frames* 249, my emphasis).

[14] Not only is postmemory not necessarily tied to family, Hirsch argues that it should also not be tied "to a group that shares an ethnic or national identity marking" (Hirsch, "Surviving Images" 9–10).

[15] It "characterizes the experience of those who grow up dominated by narratives that preceded their birth, whose own belated stories are evacuated by the stories of the previous generation shaped by traumatic events that can be neither understood nor recreated" (Hirsch, *Family Frames* 22).

[16] In regard to the US context, Dora Apel shows that since the late 1960s, the Holocaust for many American Jews has served as a "unifying theme" that is meant "to promote Jewish identity and stem the tide of intermarriage and a too-successful assimilation" (15). She argues that "the evocation of the Holocaust serves as a kind of unifying historical reminder of the inescapability of Jewishness" (17). As an example of its power, she cites the 1998 *Annual Survey of American Jewish Opinion,* in which "remembrance of the Holocaust" was mentioned as the activity with the greatest importance to respondents' Jewish identity (17).

[17] For a similar critique, see also Zelizer.

[18] See also 27–28, where she discusses the "Tower of Faces" exhibit in the United States Holocaust Memorial Museum and argues that these photos do allow for identification.

[19] These are regional histories that talk of the Jewish community before and after the Nazi onslaught, and they usually contain photos, illustrations, graphs, and names of those who were killed. In this respect, the book mirrors in a strange way the work of the photographer Roman Vishniac and his "memory project" of the "vanished world" of Polish Jews. For a critical analysis of this work, see Zemel. As Zemel points out, the Jews in Visniac's photos (taken in the 1930s in Poland) are always seen from the perspective of what lay just ahead, their destruction. Thus the viewer comes to share Vishniac's position as *knowing witness.* As a result, "the images launch a voyeuristic fascination with a marked people in the moments before

death.... This uneasy voyeurism is sanctioned, however, by turning the act of looking to commemorative ritual" (81–82).

[20] There is now a German edition of the book in print as well (Weiss, *Das letzte Album*).

[21] Texts that lend themselves well to such a reading because they interpellate the reader in a way that frustrates this desire are, for instance, Ruth Klüger's memoir *Weiter leben: Eine Jugend* (1992), or Charlotte Delbo's collected works *Auschwitz and After* (1995). While both are profoundly moving pieces of literature, they do not allow for easy self-seeking or projection. Klüger's work complicates this process because it explicitly tries to appeal to the reader outside of the text, putting us back into our place as audience, and Delbo's work prevents this by its poetic power that makes us aware of the barriers of language and the inability fully to understand the experiences of the author.

Works Cited

Alcoff, Linda. "Cultural Feminism versus Post-Structuralism: The Identity Crisis in Feminist Theory." *The Second Wave: A Reader in Feminist Theory*. Ed. Linda Nicholson. New York: Routledge, 1997. 330–55.

Apel, Dora. *Memory Effects: The Holocaust and the Art of Secondary Witnessing*. New Brunswick: Rutgers UP, 2002.

Bos, Pascale. "Women and the Holocaust: Analyzing Gender Difference." *Experience and Expression: Women, the Nazis, and the Holocaust*. Ed. Elizabeth R. Baer and Myrna Goldenberg. Detroit: Wayne State UP, 2003. 23–50.

Caruth, Cathy. *Unclaimed Experience: Trauma, Narrative, and History*. Baltimore: Johns Hopkins UP, 1996.

de Lauretis, Teresa. *Alice Doesn't: Feminism, Semiotics, Cinema*. Bloomington: Indiana UP, 1984.

———. "Feminist Studies/Critical Studies: Issues, Terms, and Contexts." *Feminist Studies/Critical Studies*. Bloomington: Indiana UP, 1986. 1–19.

Delbo, Charlotte. *Auschwitz and After*. Trans. Rosette C. Lamont. New Haven: Yale UP, 1995.

Des Pres, Terrence. "Foreword." *Legacy of Night: The Literary Universe of Elie Wiesel*. Ed. Ellen S. Fine. Albany: State U of New York P, 1982.

Felman, Shoshana. "Camus' *The Plague*, or a Monument to Witnessing." *Testimony: Crises of Witnessing in Literature, Psychoanalysis, and History*. Eds. Shoshana Felman and Dori Laub. New York: Routledge, 1992. 93–119.

Grossmann, Atina. "Feminist Debates about Women and National Socialism." *Gender and History* 3.3 (Autumn 1991): 350-58.
Hirsch, Marianne. *Family Frames: Photography, Narrative, and Postmemory*. Cambridge: Harvard UP, 1997.
———. "Projected Memory: Holocaust Photographs in Personal and Public Fantasy." *Acts of Memory: Cultural Recall in the Present*. Eds. Mieke Bal, Jonathan Crewe, and Leo Spitzer. Hanover: UP of New England, 1999. 2-23.
———. "Surviving Images: Holocaust Photographs and the Work of Postmemory." *The Yale Journal of Criticism* 14.1 (2001): 5-37.
Klüger, Ruth. *Weiter leben: Eine Jugend*. Göttingen: Wallstein Verlag, 1992.
Laub, Dori. "An Event without a Witness: Truth, Testimony and Survival." *Testimony: Crises of Witnessing in Literature, Psychoanalysis, and History*. Ed. Shoshana Felman and Dori Laub. New York: Routledge, 1992. 75-92.
Liss, Andrea. "Trespassing through Shadows: History, Mourning and Photography in Representations of Holocaust Memory." *Framework* 4.1 (1991): 30-39.
———. *Trespassing through Shadows: Memory, Photography and the Holocaust*. Minneapolis: U of Minnesota P, 1998.
Morris, Leslie. "Postmemory, Postmemoir." *Unlikely History: The Changing German-Jewish Symbiosis, 1945-2000*. Ed. Leslie Morris and Jack Zipes. New York: Palgrave, 2002. 291-306.
Ringelheim, Joan. "Women and the Holocaust: A Reconsideration of Research." *Different Voices: Women and the Holocaust*. Ed. Carol Rittner and John K. Roth. New York: Paragon House, 1993. 258-82.
Rousset, David. *L'Univers concentrationnaire*. n.p.: Pavois, 1946.
Suleiman, Susan Rubin. *Risking Who One Is: Encounters with Contemporary Art and Literature*. Cambridge: Harvard UP, 1994.
Weiss, Ann. *The Last Album: Eyes from the Ashes of Auschwitz-Birkenau*. New York: W.W. Norton & Co., 2001.
———. *Das letzte Album: Familienbilder aus Auschwitz*. Berlin: Piper, 2001.
Weissman, Gary. *Gender and the Autobiographical Reading of Holocaust Memoirs*. Paper presented at the 28th Annual Scholars Conference on the Holocaust and the Churches. Seattle, 3 Mar. 1998. 1-11.
———. "Lawrence Langer and 'The Holocaust Experience.'" *Response: A Contemporary Jewish Review* 68 (1997/1998): 78-97.
Zelizer, Barbie. *Remembering to Forget: Holocaust Memory through the Camera's Eye*. Chicago: U of Chicago P, 1998.

Zemel, Carol. "Z'chor! Roman Vishniac's Photo-Eulogy of East European Jews." *Shaping Losses: Cultural Memory and the Holocaust.* Eds. Julia Epstein and Lori Hope Lefkovitz. Urbana: U of Illinois P, 2001. 75–86.

Postmemory Envy?

Elizabeth R. Baer and Hester Baer

Our mother-daughter collaboration on an English edition of Nanda Herbermann's *The Blessed Abyss: Inmate #6582 in Ravensbrück Concentration Camp for Women* raised a series of questions for us about the relationships among our personal histories, political affiliations, generational and intellectual stances, and scholarly work. These questions emerged from our negotiations over our very different responses to this complicated concentration camp memoir by a German, Catholic woman, imprisoned for resistance to the Nazis, who is also a distant relative of ours. By reexamining the context of our collaboration here, we address the value of positionality and postmemory for studies of gender, National Socialism, and the Holocaust, and seek to problematize discourses of authenticity and legitimacy in Holocaust Studies today. (EB and HB)

In January 2001, we gave an in-store reading from our recently published edition of Nanda Herbermann's *The Blessed Abyss: Inmate #6582 in Ravensbrück Concentration Camp for Women* at a bookstore in Minneapolis. Over the five years that we worked together on the book, we had given several collaborative conference presentations, but this one was different. The audience was comprised primarily of our friends and colleagues, many of them personal friends who knew only one of us and who had heard a one-sided account of our mother-daughter collaboration on the book and our personal and intellectual feelings about the project. We conceived the reading as a hypothetical conversation between ourselves and the deceased author of the book, Nanda Herbermann, a devout Catholic and German patriot who, at the age of 38, was arrested by the Nazis for her work with an anti-Nazi priest and imprisoned in Ravensbrück for twenty months before she was released upon direct orders from Heinrich Himmler. Our presentation at the bookstore in Minneapolis consisted of a dialogue in which we explained our discovery of

Herbermann's manuscript and our research on the project, interspersed with passages from Herbermann's memoir that we read aloud.

Our presentation of Herbermann's text in the context of our own collaboration had an unexpected result: our often contradictory responses and competing interpretations of Herbermann's highly ambivalent narrative were made manifest through our very different performative styles. While Elizabeth read the excerpts from the Herbermann text with sincerity and a certain amount of gravity, Hester read them in a tone that at times betrayed an ironic stance toward the author's sentimentality and trite language.

Our individual readings of Herbermann's words functioned as a seismograph of our own positionalities, a fact that our friends and colleagues in the audience commented on extensively in the question-and-answer period. For them and for us, this performance uncovered the complicated personal and intellectual dynamics of the process by which we came to understand and interpret Nanda Herbermann's memoir. In preparing her memoir for publication in the US, we had thought about Herbermann's own complicated positionality vis-à-vis the Nazi regime and the Holocaust. However, after the bookstore experience, we realized that our insufficient reflection on our own subject positions had led to certain roadblocks in our collaboration and in our interpretation of Herbermann's text. In this essay, we begin by recounting the context in which we collaboratively edited *The Blessed Abyss,* focusing on the impact of our own individual personal and intellectual histories on our reception of Herbermann. Building on this context, we then reread Herbermann, as historical subject and as discursive construct, in order to rethink some issues pertaining to gender, memory, the Holocaust, and National Socialism in Germany.

Elizabeth

For me, the story of our collaboration on *The Blessed Abyss* begins, auspiciously enough, at the United States Holocaust Memorial Museum. I was there teaching a Holocaust course to a group of college students in January 1996. My daughter Hester had been translating some family correspondence from German to English for my mother. What she discovered while translating caused her to telephone me. "Did you know," she asked, "that we had a relative who was in a concentration camp?" This was astonishing news, and I immediately began to wonder if there was a Jewish branch of my family of which I had been unaware. All my daughter had was a name—Nanda Herbermann—and the fact that

Herbermann had been in Ravensbrück and had survived and subsequently written and published a memoir.

By the time this call came from Hester, I had been studying the Holocaust for five years, following a visit to Dachau on a family vacation in Germany during Hester's junior year abroad there. That visit was one of those epiphanies that we experience only a few times in life. My focus as a scholar of literature had always been what you might call "the literature of the oppressed": I had worked on women's literature, children's literature, and African American literature. But the visit to Dachau, in the vernacular of the 1960s, blew me away. I realized that I had learned virtually nothing about the Holocaust in my formal education. My initial impulse was to blame that on the anti-Judaism of Catholicism, as I was educated by nuns from fourth grade through college. No one talked about the Holocaust during my childhood in the 1950s; I recall only an occasional *Life Magazine* story about grisly discoveries of Nazi atrocities. Subsequently, reading Peter Novick's *The Holocaust in American Life,* I came to recognize that growing up in the Cold War era was also a factor.[1] It would have been impolitic for America to teach the Holocaust in public schools and bring "shame" to our new ally, West Germany.

In any event, as I came away from Dachau that day, two questions were haunting me: how did this happen, and could it happen again? Trained neither in history, German, nor Jewish Studies, I felt and continue to feel very much a neophyte in the field of Holocaust Studies. But I plunged into an autodidactic program, reading everything I could, and, in 1994, enrolling in a month-long study tour conducted by the Jewish Labor Committee. This experience was extraordinary: led by Vladka and Ben Meed, both survivors of the Warsaw Ghetto resistance, this program trains forty-five American teachers annually through study at death camps in Poland and at Yad Vashem and Lochami Hagetaot in Israel. The following year, I dared to teach a course on the Holocaust. So this call from Hester was a jolt. Never did I imagine that my Catholic forebears in Germany had had an experience in a concentration camp. It all seemed too weirdly symmetrical that the daughter I had taught to read in 1975, who had gone on to pursue a PhD in German, and the mother who was immersed in Holocaust Studies should be presented with a book, written by a family member, that deserved translating into English and editing.

It was my great good fortune to receive this call from Hester in the building that houses one of the most extensive Holocaust library collections in the United States. I immediately began to comb books on Ravensbrück for some reference to Nanda Herbermann. After considerable

sleuthing over a period of several weeks, in Washington and in Minnesota, we eventually learned these facts about Herbermann. She was Catholic, not Jewish, which was consistent with what I knew about my maternal great-grandfather's family before they immigrated to America in the early twentieth century. Her great-great-grandfather was the brother of my great-great-great-grandfather. She grew up in Münster, Germany, where she was arrested for her work in Catholic resistance in 1941 (the concept of Catholic resistance in Nazi Germany is a contested notion, something that would eventually become the subject of much discussion between Hester and me). Herbermann spent two years at Ravensbrück. After her release from the camp, she wrote a memoir about her experiences entitled *The Blessed Abyss: Inmate #6582 in Ravensbrück Concentration Camp for Women,* which was published in Germany in 1946.

We managed to obtain one of only two extant copies of the memoir in US libraries and Hester, fluent in German, read it, and began to send me brief translated passages. I found these passages to be both compelling and informative about the experiences of women. Of her arrival at Ravensbrück, Herbermann wrote:

> I can still remember well how I first set foot in the concentration camp where I would now live for a long time, suffering and bearing deep pain which I never could have imagined before this. It was about nine o'clock in the morning. The gigantic entrance gate was crawling with SS and overseers in uniform.
>
> We had to organize ourselves in rows of four in front of the office of the Chief Overseer: luggage was not to be unloaded and there was strict surveillance with dogs in front, behind, and next to us. So we stood, hour after hour, until the late afternoon, without even receiving something to drink in this blazing August heat. Towards evening they finally began to let four prisoners at a time into the office, where, in a large room, an overseer noted down personal information and the reason for consignment to the concentration camp. When I gave the answer that I had been arrested for being Father Muckermann's secretary for many years, I received my first beating, and it was so severe that blood poured from my nose. Then we were led into a small room where, amidst the jeers of the guards, we had to take off and give up everything which we were carrying or wearing. When it was my turn, a little old granny also came up, who was so nervous that she was not capable of unbuttoning her clothes. I wanted to assist her, but then I was given yet another beating. Robbed of our clothes, which were thrown into a corner, we stood there stark naked. SS paced back and forth between us. For hours we stood there in our nakedness.

For me it was the most difficult thing. Some cried out loud. I remained mute. Then we were led into yet another room, where the new arrivals were deloused, one after the other, by two Jehovah's Witnesses who were also inmates. Wherever a single louse or a bug was found, the poor creatures' heads were fully shaved (110-11).

We also shared these passages with family members and friends. Because of the interest the text generated—everyone wanted to read more of the memoir—Hester completed a rough translation of the entire book. After we were able to read the full memoir, we deemed it a valuable document, which should be carefully translated into English and published so as to be more widely available. Not only was it a compelling personal narrative, but Herbermann was a trained journalist and thus her account of the daily details of life in Ravensbrück, the largest camp for women, contained much useful information.[2] The writing was lucid, we thought, if a bit prosaic, pious, and, at times, self-aggrandizing. Our sense that the memoir would make an important contribution to the field was confirmed when we made a joint presentation at a Holocaust conference in March 1997, which aroused considerable audience interest.

One of the aspects of the memoir we focused on in that presentation was the potential it has to add to our understanding of the intersection between gender and the Holocaust. For example, German historians have used *The Blessed Abyss* as a source of information on the establishment of the bordellos in concentration camps, a subject that had received little attention until recently. Perhaps because she was privy to information about prostitution in camps, but was not forced into prostitution herself, Herbermann is one of the few memoirists who provides clear historical detail on this point. Herbermann was assigned as barracks elder to Block II, which primarily housed women who had been arrested by the Nazis for prostitution. In this passage, she describes how these women were then forced into prostitution in the camps by the same state legal system that had originally arrested them for working as prostitutes:

> To elucidate what I have been describing here I have to report that approximately every three months eight to ten inmates, primarily from my block, were requisitioned for the bordello of the Mauthausen Concentration Camp for Men, as well as for other camps for men. The prostitutes were chosen by the Commandant, the Inspector, and the Chief Overseer, and could also volunteer themselves of their own free will. It is a horrible fact that people who had been imprisoned for their depravity, and for "endangering human society," were now commanded by the State, which held them for this precise reason, to be depraved again. After the

stipulated time, these inmates came back and new ones were chosen. What I heard from these inmates who returned from Mauthausen and other KZ's was gruesome. I will leave it up to others to report of this in more detail. The prostitutes who were sent to Mauthausen or other camps received somewhat better food, didn't have to perform any other work, had beds rather than cots, and received money in addition, which was paid out to them by the camp administration in the case of their release. All of these superficial, material advantages exercised great powers of attraction over them. Of the five marks which each male inmate had to pay in this bordello, the prostitute received fifty pennies, the other four marks and fifty pennies were pocketed by the state (131–32).

To me, these passages represented important historical detail about women's experiences in the concentration camps.

I have often felt like a trespasser in the field of Holocaust Studies—a non-Jew trained in literature with no facility in German, Polish, Hebrew, or Yiddish. Finding Herbermann and working on her book gave me "postmemory," a claim to the Holocaust as a legacy that gave me a toehold in a field where legacy matters—even if scholars are reluctant to acknowledge this. The term "postmemory" is Marianne Hirsch's. Postmemory is that of the children of survivors (although it is important to note that the term "survivor" is increasingly shifting and malleable). According to Hirsch:

> [P]ostmemory is distinguished from memory by generational distance and from history by deep personal connection. Postmemory is a powerful and very particular form of memory precisely because its connection to its object or source is mediated not through recollection but through imaginative investment and creation.... Postmemory characterizes the experiences of those who grow up dominated by narratives that preceded their birth, whose own belated stories are evacuated by the stories of the previous generation shaped by traumatic events that can be neither understood nor created (22).

Hirsch is herself the child of survivors and, in the act of writing the book *Family Frames,* lays claim to postmemory. The book is a pastiche of "different registers—theoretical, critical, and autobiographical" (15) and contains many photographs from Hirsch's own family, particularly as they relate to her peripatetic childhood, remembered mostly as a series of exiles.

But, as Hirsch acknowledges, these experiences produce a critical tension around adopting a pose of victimhood or appropriating a trauma. Even as I write this, I experience anxiety that writing about myself in

the context of the Holocaust is self-indulgent. "The personal is political," Hester reminds me in a telephone conversation as we revise the essay. Which in turn reminds me of my long involvement in women's studies, a field where I inherently felt that I could speak authentically. In a sense, work on Nanda Herbermann provided me with a dual path toward such authenticity: I could utilize my voice inflected with gender, and, as a non-Jew, speak of the experiences of a non-Jew at the hands of the Nazis. For me, then, it was less a question of appropriating a subject position of oppression than finding a space within this most contested of fields from which I could speak as a scholar, all the while respecting the many carefully circumscribed definitions and taboos around who is and is not a Holocaust victim.

In Holocaust Studies, postmemory moves a scholar from margin to center. Second-generation scholars can claim legitimacy, inside knowledge, and insight unavailable to those not of the second generation. Hester called me to account for precisely such a claim over the course of the correspondence we exchanged during our collaboration. On 16 February 1998, she wrote me in reference to a passage from our introduction to *The Blessed Abyss*:

> In general, I am a little uneasy about two things in this part: a) (as you have already probably noticed) I feel like it asserts that the Catholic Church was primarily a victim of the Nazis. I would be more comfortable if it asserted that individual Catholics were victims, the Church certainly collaborated with the Nazis in certain arenas, and the jury is still out on a lot of these issues...and b) I feel a little hesitant calling this section "The Catholic Resistance Movement in the Third Reich" since it doesn't really address any other aspect of that movement than Bishop von Galen. Perhaps we could call it "The Catholic Resistance Movement in Münster" or something, and it could firmly state that although Catholic resistance was not particularly widespread, Münster was a hotbed of it more or less, and Bishop von Galen was one of the few important church leaders who dared to speak out.

What began to emerge in our exchanges, which were conducted electronically since Hester was in Berlin and I was in Minnesota, was that we were each having very different identifications with Herbermann and with the project. Whereas the discovery of Herbermann enabled me to trust myself in a new way in the field of Holocaust Studies, translating Herbermann made Hester suspicious—not of me, but of heroic narratives about survival and resistance, especially this one with its Christian triumphalism. Whereas I brought to the project years of study of the Holocaust, Hester brought her keen knowledge of German language,

history, and culture. Often, we could negotiate difference in perceptions and responses to the memoir. It is only in retrospect that we have begun to articulate the ways in which we were sometimes working at cross-purposes, each with a different and often unarticulated set of motivations and goals.

Elizabeth and Hester

We began working together on this project for a variety of reasons, some of which we shared, and some of which we articulated to each other only later. While most of our friends and colleagues react with astonishment (if not horror) when we tell them that we coedited a book together, for us it was not a strange or unusual decision to embark on a collaborative project. We have always shared many intellectual interests: from the time Hester learned to read, we talked about and shared books; Elizabeth often took Hester along to academic conferences; and from the time Hester was in college, she discussed her studies with Elizabeth, urging Elizabeth, for example, to learn more about feminist and critical theory. We often read and discussed each other's work. In fact, we had already collaborated once together, on a project for the American Library Association. When we discovered *The Blessed Abyss,* then, it seemed like a natural opportunity for us to collaborate again. Hester had the language skills necessary to translate the manuscript and to research sources in German that we needed to consult. Elizabeth had a detailed knowledge of the history of the Holocaust and the Nazi camp system.

It was in this context that we embarked upon a project that later proved not only more ambitious in scope than we had imagined, but also much more contentious and difficult. Through the course of working together on *The Blessed Abyss,* we discovered that we possess very different working styles, different ways of reading and approaching texts, and different ways of conducting research. We also realized that we had come to the project with very different identifications and intellectual affiliations. Only later, after the book was done, did we come to recognize the different motivations that had shaped our initial decision to work on the book: we both admitted that we did it for each other. Elizabeth thought that Hester would benefit on the academic job market from having a publication on her curriculum vitae. Hester believed that Elizabeth had a strong investment in working on the project, given that she had devoted herself intellectually to the Holocaust for many years and was surprised and moved to have found a personal and familial connection to it. Hester also knew that Elizabeth could not embark on the project without the benefit of her proficiency in German.

For both of us, work on the project corresponded to moments of professional transition, a fact that increased the stakes of our collaboration. For Hester, the process of translating and editing *The Blessed Abyss* exactly paralleled the beginning and eventual completion of her doctoral dissertation. For Elizabeth, the process accompanied the contemplation of and eventual decision to move out of an administrative position and into a faculty position. In 2000, just as the book came out, Hester received her PhD and Elizabeth became an English professor after twenty years as a Dean.

Hester

I translated *The Blessed Abyss* over the course of a long, hot St. Louis summer in the midst of my doctoral work in German. I spent my mornings struggling with Herbermann's sentimental language, her endless rants about the lack of cleanliness in the prisons and concentration camps of the Third Reich, and her often distasteful pronouncements about "little dark-haired gypsy girls" and the "immoral behavior" she witnessed in her cell block. Through my role as translator, I necessarily became a mouthpiece for Herbermann, conveying her deep-seated nationalist views and her constant invocations of God's saving graces. In contrast to my mother Elizabeth, who saw Herbermann primarily as a victim of Nazi oppression, I tended to focus on the fact that she was also a German, whose beliefs often coincided with those of her Nazi oppressors.

While I was interested in the details Herbermann offers about Ravensbrück, especially the information she presents about prostitutes and camp bordellos, it became a struggle for me to understand how someone who had contested Nazism and who had been persecuted for her beliefs and actions could go on to write a memoir filled with nationalist sentiment, racist and antisemitic stereotypes, and a blatant attitude of superiority over her fellow inmates, most explicitly manifest in her many passages about cleanliness:

> One can imagine that inmates, who for the sake of convenience relieved themselves on their cots, also did not keep their bodies or their clothing clean. Some evenings I scrubbed the dirtiest among them from top to bottom with a brush. If there was no soap there, it had to be done with sand. Since there was no hot water in the barracks, one had to undertake these washings with cold water. These little pigs just had to put up with it. It was their responsibility to keep clean, and there was always plenty of water there. It cost me enough of an effort to have to wash these often

scab-covered, stinking bodies of inmates who were, to make things worse, significantly older than me. They were not children any more, and yet I had to take it upon myself, for everything fell back on me. And I did it with rage, though certainly restrained; for my strength and nerves eventually failed me some days as well (177).

Confronted with passages like these, I had the impulse to subtly correct certain of Herbermann's views, or to excise portions of her endless ecstatic religious passages.

I was drawn to the study of German in part because of my interest in the way postwar German society has dealt (or not dealt) with the legacies of fascism and the traumas of the Holocaust. Like many Germanists, I have been especially interested in the ways that these legacies and traumas have been encoded in literature, art, and film. While an engagement with fascism and the Holocaust has provided the impetus for a rich body of literary, artistic, cinematic, autobiographical, and memorial texts—within and outside of the German context—I feel that Nanda Herbermann's memoir cannot be included among these. Eventually I came to see the sentimentality and ambivalence of Herbermann's text as one of its most compelling aspects: unlike later memoirists, Herbermann wrote with an immediacy that figured her historical proximity to the events she narrates, and, lacking models or precursors around which to orient herself, she constructed her own stylistic and psychological mechanisms for representing unfathomable experiences. It was only after grappling with Herbermann's memoir at length—and arguing with my mother about its value—that I came to regard her prose in this light.

It is striking to me in hindsight that the subject of my dissertation—which I settled upon during the same summer that I was struggling with my translation of *The Blessed Abyss*—was another set of texts that cannot be included among the canon of aesthetically interesting or politically progressive postfascist cultural productions. While the focus of my interests prior to my dissertation was the New German Cinema and the feminist German cinema of the 1970s and 1980s, I decided to write my dissertation on West German film in the period between 1946 and 1962, the same period when Herbermann published her memoir. While the cinema of this period was immensely popular, it had been largely ignored for many years by scholars of German cinema because it is generally deemed sentimental and aesthetically conventional. I began to reread this cinema from the vantage point of female spectators (who comprised seventy percent of cinema audiences during the period), as a women's cinema that in fact engages in often surprising ways with questions about visual representation after fascism. While the films I

discussed generally repress recent historical events and certainly never directly reference the Holocaust, I suggested that they address (albeit in encoded ways) issues salient to women's lives in the reconstruction period, and that they do so using interesting formal devices that often diverge from mainstream cinematic conventions. If in my dissertation I was able to find complexity in films that others had dismissed as sentimental and generic, why was it so difficult for me to extend the same approach to Herbermann?

By the time I finished translating Herbermann's book, I had come to dislike her. I found her self-aggrandizing tone insufferable, and I was disturbed that she used her persecution and imprisonment by the Nazis in the service of a narrative of Christian redemption. A devout Catholic, Herbermann grew up in a large Catholic family, some of her siblings became clergy, she attended church regularly, and she went to work for a priest. In her memoir, she repeatedly suggests that her imprisonment in Ravensbrück was a kind of tribulation designed to deepen her faith in God:

> I can truly say that I encountered the great boundlessness of God's love hourly behind the bars and fences of the concentration camp. It was as in the desert, where God let the bread of heaven rain down on his children. If it was painful for us to do without the great mercy of the living Eucharist, God could nevertheless be felt in spirit among us. And because I was allowed to experience the whole abundance of God's goodness in this hell, I can only bless these years behind bars (202).

While passages like this could temper anyone's sympathy for Herbermann, it seems clear to me now that my strong antipathy toward her has to do with the fact that she is a relative. In the back of my mind, I had always known that I had distant German relatives, but I had studied German for years and lived in Germany without ever learning where they lived, what they did, or who they were. I did not think of myself as "German"; quite the contrary, I tended to disavow my German heritage—from which I was, in any case, four or five generations removed.[3] While for my mother, the discovery of Nanda Herbermann was a kind of endorsement of her work in the field of Holocaust Studies, for me, the existence of this German relative threatened to undermine the critical distance I valued in the study of "things German." To admit that I had a German relative (especially one who was so complicit), and to translate, edit, and analyze her, forced me to renegotiate my relationship to my field, to rethink my personal stake in my objects of study. The "postmemory" offered by Herbermann, then, constituted an entirely

different paradigm of "personal connection" and "generational distance" for me than it did for my mother.[4]

All this was further complicated by my critical relationship to Herbermann's text itself. During the period when I began to translate the memoir, I was also working on a conference paper about the reception in Germany of two controversial texts about Nazism, Daniel Jonah Goldhagen's *Hitler's Willing Executioners* and Winfried Bonengel's documentary film about the German neo-Nazi Ewald Althans, *Profession: Neo-Nazi*. Because of my work on this paper—and the general frenzy over Goldhagen's book in the US at the time—I was thinking a lot about the complex function of the Holocaust in contemporary German and American political discourse and popular culture. While I ultimately found Herbermann's memoir historically valuable, I had concerns about releasing her narrative into an American public sphere in which the Holocaust is often instrumentalized as a one-dimensional lesson in morality.

For me, much of our collaboration on this book was marked by a constant debate about questions of identity and identification vis-à-vis Holocaust Studies. I felt that my mother identified too fully with Nanda Herbermann, and that this clouded her ability to analyze and edit Herbermann's text critically. My mother, on the other hand, felt that I was often too critical and failed to recognize important and moving aspects of Herbermann's story. Always central in our debates was the question of our positionality as non-Jews working within the parameters of Holocaust Studies on the writings of a non-Jewish victim of Nazi oppression, who also seemed to embody certain beliefs compatible with Nazism.[5]

Positionality and Postmemory Envy

How, then, can we use this growing recognition of the difference in our positionalities and that of Nanda Herbermann to push the theoretical boundaries of our understanding of gender and the Holocaust? We borrow the term "positionality" from Linda Alcoff, who proposes it as a way out of a central dilemma in feminist theory: how to appeal to "women"—as the agent whom feminist politics would liberate—without reproducing gender stereotypes together with the racist, classist, and heterosexist norms they sustain.[6] For feminism to succeed as a politics, it must tell stories that women can recognize, yet at the same time it must challenge the terms in which women (and men) come to know themselves in and through sexual difference.

In Holocaust Studies, we have seen an almost exact parallel to this dilemma in the approaches that scholars have taken to theorizing women and gender. On the one hand, the definitions of cultural feminism allowed sometimes persuasive arguments for the special capacities women had—nurturing, community building, domestic skills—that enabled them to survive the camp experience more effectively. However, using these same definitions, scholars often constructed special victim categories for women, based largely on essentialized notions of gender.[7] On the other hand, scholars have sometimes used approaches influenced by post-structuralism to examine the impact of gender constructions on the historical events surrounding the Holocaust.[8] The problem for Holocaust Studies in appropriating post-structuralism wholesale is, however, the same problem that faces feminist theory: the problem of subjective agency.[9] As Alcoff writes,

> My disagreement [with post-structuralists] occurs, however, when they seem totally to erase any room for maneuver by the individual within a social discourse or set of institutions. It is that totalization of history's imprint that I reject. In their defense of a total construction of the subject, post-structuralists deny the subject's ability to reflect on the social discourse and challenge its determinations (417).

Alcoff proposes the notion of "positionality" to name "woman" as a site of social processes rather than as the bearer of "a set of attributes that are 'objectively identifiable.' Seen in this way, being a 'woman' is to take up a position within a moving historical context and to be able to choose what we make of this position and how we alter this context" (434–35). Positionality helps us to explain our different identifications with Herbermann and how those identifications manifest themselves in our collaborative process—but not in ways that we were fully aware of.[10] It bears emphasizing that, as Alcoff formulates it, positionality is not entirely open to choice. We do not make ourselves out of whole cloth because it is the "historical context" that makes positions available: we can struggle against or accede to the terms that our context makes available.

The ambivalent relationships to Herbermann that we have outlined in our respective sections above figure our positionalities. Elizabeth's desire for authenticity and legitimacy as a Holocaust scholar informed her apprehension of Nanda Herbermann and her analysis of *The Blessed Abyss*. By contrast, Hester sought to disavow and problematize her relation to Herbermann as well as the discourse of authenticity and legitimacy constructed by Holocaust Studies, a position that informed

her critical reception of Herbermann's memoir. This cycle of desire for and disavowal of identifications with Herbermann and her historical significance marked our collaboration on the book. Though at the time we were not able to articulate it clearly this way, we have subsequently come to think about this complex as a case of "postmemory envy."

Elizabeth

We discovered a survivor in our past, but she was a dicey, complicated, tainted, and ambivalent survivor. She was Catholic, not Jewish; she worked for an anti-fascist priest but in the context of her Church, which was often complicit with the Third Reich[11]; she was antisemitic; she was sister to five brothers who fought for Hitler, one of them a member of the SS; and she was given privileges unavailable to most other inmates in Ravensbrück because of her "Aryan blood." Unlike members of the second generation, we did not "grow up dominated by narratives that preceded [our] birth," nor were our "belated stories...evacuated by the stories of the previous generation shaped by traumatic events" (Hirsch 22). Quite the contrary, we discovered Nanda Herbermann accidentally, and had rather different reactions to the discovery, as we have elaborated above.

In work that has appeared subsequent to Hirsch's *Family Frames,* the term "postmemory" has been further problematized.[12] For example, Leslie Morris has written:

> [T]he discursive space of "the Holocaust" now encompasses texts that explore the uncertainty of authorship, experience and identity and the slippage not only between national and ethnic identities but also between fact and fiction, between trauma and recovery, between Jew and non-Jew, and between victim and perpetrator (209).

Even though *The Blessed Abyss* is "authentic" in the sense that it was written by someone who really experienced the experiences she recounts, it does share some of the "slippage" described here. Herbermann was both a victim of the Nazis and, if not a perpetrator, a bystander. It was the former aspect of her positionality that began to resonate in me, and for Hester it was the latter.

What is the cycle of cause and effect here? Herbermann's experience in Ravensbrück destabilized her identity, and her text reveals this, sometimes unwittingly. Perhaps the fact that she was also somewhat conscious of this destabilization caused a kind of stubborn dogmatism about parts of her identity as a German, a woman, and a Catholic that she felt she could (or should) hold onto. In turn, our gradual attempts at

uncovering our positionalities regarding Herbermann caused us to write this article, which names aspects of our identities as mother and daughter and as scholars. Speaking for myself, I would say that the process overall was destabilizing for me as a scholar: while I sought authenticity as a Holocaust scholar, I was forced to recognize that what is meant by "Holocaust" is much more complex than I realized when we began work on the manuscript.

On a visit to the United States Holocaust Memorial Museum as I was working on the revision of this essay, I discovered that the museum has made the decision to shelve *The Blessed Abyss* in a section about the camps rather than in the extensive section of memoirs that they have for sale. This seems to reflect a decision on the part of the museum's staff that the book is not a Holocaust memoir, a decision that echoes the comments of the external reviewers who read the manuscript for Wayne State University Press. After a long process, I have come to accept the fact that because Herbermann was not Jewish, her memoir should not be categorized as a "Holocaust" memoir. At the same time, the shelving decision at the Museum affirms our sense that one of the most valuable aspects of the book is precisely the detail it provides about Ravensbrück, the largest camp for women and a camp about which only a few memoirs are available in English.

Hester

What does it mean, then, to have postmemory envy? Do we truly desire the authenticity, the access, the legitimacy that that entails? More to the point, what does it mean to desire to lay claim to the personal and historical traumas that have shaped the place from which the second generation speaks? The very notion exemplifies what makes me so uneasy about both the assumptions and methodologies of Holocaust Studies and about the appropriation of the Holocaust within American culture. While it is clear that Holocaust Studies has privileged authenticity because of the importance of survivor testimony, and while I do not mean to call into question the importance of such testimony, the question of authenticity has clearly become a central problem for Holocaust Studies at a moment when survivors are dying and poststructuralist approaches are trickling into the field. At the same time, the Holocaust has come to play an increasingly central role in American public and popular culture over the past decade and a half, facilitating intensified identifications with the victims of the Holocaust that ignore questions of difference and authenticity altogether.

Yet as "authentic" voices begin to exist only as recorded, videotaped, and printed testimony, it becomes increasingly important to understand that we have only representations—whether authored by survivors or not. To me, the salient questions about Nanda Herbermann are not: Is she a Holocaust victim? Is her memoir a Holocaust memoir? These questions are ultimately, in a certain sense, irrelevant. Rather, I suggest that it is much more useful to ask what Herbermann's memoir, as a representation of ideologies and experiences and a construction of memories, can tell us about the social, cultural, and political conditions that led to the rise of fascism in Germany and about the complicated circumstances in which a "good Catholic German girl" such as herself would have become a victim of the Nazis. Similarly, it seems to me that we must become increasingly wary of notions of "authenticity" and circumscriptions surrounding who is authorized to speak in Holocaust Studies. An insistence on essentialized notions of identity runs the risk of promoting problematic identifications and evacuating possibilities for critical engagement with the mediations of discursive practices that shape our understanding of history and our individual and collective (post)memories. Instead of envying the ability to lay claim to postmemory, we should focus on what can be gained from the different critical perspectives that emerge from different positionalities.

Nanda

Wayne State University Press chose a photograph of Nanda Herbermann wearing a dirndl for the cover of their 2000–2001 Jewish Studies catalog. The press made the decision to use this photo of Herbermann without consulting us, and it has understandably generated some controversy. While we might suggest that the question of whether Herbermann's text is a "Holocaust memoir"[13] is problematic and beside the point in evaluating its merit for scholars, when it comes to marketing niches this question is central once again: the Holocaust sells. The press catalog clearly situates Herbermann as a Holocaust victim, and by running her portrait under the heading "Jewish Studies" even suggests that she was Jewish. Think of the iconography: blonde Herbermann in her German folk costume hawking Jewish Studies. This was precisely what Hester was afraid of: what credible (not to mention ethical) scholarship demands—a careful distinction between Holocaust Studies and Jewish Studies—marketing terminology erodes in one banner headline.

In the photo, a smiling young Herbermann looks directly into the camera. She is seated in an armchair in front of a bookcase. The photograph was taken in close-up, and Herbermann's head and torso fill up

Figure 1. Nanda Herbermann, date uncertain. Herbermann sent this photo to her twin sister, Leni, in America in 1950. Inset: Nanda Herbermann in the early 1960s. Reprinted from the cover of the Jewish Studies 2000–2001 catalog with permission of Wayne State University Press.

the whole space of the frame. This picture, in turn, takes up the full cover of the press catalog. Floating to the left of her head in an inset on the cover is another, smaller photo of Herbermann, this one taken after the war. This second image (which also appears blown up on the back cover of the catalog) is the photograph that we chose for the cover of the book. Here Herbermann, dressed in black, holds a cigarette. Again, she sits in an armchair in front of a bookcase, but this time the armchair seems to dwarf her, and she looks exceedingly fragile and frail. Her eyes, which seem nervous and frightened, are averted from the camera. The way the second photo is positioned on the cover of the catalog, it almost appears as though the older Herbermann—now a survivor of Ravensbrück—is gazing down upon her younger self with a mixture of misapprehension and fear. Through the positioning of Herbermann's gaze, this complex layering of images becomes more than the "before and after" spread that the press perhaps had in mind. The two photographs place Herbermann in conversation with herself, a conversation that she struggled—but in many ways was unable—to achieve in her memoir. The dialogic nature of these two images suggests a different way of reading the irreconcilability of Herbermann's memoir—as testimony to her split subjectivities as a "good German," a "good woman," and a "good Catholic." Herbermann's worldview and her self-image were profoundly destabilized by her experience in the camp. The memoir reveals that she defends herself initially by a strategy of comparative victimization: as a Catholic she knew perfectly well why the prostitutes and criminals were in Ravensbrück—her question was what had she done? Hadn't she been a good girl? How could the nation that she loved do this to her? But gradually, as she came to know the prostitutes in the Block in which she had been appointed elder, and listened to their stories, she began to understand that they had become prostitutes not through some moral failing, but because they came from socioeconomically disadvantaged backgrounds. She began to see the illogic of the camps, the arbitrariness of arrest and punishment, and it began to radicalize her. As in the case of many other concentration camp survivors, Herbermann's experience in Ravensbrück led to a profound crisis of belief systems, values, assumptions, and self-perceptions.

Herbermann turned to writing to reconstruct her own subjectivity in the wake of its destabilization. She set out to teach her fellow citizens what she had learned about the social construction of value, and thereby to redeem her camp experience by imbuing it with purpose—for herself and others. In addition to *The Blessed Abyss,* she wrote a protofeminist novel, *What Love Can Bear,* based on the stories of some of the prostitutes whom she had come to know in Ravensbrück. Her avowed

project in this novel was to effect social change by acquainting her readers with the personal narratives of the prostitutes. In both her novel and her memoir, Herbermann turned to representational practices that fostered affective identification in order to present didactic messages—about prostitution as a result of gender oppression and class stratification, and about recent German history and Nazi oppression—to her audience of western German readers in the late 1940s and 1950s. This accounts for the tone that seems so insufferable and the aesthetic that seems so banal in its sentimentality.

We have reread Herbermann's text. But why should others read it? We have thought about the value of Herbermann's memoir for twenty-first-century readers in two ways. First, her text is full of the "domestic" details of women's lives in Ravensbrück. Given the neglect both of this particular camp in the overall scholarship on the camps, and of the specificity of women's persecution by the Nazis, the book is a part of the ongoing feminist project to recover women's historical experiences. Publishing Herbermann's memoir in English makes a significant contribution to the available canon of memoirs by women (and particularly of Ravensbrück memoirs, of which there are very few).

Equally important, however, are the ways in which Herbermann straddles the worlds of victims and perpetrators. This makes her memoir a source of insights for both positionalities during World War II and the Holocaust. Finally, it is this very dual image she presents—the survivor in the dirndl—that has become, for us, a synecdoche for the complexities of subjectivity, memory, and history, which is, under all the erasures and prevarications and repressed memories and denials and justifications, what we study when we study the Holocaust. Herbermann's photograph on the cover of the Wayne State University Press Jewish Studies catalog demands analysis as a representation of just such complexity.

Our different reactions to that photo—like our different performances of Herbermann's words—register the difference in our own positionalities. Hester tended to look at the photograph of Herbermann in a dirndl (which came to us from relatives along with a photo of her brother Joos in his SS uniform) suspiciously, as a signifier of Herbermann's Aryan traits and her nationalist values. Elizabeth tended to look at it with an "affiliative familial gaze" (Hirsch), and as an emblem of Herbermann's complexity as a survivor. Both these modes of looking raised questions about our family history in Germany sixty years ago, about our identifications, and about our motivations for studying the Holocaust. Our attempt in this article to begin the project of such self-reflection ultimately resists conclusions and suggests instead the need for

continuing engagement with a series of questions that we have only begun to touch on here, questions that center around the issue of how personal histories, political affiliations, and (post)memories have an impact on the way knowledge is produced in Holocaust Studies.

Notes

We presented an early version of this essay at the conference "Departures: New Feminist Perspectives on the Holocaust" at the University of Minnesota in April 2001, and we owe thanks to the participants there for encouraging us to expand our discussion of gender and the Holocaust in the context of our collaboration. We would especially like to thank Ruth-Ellen Joeres, Lisa Disch, Leslie Morris, and the anonymous reviewers of our manuscript for their insightful comments. Above all, we are grateful to Atina Grossmann. Her thoughtful engagement with our work and her helpful feedback at many stages of the project, beginning with the original book manuscript, challenged us to refine our ideas and provided a valuable contribution to our collaboration.

[1] See especially chapter 5 of Novick's book.

[2] Ravensbrück as a camp has been understudied, due in part to its location in what became the GDR and also perhaps because of its gendered history. Construction on the site, near a small lake outside Fürstenberg, north of Berlin, began in autumn 1938, and the camp opened in May 1939, with the first transport of 867 women prisoners. It is estimated that 132,000 prisoners entered the camp in its six-year history; approximately 15% of these prisoners were Jewish. The camp was liberated by the Soviets in April 1945, and the Russian Army remained in the camp, utilizing it as a military base, until 1994. Only about a dozen memoirs of life in Ravensbrück have been published in English; these include memoirs written by such well-recognized names as Charlotte Delbo, Germaine Tillion, and Gemma Gluck, the sister of New York mayor Fiorello LaGuardia. More information on these memoirs, as well as the history of the camp, can be found in our edition of *The Blessed Abyss: Inmate #6582 in Ravensbrück Concentration Camp for Women*. Another useful source of information is Jack Morrison's study, *Ravensbrück: Everyday Life in a Women's Concentration Camp, 1939–1945*.

[3] While I have German ancestors on both sides of my family, the subject of German heritage was never of interest to any of my relatives, all of whom are much more proud of their old New England roots. In fact, my discovery of Herbermann's manuscript coincided with my first attempt to

learn something about my German relatives. Soon after I began to learn German, my maternal grandmother sent me a bundle of documents in German, which she hoped I would translate for her one day. I let these documents languish in the bottom of a desk drawer for many years before I decided to read through them. When I did, I was astonished to discover a reference to *The Blessed Abyss*.

[4] The terms come from Marianne Hirsch's definition of postmemory. While Hirsch's book is part of a larger body of work by Jewish scholars addressing and problematizing their relationship to German history, the Holocaust, and their forebears in Europe, non-Jewish scholars of German studies have been much less likely to grapple with their personal connections to the German past or to problematize their relationship to their German forebears.

[5] A further complicating factor is the term "Holocaust Studies" itself. In historically accurate terms, Herbermann's memoir is a concentration camp memoir, rather than a Holocaust memoir, since Ravensbrück was a concentration camp (rather than an extermination camp) that primarily housed non-Jewish victims like Herbermann. Throughout our work on the project, we often debated the extent to which Herbermann's life and her memoir could fit into Holocaust Studies, and various readers of our original book manuscript as well as this paper further encouraged us to clarify this historical distinction. Yet as important as the historical distinction between the concentration camps and the Holocaust is, within the present configuration of academic studies it is difficult to maintain. Since our work generated interest within the discipline of Holocaust Studies, we presented papers primarily at conferences on the Holocaust, and we eventually published the book in a series of Holocaust memoirs.

[6] Many other feminist theorists have developed the notion of positionality in ways that go beyond, and sometimes explicitly challenge, some of the shortfalls of Alcoff's argument, which was an early attempt to delineate the term. Particularly problematic in Alcoff's formulation of "positionality" is her adherence to a notion of "identity politics" that remains mired in some of the problems of identity that she sets out to critique. However, we find Alcoff's clear delineation of "positionality" within the context of feminist debates over essentialism and post-structuralism useful for Holocaust Studies. Unfortunately, it is outside the scope of this paper to do justice to the debates over positionality and identity politics. See for example Leslie Adelson's excellent critique of Alcoff in *Making Bodies, Making History* (59–64) and Judith Butler's critique of identity politics in *Gender Trouble*.

[7] For an exploration and repudiation of the appropriation of cultural feminism to theorize women and the Holocaust, see Joan Ringelheim's

provocative article "Women and the Holocaust: A Reconsideration of Research." Ringelheim courageously critiques her own earlier research under the banner of cultural feminism in this piece.

[8] Marion Kaplan, for example, carefully lays out the way in which gender was constructed in Germany, by both the Jewish community and by Nazi ideology. She argues that these sometimes competing constructions of women occasionally intersected and often prevented families from making clear-headed decisions that might have saved lives.

[9] This problem is delineated by Atina Grossmann in a thoughtful and illuminating review of four new books on gender and the Holocaust: "The outpouring of work on women's Holocaust literature has not been integrated into cultural and feminist theory. This is unfortunate because feminist theory and gender studies are well positioned to mediate between those who distrust the 'fog' of theory (often fearing that postmodernism's emphasis on personal reflexivity and narrative construction will provide an opening for Holocaust deniers) and those who insist that only postmodern theory can provide the critical interdisciplinary tools needed to explicate the difficult issues of memory and representation, witnessing and history, raised by the Holocaust" (106). Another astute analysis of this problem is to be found in a recent essay by Pascale Bos on "Women and the Holocaust."

[10] It is interesting to note that a similar effort at explaining her positionality is made by Erica Fischer in an epilogue to her book *Aimée and Jaguar*. Fischer, a Viennese journalist, compiled this story of a love affair between two women: Felice Schragenheim (Jaguar), a Jew hiding in Nazi Berlin, and Lily Wust (Aimée), the wife of a Nazi officer. Fischer incorporated many primary documents from the period, including letters and journals by the two women, and she interviewed Wust about her memories. Schragenheim did not survive the Holocaust. Fischer explores in her epilogue her emotions, particularly anger and frustration, when dealing with Wust and her greater identification with Schragenheim. She draws connections between her own experiences of exile and those of Schragenheim. Finally, she questions the usefulness of her work on the book during a time when her husband was helping Muslim refugees from Bosnia to find asylum in Germany.

[11] Recent books by Conwell and Phayer have carefully delineated this complicity.

[12] See for example Andrea Liss and Leslie Morris. Morris uses the concept of postmemory to discuss "postmemoirs": not only the memoirs of second-generation writers, such as Sarah Kofman, but also "inauthentic" memoirs like that of Binjamin Wilkomirski.

[13] On this aspect of researching and publishing the Herbermann memoir, see Elizabeth Baer.

Works Cited

Adelson, Leslie. *Making Bodies, Making History: Feminism and German Identity*. Lincoln: U of Nebraska P, 1993.

Alcoff, Linda. "Cultural Feminism vs. Post-Structuralism: The Identity Crisis in Feminist Theory." *Signs: Journal of Women in Culture and Society* 13 (1988): 405-37.

Baer, Elizabeth. "Complicating the Holocaust: Who Is a Victim? What Is a Holocaust Memoir?" *Remembering for the Future*. Ed. John Roth. London: Palgrave-McMillan, 2001: 15-23.

Bos, Pascale. "Women and the Holocaust: Analyzing Gender Difference." *Experience and Expression: Women, the Nazis, and the Holocaust*. Ed. Elizabeth Baer and Myrna Goldenberg. Detroit: Wayne State UP, 2003. 23-50.

Butler, Judith. *Gender Trouble: Feminism and the Subversion of Identity*. New York: Routledge, 1990.

Conwell, John. *Hitler's Pope: The Secret History of Pius XII*. New York: Viking, 1999.

Delbo, Charlotte. *Auschwitz and After*. Trans. Rosette C. Lamont. New Haven: Yale UP, 1995.

Fischer, Erica. *Aimée and Jaguar: A Love Story, Berlin 1943*. Trans. Edna McCown. New York: HarperCollins, 1995.

Gluck, Gemma. *My Story*. New York: David McKay, 1961.

Grossmann, Atina. "Women and the Holocaust: Four Recent Titles." *Holocaust and Genocide Studies* 16 (2002): 94-108.

Herbermann, Nanda. *The Blessed Abyss: Inmate #6582 in Ravensbrück Concentration Camp for Women*. Trans. Hester Baer. Ed. Hester Baer and Elizabeth Baer. Detroit: Wayne State UP, 2000. Trans. of *Der gesegnete Abgrund: Schutzhäftling Nr. 6582 im Frauenkonzentrationslager Ravensbrück*. Nürnberg: Glock und Lutz, 1946.

――――. *Was Liebe erträgt*. Celle: Verlagsbuchhandlung Joseph Giesel, 1949.

Hirsch, Marianne. *Family Frames: Photography, Narrative, and Postmemory*. Cambridge: Harvard UP, 1997.

Kaplan, Marion. *Between Dignity and Despair: Jewish Life in Nazi Germany*. New York: Oxford UP, 1998.

Liss, Andrea. *Trespassing through the Shadows: Memory, Photography, and the Holocaust*. Minneapolis: U of Minnesota P, 1998.

Morris, Leslie. "Postmemory, Postmemoir." *Unlikely History: The Changing German-Jewish Symbiosis, 1945-2000*. Ed. Leslie Morris and Jack Zipes. New York: Palgrave, 2002. 291-306.

Morrison, Jack. *Ravensbrück: Everyday Life in a Women's Concentration Camp, 1939-1945*. Princeton: Marcus Wiener Publishers, 2000.

Novick, Peter. *The Holocaust in American Life*. Boston: Houghton Mifflin, 1999.

Phayer, Michael. *The Catholic Church and the Holocaust 1930-1965*. Bloomington: Indiana UP, 2000.

Ringelheim, Joan. "Women and the Holocaust: A Reconsideration of Research." *Signs: Journal of Women in Culture and Society* 10 (1985): 741-61.

Tillion, Germaine. *Ravensbrück*. Trans. Gerald Satterwhite. New York: Anchor Press, 1975.

Making the Stranger the Enemy: Gertrud Kolmar's *Eine jüdische Mutter*

Irene Kacandes

The search for satisfactory explanations of how the German population supported mass marginalization, deportation, and extermination of Jewish and other undesirable fellow citizens is not likely to end soon. This essay strives, nonetheless, to contribute to our understanding of the complex processes that allowed Germans to consider a neighbor a stranger, this stranger an enemy, the enemy a target, by closely reading a text of the Weimar Republic that illustrates one such scenario. Gertrud Kolmar's short novel, *Eine jüdische Mutter* (*A Jewish Mother*), is particularly apt for such an investigation, both because its plot concerns the marginalization of an individual just when she appears to become assimilated, and because the way the story is told creates gaps that allow readers insight into the false and unjust logic that supports the process. (IK)

In his preface to *Survival in Auschwitz,* Primo Levi writes:

> Many people—many nations—can find themselves holding, more or less wittingly, that "every stranger is an enemy." For the most part this conviction lies deep down like some latent infection; it betrays itself only in random, disconnected acts, and does not lie at the base of a system of reason. But when this does come about, when the unspoken dogma becomes the major premise in a syllogism, then, at the end of the chain, there is the Lager. Here is the product of a conception of the world carried rigorously to its logical conclusion; so long as the conception subsists, the conclusion remains to threaten us (5).

In this essay, I unpack several of the steps that did lead to the Lager from Germany. I do so by closely reading Gertrud Kolmar's short novel, *Eine jüdische Mutter* (*A Jewish Mother,* 1930-31)[1] as a cultural key to the historical moment in Germany when Levi's "random,

disconnected acts" and "unspoken dogma" start to become the "major premise."

On the most superficial level, Kolmar's work might seem an apt choice because it is the story of a Jew who goes from apparent acceptance and assimilation into German society (its protagonist marries a gentile) to marginalization and death (the protagonist comes to feel so alienated from those around her that she kills herself). On a more significant level, Kolmar's prose work provides particularly fruitful terrain to investigate the problematic that Levi outlines for two reasons at least: first, because its story (in the technical sense of the narrated events or the "what" of the narrative) catalogs Weimar attitudes about gender roles, sexuality, and race; and second, because its discourse (in the technical sense of "how" the story is narrated) and its publication history open up a space for critically assessing these attitudes as well as the process of hating, marginalizing, and even exterminating "Others" that is illustrated through the story.

The plot of *A Jewish Mother* is well-known: in the cosmopolitan Berlin of the Weimar Republic, its Jewish protagonist Martha Jadassohn meets gentile Friedrich Wolg at a tenants' council meeting. They fall in love, marry, and have a daughter, Ursula (Ursa). Mother and child are abandoned when the husband seeks his happiness in America; he returns to Germany deathly ill, and soon dies. The widow manages to make a living for herself and Ursa as a studio photographer. One evening when the five-year-old does not return home at the accustomed time, Martha seeks her among her playmates, only to be told by them that Ursa has gone off with a man who had said her mother was looking for her. After a frantic evening of questioning the neighbors, a sleepless night, and an agonizing morning, Martha finds her daughter's limp body in an abandoned shed in an outlying garden district. The child is still breathing, but her torso is bloodsoaked. With the assistance of some alarmed local women, Martha manages to get the unconscious child to the nearest hospital. Several days later, the ravaged girl is helped to her presumed inevitable death through sleeping powder administered by her mother. Martha swears revenge against the murderer of her child, whom she assumes to be lurking somewhere in Greater Berlin. Her affair with Albert Renkens, a friend of her late husband's, is premised on an exchange of sex for investigative help, but comes to mean much more to Martha. Her attempt to shift the basis for their relationship fails. Rebuffed by Albert, she focuses on a new sense of her own culpability for her daughter's death and plunges into the River Spree, expiating a crime she now believes she perpetrated.

Even this thumbnail sketch reveals how many serious social issues under debate in Weimar are assembled in this story: socialism; relations between Jews and Christians; women and motherhood; women and work outside the home; sexual violence; euthanasia; extramarital sexual relations; suicide. Other plot elements raise the additional issues of abortion, the death penalty, homosexuality, the role of the media, the nature of criminals, and even the effectiveness of the police. Anja Colwig suggests that Kolmar's inclusion of such subjects as well as of real geographical locations and dates meant that she could count on readers making connections between her story and their actual knowledge of Weimar Berlin—for instance, between Ursa's abduction and rape, and the child and serial murders perpetrated by Fritz Haarmann, Karl Denke, and Peter Kürten (Colwig 96-97). While I agree with Colwig that the text describes much about Weimar society, it might be even more valuable for its depiction of potentialities in that society that we retrospectively can assess as vital clues to the inchoate or at least unspoken dogma that fascinates and horrifies Levi. What are the various factors leading to marginalization and death that Kolmar could imagine? Specifically: How does Martha become the stranger? What kind of stranger is she? How is the stranger perceived as enemy? Why does the stranger-enemy have to die? What do the text and Kolmar seem to be telling us about this logic, that the stranger is the enemy who has to—or might as well—die?

Weimar society as depicted by Kolmar is so far along Levi's chain leading to the Lager that looking at almost any scene in the novel will reveal much about the answers to these questions. I will focus here on moments when a conflict between the logic of character and/or plot and the logic of the text taken as a whole seem the clearest. These are Friedrich's alienation from his wife, Albert's rejection of Martha as his lover, and Martha's "rejection" of herself through suicide. To understand Martha's view of herself, it will also be necessary to consider Ursula's death. Accounting for discrepancies between the story and its telling reveals some of the unspoken dogmas of late Weimar Germany and modifies readers' sense of what the story of *A Jewish Mother* is, shifting our attention from the protagonist Martha Wolg to the society in which she lives.

Recently, some prominent scholars have suggested that literature can play such a vital role in historical understanding. In the introduction to their widely read book *Testimony: Crises of Witnessing in Literature, Psychoanalysis, and History,* Shoshana Felman and Dori Laub maintain that in an age of trauma, "literature becomes a witness, and perhaps the only witness, to the crisis within history which precisely cannot be

articulated, witnessed in the given categories of history itself" (vxiii). William Paulson similarly argues in *Literary Culture in a World Transformed: A Future for the Humanities* that there are certain kinds of cultural work that only literature can do. He advocates particularly the study of literature from other cultures and times to expand our own notions of how people "respond to the state of the world and attempt to act on it" (119). In this analysis, I am illustrating one of the ways narrative literature can serve as witness to historical events that traditional forms of history cannot: through the interaction of story and discourse mentioned above. By investigating some incongruities between the story and its telling in *A Jewish Mother,* I draw attention to how at least one person living in Weimar Germany, Gertrud Kolmar, imagined the process of making "the stranger the enemy."

Friedrich and Martha

In 1928 Alfred Polgar published in the journal *Uhu* a fictitious dialog between a father and a son to look at the changed relationships between men and women. The father challenges the son on why he does not treat women chivalrously, and the son explains to the father that the New Woman wants to be treated equally, with no regard to physical differences. Thus, the son proclaims, a modern man "distinguishes in his behavior as little between man and woman as, for example, between Christian and Jew" (Polgar 204). To begin my analysis of *A Jewish Mother* at the level of the "story," I observe that Gertrud Kolmar initially projects such an attitude about gender and religion onto her character Friedrich Wolg. Friedrich first notices Martha Jadassohn at a tenants' council meeting, when her speech, with its "quiet, terse manner, yet determined and firm" (1997: 11; 1981: 15), contrasts favorably in his eyes with that of the other women there who cannot seem to keep their minds or their language on the matter at hand. The facts of her birth in the East and of her Jewishness do not even seem to register with him. Friedrich pursues the earnest young woman, and Martha responds to his attention. Despite the active attempts of the antisemitic senior Mr. Wolg to discourage the relationship and the lukewarm acquiescence of Martha's parents, the couple marries. Their sexual relations are described as explosive, Friedrich calling Martha his "Vesuvius or Etna or Krakatoa" (1997: 13; 1981: 16). Thus, the initial interaction between these two young people seems to fit the ideal new relations between men and women humorously conveyed by Polgar. The couple's apparent compatibility does not last long. Although Martha might fit the New Woman mold in terms of her unabashed interest in sex, she does not

share Friedrich's enjoyment of other aspects of Weimar life, like motorcycle riding, listening to the radio, or going to movies. When he proposes socializing, she finds an excuse to stay home.

In a short amount of time, the text describes a distinct series of changes in Friedrich's attitude toward his wife. First he considers whether her behavior, rather than a sign of her superiority above other women, is not actually a sign of her essential otherness: "Maybe it was because she was of different blood [*Blut*], a Jewess [*Jüdin*]" (1997: 13; 1981: 17). He entertains this thought despite the fact that Martha does not observe the Jewish sabbath nor go to the synagogue. As if having the thought makes the fact true, the text then narrates an incident in which religious difference plays a role. The expectant parents go shopping and see a pretty dress in a shop window. When Friedrich comments that it would make an appropriate baptismal dress if they have a girl, Martha replies with amazement that their children will not be baptized. When he tries to back out of what appears to have been a premarital agreement about religious upbringing, a calm exchange escalates into an unspecified threat on Martha's part that "if you take it [the child] from me, I will find it no matter where" (1997: 14; 1981: 17–18). In conveying the argument to his parents, Friedrich begs that they not fight with Martha, but rather leave her in peace: "'You don't know her. She is capable of killing the child; she is a Medea!'" (1997: 14; 1981: 18). From wondering about his wife's unorthodox social and sexual habits, Friedrich suddenly believes she could commit infanticide. The kind of rhetorical and emotional leap Friedrich makes here is one of the things that contributes to the odd, even melodramatic tone of the novel. More importantly, such leaps provide ways of detecting the unspoken dogmas of Weimar Germany—in this case that Jews are hysterical, possessive, and ultimately dangerous (for one such portrait of Jews, see Goebbels 138). (The fact that Martha does play a role in the death of her actual child is not relevant here, I believe, although I will treat this plot element below.)

Once Friedrich has articulated the thought that what is different about Martha must be her Jewishness, other negative stereotypes accrue: for instance, the in-laws describe the new mother as falling over the baby girl "like a hungry she-wolf" (1997: 14; 1981: 18). Although mothers are often described in Western culture as ferociously protecting their children, in the context of the developing portrayal of Martha, I maintain that we should connect this metaphor to an ancient attitude of Christian Europe that Jews are closer to animals than humans. The more recent (nineteenth-century) additional idea that Jews belong to a different race comes through in comments like that quoted above about "blood."

Ideas about racial hygiene are also communicated metonymically, that is, through the novel's description of the child born to Martha and Friedrich:

> It was her child, only hers. As if the lightness [*Helle*] of the father had been battling [*gekämpft*] with the darkness [*Dunkel*] of the mother as it was coming into being, and as if her darkness [*Finsteres*] had in the end demolished [*erschlagen*] his light [*Lichtes*] and devoured [*aufgefressen*] it, Ursula's eyes and hair were nocturnal, her skin yellowish, almost brown, and of an even deeper hue than the ivory tone of her mother's face. Her features likewise betrayed nothing of Friedrich Wolg (1997: 14; 1981: 18).

If skin tone is a main marker of race, the Jewish element is so dominant, virulent, and bestial—note the violent verbs to describe gestation: battling, demolished, devoured—that it will produce offspring that not only eliminates the lightness of the gentile element but becomes even more dark, more "Jewish" in this ideological view, than the Jewish parent. Martha is "ivory" whereas the child is "almost brown." In a reverse metonymy in the passage that follows, the "nocturnal" child seems to make the postpartum Martha even more animal-like than the gestating Martha: "His wife now often appeared to him like a savage [*eine Wilde*] he kept in a cage by force.... Whenever he came near her, she held the child up against her breast, then she looked at him without saying a word, but with the strange, ominous glowering of an animal mother [*Tiermutter*] who trembles for her young" (1997: 14; 1981: 18). Friedrich fulfills his father's prediction and flees to America.

In sum, Martha and Friedrich's relationship begins because Friedrich is attracted to someone who does not behave like a traditional woman: she speaks seldom but forcefully; she makes loves passionately; her background is initially irrelevant. But behavorial differences seem to metamorphose into essential differences. Friedrich comes to believe that Martha's essence threatens his very existence. The plot provides a bizarre confirmation of Friedrich's view by virtue of the fact that he does indeed die after his almost year-long sojourn in America.

What I have thus far enumerated, however, only partly analyzes the information the text provides readers. Before one concludes that Kolmar was trying to portray a negative image of a Jewish character—that Jews are super-sexed or like animals; that they do have strange blood—or to conclude that Kolmar herself had internalized antisemitism, was herself a carrier of Jewish self-hatred, as so many of the analyses of this text have in fact concluded (e.g., Lorenz, *Verfolgung* 24; *Keepers* esp. 97–100), one must consider in what manner this view of Martha is

rendered. I refer to the level of "discourse," specifically of issues of enunciation (who speaks) and focalization (who sees, i.e., through whose perspective events are seen) (Rimmon-Kenan 71–105). It is critical to note that almost all of the negative pieces of the portrayal of Martha—not only in these early sections of the book, but also in later ones—come through direct quotations from other characters who clearly are antisemitic or through passages of "narrated monolog," a technique that maintains the person (third) and the tense (past) of the narrator but in order to articulate "a character's mental discourse in the guise of the narrator's discourse" (Cohn 14). To illustrate these techniques from the examples already presented: the idea that Martha's behavior is due to her different blood, to her Jewishness, is clearly presented as a thought of Friedrich's. He is pondering how he feels about his marriage and wants a name for what is different about Martha. Once he hits on a racial explanation—one that readers already know will be supported by his father, and one that readers knowledgeable about Weimar know would be supported by many elements in the society in which the story is set—a series of interpretations of Martha's behavior confirming that thought follows. Martha imagines the scenario of Friedrich taking the child from her and threatens to come find it anywhere. But the more serious leap to the idea of infanticide through the label of "Medea" comes in a quotation from Friedrich.

Once a child is actually born, the evaluation of the young mother as falling over the child "like a hungry she-wolf" is clearly attributed to the Wolg seniors; the text tags the comment with: "as the in-laws remarked." The fact that the actual slur does not appear in quotation marks, however, is important for the narrative, and hence moral, ambiguity. For following the analogy to a "she-wolf," located in the same paragraph, are the more elaborate racial evaluations of the newborn child quoted above. The highly negative language in this passage— the numerous words that evoke animality, and most especially the ideas of light and dark and specifically the word "finster," which carries with it moral connotations of evil—is sandwiched in between the highly negative view of Martha held by Friedrich's parents and negative views that follow that must be attributed to Friedrich himself. Therefore, even the factual dimension of what is conveyed in that passage may or may not be true. Is the child really so dark; does she truly resemble only the mother; or does the already alienated father perceive her that way? We cannot know for sure, since the text provides no other confirmation of this information. (Ursula is darker than the blond playmate Elsa, but how much darker is never made unambiguously clear.) However, that Friedrich indeed might be the source, not only linguistically, for these

negative portrayals of mother and child, but also for their moral consequences, is supported by the sentence describing Martha like a savage in a cage. Friedrich thinks of himself as the one who has put her there: "like a savage he kept in a cage by force" (1997: 14; 1981: 18).

This technique is used over and over again in the book. Readers know almost nothing about Martha that does not derive from another character's view or from ambiguous passages of narrated monolog. Passages of quoted interior monolog rendering Martha's thoughts exist but are relatively few for a text that is mainly focalized through her. However, I have also reviewed these early views of Martha at length because a too-quick reading of this flashback to Martha and Friedrich's courtship and marriage, one only of its content and not of the technique that renders that content, can lead to the belief that everything that happens afterward in the plot—the social destitution and isolation of mother and child, the abduction and rape of this child (why not one of the other playmates?), the reaction of the mother to that crime, ultimately resulting in her suicide—is Martha's fault. After all, Martha herself comes to believe that she is essentially different from those around her—"'I am different'" ("Ich bin anders") she protests to her employer (1997: 49; 1981: 52). These negative views of Martha, including the ones she harbors about herself, cannot be attributed unambiguously to the narrator and therefore to the moral scheme of the book. To put it otherwise, they serve to render precisely that process that interests Levi: how disconnected views and acts can come together into a dogma that allows a society to sanction hate, ostracization, and violence. To gain further insight into how Kolmar imagines this process and what moral valence she attaches to it, readers must similarly interrogate story and discourse in the final section of the book, rendering Albert's rejection of Martha as a lover and Martha's suicide.

Albert and Martha

Kolmar's text depicts Albert and Martha's relationship much more extensively than it depicts Friedrich and Martha's marriage; almost two-thirds of the book describes Martha's life after the child is dead. Albert is attracted to and then gets tired of Martha for reasons similar to Friedrich's. Her taciturnity in particular begins to turn him off, and he is shown in several scenes enjoying conversation with the kind of shallow, chatty women he initially complained to Martha about (1997: 110–11; 1981: 111). Interestingly, both Friedrich and Albert justify their respective abandonment of Martha by viewing her only as a mother, and as a bad mother at that. In the case of Friedrich, readers do not have

outside views to evaluate his opinion of her as an overly possessive mother. In the case of Albert, however, the text clearly gives information to suggest that Albert uses Martha's attachment to her dead child as an excuse to get out of the relationship at the point that Martha herself is trying to free herself from her maternal role. Martha's reactions to her suspicion that Albert is seeing other women and then to Albert's attempt to end the relationship complicate her view of herself and our view of the value system of the novel, and for this reason should be examined closely.

Martha suspects Albert's dishonesty for the first time when a note is delivered to her apartment from a male friend he says he was meeting that morning. Albert has already gone, but the time for the rendezvous does not jibe with the time of his departure. In her confusion about what to make of this, Martha takes out the only photographic portrait she had taken of her child, made shortly before her death and stored away until this moment. Gazing upon the image, however, does not clarify her emotions the way Martha hopes it will: "Ursa was far away, and the pain [*Qual*] was far away, the passionate mourning [*leidenschaftliche Trauer*]" (1997: 135; 1981: 136–37). Here is the first self-discovery: Martha's pain over her child's death has lessened, even changed qualitatively. Furthermore, she realizes that her relationship to her (dead) child cannot guide her decision about her relationship to her (living) lover. Maybe the maternal does not define her as fully as she had hitherto believed.

Martha's second self-revelation comes upon the heels of a report that Albert has been seen in the neighborhood of her building getting into the car of a beautiful woman. In a series of thoughts about who this woman could be, Martha calls to mind Solange Methivet de Vigo, aka Marie Fehlandt, a woman friend of Albert's at whose home they have recently dined. During a tête-à-tête with the hostess that evening, Marie reveals to Martha that she had aborted a child when she was eighteen and just starting her career as a dancer. Martha falls into a reverie about what Marie's—or rather Solange the dancer's—life was like at the time, but cannot bring herself to think of the abortion. Martha says to herself: "I would have carried it to term. I would have toiled, would have starved my way through. I would have tried to live with it; maybe there is such a thing as mercy. If not...I would have died with it. I would not have killed it. Never" (1997: 141; 1981: 143). As one of few quoted interior monologs of Martha's, this passage provides rare insight into Martha's self-image as a good mother; it also reveals her self-righteousness, adding to readers' negative evaluation of Martha.

At this point in her thoughts, Martha glimpses portraits of her parents as young adults and perceives the photo of her father as literally accusing her: "'You are lying. You, too, have murdered your child.'" Martha is startled by this idea she has never considered before: "The paralyzing brew was mixed and administered to her child. Then it fell into a deep sleep..." (1997: 141; 1981: 143). As the passive constructions, absence of an agent, and euphemism betray, until this moment, Martha had never thought of herself as taking her child's life. On the contrary, she had called the perpetrator of the abduction and sexual violence a "murderer" (*der Unhold*), never herself. In reaction to "hearing": "'Murderer—that is you'"—a quotation that stands in its own paragraph, untagged—Martha tries to defend herself: "It is not true. Snap it shut [*Klapp' zu*]" (1997: 142; 1981: 144). Her child's death, she reasons, had been inevitable, had been for the best. Ursa's life could not have been saved, given the terrible hurt to her body and her psyche. Only now does the mother consider: "What if we were all wrong?... What if the child had gotten well again?...what if Ursa had recovered in spite of the horror, had recovered had it not been for my deed? Or my—crime?" Martha responds to this interior thought with an articulated protest: "'No,' she stammered, her fists clenched, 'no...oh, no!'" (1997: 142; 1981: 144). As in the passage about the birth of Ursula, this passage could be analyzed at length for the way it obscures any "truth." The content of Martha's reflections shows how clearly she believed and still believes that she was euthanizing, not poisoning or murdering her child. For herself, she wants to reject the idea that she actually has murdered. But like Friedrich's experience of thinking about Martha as having different blood, as being of a different race, once Martha has this thought, however bizarrely it is planted in her consciousness, the thought seems to control how she perceives herself and will now be perceived by others (specifically Albert).

Additionally, however, at the same time that plot and characters' attitudes seem to supply one interpretation, the text leaves an opening for another. Recall that this scene begins with Martha reacting as a lover to the news that Albert has been seen with another woman. If Martha had not been jealously trying to figure out who the other woman was, would she have thought of Marie/Solange and her abortion, and then in turn that she could never have done such a thing, and then in fact that she did? Let me be clear that I am not taking a position on whether Martha's administration of the sleeping powder to her child should be called euthanasia or murder. Rather, I am trying to draw attention to the particular series of events and concomitant linking of ideas that put Martha into the position of thinking of herself as a criminal. That sexual

desire is at the start of this particular chain is not, I believe, coincidental. As Alice Rühle-Gerstel commented in 1933 about the failure of the New Woman to become the standard:

> Her old womanly fate—motherhood, love, family—trailed after her into the spheres of the new womanliness...she therefore found herself not liberated, but now doubly bound: conflicts between work and marriage now appeared, between uninhibited drives and inhibited mores, conflicts between the public and private aspects of her life, which could not be synthesized (218).

The continuation of the plot confirms that Martha struggles to synthesize aspects of her identity and, specifically, her sexual desire. Albert ends the affair. Once again, Martha experiences a range of emotions and goes through a number of scenarios in her head. But after being miserable for several days, she decides to act. Taking the envelope with Ursula's photograph, Martha goes to Albert's boarding house and awaits him. Received curtly by the landlady, she is shown into the parlor, where, much to her discomfort, she discovers an antisemitic pamphlet. This pamplet accomplishes a number of things: in terms of the plot, it drives Martha outside the building to wait for Albert, physically and mentally numbing her. It also serves to reinject the Jewish part of Martha's identity into how she is viewing herself at that moment and how readers view her. Finally, I suggest that it also serves to create a synecdoche between Albert and gentile Berlin since the pamphlet is found in the shared space of the boarding house.[2]

When Albert arrives home, he greets Martha, gently but firmly insisting that he "'cannot bring it back to life.'" Martha misunderstands him, assuming he means her child. "No, that's the problem," Albert retorts, "our love is dead because this child's corpse always lay between us." But for this objection Martha is prepared, responding:

> "I shall bury it. I promise."
> "You cannot promise anything."
> "Oh, yes, I can."
>
> She showed him a very large envelope with a string tied around it. "Do you know what this is? Ursa's picture. I just don't want to take it out of the envelope—you will spare me this—if you want to, you can...later you can examine the cut-up scraps.... Look here!" She took it as with animal claws [*mit Klauen*] and tore it to pieces.
> He stared at her. "You...and you want to know why I don't love you anymore? By the way..." He paused abruptly, fell silent. After a while, very seriously: "You are not a good mother. At first you engaged in an idolatrous cult [*Götzendienst*] over your Ursa; now you break the idol in pieces. One is as wrong as the other."

"What do you want me to do?" she pleaded meekly [*demütig*]. "Please tell me what you want me to do. So you'll know that I am telling the truth" (1997: 154-55; 1981: 156).

To reverse the rupture with Albert, Martha feels she must make him believe that she has given up on the reason that first brought them together: avenging Ursula's death. She understands that she must symbolically bury the child, as she has already buried it physically. But her attempt to communicate this change of heart, indeed of purpose, by destroying Ursula's portrait is rejected by Albert. In a sense, by calling her a bad mother, he is forcing her back into the maternal role she is trying to leave behind. (The evocation of her maternity is reinforced for readers by mention of Martha's tearing the envelope with "claws," since it recalls the original portrayal of Martha as an animal mother when she gives birth to Ursa.)

In the continuation of this scene Martha makes another attempt at freeing herself from the original premise of their relationship by confessing to Albert that she should be considered the murderer of her child, since she administered the sleeping potion that ended Ursula's life. By doing so, she hopes to end the search for the perpetrator, but also to create intimacy by putting herself in Albert's hands. However, Albert uses this, too, to push her away, reproaching her with his assurance that he believes what she is telling him: "'You are capable of it. Only...if something could separate us even more clearly, this is it. You have made me an unwitting accessory [*Mitwisser*] to your act. I cannot love a woman about whom I know something like this'" (1997: 156; 1981: 158). Albert once again refuses Martha's bid for intimacy, rejecting Martha as a suitable lover. As I have argued elsewhere, he is also rejecting her on a more general human level by refusing to receive her attempt to bear witness to her own psychological trauma suffered around the death of her child; he does not want to "know with" (*mitwissen*) her, the action at the heart of psychological co-witnessing (Kacandes, "Narrative" 61; *Talk* 126).

Remarkably, Albert's cruel reply does not completely crush Martha immediately. Her last comment, spoken "in a contained, strangely subdued voice"—a voice that reflects her confidence that she has correctly interpreted what has just transpired—comes in the form of a question: "'You love another, do you?'" ("Du liebst eine andere. Ja?") (1997: 156; 1981: 158). Perhaps Albert himself realizes the truth of what Martha has just said, since he quickly decides to go after her. But by the time he reaches the front door, she is already gone. Even such details bear noting, because in the larger societal framework in which

these events takes place, people resort to ostracization as a way of disguising their own selfishness (striking examples occur when Martha is originally looking for her daughter after the abduction; people she questions treat her as an intruder [*Eindringlingin*] [1997: 21; 1981: 25], and a crazy, strange one [*Fremde*], so that they can go back to what they are doing [1997: 35, 36; 1981: 38, 39]). Martha may, in fact, have serious psychological imbalances. But the text matches the negative characterization of Martha from Albert's point of view and even from Martha's own, with numerous hints that Albert blames her for the rupture so that he does not have to take responsibility for following his own desires.

Whatever the correctness of my larger interpretation, in the world of the story, Martha seems to use up her last reserves of strength and sense of self by posing that question to Albert. As she wanders aimlessly toward home, she is filled with thoughts about her stripped-down life:

> What was left to her? Nothing. A few pieces of stiff paper, the torn picture of her child. She had killed Ursa.... What else? Nothing. Not even this aching, wretched passion [*wehe, unselige Glut*]. The love for a man, the desire, her lust was as if touched by the nocturnal cold, frozen, diminished (1997: 157; 1981: 159).

It is important to note that whereas the idea that she murdered her child is first rejected by Martha ("No," she shouts back at the photo of her father), it is then used instrumentally as a way to try to win back her lover. After that failure in the intimate realm, Martha seems to take it as a fact. And yet, once again, readers must question its status as fact or opinion, and if opinion, whose, since the text delivers this information in narrated monolog, ambiguously tying it to Martha's view rather than to a clear statement of the narrator's, which we could extrapolate to mean that in the moral scheme of the book she is, in fact, to be considered a murderer.

Martha's Suicide

When Martha leaves Albert's apartment, she has been positioned and ostracized as a Jew once again (this time, by the society at large represented by the anonymous pamphlet in the boarding house salon); she has been rejected as a desirable lover by Albert, who also confirms her worst fears that euthanizing her child was actually murder. It is at this point that Martha again dons the mantle of mother. She "sees" Ursula in the snowy landscape and gathers her into her arms. What the text tells us at this penultimate moment in the story is critical: "She was

after all no longer a worker, a photographer—no wilting woman or widow, nor any man's lover or a poor woman in despair [*Verzweifelnde, Arme*]. She was still the mother with a child whose heart beat against her breast" (1997: 159; 1981: 161). The only positive piece of an identity left to Martha is her maternity; and believing that she had killed her child (who is now somehow alive in her arms), she must take her own life. Most analyses of Kolmar's text have argued that the book as a whole and the suicide in particular illustrate the failure of Jewish assimilation (e.g., Colwig 114; Lorenz, *Keepers* 100–01). While there certainly are textual elements that support this view, I propose that this passage, in light of the book as a whole, reveals a slightly different or at least additional emphasis: Martha is an example of the failure of assimilating multiple new roles for women. As one Weimar magazine put it: "Housewife, mother and working woman. The synthesis of these three life styles is the problem of the age" (qtd. in Grossmann 62). With regard to Kolmar's character, the enumeration of the list of things she is not foregrounds the roles she has played in the past and has not been able to synthesize. The possibility that her life did not have to end this way is supported by textual evidence that this limited identity is to a large extent forced on Martha by others around her, and, even more confoundingly, that readers cannot be completely sure what Martha thinks of herself, since, yet again, narrated monolog is used to render this last self-view. In other words, if readers have been paying attention all along, they will be uncomfortable and suspicious about this character and this society that is willing to let a potentially complete person be reduced to a failed Jewish mother.

Such an interpretation is supported by the continuation of the text—which does not conclude with Martha's suicide (something many critics ignore, e.g., Woltmann 163, but not Shafi). Rather, after a blank space, the book ends with the reproduction of a "Newspaper clipping" of the "Daily accident report" (Kolmar's capitals). A twenty-eight-year-old man was apparently run over by a truckdriver who had lost control of his vehicle. Although the man was rushed to the hospital, he "succumbed shortly thereafter to his serious injuries" (1997: 159; 1981: 162). Kolmar provides no explanation for the placement of this newspaper article and no prior mention of the victim, "Heinz Köfer of Charlottenburg"—at least not by name. Since Martha's perspective has been the controlling perspective of the novel, but Martha herself is dead at this point in the text, the relationship of this article to the rest of the novel is particularly mysterious; technically, it cannot be something Martha saw or read. Given the dramatis personae of the preceding story and the fact that Martha and Ursula resided in the Charlottenburg

section of Berlin, a reader might well wonder if this man is meant to be the elusive perpetrator of Ursula's rape.

Although nothing in the text proves, as one critic hypothesizes, that Heinz Köfer is the perpetrator (Shafi, "'Niemals'" 704; *Einführung* 194), I would insist that, at the very least, the inclusion of this article forces readers to reconsider the moral framework of the story. Most obviously, we wonder whether this man is Ursula's abductor meeting his just end, and, in turn, whether drawing our attention to this man is one way of reminding us that the whole tragic string of events was started by him, not by Martha, and therefore that Martha's final view of herself as murderer is unduly harsh. A re-examination of Martha's decision to euthanize the child supports such a conclusion. Not only is the mother extremely distressed by witnessing the child's pain and suffering. She also feels she must interpret the deafening silence from the doctors on Ursula's condition as their hopelessness about the child's recovery. Furthermore, Martha is extrapolating from her own experience. In a passage that previous interpretations ignore, Kolmar describes Martha's subjection as a young child of eight or nine to a man exposing himself in a public place (1997: 40–41; 1981: 43). No matter what type of social violation we consider flashing, the text makes it quite clear that the event was traumatic for the young Martha. For more than a year afterward, the child had nightmares and flashbacks and was completely unable to talk about the incident with another person. Although the text only specifically suggests that Martha uses this self-knowledge to assure herself that if Ursula survives she will never forget what happened to her, an attentive reader could imagine that, realizing how much more severe Ursa's violation was, Martha decides that her daughter will not only not be able to forget, but will be made completely crazy by the memory. This sequence of thoughts renders Martha so upset that she cannot sleep, and in her need to get some rest, she remembers that she has sleeping powder, the very powder that she will use in a few days to help Ursula "forget" her parallel violation. By reviewing these details here, I emphasize again that I am not myself trying to adjudicate whether Martha's deed should be evaluated as "euthanasia" or "murder"; rather, I am trying to point out the various ways in which Kolmar's text as a whole makes it plausible that Martha believed she was doing the best for her child, while not erasing the possibility that her reasoning was faulty.

In a very different, although not incompatible, interpretation, one could consider inclusion of the article about Heinz Köfer's death as the text's way of demonstrating what kind of violence was deemed worthy (and by default unworthy) of mention in a public forum in Weimar

Berlin. Martha's suicide, we might conclude, does not merit a newspaper article, whereas this accident or Ursula's abduction (which was reported in the papers) does. Kolmar may have been trying to tell us something about her society by demonstrating what it considered tragic and therefore who could be considered a victim. As legal scholar Martha Minow suggests in an analysis of contemporary US society, to decide "whose suffering we care about" is also to "define ourselves and our communities" (1445). This method, too, is one way to begin to understand the unspoken dogma of a community. The Weimar society depicted in Kolmar's novel does not care about Martha's suffering. Is this because she is a Jew? a single, working mother? a passionate woman? a possible murderer? Although the text is fuzzy on many specific points, all of these factors certainly work against Martha's social integration.

In a coda of my own, I would like to mention that although Kolmar was a published poet, and although she completed this novel two years before the Nazis came to power and imposed actual publishing restrictions on Jewish authors, as far as my research can uncover, she never tried to publish this novel. The fact that Kolmar did publish a book of poems in 1938 (which, however, was confiscated and destroyed by the Nazis) could point to Kolmar's belief that the novel did not merit publication on aesthetic grounds. However, following Levi, I would hypothesize that in the late Weimar period, Kolmar knew of people being marginalized by being seen as unassimilable others; *The Jewish Mother* tells the story of one such marginalization. I would further hypothesize that Kolmar feared publishing the story in the late Weimar and early Third Reich periods lest its circulation somehow help accelerate the process of marginalization of people like its protagonist.

Speculation aside, I hope to have shown that, from our retrospective standpoint, we can judge one of the merits of Kolmar's book to be a staging of some of the attitudes that were to characterize the Third Reich. Interestingly, these attitudes are distributed among narrator, protagonist, and other characters, rendering the impression that everybody shares in this marginalization of the other, including Martha, in the form of self-hatred.[3] *The Jewish Mother* can now be seen as a kind of blueprint for how "random, disconnected acts" might come together to create the belief that persons you think you know are actually strangers, and that "every stranger is an enemy." Kolmar herself was deported from Berlin and murdered in Auschwitz in March 1943; her sister Hilda Wenzel eventually granted permission for the manuscript to be published under the title *Eine Mutter* (A Mother) in 1965. Why Wenzel changed the title must be taken up in a separate examination of the unspoken dogma of the postwar German-speaking world.

Notes

[1] As I will explain by way of concluding this article, Kolmar herself never published this novel. It first appeared posthumously in 1965. While the text is usually referred to as an "Erzählung," a story, I prefer to call it a "short novel," because it treats such a breadth of topics. A competent English translation of the text appeared in 1997 (trans. Brigitte M. Goldstein). Quotations here will be from this translation and will also include reference to the 1981 Ullstein paperback edition of the original German text when matters of diction or syntax are of interest.

[2] Precisely because of this and other connections made between Albert and mainstream Berlin society at large, I consider translator Brigitte Goldstein's retitling of Kolmar's text appropriate: *A Jewish Mother from Berlin* (Kolmar 1997). Note that Lorenz states incorrectly that the pamphlet is found on Albert's desk (*Keepers* 100). Albert himself has admitted to the antisemitic environment in which he was raised, but this pamphlet should not be too exclusively associated with him. Rather, there is a possible two-way infection of antisemitism operating here: Albert to his society; his society to Albert.

[3] For an analysis that emphasizes Martha's self-hatred, see Lorenz (*Keepers,* esp. 98–102).

Works Cited

Cohn, Dorrit. *Transparent Minds: Narrative Modes for Presenting Consciousness in Fiction.* Princeton: Princeton UP, 1978.

Colwig, Anja. "*Eine jüdische Mutter*: Erzähltes Berlin, deutsches Judentum und Antisemitismus in Gertrud Kolmars Erzählung." *Lyrische Bildnisse: Beiträge zu Dichtung und Biographie von Gertrud Kolmar.* Ed. Chryssoula Kambas. Bielefeld: Aisthesis Verlag, 1998. 89–114.

Felman, Shoshana, and Dori Laub. *Testimony: Crises of Witnessing in Literature, Psychoanalysis, and History.* New York: Routledge, 1992.

Goebbels, Joseph. "Why Are We Enemies of the Jews?" Kaes et al. 137–38.

Grossmann, Atina. "*Girlkultur* or Thoroughly Rationalized Female: A New Woman in Weimar Germany?" *Women in Culture and Politics: A Century of Change.* Eds. Judith Friedlander et al. Bloomington: Indiana UP, 1986. 62–80.

Kacandes, Irene. "Narrative Witnessing as Memory Work: Reading Gertrud Kolmar's *A Jewish Mother.*" *Acts of Memory: Cultural Recall in the*

Present. Eds. Mieke Bal, Jonathan Crewe, and Leo Spitzer. Hanover: UP of New England, 1999. 55–71.

———. *Talk Fiction: Literature and the Talk Explosion*. Lincoln: U of Nebraska P, 2001.

Kaes, Anton, Martin Jay, and Edward Dimendberg, eds. *The Weimar Republic Sourcebook*. Berkeley: U of California P, 1994.

Kolmar, Gertrud. *Eine jüdische Mutter*. Frankfurt a.M.: Ullstein Taschenbuch Verlag, 1981.

———. *A Jewish Mother from Berlin: A Novel; Susanna: A Novella*. Trans. Brigitte M. Goldstein. New York: Holmes & Meier, 1997.

Levi, Primo. *Survival in Auschwitz: The Nazi Assault on Humanity*. Trans. Stuart Woolf. New York: Collier Books, 1961.

Lorenz, Dagmar C.G. *Keepers of the Motherland: German Texts by Jewish Women Writers*. Lincoln: U of Nebraska P, 1997.

———. *Verfolgung bis zum Massenmord*. Frankfurt a.M.: Peter Lang, 1992.

Minow, Martha. "Surviving Victim Talk." *UCLA Law Review* 40 (1993): 1411–45.

Paulson, William. *Literary Culture in a World Transformed: A Future for the Humanities*. Ithaca: Cornell UP, 2001.

Polgar, Alfred. "The Defenseless: A Conversation between Men." Kaes et al. 204.

Rimmon-Kenan, Shlomith. *Narrative Fiction: Contemporary Poetics*. London: Methuen, 1983.

Rühle-Gerstel, Alice. "Back to the Good Old Days?" Kaes et al. 218–19.

Shafi, Monika. "Gertrud Kolmar: 'Niemals "die Eine" immer "die Andere"': Zur Künstlerproblematik in Gertrud Kolmars Prosa." *Autoren damals und heute: Literaturgeschichtliche Beispiele veränderter Wirkungshorizonte*. Ed. Gerhard P. Knapp. Amsterdam: Rodopi, 1991. 689–711.

———. *Gertrud Kolmar: Eine Einführung in das Werk*. Munich: Iudicium Verlag, 1995.

Woltmann, Johanna. *Gertrud Kolmar: Leben und Werk*. Göttingen: Wallstein Verlag, 1995.

In the Waiting Room of Literature: Helen Grund and the Practice of Travel and Fashion Writing

Mila Ganeva

Helen Grund was one of Weimar Germany's most intriguing authors of fashion journalism and short prose. Her essays, published between 1925 and 1935 in the *Frankfurter Zeitung* and *Die Dame,* enriched in various ways the generic spectrum of the feuilleton and the travelogue (*Reisebericht*) and thus constructed a medium of expression frequently preferred by many women writers and reporters of that time. Grund's short prose could also serve as an example of the representation of a specifically feminine experience in the modern metropolis and can be read as a testimony of the German *flâneuse*. (MG)

In 1929, Franz Hessel published a volume of essays, *Spazieren in Berlin,* that became the aesthetic and artistic credo of the belated *flâneur* in German literature. In one of those kaleidoscopic images, the description of Berlin's press district, the *flâneur* presents himself in one of his quintessential roles: as a free-lance contributor to some of Germany's popular illustrated magazines and daily newspapers. He spends hours waiting in the reception areas of the publishing conglomerates in the hope of drawing the attention of the editors to his "charming short pieces" ("reizende kleine Sachen"; 258).[1] Here is how Hessel characterizes the group of those aspiring writers who share the same fate in the "waiting rooms" of the press:

> Good-looking and friendly doormen let us in with all our manuscripts and requests.... Oh, we don't want to go to the serious departments of the newspapers where they talk politics and business. We belong in the commentary section ["unter den Strich"] and in the entertainment supplements.... There are many women among us; some of them are somewhat shy and anxious, and they are the

very ones who write the impertinent reports on the latest fashions (258).

Two points in this short paragraph prompt a closer look. First, in a self-ironic gesture Hessel draws our attention to a seemingly marginal genre (which belongs "unter den Strich"), namely, the feuilleton, the short prose form, "die kleine Form," that gained extreme popularity in the Weimar years.[2] As many scholars of the period have noticed, feuilleton became the "ideal form for recounting the pointillist splendor" of the modern city;[3] the feuilleton writers observed rather than explained, and produced a large number of sketches, snapshots, and vignettes that captured the endless variety of city experiences.[4] In addition, as Hessel points out, many aspiring women writers at the beginning of the century ventured into the realm of entertaining mass literature and fashion journalism using the form of feuilleton and fashion vignettes as a springboard for a future literary career.

In fact, it is Hessel's wife, Helen Grund, who can serve as an exemplary case of this connection between the medium of fashion writing and the transformation of modern literary forms. Her presence on the German literary and artistic scene from the early 1920s until the mid-1930s demonstrated how professional writing on fashion could be transformed into an idiosyncratic sphere of creativity where female *flânerie,* modernism, and surrealist experimentation crossed paths.

Grund was one of Weimar Germany's most intriguing authors of fashion journalism and short prose. In addition to being an expert on fabrics, cuts, hats, furs, and other fashionable accessories, she was a fascinating public personality whose writings for the *Frankfurter Zeitung* and *Die Dame* were followed with interest by a large middle-class female audience. A close reading of her writings goes beyond the rediscovery of some long-forgotten essays on the minute twists and turns of fashion in the decade between 1925 and 1935. The essays published by the then-famous fashion journalist enriched in a variety of ways the generic spectrum of the feuilleton and the travelogue (*Reisebericht*) and thus constructed a medium of expression frequently preferred by many women writers and reporters of that time. As we revisit her texts we can also remedy an omission in numerous contemporary studies of the Weimar feuilleton that examine the features of the male *flâneur* and are interested mainly in the writings of Siegfried Kracauer, Joseph Roth, and Bernard von Brentano.[5] In the narrators in Grund's essays we recognize the German *flâneuse,* who presents the female counterpart to the *flâneur* within the Weimar cultural and literary scene.

Written in the form of reflective accounts on enchanting travels, strolls, and encounters in the French capital, Grund's short prose could serve as an example of specifically feminine experience in the modern metropolis. Her texts reveal her contribution both to the representation of feminine subjectivity in the mass press and to the creation of a women's public sphere in the 1920s. The fashion journalist's writings often reach beyond the topic under immediate discussion, namely the season's fashions, and address in a critical manner a variety of social and cultural aspects of the fashion industry. Grund reported exclusively on and for the constantly growing number of women who designed, sewed, exhibited, and consumed the new fashions, but she was distinctly less interested in the well-known male designers. Thus she demonstrated how writing on fashion can be a constitutive force shaping a public sphere exclusively dominated by women's aesthetic visions and creative practices. Within this public sphere a notion of women's modernity emerged that veered away from the traditional fixation on a modernization of life associated predominantly with technology, architecture, and youth culture. The enduring appeal of Grund's work stems from the fact that she attempted to offer her own original definitions of fashion and modernity on the basis of her direct involvement in the *everyday* culture and practices of fashion.

Who Was Helen Grund?[6]

For decades of intensive studies of Weimar's culture, Grund herself remained "under the line," appearing usually as a mere biographical detail in a footnote to scholarly essays on Franz Hessel.[7] She is perhaps best known as the prototype for the Jeanne Moreau character Kathe in François Truffaut's film *Jules and Jim* (1962), the other real-life prototypes in the film being her husband Franz Hessel (Jules) and his best friend in Paris, Henri-Pierre Roché (Jim).[8]

Walter Benjamin's collection of quotations and notes ("Aufzeichnungen und Materialien") for his unfinished *Arcades* project (*Das Passagen-Werk*) also acknowledges Grund as an author in her own right. Her 1935 essay *Vom Wesen der Mode* (The Nature of Fashion) is among the works most frequently cited by Benjamin in the section "Mode" (Fashion), along with texts by philosophers, sociologists, and writers such as Melchior Vischer, Georg Simmel, and Paul Valéry.[9] Benjamin and Adorno were regular readers and ardent admirers of Grund's fashion reviews for the *Frankfurter Zeitung* between 1925 and 1935, not only because she was the wife of Benjamin's close friend Hessel but also because her writings revealed some of fashion's hidden implications for

an understanding of modernity and mass culture. After reading an exposé of the *Arcades* project, and especially the section on fashion, Adorno offers Benjamin some criticism and advises him to discuss the issue further with Mrs. Hessel:

> I read your passage on fashion and I found it very significant although its argument should be separated from the category of the "organic" and should be related to the category of "life." In that respect, I thought of that shimmering French fabric "changeant" that people in the nineteenth century endowed with expressive power although it was also tied to industrial methods of production. Perhaps you should explore this idea further. Mrs. Hessel, whose reports in the *FZ* we always read with great interest, will certainly know more about this.[10]

These seemingly unpretentious, but highly evocative texts on contemporary fashions shed light on Grund's contribution to the modernist tradition of the Weimar period. Before analyzing in more detail her published essays and discussing how fashion journalism enriched and transformed the genre of the feuilleton, it may be useful to review what little is known about her life and career.

Born on 30 April 1886 in Berlin, Grund moved to Paris in 1912 in order to study art. As a student of Fernand Léger and Le Fauconnier, she mixed with artistic circles, frequently visited the famous Café du Dôme, where she also met another Berlin bohemian, Franz Hessel, introduced to her by his friend Henri-Pierre Roché. In 1913, the dynamic, vital, and adventurous Helen married the mild-mannered, rather phlegmatic, and dreamy Franz.[11]

The most productive, independent, and professionally fulfilling part of Grund's life began in 1925, when she moved with her children from Berlin to Paris to assume the newly created position of foreign fashion correspondent for the national edition of the prominent, liberal *Frankfurter Zeitung* (*FZ*). Initially, she contributed only to the feuilleton section of the newspaper. Soon she became responsible for the fashion section in the monthly supplement *Für die Frau: Monatliche Beilage für Mode und Gesellschaft* that was launched in 1926 and aggressively advertised in the pages of the *FZ*. Grund remained the chief fashion reporter for the *FZ* until 1935, by which time she had published over sixty essays (excluding some short, topical commentaries). She became well known to avid readers of *FZ*'s feuilleton section, whose frequent contributors included also Siegfried Kracauer, Walter Benjamin, Robert Walser,

Joseph Roth, Bertolt Brecht, Kasimir Edschmid, and Else Lasker-Schüler.

After 1933, Grund grew very close to the community of German writers in France, and later settled in the little coastal town of Sanary-sur-Mer, one of the major centers of literary exile. After the end of the war and until her death in 1982, Grund lived in Paris in the house of the painter Ann-Marie Uhde. Her most remarkable literary activity of the late 1950s was the first German translation of Vladimir Nabokov's *Lolita*.[12] In the early 1970s the life and work of her husband Franz Hessel were enthusiastically rediscovered and examined by German literary historians. Grund's achievements, by contrast, still remain obscure.

Early Publications

Before assuming the position of chief fashion editor for the *FZ*, Grund published sporadically in the literary press. Her breakthrough in feuilleton writing came in 1924–1925. Among her best-known essays from this period are impressions of Paris, which she wrote in the style of the *flâneur*'s account of city experience: "Pariser Bilderbogen" (Picturebook of Paris) and "Aufatmen in Paris" (A Sigh of Relief in Paris) were published in the journal *Das Tage-Buch* in 1924, and "Musikalische Magier" (Musical Magicians) appeared in the *FZ* in 1925. Another publication in the elite intellectual magazine *Der Querschnitt* testifies to Grund's attempt to assert herself as a fashion expert whose writing appeals to a broader female public as well as to more "intellectual" readers. In 1925, her essay "Im Klima der Mode" (The Climate of Fashion) appeared in the pages of Ullstein's "journal for the exacting taste" ("Zeitschrift für die Anspruchsvollen"), which prided itself on "reflecting the intellectual and artistic activity of modern life" and "leaving no room in it for cheap sensations."[13]

Between 1924 and 1925 Grund wrote mostly travel narratives that fit well into a long-established German literary tradition of travel accounts from Paris extending from the early nineteenth century (the Paris letters by Heinrich von Kleist, Heinrich Heine, and Ludwig Börne, for instance) to the 1920s (journalistic reports by Siegfried Kracauer, Joseph Roth, and Franz Hessel).[14] A major characteristic of this tradition was that it linked in the German literary imagination the experience of modernity with the experience of Paris.

In the nineteenth century, Börne hinted at an important gender differentiation in perceptions and observations of the French metropolis. For women, according to Börne, it was the encounter with new fashions and the possibility of bragging about them when they return home that constituted the quintessential experience of Paris: "While men find it

pleasant to be in Paris, for women it is a far greater pleasure to have been there and to report about their experience" (33). This quotation acquired renewed topicality in the mid-1920s when, after several postwar years of severe economic restrictions, rigid protectionist trade policies, and loud nationalistic attacks in the German press, Paris reappeared in German magazines and newspapers as the most attractive and accessible destination for travel, especially for the many female fashion journalists. Börne's Paris impressions, indeed, were rediscovered and quoted in the fashion magazine *Styl* by Julie Elias, an active contributor to this and other illustrated women's periodicals (*Die Dame*), and linked to the renewed obsession of German women with Paris and Paris fashions.[15]

Written as travel accounts from Paris, Grund's essays from the early 1920s offer intriguing glimpses into a barely studied aspect of the genre.[16] They demonstrate how women authors in the Weimar period used the travelogue to convey a notion of female sensibility for and female experience of the modern metropolis. Her essays "Aufatmen in Paris" and "Pariser Bilderbogen" are exemplary in this respect. Each represents a loose travel narrative consisting of more than a dozen short episodes located in places and involving characters that constitute the conventional topoi of the genre: the train-ride from Cologne to Paris, the Paris Metro, the atelier of a French sculptor, the luxurious restaurant, the bistro, the night club, the hotel, the circus, the fashion show, the street, the old landlady. The tone of the accounts is that of an aloof, almost impartial observation.

At first blush, both essays exhibit most of the typical elements of the *flâneur*'s account of a big city. The narrator takes immense pleasure in her immersion in the colorful city crowds, and as she wanders around Paris, she does not seem to have a particular goal or a clear destination in mind. It seems that the street, to use Benjamin's classical formulation, has truly "become her living-room." Like the *flâneur,* her attention is attracted by surface phenomena and external appearances; she is constantly engaged in the incessant and conscious process of "reading" the street and deciphering the signs of electric city lights, old façades, or display windows.

Yet there are some subtle differences that distinguish these Paris essays from the many others written by male writers and journalists in that genre. It strikes the reader that the narrator uses mostly the first person plural to refer to the subject of experience: a timid "wir" instead of an independent "ich." "In a side street off Boulevard Haussmann we find the inconspicuous entrance to a restaurant where the salespeople from the nearby department stores spend a cheerful lunch break," the author writes, or: "We slow down: for a moment we pause amidst the busy

traffic" ("Aufatmen in Paris" 147-49). "We" refers to the narrator herself as well as her unnamed male companion, who is obviously more knowledgeable about the city, the people, and the history of Paris and who leads her firmly and confidently on her journey. "My companion has a story to tell about most of these people," she comments (153).

Although almost every thematic section of the travel narrative starts with one of those sentences, in which a "we" is the subject, a clear pattern also emerges as to when an "I" appears and where it draws its poise from. The self-awareness of the "I" is often highlighted in relation to her external appearance, to her clothes. Surrounded by "blocks of marble, wood, plaster, columns, pedestals" in the atelier of a sculptor, the narrator suddenly becomes self-conscious about her appearance: "I am alone and I don't move. I am afraid that I am disturbing the peace of this studio with the bold colors of my clothes" (139).

A visit to a Paris designer house and to its regular afternoon show is another occasion on which the narrator confidently adopts the first-person-singular point of view. This segment of the narrative entitled "Amélie rue Castiglione" describes a visit to a big department store, "Trois Quarters," and forms a strong contrast to the episode in the sculptor's atelier. It is rendered entirely in the "I" form, although her knowledgeable companion is still present. In Grund's account, the dazzling multitude of impressions that is emblematic for the representation of the modern metropolitan street and big city traffic is now associated with the display of fashionable attire, with the trying on of clothes, and with the numerous possibilities of adopting a new and more attractive appearance:

> What would you like, Madam? Fabrics unroll, folds and creases surround me, chairs are moved, people sit down and get up, dull light and thundering noise come through the windows—out on the street the flow of cars is rushing in circles and small exhaust clouds caress the pavement.... And all of a sudden four girls are busy around me sliding one blouse after the other over my head. The tall thin one seduces me with the newest types of "rayon" and shows me little silk dresses, multicolored and black ones, draped and pleated ones.... I see my self transformed multiple times in the generous wide mirror and the hands of the girls work in an intimate, sisterly way. Their deft fingers touch me like a gentle drizzle (146, 149).

In the course of the narrator's account, two views of creativity and artistic self-expression become apparent. The one view is associated with the male sphere of art, which Grund perceives as permeated with coldness ("eisig, arktisch") and as "a field of ruins" ("ein Trümmerfeld").

Walking around the artist's studio, she touches the various sculptures "with fear, even horror" (139). When she comments on some male dancers and their female partners, the contrast between coldness and warmth, lifelessness and vitality again comes to the fore: "Ah, these men: pale and unseeing, they hold in their arms the warm bodies of their partners. A frightening image, as if life has withdrawn from their faces and pulses somewhere else, hidden from view" (144). The other view of creativity is associated with the female playground of fashion, which the narrator finds one of the most enchanting spectacles of Paris: "This city is brimming with women! And all these sisters, how naturally they play the game of seduction! I don't see them sizing each other up, I don't detect a gesture or a posture that aims at anything but pleasing the others and enjoying oneself" (145). In this sphere of public life, the sense of fear and dependence disappears and the *flâneuse* envisions herself as a respected participant—both as an understanding viewer and as an active performer, or as she puts it: "as a player in the celebration of beauty" ("als Mitspieler des feierlichen Hübschen").[17] And it was a very fortunate development in Grund's life that her sincere admiration of the "modern" personified by Paris women, by their sense for fashion, elegance, and playfulness, coupled with her own passion for writing, could be transformed into a steady professional engagement when she became a fashion journalist for the *Frankfurter Zeitung*.

Helen Grund and the *Frankfurter Zeitung*

When Joseph Roth, a well-known contributor to the cultural section of the *FZ*, published in the pages of the newspaper a series of short and humorous character studies devoted to fellow journalists, one of the essays, entitled "Fräulein Larissa, der Modereporter" (Miss Larissa, the Fashion Reporter), drew a mild caricature of the fashion journalist as he remembered her from the years before World War I:

> Mademoiselle Larissa had a pen name but apparently no last name.... She had been a loyal contributor to the paper from time immemorial.... She was a fashion reporter. However, since writing on fashion alone did not pay enough, Larissa covered all topics of public interest that, according to widespread opinion, were "nearer and dearer" to women than to men: protection of mothers, for example, orphans, benefit events, lotteries, divorce cases, flower exhibits, and asylums for the homeless.... Being well connected, she was dressed not in the "latest fashion," but in the one that was yet to come.... That was the highest level of journalistic perfection: she transformed herself into her articles, and the lines that she wrote that were edited out were clumsy only because her

appearance created certain presumptions about her skills as a journalist (25–28).

Roth's portrait of his colleague Larissa reveals the ambiguous and subtly disparaging attitude toward female fashion journalism that was prevalent during the rise of the mass press in the pre-Weimar period. On the one hand, the fashion reporter acquires some of the aura of the theater actress or the movie star: she adopts an artistic alias, becomes in the public mind the represented character herself, and transforms herself into a model whose external appearance would be admired and imitated on a mass scale. On the other, however, the missing and long-forgotten family name is a sign of illegitimate and unacknowledged authorship. The fashion writer dissolves and disappears into her subject matter. Yet at the end of his essay, as Roth writes about Larissa's death from typhus as a nurse during World War I and about the first and last mention of her family name in the paper, he suggests that with her a chapter in German fashion journalism has ended and that soon, namely from the mid-1920s on, a new type of *Modereporterin* will emerge.

Indeed, Larissa's successor at the *FZ*, Grund, had quite a different public presence and professional reputation. From the very beginning of her career as a reporter for the *FZ* in 1925, her regularly appearing fashion vignettes were always signed with her maiden name, Grund. Whenever she sought to reach beyond the narrow limits of topical fashion journalism, she was not willing to write on just any theme that appeared "suited to the female nature," but ventured quite self-confidently into the domain of short literary prose. Grund had a pioneering role as a fashion journalist in the mass press, because her contributions to the *FZ* transformed entrenched notions of the role of women intellectuals in the expanding sphere of Weimar's mass culture.

Still, despite her tremendous success with the reading public of the newspaper for nearly a decade, she was completely ignored by the "official" chroniclers of the *FZ*. One explanation could be found in the fact that women were simply not admitted to the editorial board and to leading decision-making positions, although many of them contributed to the newspaper on a regular basis. As Karl Apfel, an editor and long-time correspondent to the newspaper in the period 1925–1942, writes in his memoirs: "As a matter of principle, women were not accepted on the editorial boards" (236).[18] For this reason, the narrated and documented history of that prominent institution of liberal democratic consciousness in Germany rarely includes the names of these women. Similarly, more recent studies of the *FZ* and the genre of feuilleton also disregard essays on fashion as unworthy of any analysis—a gesture that is very similar to

the condescending attitudes toward fashion journalism in the early 1920s.[19]

In the course of her successful career as a fashion reporter in Paris, Grund published texts that continued to tap into the tradition of the travelogue, but at the same time tended more toward another genre of short prose writing, the feuilleton, and contributed considerably to its innovation. Feuilleton was extraordinarily popular in Weimar Germany for a number of socio-historical reasons. With the rise and expansion of the modern metropolis, both short forms, feuilleton and travelogue, focused thematically on the experience of the big city or even attempted to emulate its dynamism in their form.[20] The press emerged as the primary public forum for vigorous disputes on issues of modernization, and within the institution of the mass press, the feuilleton assumed the function of mediating and explaining new cultural practices to the public. Feuilletons were not only highly informative on non-political issues such as literature, art, everyday life, health, theater, and fashion, but they also served as a vehicle of mass entertainment. In other words, both genres (feuilleton and travelogue) were transformed as a result of the rhetorical interaction of pragmatic and aesthetic intentions. They embraced the metropolis as a paradigm of modernity and became symptomatic of the changes in the public sphere as traditional literary hierarchies were unsettled and non-canonical forms of aesthetic reflection came to the fore.

An inquiry into the modernist form of feuilleton produced by women writers for predominantly female audiences offers glimpses into an intensely politicized debate on the appeal of a particular literary form to particular groups of authors and readers. While admirers of the feuilleton in France and Germany from the 1870s on and especially after World War I saw it as a "daily corrector of opinions and conceptions that were becoming instantly obsolete," the conservative critics of the genre considered it a dangerous symptom of the trivialization of literature. If proponents of modernism considered it the "only means for modern man to keep abreast of the spirit of his own time," others disliked the high entertainment value of feuilleton and blamed its superficiality on the poor tastes of women readers (Haacke II: 224–25; I: 294–95). Theories emerged that explained the general popularity of short prose with the female public by allusions to women's supposedly shorter attention span. Other critics attributed the rise of the feuilleton to the economic success of the newspaper as a vehicle of mass entertainment: "Due to the feuilleton, which combined serious political and economic content with a light entertaining element, the newspapers

became popular with large sections of the population, especially women," wrote Karl Bücher in 1919 (Haacke I: 295).

The study of the feuilleton as an aesthetic form for the mediation of the mass experience of modernization and metropolitan life began in the late twenties with a groundbreaking work by Hermann Hausler, *Kunstformen des feuilletonistischen Stils: Beiträge zur Ästhetik und Psychologie des modernen Zeitungsfeuilletonismus* (The Forms of Feuilleton Style: On the Aesthetics and Psychology of the Contemporary Newspaper Feuilleton, 1928). Hausler defines feuilleton as the medium for impressions, subjective experiences, and observations, and focuses on one of its variations, the *Plauderei* (informal commentary), which he characterizes as follows: "It should give a descriptive and lively account of phenomena that attract great interest as well as of contemporary events and trends" (27–28). Further requisites of the genre are its vivid descriptions through the eyes of an expert (*Anschaulichkeit des Speziellsehens*) as well as its preference for concrete detail (*Bevorzugung des Konkreten*) and sensory image (*sinnliches Bild*), especially when it comes to the depiction of clothes, textures, and colors. And generally, the *Plauderei* should be "topical, pointed, interesting, entertaining, and stimulating" (29). Against the backdrop of these methodological premises, it comes as a surprise that Hausler's elaborate discussion never refers to fashion as a possible topic for a feuilletonistic essay nor does it mention a single female journalist as an author of feuilleton.

In the pages of the press, however, the very term "Plauderei" appeared quite often in the rubric *Modeplauderei,* which, in turn, had become an indispensable element in virtually every daily newspaper and weekly illustrated supplement or magazine by the 1920s. Because of its ubiquitousness, the genre was often looked down upon as a less sophisticated and rather routine mode of writing. Even fashion journalists themselves distinguished between the *Modeplauderei* as a mundane, superficial, merely descriptive piece of prose and a more philosophical, sociologically inflected essay on the phenomenon of fashion. In the introduction to her talk *Vom Wesen der Mode* (The Nature of Fashion) (which she gave repeatedly between 1935 and 1937 to young women venturing into the career of fashion design in the Meisterschule für Mode in Munich), Grund emphasized with an obvious defensiveness in her tone that this time she intended to offer her audience not a mere *Modeplauderei* but a much more serious presentation:

> It doesn't seem appropriate to present you with something like fashion chit-chat [*Modeplauderei*]; it doesn't seem appropriate for us to content ourselves with entertaining yet superficial

descriptions. At the risk of disappointing some, I have decided to treat the topic with all the seriousness due it (*Vom Wesen der Mode* 3).

It was Grund's ambition and constant effort throughout her journalistic career to transcend the narrow limitation and "superficiality" of the popular genre of *Modeplauderei* and to tie her writings on fashion to the more distinguished tradition of feuilleton.

We can see the specific ways in which fashion journalism conformed to as well as modified the generic conventions of the feuilleton if we take a closer look at the texts that Grund published in *Für die Frau,* the women's supplement to the *FZ*. On the surface, these texts appear to be dominated by a nonchalant tone and a somewhat overly playful approach. Permeated with numerous sartorial details, they focus on the fragmentary experiences of everyday life, on the apparently ephemeral, the trivial, and the deeply inauthentic. The fashionable details themselves seem to evolve from experience "which appears sensuous, ornamental, and superfluous" (Tautz 201).

At the same time, however, the inclusion of a myriad of fashion details in the narrative mirrors the inscription of Weimar fashion practices into women's everyday lives. It would not be an exaggeration to say that Grund's collection of sartorial minutiae resembles in some ways Benjamin's archival project: she retrieves microscopic pieces of the present in order to read them as symptomatic for various sociological trends.

Many of these essays, for example, offer a provocative and rare inside look into fashion as the field of professional fulfillment for many lower- and middle-class women. In a 1928 essay, Grund introduces her readers to one of the numerous behind-the-scenes actors on the glamorous stage of the fashion industry. In the course of her first-person account, the author praises, for instance, the intelligence and taste of Renée, a public-relations person of a Paris designer house, whose duties include keeping journalists up-to-date about the newest production ("Für die erste Reise 1928" 11). Other reports and interviews are dedicated to the work of less famous self-made female fashion designers who had successfully established themselves in Paris in rigid competition with the undisputed grand names in the profession, such as Patou or Worth. One of them, for example, is Renate Green, a former disciple of the Bauhaus school and a creator of clothes "designed according to completely new social principles" ("Deutsche Mode" 2). When she interviews the designer, Grund takes the opportunity to describe the atmosphere of the professional field, where Green is known for her simpler and more affordable designs:

> What I saw was an enormous effort, in which both snobbism and the desire for high profits played a large role. No one, however, had the goal of giving women of all classes the opportunity to dress well and beautifully at the lowest possible cost ("Deutsche Mode" 2).

As in many of her reports and interviews, Grund uses the opportunity to promote her own notion of the ideal fashion for modern times, embodied in "dresses that all women can wear regardless of their social class—the banker's wife as well as the young shop assistant, the aristocrat as well the maid" ("Deutsche Mode" 3).

In her provocative inquiries into the often invisible life and work of many women professionally engaged with fashion, Grund also pays tribute to the mannequins. This is a highly visible group of women whose dreary professional duties, however, often remain concealed from the public. The journalist sees it as her task to disperse the romantic aura surrounding the mannequin and remove the veil of glamour that made that profession extremely attractive to many young women in the Weimar period. In her 1928 essay "Vorzeitiger Abschiedsgruß" (An Early Goodbye) Grund paints a negative picture of the tedious and senseless work of the mannequin in a typical medium-sized designer house in Paris:

> Twice a day for two hours [the mannequin] would put on and take off thirty or more outfits with all the appropriate accessories—belts, buttons, sashes, and ribbons, keeping her hairdo and her mood intact and presenting each dress as "unique," turning, posing, being criticized in the studio of the designer [*Modistin*] like a lifeless thing, unable to hear or feel. While talking to a customer, the boss puts an arm around her hips, calls her "my dear"; the chief dressmaker [*die Direktrice*] scolds like a strict headmistress, noting at a single glance every defect, every wrinkle..., any excess of powder or smear of lipstick ("Vorzeitiger Abschiedsgruß" 9).

In a few powerful brush-strokes the author depicts the human features concealed under the mask of perfect beauty and elegance: the tiredness, the dignity, the variety of personal opinions and feelings. Grund interviewed many of these mannequins and quoted their not always flattering views of the fashion trade. In these quotations, as well as in Grund's own observations, the reader discovers the darker side of the Twenties' obsession with glamorous fashion, namely the pervasive objectification of women. The body of the mannequin is transformed into a lifeless platform on which attractive clothing is paraded in front of potential customers. At the end of this essay Grund offers a solution that would put

an end to the humiliation at least of the living female body: she suggests that clothes be displayed only on artificial mannequins in order to save the live women's bodies from the pressures of continuous objectification.

The acuteness of Grund's comments on the fate of the female mannequins in the Weimar age is not surprising, given the fact that in her writings she was always extremely self-conscious of her own professional status. Not without self-irony and criticism, she remarked that in modern times fashion reporters were often placed in the peculiar position between a "mere" mannequin and a "real" writer: they are both avid observers and mediators of aesthetic judgment, and, at the same time, objects of intense observation and critical verdicts from the public. In her 1930 essay "Premiere der Wintermode" (The Premiere of Winter Fashions) Grund introduces the reader to one of "the most demanding and attractive shows that Paris can offer" as she analyzes not only the new models but also the modes of self-presentation of her fellow fashion journalists:

> While we are laughing, the fat lady with the turquoise cape is too busy taking notes to let herself be distracted. She represents one of the most important New York newspapers and writes a daily column for that paper. Particularly beautiful is the Creole woman in the white evening dress with her shining black head. She writes for a Hollywood studio and is interested only in photogenic clothes, mostly tea gowns. Two blond Swedes are chatting, smoking, and drinking. If you have been around longer, you can tell by the position of the correspondents in the room how their respective paper is ranked and what its circulation is. In the main room are the reporters for *Vogue* and *Femina, Harper's Bazaar* and *Jardin des Modes*: they are escorted by men in impeccable tailcoats and their place is next to the sketch artists and fashion photographers, the textile manufacturers, the jewelers, and the friends of the house ("Premiere der Wintermode" 8).

Grund's essays disclose the real responsibilities and the daily tasks involved in the glamorized profession of the fashion reporter. In many respects it was a show within a show, in which the journalists themselves were expected to perform as promoters of certain fashion trends, to embody the status and prestige of various mass media institutions. At the same time, there was ample and somewhat wearisome work to be done, a fact that often remained hidden from the numerous readers of the fashion magazines:

> In the course of two weeks, the conscientious fashion journalists look at two to three collections per day, in the mornings, in the afternoons, and at night, and that makes a total of some 3,500

models. These numbers give you an idea of the sifting process that takes place before the coining of the "slogans" and the determination of the "big hits" that will dictate the future course of fashion (*Vom Wesen der Mode* 21).

Grund was the only fashion reporter of her time to convey to readers the essence of her work and to demystify the daily routine performed by the fashion reporter of the Weimar era. As she explained to the public, the field of fashion meant not only glamour and glitz, but involved also time-consuming, diligent work on the part of numerous women.

Work outside the home and the constant exposure to public attention constitute just one side of the experiences of the modern, professionally engaged female intellectual of the 1920s and early 1930s. In her publications for the *FZ*, Grund also ventured to describe the modern woman's experience of leisure. Representative of that attempt is her 1931 essay "Zwischen Abreise und Ankunft" (Between Departure and Arrival), which succinctly conveys the author's perceptions and thoughts on driving a car out of Paris into the French countryside for a weekend.[21] At first glance it seems that this text feeds into the Weimar mythology that employed the image of the woman driver as symbol of modernity (although in fact the number of women who could afford a car was very small). But upon closer look, the essay offers a rare insight into the actual experience of this "modernity" from the standpoint of the woman. It differs tremendously from numerous other texts published in *Für die Frau,* such as Heinrich Hauser's "Auto und Frau" (Cars and Women), which presented a quasi-sociological approach to the phenomenon of women driving cars and mostly emphasized the importance of cars to women as just another fashion accessory (11–12). Grund's essay, by contrast, reveals the purely subjective experience of driving alone and translates it into a statement of independence and freedom: "Off I go...today! No, now! 'Au revoir, my dear. Be happy.' My coat is on the passenger seat and the maps are in the pocket. Farewell!" The guided tour of Paris that started more than a decade ago with the knowledgeable *flâneur* at her side now has been transformed into a race for independence and self-assertion. The initial timidity of the "I" in the early essays of the *flâneuse* has given way to the sovereign "I" of the unstoppable traveler:

> The cool air is pleasant, it covers my face with a gentle mask; the gray strip of highway stretches smoothly and shimmers with unrelenting attraction. And then, suddenly, the real thing happens. Departure and arrival evaporate and become empty shells between which stretches sheer happiness: I'm on the road! In this moment

> there is no more promise of tomorrow, no sense of relief about yesterday. This is pure, unfettered happiness that stands on its own...how nice to be by myself ("Zwischen Abreise" 10).

The outwardly directed gaze of the classical *flâneur* who feels at home in the big-city street is replaced here by a much more introverted *flâneuse*. She is equipped with one of the latest technological achievements of modern age—the car—and is determined to make up for something that has been denied to her for many centuries, namely, the opportunity to explore her freedom and independence.

Grund's essay resonates, too, with the emancipatory notes permeating the writings of a contemporary woman writer from another, younger generation, Erika Mann, who also published frequently in *Für die Frau* and who also drove a car alone around Europe. Perhaps not coincidentally, Mann provided the best indirect characterization of Grund's contribution to German literature and culture of the Weimar period. As a young and aspiring actress, Mann started a career in occasional journalism in 1928 with travelogues and feuilletons that appeared in most of Ullstein's publications.[22] She displayed an acute understanding of a new type of female intellectual who established herself in the 1920s and of whom Grund was an eminent representative. Her 1931 essay "Frau und Buch" (Women and Books) may serve as a succinct summary of both the general phenomenon and the specific case of Grund:

> Recently, a new type of woman writer has emerged, and I think that this type has good prospects: the woman who reports ["Reportage schreibt"] in essays, plays, and novels. She doesn't pour out her heart nor does she scream her head off; she sets her own life quietly aside and practices reporting rather than confessing. She knows the world, she knows the score, she is clever and has a good sense of humor and the power of detachment. It is almost as if she were translating life into literature, into a literature that does not occupy celestial heights and yet is decent, useful, and often charming.
>
> Yesterday, as I was driving on the Hohenzollerndamm I met a middle-aged gentleman. He was a dreamer, looking at the sky, and I almost ran him over. He said to me: "Women, women, why don't you stay in the kitchen!" This essay is dedicated to this gentleman (11–12).

Coda

Grund was one of the few fashion journalists of the 1920s whose career was not interrupted in the wake of the Nazis' coming to power in 1933, although it experienced some critical changes. She remained on the staff of the *Frankfurter Zeitung* until 1935 and then started working for *Die Dame,* a magazine that even after 1933 was still determined to publish regular fashion reports from Paris. This situation remained fairly unchanged until late 1936. In strong contrast to the pompous editorial rhetoric about Italian and traditional German forms of dress that filled most other fashion periodicals, the issues of *Die Dame* from 1935 and 1936 continued to publish French designs and articles sent directly from their Paris correspondent.[23]

It was Grund, in fact, who sent detailed reports from the French capital. Grund's texts from the 1930s do not strike the reader as radically different in tone from what she wrote before 1933. Any references to the new political mission of fashion are missing in her essays. Even their form became controversial because she sent them as "letters" with a reproduction of the letterhead of a Paris hotel appearing at the top of the page, and she defiantly continued to use French terms in her reports. Her highly individualized and uncompromised style in *Die Dame* prompted the SS newspaper *Das Schwarze Korps* to launch a fierce attack against her:

> *Die Dame*'s foreign correspondent writes from Paris. Yes, "from Paris," and the reports are signed with the beautiful name Helen.... We think it is really important to inform our readers about this latest fad of western femininity.... If Mademoiselle Helen were not able to escape from us abroad, we would force her to produce a fair copy of her reports by lantern light with goose-quills.... We will expose her writings for what they really are: foreign despite all the aryanization ["artfremd trotz aller Arisierung!"] (29 Sept. 1938: 31).

Despite the fiery rhetoric of this anonymous editorial, the writer has intuitively grasped a trend in Grund's recent publications, namely her ambition to link fashion to the more general issues of modern femininity. Grund's public lecture "Die Beziehung der Frau zu ihrer eigenen Erscheinung" (Woman's Relation to her Own Appearance), which she published in 1935 under the title *Vom Wesen der Mode* (The Nature of Fashion), testifies to the increased sophistication of her writing on fashion in the last years of her career. At the same time, it seemed designed to infuriate the authorities.

After stating that her approach to fashion is serious and grounded in professionalism, she declares that she will talk about a topic she knows inside and out, one that deserves wide public and critical attention: "Pariser Modeschaffen" (fashion design in Paris). Her subsequent justification of the choice of lecture topic is like a slap in the face of nationalist propaganda:

> All attempts to create a national fashion—and there have been such in England, America, and Germany—have failed so far. Only Vienna was able to create and maintain a unique style that is strong enough to influence the region and flexible enough to open itself up fearlessly to Paris. This sole exception is very interesting. It confirms for me the validity of theories that we will address in a moment (Grund, *Vom Wesen der Mode* 4).

The anti-nationalistic line of her argument has an anti-paternalistic underpinning. It is, according to Grund, mostly German men who misinterpret the function and meaning of fashion for women and spread hostility toward Paris styles. In a gesture of seeming appeasement to the regime, the author actually ridicules the practice of male writers who dictate to women what is currently fashionable:

> In France you would rarely find a man who would make fun of some new fashions or stop his wife from following them. To the same extent that the German woman would not even think of laughing at the heroic essence of a man, a French or a Viennese man would never feel any right to despise a woman's instinct for beauty regardless of the form that it may take, and would never reproach her about red nail polish, a powdered face, a fancy hairdo, or painted lips. Whether he is aware of it or not, he respects the driving force behind these phenomena (9).

This insistence on the autonomy of women's opinions and decision-making in matters of fashion allows Grund to sneak into her presentation some more general observations about fashion as a sphere of self-reflective and self-assertive practices. "Fashion teaches woman to be constantly aware of her body ("ein fortwährendes Bewußtsein ihrer Körperlichkeit"), she wrote, and argued ardently against the usual assumption that women are predisposed to be obsessed with changing clothing styles because fashion is in itself "unreasonable" and "superficial." In response to such clichés, the author offered convincing explanations as to why fashion is only "*seemingly* irrational" ("das *scheinbar* Unvernünftige," 5–6). At the same time, however, it would be incorrect to interpret her lecture as a daring feminist statement, since Grund often spoke in favor

of many traditional functions associated with fashion, such as facilitating the natural purpose of women to seduce men to love (8).

Grund's career came to a close after a renewed series of attacks against her in the Nazi press in 1937–38. In an inflammatory article, "Die Sorgen einer Meisterschule" (The Concerns of a Professional School), *Das Schwarze Korps* wrote: "Recently, no other than Helen Grund was preaching in Munich about German women's culture. We can't tolerate this.... Even in Munich, *Gemütlichkeit* ends where Helen Grund, of all people, proposes to lecture on the culture of German women" (21 Jan. 1937: 1). The former correspondent of the "most Jewish newspaper of all" was threatened with sanctions if she did not stop her anti-German propaganda. As a result, she retreated into silence and subsequently into oblivion, which lasted for decades. Yet despite literary history's neglect of her, Grund's writings on fashion from the 1920s and 1930s remain exemplary for the ways in which a talented fashion journalist in Weimar Germany not only participated in the debates on modernity, but also made a lasting contribution to the development of the modernist genres of feuilleton and travelogue.

Notes

I would like to thank Miriam Hansen for her encouragement to pursue this project and for her comments on an early version of the text. I am indebted to Venelin Ganev and Ruth Sanders for editorial suggestions on later drafts of the paper. All translations are mine.

[1] Franz Hessel, *Spazieren in Berlin* (1929). The 1984 edition appears under the title *Ein Flaneur in Berlin*. All references are to the newer edition.

[2] The expression "unter den Strich" carries a double meaning. In its idiomatic usage it means "of lower quality," "below par," and refers to the way the genre of the feuilleton is looked upon by literary and journalistic establishments. For writers of literary fiction, it is too journalistic, and for journalists, it deals with issues less serious than politics and economy. At the same time, however, the phrase "unter den Strich" depicts literally the location of cultural discussions, short essays, and book reviews on the page of most German daily newspapers during the twenties, namely in the bottom part, separated from the other news articles by a thick line.

[3] See, for example, Fritzsche, *Reading Berlin 1900*.

[4] See Köhn, *Straßenrausch*.

[5] A notable exception is Anke Gleber's book *The Art of Taking a Walk: Flanerie, Literature, and Film in Weimar Culture*. See esp. 171–213.

⁶ Although she always signed her published texts with her maiden name "Grund," in secondary literature she is often referred to as Helen Hessel or Mrs. Hessel. Throughout this piece I will refer to her as (Helen) Grund.

⁷ See Vollmer (734-35). There is more on Helen Hessel in Puttnies and Smith, who quote from her correspondence with Benjamin and draw parallels between the two couples—the Hessels and the Benjamins—in which both women, Helen Grund and Dora Sophie Kellner, stood out as independent, ambitious, and practical personalities with successful journalistic careers of their own (214-15). Benjamin's wife Dora wrote for Ullstein's illustrated periodicals (mostly for *Die Dame*) and after 1926 became an editor for the fashion magazine *Die praktische Berlinerin*.

Numerous references to Grund as the professional fashion reporter from Paris and expert on fashion writing appear also in Kurt Tucholsky's reviews of Franz Hessel's books. Tucholsky goes so far as to hint at Grund's influence on her husband's writing. His assertion that there was something of a "female quality," not "masculine enough," and "too coquettish" in Hessel's writing could best be interpreted as an allusion to the fact that in reality Helen did—upon her husband's request—write or revise passages that described with some sophistication clothes, appearances, designer stores, and fashion shows (see Tucholsky 2: 1128, 3: 217; also Flügge, *Gesprungene Liebe* 193-94).

⁸ In 1953 Henri-Pierre Roché, a French art dealer and Grund's lover for over 10 years, published a novel based on his journal entries. In 1955, François Truffaut stumbled onto Roché's novel and immediately decided to use it as a script for a film. He discussed his plans with the author and after looking at some photographs of Jeanne Moreau that Truffaut had sent him, Roché agreed that she was probably the best choice for the role of Kathe. Roché died in 1959, before the premiere of the film in 1962. According to Truffaut, Grund was in the audience during the premiere and later wrote in a letter to him: "But what disposition in you, what affinity could have enlightened you to the point of recreating—in spite of the odd inevitable deviation and compromise—the essential quality of our intimate emotions? On that level, I am the only authentic judge because the other two witnesses are no longer here to tell you 'yes.'" For more on the "real story" behind the film, see Andrew and Flügge (*Gesprungene Liebe*).

⁹ See Benjamin (110-32).

¹⁰ A letter from Adorno to Benjamin of 2 August 1935. See Benjamin (5.2: 1133).

¹¹ For more biographical data on Grund, see Rheinsberg; Ungeheuer; Becker. I am indebted to Manfred Flügge for giving me the most precise and comprehensive accounts on the life and career of Grund. See also Flügge, *Letzte Heimkehr nach Paris* and *Wider Willen im Paradies* (100-04).

[12] See Winter (28).

[13] See *Der Verlag Ullstein zum Weltreklamekongress* (11).

[14] Hessel called these texts Paris's "most desirable export for the German newspaper." See Franz Hessel, "Vorschule des Journalismus: Ein Pariser Tagebuch," *Nachfeier* (160).

[15] See Elias (33-34). *Styl* was a short-lived, expensive monthly publication of the *Verband der deutschen Modeindustrie,* which appeared only in 1923 and 1924 and was sponsored by leading German designer houses such as H. Gerson, Mannheimer, E. Mossner, M. Gerstel, Regina Friedländer, and Martha Löwental. The goal of the organization was to elevate the prestige of German designers and promote a "national style" in fashion.

[16] Substantial research has been done within the field of German studies on women and journalistic travel writing in the eighteenth and nineteenth century, with a focus on the travel accounts by Sophie von La Roche, Fanny Lewald, Ottilie Assing, Ida Pfeiffer, Ida Hahn-Hahn, and Johanna Schopenhauer. For a comprehensive examination of paradigms of feminine experience of travel and the ensuing transformations of the travelogue genre, see Frederiksen (104-22) and Felden.

[17] My understanding of the emerging notion of female subjectivity tied to the experience of fashion corresponds to Birgit Tautz's observations in her illuminating essay on the fashion discourse in an eighteenth-century travel narrative. Tautz demonstrates how for the male writer/traveler women's fashions signal instability, fear, and insecurity, while "women become the *media* of fashion in the narrative" (203).

[18] Other regular contributors to the *Frankfurter Zeitung* included Irene Seligo and Heddy Neumeister. On discrimination against female journalists, especially those who aspired to be political commentators and foreign correspondents, see Boveri (157, 218, 222).

[19] See Todorow, *Das Feuilleton*; Todorow, "'Wollten die Eintagsfliegen'" (697-740), and Schivelbusch (42-62).

[20] For an elaborate argumentation of these theses, see Köhn (7-15); Gleber (463-89).

[21] For more on Grund's own inexhaustible passion for travel, see Wolff (112-17). Charlotte Wolff, a psychiatrist who was forced to leave Germany in 1933 and found shelter in Grund's Paris apartment, accompanied Grund on many trips.

[22] See Lühe (44-47), who states that Mann published more than 100 articles, essays, and travelogues in the period between 1928 and January 1933, the majority of them in Ullstein's newly founded daily *Tempo.*

[23] For an excellent analysis of how little the journalists of *Die Dame* as well as popular Berlin fashion designers complied with the official appeals

to "liberate the German woman from the tyranny of French fashions," see Stamm (189-203).

Works Cited

Andrew, Dudley. "Jules, Jim, and Walter Benjamin." *The Image in Dispute: Art and Cinema in the Age of Photography.* Ed. Dudley Andrew. Austin: U of Texas P, 1997.

Apfel, Karl. "In den zwanziger Jahren: Erinnerungen an die Frankfurter Zeitung." *Archiv für Frankfurts Geschichte und Kunst* 55 (1976): 67-79.

Becker, Claudia. "Helen Grund." *Genieße froh, was du nicht hast: Der Flaneur Franz Hessel.* Ed. Michael Opitz and Jörg Plath. Würzburg: Königshausen & Neumann, 1997.

Benjamin, Walter. *Gesammelte Schriften.* Ed. Rolf Tiedemann and Hermann Schweppenhäuser. Vol. 5.1. Frankfurt a.M.: Suhrkamp, 1982.

Börne, Ludwig. *Sämtliche Schriften.* Ed. Inge and Peter Rippmann. Vol. 2. Düsseldorf: Melzer, 1962.

Boveri, Margret. *Verzweigungen: Eine Autobiographie.* Frankfurt a.M.: Suhrkamp, 1996.

Elias, Julie. "Die Dame im Sommer." *Styl* 2 (1924): 33-34.

Felden, Tamara. *Frauen reisen: Zur literarischen Repräsentation weiblicher Geschlechterrollenerfahrung im 19. Jahrhundert.* New York: Peter Lang, 1993.

Flügge, Manfred. *Gesprungene Liebe: Die wahre Geschichte zu "Jules und Jim."* Berlin: Aufbau, 1993.

──────. *Letzte Heimkehr nach Paris: Franz Hessel und die Seinen im Exil.* Berlin: Arsenal, 1989.

──────. *Wider Willen im Paradies: Deutsche Schriftsteller im Exil in Sanary-sur-Mer.* Berlin: Aufbau, 1996.

Frederiksen, Elke. "Blick in die Ferne: Zur Reiseliteratur von Frauen." *Frauen—Literatur—Geschichte: Schreibende Frauen vom Mittelalter bis zur Gegenwart.* Ed. Hiltrud Gnüg and Renate Möhrmann. Stuttgart: Metzler, 1985. 104-22.

Fritzsche, Peter. *Reading Berlin 1900.* Cambridge: Harvard UP, 1996.

Gleber, Anke. "Die Erfahrung der Moderne in der Stadt: Reiseliteratur in der Weimarer Republik." *Der Reisebericht: Die Entwicklung einer Gattung in der deutschen Literatur.* Ed. Peter J. Brenner. Frankfurt a.M.: Suhrkamp, 1989. 463-89.

Grund, Helen. "Aufatmen in Paris." *Bubikopf: Aufbruch in den Zwanzigern. Texte von Frauen.* Ed. Anna Rheinsberg. Darmstadt: Luchterhand, 1988.

———. "Deutsche Mode in Paris: Ein Gespräch mit Renate Green." *Für die Frau* 1 (1932): 2.
———. "Im Klima der Mode." *Der Querschnitt* 6 (1925): 514-15.
———. "Musikalische Magier." *Frankfurter Zeitung* 9. Dec. 1925.
———. "Pariser Bilderbogen." *Das Tage-Buch* 5 (1924): 696-702.
———. "Premiere der Wintermode." *Für die Frau* 9 (1930): 8-10.
———. *Vom Wesen der Mode*. München: Meisterschule für Deutschlands Buchdruck, 1935.
———. "Vorzeitiger Abschiedsgruß." *Für die Frau* 5 (1928): 11-12.
———. "Zwischen Abreise und Ankunft." *Für die Frau* 8 (1931): 9-10.
Haacke, Wilmont. *Handbuch des Feuilletons*. 3 vols. Emsdetten: Lechte, 1951.
Hauser, Heinrich. "Auto und Frau." *Für die Frau* 7 (1927): 11-12.
Hausler, Hermann. *Kunstformen des feuilletonistischen Stils. Beiträge zur Ästhetik und Psychologie des modernen Zeitungsfeuilletonismus*. Stuttgart: Württemberger Zeitungsverlag, 1928.
Hessel, Franz. *Ein Flaneur in Berlin*. Berlin: Arsenal, 1984.
———. *Nachfeier*. Berlin: Rowohlt, 1929.
Köhn, Eckhardt. *Straßenrausch: Flanerie und kleine Form*. Berlin: Arsenal, 1989.
Lühe, Irmela von der. *Erika Mann: Eine Biographie*. Frankfurt a.M.: Campus, 1993.
Mann, Erika. "Frau und Buch." *Bubikopf: Aufbruch in den Zwanzigern. Texte von Frauen*. Ed. Anna Rheinsberg. Darmstadt: Luchterhand, 1988.
Puttnies, Hans, and Gary Smith. *Benjaminiana: Eine biographische Recherche*. Giessen: Anabas, 1991.
Rheinsberg, Anna. "'Alle Risiken auf sich nehmen und für alles bezahlen': Helen Grund." *Zwischen Aufbruch und Verfolgung: Künstlerinnen der 20er und 30er Jahre*. Ed. Denny Hirschbach and Sonia Nowoselsky. Bremen: Zeichen + Spuren, 1993. 158-64.
Roth, Joseph. *Panoptikum: Gestalten und Kulissen*. Köln: Kiepenheuer & Witsch, 1983.
Schivelbusch, Wolfgang. *Intellektuellendämmerung: Zur Lage der Frankfurter Intelligenz in den zwanziger Jahren*. Frankfurt a.M.: Insel, 1983. 42-62.
Das Schwarze Korps. Editorials. 21 Jan. 1937; 29 Sept. 1938.
Stamm, Brigitte. "Berliner Modemacher der 30er Jahre." *Der Bär: Jahrbuch des Vereins für die Geschichte Berlins* 38-39 (1989/90): 189-203.
Tautz, Birgit. "Fashionable Details: Narration in an Eighteenth-Century Travel Account." *Germanic Review* 72 (1997): 201-12.

Todorow, Almut. *Das Feuilleton der "Frankfurter Zeitung" in der Weimarer Republik: Zur Grundlegung einer rhetorischen Medien Forschung.* Tübingen: Max Niemeyer, 1996.

———. "'Wollten die Eintagsfliegen in den Rang höherer Insekten aufsteigen?' Die Feuilletonkonzeption der *Frankfurter Zeitung* während der Weimarer Republik im redaktionellen Selbstverständnis." *Deutsche Vierteljahrsschrift für Literaturwissenschaft und Geistesgeschichte* 62 (1988): 697–740.

Truffaut, François. Introduction. *Jules et Jim*. By Henri-Pierre Roché. Trans. Patrick Evans. New York: Marion Boyars, 1993.

Tucholsky, Kurt. *Gesammelte Werke: 1925–1928.* Vol. 2. Ed. Mary Gerold-Tucholsky and Fritz J. Raddatz. Reinbek bei Hamburg: Rowohlt, 1960.

Ungeheuer, Barbara. "Helen Hessel." *Femmes Fatales: 13 Annäherungen.* Ed. Ines Böhner. Mannheim: Bollmann, 1996. 71–80.

Der Verlag Ullstein zum Weltreklamekongress. Berlin: Ullstein, 1929.

Vollmer, Hartmut. "Der Flaneur in einer 'quälenden Doppelwelt': Über den wiederentdeckten Dichter Franz Hessel." *Neue Deutsche Hefte* 34 (1987): 730–55.

Winter, Helmut. "Pockennarbig von Fallen: Eine kleine Geschichte der Übersetzungen von Nabokovs 'Lolita.'" *Frankfurter Allgemeine Zeitung* 27. Jan. 1990. 28.

Wolff, Charlotte. *Hindsight*. London: Quartet Books, 1980.

A Female Old Shatterhand? Colonial Heroes and Heroines in Lydia Höpker's Tales of Southwest Africa

Jill Suzanne Smith

This article analyzes two novels by the colonial *Farmersfrau* Lydia Höpker, *Um Scholle und Leben* (1927) and *Und wo der Wind weht* (first published in 1994), works as yet virtually untouched by German Studies scholarship. Focusing on Höpker's narrative use of gossip, I demonstrate how the depictions of work, sport, and leisure, and the treatment of colonized African workers aid in the literary construction of a German colonial heroine. While Höpker employs gossip to destabilize and redefine gender hierarchies, her novels—written in the postcolonial period between 1913 and 1945—can be read as documents of historical revisionism and "colonial fantasy" that rework the history of colonial loss and reinforce the power of white Germans within the colonial space. (JSS)

Over the past two decades, the German colonial *Farmersfrau* or settler woman has become a figure of fascination for postcolonial scholars. While two influential studies on German colonial life and literature written in the 1980s use the memoirs of settler women to portray the colonial farm as the indisputable domain of the man (see Benninghoff-Lûhl; Sadji), more recent scholarship has analyzed these texts as narratives of women's empowerment, arguing that the space of the colonial farm "blurred the gendered division of labor between unpaid work at home and paid work outside the home" (Wildenthal, *German Women for Empire* 5). "As a site of both economic production and family reproduction," the farm allowed women to occupy the traditional position of wife and mother while taking on such additional duties as raising livestock, working the land, and even disciplining the indigenous workers (Wildenthal, *German Women for Empire* 5, 143).

Writing between 1900 and the First World War, colonial memoirists such as Clara Brockmann, Margarethe von Eckenbrecher, Helene von Falkenhausen, and Else Sonnenberg portrayed themselves as brave, hard-working individuals thriving in the colonial setting—an image that may have contributed to the surge in female emigration to German Southwest Africa (today Namibia) between 1908 and 1914.[1] Feminist scholars who have closely analyzed works by these settler women have pinpointed three sources for their sense of empowerment. First, their perceived or actual autonomy from men allows them to portray themselves as agents and diminish the role of German men within their narratives. For example, although both Helene von Falkenhausen and Margarethe von Eckenbrecher followed their husbands to the colony, von Falkenhausen was already a widow when she wrote her memoir, and von Eckenbrecher, though she was not yet divorced from her husband, gave him a "remarkably marginal role" in her 1907 autobiography *Was Afrika mir gab und nahm* (What Africa Gave and Took from Me; Gerstenberger 75). Narrative exclusion of men is especially evident in the writings of Clara Brockmann who, as a single woman, journalist, and civil servant working in Windhoek, "deliberately excised" German men from her texts (Klotz 111; Wildenthal, "She is the Victor" 373, 388). The second source of power for women such as Brockmann, von Falkenhausen, and von Eckenbrecher is their elevated class standing (upper middle-class or aristocratic), which affords them a sense of freedom and luxury quite anomalous to everyday settler life in the colonies (see O'Donnell 19). The third and perhaps most important source of their privilege is their racial identity as "white women." As Lora Wildenthal so adeptly argues, these women "saw themselves first as Germans, then as female. They could not express, nor apparently imagine, a raceless femininity" (*German Women for Empire* 52). German men may have conquered the "wide open spaces" and the native peoples of Southwest Africa, but it was up to German women to domesticate the wild African landscape, its farms, and its people.[2] As arbiters of domesticity and respectability, these "white women" proclaimed their moral and racial superiority over the African natives.

Despite the significant amount of scholarly material analyzing settler women's literature, German Studies scholars have hitherto neglected to look closely at the works of Lydia Höpker. Marking the years between 1907 and 1914 as the heyday of the *Farmersfrau*, Marcia Klotz contends that settler women failed to resurface on the literary scene after the Great War (64).[3] In contrast, Wildenthal cites Lydia Höpker's first autobiographical novel, *Um Scholle und Leben: Schicksale einer deutschen Farmerin in Südwest-Afrika* (For Land and Life: Fates of a German

Woman Farmer in Southwest Africa), which was published in 1927, as a work that assured readers in Weimar Germany of a continued German presence in Southwest Africa despite Germany's forced relinquishment of colonial power in 1919 (*German Women for Empire* 172; 274).[4] Much like the work of her predecessors, Höpker's novels depict a "white woman" who not only excels in the domestic sphere, but can also out-perform most male colonizers in the public arena by successfully hunting large game, plowing her own fields, and disciplining her indigenous servants. Also similar to earlier writings by settler women, Höpker's works reveal that however experimental the colonial space may have been in terms of gender, it was not nearly as innovative in terms of racial power structures. Claiming continued dominion of white colonizers over black Africans, Höpker takes on the additional task of propagating "the dream of a colonial empire" after the humiliating loss of the colonies to the Entente Powers (Warmbold 10).[5] While *Um Scholle und Leben* laments the forced capitulation of the German colonial authorities to the British, her second novel—*Und wo der Wind weht: Ein heiteres, buntes Buch aus dem südwest-afrikanischem Busch* (And Where the Wind Blows: An Exciting, Colorful Book from the Southwest African Bush, 1945)—revises history by erasing the English presence in the colonies and reestablishing German rule, along with its harsh treatment of the indigenous population.

In addition to the temporal distance between Höpker and her predecessors, there are several factors that set her writings apart. Unlike "genteel women writers" such as von Eckenbrecher and Brockmann (O'Donnell 19), Höpker tells the story of a settler woman who did not follow a husband to the colonies or occupy a position of class privilege. *Um Scholle und Leben* centers around "Fräulein Irmhoff," a young, single woman who leaves her German town for a farm in Southwest Africa, where she is expected to maintain a household inhabited by three single male farmers. Although the protagonist's experiences bear a striking resemblance to Höpker's own biography—including her arrival in Southwest Africa in 1913 under the auspices of the Female Emigration Program, her work on a farm owned by several German men, the postwar purchase of her own farm, and her 1920 marriage to Carl Höpker—the fact that the author chose to fictionalize the names of characters and places in her work leads me to approach the work as an autobiographical novel rather than a memoir.[6] Fräulein Irmhoff fits the historical model of the young, single German women sent to Southwest Africa under the sponsorship of the German Colonial Society (*Deutsche Kolonialgesellschaft*) and its Women's League (*Frauenbund*) between 1898 and 1914. These women were meant to serve as potential farmwives, to

deter sexual relations between white German men and African women, and to use their domestic talents to bring order and cleanliness to the farm (Chickering 178; Klotz 14; Mamozai 137; O'Donnell). Writer Clara Brockmann openly snubbed such women, seeing them as opportunistic country bumpkins or social climbers who "tried to play the lady" (qtd. in Wildenthal, "She is the Victor" 385), and she was not the only one to be casting aspersions. Many settlers aimed malicious gossip at the female transportees, whose alleged sexual proclivities and "self-interested conduct" earned them "dubious reputations" (O'Donnell 15, 133). Höpker's Fräulein Irmhoff, however, counters such gossip with her bravery, industriousness, and respectability.

This is not to say that gossip is absent from Höpker's work; just the opposite, it is her chief narrative device. Gossip, as Krista O'Donnell argues, "was central to structuring colonial relationships between racial groups as well as within them" (262), and Höpker employs gossip to set her protagonist apart from both the native women and many of the German men in her novels. With gossip, I will argue, Höpker creates a privileged space for the heroine—a narrative space in which she can be critical of the indigenous women's idleness, the German men's occasional follies, and even the institution of marriage. Although Irmhoff's decision at the end of *Um Scholle und Leben* to wed her brave, strong neighbor Rolf Witte shows that she is not completely averse to marriage, it does indicate her freedom to select her own life partner. The fact that Rolf is a model farmer and valiant hunter is no mere coincidence, for these qualities, we shall soon see, make him worthy of Irmhoff's affections. As Klotz argues in reference to the popular colonial novels of Frieda von Bülow, colonial romances are "centrally concerned with defining a male hero," but "it is the *female* viewer who recognizes his superiority over those around him" (47, emphasis in original). I would go further than Klotz to argue that Höpker's novels define heroism by offering a model *heroine,* against whom all colonial men are to be measured. Rolf, the man who does measure up, can enter into a partnership with the female protagonist. In contrast to women like Brockmann, whose works are virtually devoid of men, Höpker's novels are filled with them, exemplifying what Wildenthal describes as the interwar "comradeship with German men that permitted independence for women without feminist critique of existing social relations" (*German Women for Empire* 196). In Höpker's writings, the "old image of the *Farmersfrau,* the woman who produced economic and cultural value apart from industrial capitalism, class conflict, and competition with men, retained its power" (Wildenthal, *German Women for Empire* 196). My close reading and comparison of Höpker's novels, with an analysis of their

narrative use of gossip, will demonstrate the importance of work, sport, and leisure, and the treatment of the African natives in the literary construction of a German heroine who could easily stand up to the likes of a male hero such as Karl May's Old Shatterhand.

Getting her Giggles: The Role of Gossip in Höpker's Writings

In her 1985 study entitled *Gossip,* Patricia Meyer Spacks challenges a long-held assumption that gossip is an inherently malicious form of communication associated with women's chatter (4). The purpose of her study is to outline a more positive, meaningful notion of gossip, which she calls "serious gossip," talk that "takes place in private, at leisure, in a context of trust" (5). Lest we be deceived by the term "serious gossip," Spacks assures us that the tone of gossip "insists on its own frivolity"(6).[7] The effects of such gossip, however, can be quite serious.

The frivolity of gossip pervades the narrative tone of Höpker's novels, which is perhaps one of the reasons her work has been characterized as "entertaining" (Sadji 236). As often as they report on their own daily toils, the female narrators in Höpker's books spin amusing tales about their European neighbors. In *Und wo der Wind weht,* for example, the unnamed female protagonist's anecdotes concerning family life and the search for romance and domestic bliss in the colonies sometimes read like episodes from our modern-day sitcoms, and she always has a role to play in them herself. But most often it is the men of the colony who provide her with the best material. Whether they are shooting at cockatoos instead of lions (*Um Scholle und Leben* 25), trying desperately to make money by drilling for non-existent oil, growing artichokes that no one will eat (*Und wo der Wind weht* 52, 59), or competing for the attention of the newest single woman in the colony (both novels), the men rarely escape the narrators' fun-poking gossip. In *Und wo der Wind weht,* the most frequent object of the narrator's amused chuckles is Wilhelm Osterroth, a fellow farmer who is constantly begging for water from the protagonist and her husband. Tired of living alone in his farm shanty, Osterroth writes a letter to a German newspaper in hopes of finding a bride (13). And he finds her: a large-boned red-headed woman appropriately named Amanda Groß arrives in the colony ready to consummate the marriage arranged by the German press. Yet she takes one look at Osterroth's "primitive" shack and retracts her decision to marry him. Instead, she gallops away with the female narrator to live at her more sophisticated farm, equipped with guest quarters and a veranda (19). As in *Um Scholle und Leben,* the idea of an uncontested marital union arranged by a German organization is

problematized. This scenario does hold a grain of truth, for, as O'Donnell documents, it was not unheard of for prospective brides sent by the German Colonial Society to take advantage of their newfound freedom and break their engagements upon arrival. Amanda's rejection of Osterroth proves that he is not the proper object of desire, for he is unsuccessful in both the traditionally masculine occupation of farming and the traditionally feminine task of keeping a proper household. The gossip about men in Höpker's novels has a subversive side, for it offers the female protagonist as a model farmer, giving her the right to challenge traditional assumptions about gender. After all, Amanda rides off into the Southwest African sunset with *her,* not with Osterroth. This subversive function of gossip is highlighted by Spacks: "Gossip as a phenomenon raises questions about boundaries, authority, distance, the nature of knowledge; it demands answers quite at odds with what we assume as our culture's dominant values" (12). The gossip about the colonial men goes beyond mere story-telling; it contains a critical element that places the female voice in a position of authority. Spacks recovers the connection between gossip and women not to portray women as idle and malicious, but in order to grant women the power to be playful and critical at the same time (26). If gossip provides women with a forum that "violates traditional hierarchy" (35), then the narrator's gossip about her male neighbors exposes their deficiencies and points to her own strengths.

It is important to note, however, that men are not the exclusive focus of such critical gossip. Women who are neither tough nor diligent enough to face the challenge of survival in Africa also become the subjects of the narrator's anecdotes. Even though Amanda Groß "violates traditional hierarchy" by snubbing Osterroth's proposal, her perspective on colonial life is portrayed as naïve. Used to a more metropolitan environment, Amanda exclaims to Osterroth, "How primitive it is here! At home I owned a lovely *apartement* with *Biedermeier*" (*Und wo der Wind weht* 19). To show how foreign the concept of *Biedermeier* décor is to a colonial farmer, the female narrator tells the reader that Osterroth "became somewhat jealous because he thought that Biedermeier might be Amanda's German lover" (19)! When Amanda arrives in Southwest Africa, her mind is filled not only with European concepts of taste, but also with elaborate fantasies about Africa as a land where she could ride bareback on zebras or recline on a shady porch, fanned by a cluster of adoring natives (20). Her fantasy of luxury is shattered by the sight of Osterroth's porchless shack, but Amanda continues to seek an exotic experience in Africa. In a rather formulaic yet hilarious scene, she traipses off into the bush to take an "open-air bath" (22). After hanging

her clothes on a nearby tree and savoring her bath, Amanda is distracted by an exotic bird, which she follows far into the bush, not noticing that she is lost. Fumbling naked through the bush, she starts to panic as evening draws near. Luckily, she is rescued by Ewermann, a local farmer and orderly bachelor who is often the positive focus of the narrator's attention. Arriving back at the narrator's home, wrapped safely in one of Ewermann's blankets, a shaken Amanda finds that one of the male house servants, Mutenja, has found and donned her abandoned clothes. She lets him keep her high heels, and the episode ends with a communal laugh. This laugh, however, is directed as much at Amanda as it is at the native man in drag, for her desire to swing in a shaded hammock and take open-air baths is seen to be as ridiculous as Mutenja's desire to wear her high heels. Both Mutenja and Amanda are fascinated by what they perceive to be the exotic curiosities of the other's culture. The narrator's criticism of Amanda could also be read as an implicit critique of "socially elite" colonial writers like Brockmann, who enticed readers (such as Amanda perhaps) with images of twilight horseback rides and cool nights lounging on the veranda (O'Donnell 19; Brockmann 45–46). Ultimately, Amanda chooses town life over the frontier (as did Brockmann) and becomes a cook, one of the highest-paying professions open to colonial women (O'Donnell 255).

The above anecdote is important in both its critique of Amanda's naïve vision of Africa and its choice of Ewermann as her rescuer or hero. The opposite of the hapless Osterroth, Ewermann works his own small farm, maintains a pristine household, collects minerals, and teaches himself to dance (58). He is an exemplary bachelor, a man whose activities reflect both masculine and feminine traits, a positive result of what Russell Berman has called the "hybridizing utopia" of the colony (174).[8] It is therefore no surprise to the reader when Ewermann wins the love of Dorothea, a young teacher who travels to *Südwest* to start a German school for the settlers and is romantically pursued by most of the single farmers (71).

The gossip in Höpker's novels creates a distinction between positive and negative role models, using work and leisure activities as paradigms for that distinction. Just as hard labor structures the German farmers' days, so do organized leisure activities—hunting, Christmas parties, dinners, dances, and *gossip*—help bring order to their evenings and free time. The protagonists' gossip privileges a white, European, agrarian community comprised of dutiful, hard-working men and women and places them in a position of superiority and authority over the "idle" natives.

As O'Donnell admits in her analysis of gossip in Southwest Africa, "gossip concerning Europeans and Africans [was] weighted quite differently in colonists' minds," and colonial women writers such as Höpker often took great pains to distinguish their white heroines from indigenous women through their sexual behavior and work ethic (296). In his book *White Writing,* J.M. Coetzee traces the emergence of the idea that "idleness is a betrayal of one's humanity" back to post-Reformation Germany, arguing that this concept was later adopted by European colonizers in southern Africa to criticize the natives and justify white rule (20–21). Germans conceived of themselves as industrious, not idle. Coetzee also calls our attention to "the humanistic opposition of leisure (Roman *otium,* Greek *schole,* time for self-improvement) to idleness" (25) and argues that even European play, or leisure, was consistently viewed by the colonists in contrast to the "indolence, sloth, laziness, torpor" of the indigenous peoples (16). The form of gossip that reinforces this distinction between active whites and slovenly blacks is referred to by Coetzee as the "Discourse of the Cape" (16), and it surfaces multiple times in both of Höpker's books. Fräulein Irmhoff spends the first pages of *Um Scholle und Leben* distinguishing her own "good will" and "strong ambition" (10) from the sloth of the two African housemaids, Kanakawi and Jadura. Her gossiping voice takes on a derisive tone when she describes Jadura's lack of hygiene and work ethic:

> Jadura, a Damara woman, was not to be cultivated. She laughed, sang, or slept and stank from a distance of three meters. *Her laziness knew no bounds.* While making butter, she always sat on the ground, the butter churn between her dirty thighs; ...she often fell asleep while churning, and a poke in the ribs was needed to wake her again (12; emphasis added).

This passage, in its admonishment of the indigenous women who, left to their own devices, would simply sleep all day, establishes a clear hierarchy of power in the colonial household, with the white European woman as the master and black African women as her slaves. This hierarchy is evident in *Und wo der Wind weht* as well, when the female protagonist scolds her maid Albertine for her indolence and promiscuity, only to turn around and tell her readers that such behavior is to be expected, for "they [the Africans] are still very primitive people" (73). Throughout the novel, Höpker's narrator gossips about Albertine's domestic dramas, her readiness to accept gifts from men other than her husband (52, 67, 72), and the eventual termination of her labor contract based on the claim that she had become "horribly fat and lazy" (123). Such indictments of the native Africans for their alleged immorality and

idleness are clear examples of the "Discourse of the Cape." While the gossip aimed at white settlers is mostly playful (as in Spacks) and encourages the blurring of traditional gender boundaries, the gossip aimed at the natives (Coetzee's "discourse") is derogatory and demeaning, serving to keep the racial power structure in the colonies intact. Höpker's use of gossip in the narrative of both novels destabilizes, then redefines, male authority, yet it also reinforces the power of white Germans within the colonial space.

Heroic Tales: The Narrative Reestablishment of German Rule in Southwest Africa

Beyond noting how gossip functions in Höpker's novels to define white heroics as well as colonial power relations, it is important to examine the author's written reaction to historical events such as the Herero-Nama revolts of 1904–1907, the defeat of German colonial forces by the British during the First World War, and the subsequent decolonization of the 1920s and 1930s. The period in which Höpker wrote—from 1913 to the 1940s—straddles the colonial and postcolonial eras and thereby presents the author with the dilemma of how to represent the German loss of colonial power. Her solution to this dilemma is to revise history, depicting German colonizers first as victims of the Entente Powers, and then as ideal colonizers who deserve to have their power restored.[9]

The fictional twisting of historical failure into triumph is not a foreign act for German writers. As Susanne Zantop documents in her seminal study *Colonial Fantasies,* Germans began rewriting their ill-fated colonial ventures as far back as the sixteenth-century debacle of the Welsers in Venezuela. Despite the "black legend" that followed the Welsers' violent expropriation of the Venezuelan natives, Zantop writes, "the 'subtext' of failure was converted into, and contained by, an ultimately triumphalist fantasy" (29). This early fantasy attempted to shift the blame for bad colonial policy from the Germans to the Spaniards (24), and this blame shifting became almost essential to German colonial self-representation. While the sixteenth-century revisionist fantasy meant to demonize Spaniards and exonerate Germans, showing them to be "benign, superior" colonizers, the fantasy of the "postcolonial" (postwar) period was that of "past glory and imaginary restitution" (Friedrichsmeyer, et al. 24–25). This fantasy celebrates German colonizers of the early twentieth century not as "benign," but as strong, righteous, and heroic. They had exercised their authority decisively over the indigenous population and thus "deserved" to regain that authority.

This is the sort of revisionism that flows from Höpker's pen. In *Um Scholle und Leben,* she makes several moves to rewrite history. First, her narrator harshly criticizes the precolonial hierarchy among the indigenous inhabitants of Southwest Africa in order to establish Germans as superior colonizers. She offers the reader a short lesson in the history of *Südwest* before it became German, looking back in horror at the sadistic punishments that the ruling Herero enacted upon the enslaved native peoples, the Damara and the "Bushmen" (the Khoi-San):

> The Herero actually used to be the masters of the land before the Germans came. The Damara and Bushmen were their slaves and were oppressed and horribly mistreated. At the slightest mistake, or if the Herero were in bad humor, the slaves would either be crippled or beaten to death with a club. Quite often, the tendons in their feet would be severed to prevent them from running away. To this day the Bushmen and Damara still carry with them the fear of their former masters. For the Germans, who were their *liberators,* they had nothing but a solid sense of *respect* because, with the exception of the occasional *well-deserved* beating, they had nothing to fear from us (43; emphasis added).

In designating German colonizers as the "liberators" of the Khoi-San and Damara, this passage offers a clear indictment of Herero brutality and praise for German moderation. Instead of inspiring fear and trembling, the Germans gain the respect of the native subjects. After all, they are not nearly as excessive in their punishments as the Herero; Germans only dole out "well-deserved" beatings. Without denying the Germans' use of corporal punishment, the narrator hints that such moderate beatings are the most effective way to deal with an indigenous labor force.

Höpker's second revisionist move in *Um Scholle und Leben* is to rouse suspicion toward the colonial policies of the British by portraying their "indigenous politics" as inappropriate to the colonial setting (82). With British rule in Southwest Africa came laws forbidding corporal punishment of the native workers and proposing other, gentler forms of punishment such as short-term imprisonment (Sadji 254). This enlightened policy frustrated German settlers who had little time or patience for dealing with the British colonial police and tedious trial proceedings. Settlers such as Höpker's Fräulein Irmhoff viewed these policies as ultimately detrimental to the German farmers, for they deprived them of a crucial source of hard labor. Irmhoff claims:

> The situation with the natives was horrible. They were disobedient and lazy, and yet one could do nothing about it. Beatings were forbidden; the new government proclaimed that the blacks were

supposed to have the same rights as the whites.... Only *we* suffered if the black worker, whom we desperately needed for labor, was incarcerated for weeks or months, something that he did not even perceive as punishment. It was an awful time (82).

In this view, the western Enlightenment principles of justice and tolerance enforced by the British fail miserably in the colonial setting, revealing what Berman calls "the distance between Enlightenment and empire" (199).[10] Irmhoff posits the German settlers' use of immediate physical punishment as the more effective policy toward the "disobedient and lazy" indigenous workers, and she waxes nostalgic about "how wonderful it was during the German era" and "how much better the relations with the natives were" (112). "The black worker saw, in the German, his lord and master, and therefore one could work very well with him" (112). This evaluation, read alongside the above description of Germans as "liberators," praises German colonizers for setting up clear racial power structures and exacting swift and effective justice upon the natives.

Having set up the Germans as ideal colonizers, Höpker ends *Um Scholle und Leben* by invoking feelings of pity for the Germans, who were so unjustly stripped of their colonies. To do so, she portrays the narrator as deeply mourning the loss of the colonies and describes how the entire African landscape mourns with her. Irmhoff laments, "My beloved Fatherland defeated and trampled to the ground, and our beautiful Southwest lost! It was to be German no longer! I could not believe it. The entire bush was filled with sadness, the trees, the birds, all were mourning" (134). This passage is crucial, for it leaves the reader with the sense not only that the Germans were the true victims of colonial conflict, but also that their removal from power was unwanted (Wildenthal, *German Women for Empire* 173). It makes no mention, however, of the native peoples, such as the Herero, who actually suffered in such great numbers under German colonial rule (see Bley).

In Höpker's writings the Herero pose the most significant threat to German rule because of their past position of authority in Southwest African native culture. While in her early novel they are portrayed as brutal and sadistic in their actions toward their fellow Africans, in *Und wo der Wind weht* the Herero and the Bushmen "liberated" by the Germans become aggressive attackers who leave the German colonists no choice but retaliation. Two veteran colonists interrupt the female narrator to tell their stories of violent conflict with the natives—tales of heroic survival in a land that requires tough justice. Both tales go back

in time to the period of German rule, recounting the early days of colonial conquest in Southwest Africa.

The first narrative is told by "old Griesel," a German man whose family settled first in South Africa and then moved to *Südwest* when he was just a boy. Sitting in front of the campfire in the bush with the narrator and her husband as his rapt listeners, he spins a harrowing tale of his father's demise at the hands of a "Bushman" and the subsequent capture of his entire family and their livestock. Griesel's family is tied to trees and forced to watch in horror as the Bushmen slaughter their animals and hold a wild orgiastic festival around a fire. The captors are described as wild animals as Griesel recalls the Bushmen's feast:

> A great feast began. To heighten their pleasure, they stuck us with sharp sticks, hit us, and shot at us with small arrows. We were half-dead and crazed with fear and screamed miserably, which evidently pleased them even more. They sang and danced and drummed out rhythms until froth dripped from their lips (6).

A reader who is familiar with stories of the American Wild West or who has seen movies or sitcoms staged in exotic tropical settings will recognize Griesel's story as a stock fantasy: the restless, barbaric natives capture the poor, innocent white travelers and tie them to poles or trees in front of a blazing fire surrounded by more feasting, dancing natives. By using such a fantastic tale to portray the natives as sadistic and subhuman, Griesel is able to justify the end to his story: the white settlers' revenge.

Ultimately Griesel's family escapes and returns with reinforcements from the settler community. The white settlers—led by the young Griesel—ride out into the bush in search of the perpetrators. He recounts their act of merciless revenge with pride: "We found the Bushmen in a ravine, sleeping off their hangovers. We shot them all" (7). Griesel wants his listeners to believe that he and the other settlers were provoked by the Bushmen and that their violent retaliation was therefore justified. He achieves his desired effect, for after he finishes his story, the female narrator acts as if she has just heard a ghost story. Fearing another native ambush, she says, "I cast an uneasy glance around our circle.... I imagined a Bushman crouching behind every shrub" (7). Griesel's story confirms the narrator's distrust of the natives by offering an image of them as stealthy and brutal. However, it also contradicts the image of Germans as the Bushmen's respected liberators, and surely this massacre goes far beyond a "well-deserved beating." Instead, this narrative demonizes the Khoi-San and marks the German settler (in this case Griesel) as the heroic victor in a bloody encounter that ends in the

elimination of the native group, a scenario we find repeated in the second male narrative at the end of *Und wo der Wind weht*.

The second narrative is told by Blaudruck, a German colonizer who first came to Southwest Africa in 1903. Shortly after taking over his brother's store/saloon, Blaudruck is involved in a verbal scuffle with three Herero chiefs, to whom he refuses to sell alcohol. The Herero men threaten Blaudruck, and he orders his dog to attack, chasing them out of the store (165). In this story, efforts by the chiefs to challenge the racial hierarchy of the colony are answered with violence, meant to drive them out of "white" colonized territory. But the spurned Herero men have not been chased away for good; one of them returns for revenge in the middle of the night. Hiding under Blaudruck's bed, he surprises the German (another ambush!) and tries to strangle him. In "defense," Blaudruck picks up a piece of firewood and clubs the Herero over the head until he collapses (165–66). Not knowing whether the Herero is dead or alive, Blaudruck picks him up, dumps his body in the dunes outside, and returns to the bar to serve beer.

This brutal struggle between white and black men is punctuated at the end of the story by Blaudruck's mention of the Herero Revolt of 1904. He reminisces, "Shortly thereafter, the Herero Revolt broke out. I fought with [the German forces]" (166). Those who know the history of the Herero uprising know it as one of the most infamous conflicts in German colonial history, resulting in casualties on both sides. In response to the killing of 100 German men, mostly settlers and soldiers, the German colonial militia, let by General Lothar von Trotha, fought and defeated the Herero at the Battle of the Waterberg in August of 1904. Most of the Herero (men, women, and children) who did not fall in battle were driven into the Omaheke Desert, where they died of thirst and starvation. By the close of 1904, over 70% of the Herero population had perished.[11]

Blaudruck's mention of the Herero conflict, which some contemporary historians have defined as one of the first genocides of the twentieth century (Bley), turns his story into a miniature prelude to that debacle. Blaudruck elicits sympathy by describing how the Herero man ambushed him while he was sleeping, just as many white settlers were surprised by the Herero's stealth attacks on their farms (Bley 175–76). He dumps his victim in the dunes, leaving him for dead, an act that mirrors the abandonment of the Herero in the desert. Both the historical reality and the fictional narrative portray a cycle of violence that ends in the extreme, brutal retaliation of the Germans and the annihilation of the natives. By allowing both Blaudruck and Griesel to tell their stories, Höpker's narrative valorizes this brutality, holding it up as an example

of colonial heroics. Stepping temporarily into the background, the female protagonist acts as a listener and observer, a voyeur fascinated by the "sadistic male hero" and his bloody exploits against the indigenous Africans (Klotz 50).

Griesel and Blaudruck's narratives may allow male heroics to frame Höpker's second novel, but the female narrative that takes shape between them is a testament to the triumph of the *Farmersfrau*. It is important to note that both of the men's stories take place in the first years of the twentieth century, before most women had arrived in the colony (Chickering 175).[12] The bulk of the narrative, however, spans the interwar period and tells the reader that men were no longer the *only* heroes in Southwest Africa. Höpker's protagonist is nothing less than a woman warrior, traversing the landscape with ease, riding and hunting with the men, shooting antelopes at sunrise and trapping lions for sport (*Und wo der Wind weht* 42-43). Although the protagonist is a married woman, she does not only play the traditional role of housewife; it is she who travels alone to the nearest town to trade livestock and chickens while her husband stays home (55). More than Griesel or Blaudruck, she is admired by both men and women for her courage, and she shows no fear of battling the elements in a land of severe dust- and rainstorms (141). When she and her son are caught in a rainstorm that quickly turns into a flood, she gives him courage by comparing herself to one of German popular literature's best known heroes: "I grabbed his hand, and we faced the fight against the elements. And once I had told him that I was Old Shatterhand, and he was Big Snake, and we were both on the warpath, he felt much better" (115). By stepping into the popular masculine role of Karl May's Old Shatterhand, she presents herself as a hero and "supermom," usurping her husband's role as protector by leading her son to safety. Her son's primary educator, she becomes the model by which his development is measured, and she is instrumental in leading him through the transition from childhood to adolescence, when he plays a Teuton warrior in the Christmas play (111), and to young adulthood, when he is ready to take on the responsibilities of the farm (154). The narrator's evocation of Old Shatterhand—and thereby one of Germany's most popular authors—not only grants her heroic status but also marks the continued presence of German culture in Southwest Africa.

In Lydia Höpker's novels, the colonial space is one in which the settler woman can work her own farm, raise her own livestock, discipline insolent natives, and educate her family, community, and her readers in what it means to be a hero—or rather, a heroine. Justifying the violent conquest of African natives through Griesel and Blaudruck's

narratives in the second novel and lamenting the political loss of the colonies in the first, the settler woman's narrative in both novels portrays the farm as the imagined space of continued German rule and the woman farmer as rightful ruler. By the end of Höpker's second novel, which avoids any mention of the British colonial authority, the reader is led to believe that German power over the colony has been peacefully restored, and that the *Farmersfrau* is the agent of that restoration. In direct contrast to the scene of mourning in the post-World War I colony in *Um Scholle und Leben,* the end of *Und wo der Wind weht* offers the reader a glimpse of a German colonial farm idyll. As the female Old Shatterhand and her family ride back to their farm, they marvel at its lushness and fertility, a product of their labor and exquisite domesticating talents. The narrator gushes, "How lovely it was to sit at home...to breathe the fragrant air, and hear the singing, humming, and croaking. Frogs, birds, and beetles sang: how lovely is *our home!*" (171). By focusing on the farm as the locus of German culture, Höpker takes on the task of "reconstructing [a] German colonial [community] that had been uncoupled from German rule" (Wildenthal, *German Women for Empire* 7). Her novels open up a narrative space that allows the German settler woman to cross traditional gender boundaries, keep the men of the colonies as her comrades, and rebuild the foundations of German colonial power with her patriotic fortitude.

Notes

My sincere thanks to Katrin Sieg, Katharina Gerstenberger, William Rasch, and the editors of the *Women in German Yearbook* for their helpful commentary on various versions of this essay. Unless otherwise noted, translations from the German are my own.

[1] Works by settler women include Clara Brockmann, *Die deutsche Frau in Südwestafrika: Ein Beitrag zur Frauenfrage in unseren Kolonien* (Berlin: Mittler, 1910) and *Briefe eines deutschen Mädchens aus Südwest* (Berlin: Mittler, 1912); Margarethe von Eckenbrecher, *Was Afrika mir gab und nahm: Erlebnisse einer deutschen Ansiedlerfrau in Südwestafrika* (Berlin: Mittler, 1907); Helene von Falkenhausen, *Ansiedlerschicksale: Elf Jahre in Deutsch-Südwestafrika, 1893–1904* (Berlin: Reimer, 1905); Else Sonnenberg, *Wie es am Waterberg zuging: Ein Beitrag zur Geschichte des Hereroaufstandes* (Braunschweig: Wollermann, 1906). Between 1908 and 1914, the Women's League of the German Colonial Society sent 561

unmarried women to German Southwest Africa, five times the number sent between 1898 and 1907 (Wildenthal, *German Women for Empire* 163).

[2] I take the term "wide open spaces" from John K. Noyes. In his 1992 article "Wide Open Spaces and the Hunger for the Land: Production of Space in the German Colonial Novel," Noyes demonstrates how German colonial literature portrays the African landscape as empty and therefore open to German colonization and control. The novels of the colonial period, he postulates, serve to produce space in the mind of the reader, an uninhabited space that welcomes German habitation and domestication. For the domesticating role of German women, see Wildenthal (*German Women for Empire* 168) and Klotz (4–5).

[3] Klotz writes, "the empowered position of the white woman is slowly eroded in the years following Germany's loss of the colonies, as the role of the male community gains importance, eventually coming to eclipse the importance of white women within the colonial narrative altogether" (64).

[4] *Um Scholle und Leben* appeared in three editions. The first was the 1927 version, published in Minden in Westfalen, and a second revised edition was published under the title *Als Farmerin in Deutsch-Südwest: Was ich in Afrika erlebte* (As a Woman Farmer in German Southwest: What I Experienced in Africa) in 1936. A new edition of that second version was recently published by Höpker's granddaughter, Edna Will, in 1995, and carries a title that combines those of the two previous editions: *Als Farmerin in Deutsch-Südwest oder Um Scholle und Leben*. In the foreword to this new edition, Will claims that she published the text exactly as her grandmother wrote it, with the exception of changing the names of certain towns that had been fictionalized by the author. Höpker's second novel, *Und wo der Wind weht: Ein heiteres, buntes Buch aus dem südwest-afrikanischem Busch* (And Where the Wind Blows: An Exciting, Colorful Book from the Southwest African Bush), the manuscript of which was discovered by Will, was first published in 1994. I used the most recent editions of both texts for my research.

[5] In his survey of German colonial literature, Joachim Warmbold cites the years between 1918 and 1945 as the "main creative period" for colonial writers, noting that this was also a time in which the (non-existent) colonial project remained virtually uncontested by the German people. See also Klotz (21) and Wildenthal (*German Women for Empire* 172).

[6] Biographical information on Höpker comes from an excerpt from the "Heimatkalendar 1975," which Edna Will includes in the most recent edition of the novel.

[7] My insistence on the playful nature of some gossip differentiates my work from that of O'Donnell, who describes all colonial gossip as derisive in tone.

[8] The "hybridization of gender" surfaces in *Um Scholle und Leben* as well, with the character of "Mister Kakadu." Although he is criticized at the beginning of the novel for his lack of talent as a hunter, the settler Amandus Degenkolb eventually makes the transition to colonial life. As Fräulein Irmhoff gossips about old friends with her neighbor Herr Ralph, she learns that "Mister Kakadu was now an able hunter who brought home quite a few antelope bucks. He was also *a girl of all trades,* raising the children, helping with the laundry, making sausage, shining shoes, tilling, rocking the baby to and fro, and singing it to sleep" (103; emphasis added).

[9] For the German colonists' view of themselves as victims of World War I, as well as their fantasy of the restoration of colonial power, see Wildenthal (*German Women for Empire* 173-74).

[10] Höpker's critical portrait of the British colonizers as inappropriately mild in their treatment of the indigenous Africans stands in contrast to their depiction as brutal and inhumane in the fascist German colonial films of the 1940s. See Sabine Hake's "Mapping the Native Body: On Africa and the Colonial Film in the Third Reich" (Friedrichsmeyer, et al. 163-87).

[11] The information on the Herero Revolt was derived from a variety of sources, most notably from Bley (149-50) and Wildenthal (*German Women for Empire* 94-95).

[12] See note 1. In 1901, for instance, there were only 100 German women to the 1,763 men living in Southwest Africa (Gerstenberger 77).

Works Cited

Benninghoff-Lûhl, Sibylle. *Deutsche Kolonialromane 1884-1914 in ihrem Entstehungs- und Wirkungszusammenhang.* Bremen: Übersee Museum, 1983.

Berman, Russell A. "Colonial Literature and the Emancipation of Women." *Enlightenment or Empire: Colonial Discourse in German Culture.* Lincoln: U of Nebraska P, 1998. 171-202.

Bley, Helmut. *South-West Africa under German Rule 1894-1914.* Tr. Hugh Ridley. Evanston: Northwestern UP, 1971.

Brockmann, Clara. *Briefe eines deutschen Mädchens aus Südwest.* Berlin: Mittler, 1912.

Chickering, Roger. "'Casting Their Gaze More Broadly': Women's Patriotic Activism in Imperial Germany." *Past and Present* 118 (Feb. 1988): 156-85.

Coetzee, J.M. *White Writing: On the Culture of Letters in South Africa.* New Haven: Yale UP, 1988.

Eckenbrecher, Margarethe von. *Was Afrika mir gab und nahm: Erlebnisse einer deutschen Ansiedlerfrau in Südwestafrika*. Berlin: Mittler, 1907.

Friedrichsmeyer, Sara, Sara Lennox, and Susanne Zantop, eds. *The Imperialist Imagination: German Colonialism and Its Legacy*. Ann Arbor: U of Michigan P: 1998. 1–29.

Gerstenberger, Katharina. "The Autobiography of a White Woman: Margarethe von Eckenbrecher's Colonial Memoir." *Truth to Tell: German Women's Autobiographies and Turn-of-the-Century Culture*. Ann Arbor: U of Michigan P, 2000. 64–99.

Hake, Sabine. "Mapping the Native Body: On Africa and the Colonial Film in the Third Reich." Friedrichsmeyer, et al., 163–87.

Höpker, Lydia. *Als Farmerin in Deutsch-Südwest oder Um Scholle und Leben*. 3rd ed. Otavi: Edna Will, 1995.

——. *Und wo der Wind weht: Ein heiteres, buntes Buch aus dem südwest-afrikanischem Busch*. Swakopmund: Peter's Antiques, 1994.

Klotz, Marcia. *White Women and the Dark Continent: Gender and Sexuality in German Colonial Discourse from the Sentimental Novel to the Fascist Film*. Ann Arbor, UMI, 1995.

Mamozai, Martha. *Schwarze Frau, weiße Herrin*. 2nd ed. (originally published under the title *Herrenmenschen* in 1982). Reinbek bei Hamburg: Rowohlt, 1989.

Noyes, John K. "Wide Open Spaces and the Hunger for Land." *Faultline: Interdisciplinary Approaches to German Studies* 1 (1992): 103–17.

O'Donnell, Krista Elizabeth. *The Colonial Woman Question: Gender, National Identity, and Empire in the German Colonial Society Female Emigration Program, 1896–1914*. Ann Arbor: UMI, 1996.

Sadji, Amadou Booker. *Das Bild des Negro-Afrikaners in der Deutschen Kolonialliteratur, 1884–1945: Ein Beitrag zur literarischen Imagologie Schwarzafrikas*. Berlin: Reimer, 1985.

Spacks, Patricia Meyer. *Gossip*. New York: Knopf, 1985.

Warmbold, Joachim. *Germania in Afrika: Germany's Colonial Literature*. New York: Peter Lang, 1989.

Wildenthal, Lora Joyce. *German Women for Empire, 1884–1945*. Durham: Duke UP, 2001.

——. "'She is the Victor': Bourgeois Women, Nationalist Identities, and the Ideal of the Independent Woman Farmer in German Southwest Africa." *Society, Culture, and the State in Germany, 1870–1930*. Ed. Geoff Eley. Ann Arbor: U of Michigan P, 1996. 371–95.

Zantop, Susanne. *Colonial Fantasies: Conquest, Family, and Nation in Precolonial Germany, 1770–1870*. Durham: Duke UP, 1997.

Searching for Missing Pieces around Us: Christa Wolf's *The Quest for Christa T.* and Ingeborg Drewitz's *Who Will Defend Katrin Lambert?*

Michelle Mattson

How do Christa Wolf's *The Quest for Christa T.* and Ingeborg Drewitz's *Who will Defend Katrin Lambert?* construct female characters who in different ways oppose models of social participation dominant in their respective states? The two authors test the related tensions within the individual between wanting to fulfill one's social responsibilities, wanting to respond to the demands that society lays before us, while nonetheless resisting institutionally driven identity constraints and destructive expectations of conformity. In order to rethink the two main characters here, this article works with the concept of an "audit self" from recent scholarship in feminist theories of autobiography. (MM)

Both Christa Wolf's *The Quest for Christa T.* (first published in 1968) and Ingeborg Drewitz's *Who Will Defend Katrin Lambert?* (1974) focus on how a first-person narrator attempts to understand the life and death of a female acquaintance. Both narrators seek answers to the questions that the two women have left behind. Both authors frame their questions and their tentative answers with reference to the individual's place within a number of interlocking social communities and within history more generally. Wolf and Drewitz went on after these novels to explore such issues far more explicitly and more extensively.[1] The earlier texts, however, give us an opportunity to watch them probe these issues in a much more limited format.

This article examines how Wolf and Drewitz construct characters (both the narrators and Christa T./Katrin Lambert) who find themselves in different ways in opposition to models of social participation dominant in their respective states. They sketch out the tensions that obtain between the individual's attempts at self-determination and society's

efforts to define her in such a way as to fulfill certain interpersonal and/or social functions. They also test the related tensions within the individual between wanting to fulfill one's social responsibilities, wanting to respond to the demands that society lays before us, while attempting nonetheless to resist institutionally or externally driven identity constraints and overly destructive expectations of conformity. In other words, these two works lay out the struggle that women in both German states faced to set the parameters of their own selves, while simultaneously giving into and resisting society's attempts to frame them within a particular social landscape.

Needless to say, Wolf and Drewitz addressed these issues at a specific historical juncture. Both wrote after the pressing difficulties of the immediate post-war years had been surmounted and after the Wall had divided what seemed to be irreconcilably different socio-political realities. On the other hand, they were writing as both societies tried to develop a sense of permanence (itself to prove illusory) or some level of self-assuredness. In order to return to these works more than ten years after unification, we need to keep present before us the ways in which the period they portray no longer exists. Nonetheless, we can examine both novels with an eye to the ways in which society co-constructed the female self at this time, and we can do so using theoretical approaches that have developed at least partially as a way to understand the dynamics of identity construction in our historical present.

Christa Wolf's *The Quest for Christa T.* has been read through innumerable interpretive filters.[2] In this article, I highlight the ways in which early GDR society managed the creation and maintenance of "audit selves,"[3] that is, public selves that are categorized by type and function. I am borrowing this term from recent feminist work in autobiography theory. This new research allows us to shed a different light on these two texts and to glean new insights into how they lay out the ways in which external identity constraints create certain performance expectations that individuals may or may not be able to fulfill.

A Brief Comparison

Christa Wolf's novel takes place within a specific context: a young state premised on achieving common and equitable prosperity requires every individual to contribute to that goal. Such a society offers a limited number of possible social roles and essentially requires individuals to select one. Christa T. cannot come to terms with the spectrum of choices or expectations, even though she wishes to do so. When she considers what the world needs to become perfect, she secretly clings to

the hope that she can play that role (57). Early on, the narrator tells us, Christa T. actively questioned what the changes in society meant, and what would be needed to achieve them: "The new man, she heard people say; and she began to look inside herself" (56). We thus become familiar with a character who is eager to meet a new society's demands for everyone to participate, but who ultimately cannot successfully negotiate a space for herself within the boundaries set by that society.

In many ways, Drewitz's *Who Will Defend Katrin Lambert?* represents a refiguring of Wolf's narrative premise within a West German, explicitly capitalist framework. Drewitz's work appeared six years after the East German publication of *The Quest for Christa T.* and three years after the first West German edition. It recast the title character within a society in which individuals learn to focus primarily on their own goals, their own interests, and what they personally gain from their actions and the actions of the people around them. At the same time, Drewitz confronts her disparate cast of characters with a figure, Katrin Lambert, who seems to live almost solely for others. Indeed, one of her acquaintances tells the narrator that near the end Katrin had virtually no sense of self left, a circumstance others exploited to meet their own needs (100).[4]

In contrast to Christa T., Katrin is not engaged in a struggle to preserve a sense of self and space for individual self-development in the face of a state philosophy that seeks to subordinate the needs of individuals to the needs of state formation. Rather, Katrin herself tries to instill in the people around her a sense of responsibility for others. In this novel the emphasis is still mainly on local influences (i.e., family, friends, community members), but readers will find here the beginnings of Drewitz's interrogation of individual responsibilities and her attempts to see how they include ever-broader overlapping groups. Novels such as *Yesterday Was Today* (1978) and *Ice on the Elbe* (1980) were in many ways devoted to mapping out numerous layers of individual responsibility in the late twentieth century. In a sense, *Who Will Defend Katrin Lambert?* represented for Drewitz a first foray into this area from a woman's perspective, since it was her first published novel to center on two female protagonists, and initiated a series of novels in which the perspective of women on the issues of individual responsibilities took on increasing importance. As such, it marked an important turning point in Drewitz's oeuvre, one that also revealed heightened sensitivity to gender-related issues.

Drewitz's Katrin Lambert is considerably older than Christa T.. She has two adult children, works as a social worker who focuses on troubled youth, and is a person whose capacity for empathy and giving

leads others to feed off her emotionally. The narrator, who knew Katrin Lambert only from one year together at school, is a successful journalist who leads a solitary, emotionally distanced life. Instead of dying from leukemia, as did Christa T., Katrin Lambert drowns after falling through thin ice. No one is really sure whether her death was intentional or an accident, and of course, the novel never resolves that question either.[5]

Feminist Theories of Autobiography and Audit Selves

Recent feminist work on autobiography theory by Carolyn Steedman, Liz Stanley, and Mary Evans led me to revisit the constitution of the self in these works.[6] Their work offers a productive new angle from which to approach these two novels. However, a word of caution here is necessary: although *The Quest for Christa T.* has been read autobiographically,[7] I am not interested in pursuing the work in this way. Drewitz's novel is also not an autobiography, and may be one of the least autobiographical of her works that focus on female protagonists. However, theories of autobiography deal quite directly with the configuration of selves—specifically with the many selves individuals try to draw together. Furthermore, the theories from which I draw here are not about more traditional, literary autobiographies, but rather about a number of very different autobiographical practices. Taken together, Stanley, Steedman, and Evans refocused my view of *The Quest for Christa T.* and *Who Will Defend Katrin Lambert* to see how society at large and specific individuals constrain the self-generation and self-representation of the two main characters.

Steedman's article "Enforced Narratives: Stories of Another Self" draws attention to the fact that work on autobiography has traditionally viewed it as a voluntary, self-generated written account of an individual's life. In contrast to the more intentional, traditional autobiographies studied by scholars of autobiography, recent archival discoveries have uncovered early autobiographical accounts that were generated within an institutional context and required of the individual a highly specific rendering of their lives. Although the accounts Steedman examined arose out of an interview format, the voice of the interlocutor is routinely suppressed, as is the way the questions then predetermined the account an individual gave of him or herself. Thus, the autobiographical self is one that emerges from the questions posed to the "speaker." In such a context, both the voluntary aspect of autobiography as well as the spectrum of information the autobiographical material provides are severely limited by institutional contexts.[8]

Stanley's "From 'Self-Made Women' to 'Women's Made-Selves'? Audit Selves, Simulation and Surveillance in the Rise of Public Woman" also examines how institutional demands force individuals to make themselves accountable for their lives according to quite rigid criteria. Examples she uses are the academic curriculum vitae, performance evaluations in other work-place settings, and applications for employment. All of these represent autobiographical practices, but they do not give the individual significant space for variation and creativity in self-representation: what the institution wants to know, it finds out. What it does not care about does not officially exist.

Stanley emphasizes here that institutions use "audit selves" as "publicly created profiles" against which individual behavior is measured and predicted (48). Although we will return to the significance of this for Wolf and Drewitz shortly for further elaboration, a few things are worth noting at this point. Stanley stresses the connection of audit selves to the growing presence of women in the public sector and the increasing intervention of institutionally driven organizational efforts to structure society that have an impact on both men and women. Certainly, one could argue that women's roles in the public sphere began to grow around World War I. However, it was not until the advent of the second women's movement in the 1960s and 1970s that women entered and stayed in the work force in large numbers.[9] Of course, women's social options were monitored by any number of institutions prior to this, but institutional oversights changed considerably once women became a regular part of the labor force. At this point, the presence of women in the public arena came under standards of accountability and performance that opened up new areas for women to explore, while at the same time placing (or, one could argue, maintaining) serious constraints on personal behavioral choices.

Finally, Evans' work on Sylvia Plath's *The Bell Jar* lays out how the historical standards of autobiography as genre have imposed certain pressures on people, particularly women, and how they represent themselves publicly. Autobiography, in its more traditional manifestations, presented a self that was autonomous and wholly formed. Evans looks at how Plath's autobiographical novel multiply refracts the self. In doing this, Plath refuses to present a finished public self to her readers. Evans discusses also how Plath's protagonist, Esther, struggles to achieve a publicly recognized self, only to discover that "the costs of maintaining an appropriate self can be overwhelming and...debilitating. These costs are made greater since the self to be maintained is not one which is voluntarily chosen, but at least in part imposed by an external culture" (84). Similarly, albeit in different cultural contexts, Wolf and Drewitz

examine how women in the post-World War II era try to meet the new public demands that society brings to them and what costs their efforts entail.

While their work helps us to understand the constraints of self-presentation for women, Evans, Steedman, and Stanley all remind us that self-description is at best partial, and potentially a wholly inadequate means to understand an individual. In the case of *The Quest for Christa T.,* the reader sees the narrator's explicitly self-conscious portrait of Christa T., some of Christa T.'s own thoughts, and the many ways in which GDR society tried to mold her into a functioning, acceptable member of society. In order to see how the individual emerges at the points of tension between these aspects of Christa T.'s and the narrator's lives, the reader must mediate among the various levels of performance expectations. Drewitz's novel, which rarely gives Katrin herself a voice, probes—through the people she left behind—the way Katrin is eventually destroyed by her efforts to respond to the needs of those around her. Her well-developed sense of moral responsibility in its various nuances fails to protect her adequately from the energy-draining demands that caring for others can entail.

The Quest for Christa T.

One approach to this work would be to rethink the character of Christa T. as not representing a person, but rather as part of an inner dialogue or a confrontation between two conflicting theories of the individual's place and/or function in society, his or her obligations to society and society's obligations to the individual.[10] However, Liz Stanley's theory of "audit selves" allows us to read *The Quest for Christa T.* through a slightly different lens—particularly Christa T.'s exhausting search to find a social role she felt she could fulfill both satisfactorily as well as willingly. Structurally, the work can be seen as part of the process of social surveillance through which audit selves are monitored and evaluated by society. The main character does not tell her own story. Instead, the narrator draws from her own memories, the thoughts and judgments of Christa T.'s friends and acquaintances, and to a marginal extent from the papers Christa T. left behind. Through these pieces the narrator fits together a portrait of Christa T. that she wishes to present to the readers as a particular kind of model.

Stanley's "audit self" is a socially imposed definition of identity as well as an evaluative judgment on how well a certain individual fits that imposed definition. However, when the reader first encounters her, Christa T. has not yet given in to seeking approval from others. In fact,

while still a school girl, Christa T. demonstrates a kind of serene disregard for society's expectations and an enviable spontaneity. The narrator tells us that Christa T. is not particularly interested at first in becoming part of the in-crowd: "She didn't go out of her way to find a welcome, friendly or unfriendly. She wasn't interested in being accepted. We didn't interest her 'excessively'" (8). Furthermore, it is Christa T.'s trumpet call that fascinates the narrator because it comes so unexpectedly, so completely out of context (18). At that point, the narrator intuits, rather than grasps consciously, what such spontaneity might mean for society: she seeks to be near a person capable of behaving unexpectedly and without any immediate mission.[11]

In the founding years of the GDR, however, Christa T. is eager to contribute to creating a more just society and frustrated by her own inability to choose a social path that would allow her to do so, something most of the people in her environment seem able to do without much consideration: "One didn't spend much time reflecting, one virtually fished out a life for oneself, without looking, hardly ever asked if it suited oneself, simply lived it, and so it came to suit one. That was what one thought as time went by, anyway" (41-42). In contrast, Christa T.'s efforts to find her path are vague and never convincing—either to her or to her circle of acquaintances. Her inability to choose a socially recognized and sanctioned public role meets with dissatisfaction. Even those who admire her disapprove of her inability to be "useful" to society. Of Günter the narrator states:

> He may in those days already have admired her as an individual; there are several indications of this; but he couldn't get along with her as a type. He believed too steadfastly that everything in existence had to be useful; and he was tortured by the question why an invention like her had to be necessary—though she had "all the makings," as he himself admitted (86).

Christa T. fails to be useful within a state/social philosophy that demands that the individual further the development of the nascent state—albeit in the name of a social utopia.

In a structurally more traditional bourgeois society, Christa T.'s decision to become housewife and mother would have been seen as the epitome of social usefulness, but when society began to allow and, in the case of the GDR, even to demand women's participation in the public sphere, the definition of "socially adequate" changed drastically. With regret Christa T. resists the state's demands of her, but is torn by society's rejection and her own sense of inadequacy.[12] Rainer Nägele

lays out the situation in reference to a part of the text that cites the *Merseburger Zaubersprüche*:

> If...the magical formulas of liberation and unification are relevant for both the sociopolitical body of the newly founded state and for its individuals, the parallel desires are at the same time in conflict with each other: the liberation and unification of the political body restrains that of the individual and demands their splitting as specialized functional members of the socioeconomic body (254).

Christa T. does not know how to fit into a society that expects people to fulfill a specific function. Furthermore, in Christa T.'s inability to answer the question "what do you want to be?" there is an opposition to a functionalist approach to the individual's responsibility in society: one is a teacher and teaches, one is a doctor and heals, etc. Although she tries to meet these expectations, ultimately she does not trust such designations:

> She didn't trust these names, oh no. She didn't trust herself. She was doubtful, amid our toxic swirl of new name-giving; what she doubted was the reality of names, though she had to deal with them; she certainly felt that naming is seldom accurate and that, even if it is accurate, name and thing coincide only for a short time. She shrank from stamping any name on herself, the brand mark which decides which herd you belong to and which stable you should occupy....
>
> What are you going to be, Krischan? A human being? Well, you know... (35).

As Myra Love (91) points out, it is not the idea of serving society that troubles Christa T., but rather the inadequacy of such terms to grasp the individual adequately and the way they force individuals into functional straightjackets. They may allow society to "herd" its members into clearly delineated collectives, but they seldom bear any meaningful relation to the individuals so designated.

Even the narrator, a self-defined close friend, feels compelled to redefine "publicly useful" in order to redeem her friend from social condemnation.[13] She admits that she has undertaken her project because she has the feeling that Christa T. is rapidly disappearing from their emotional grasp, insisting at the same time, "Because it seems that we need her" (5). Although she argues that her very unexemplariness is what makes her a worthy example, she also concedes at every turn the power she has over Christa T. as the author of her narrative. Love makes this point somewhat differently by suggesting that GDR society needs Christa T. because she represents the power of fantasy to break up

reified thought (74). Ultimately, the narrator, just like the society around her, wishes to construct a socially useful identity for Christa T., whereas Christa T.'s own efforts toward self-definition remain hasty, fragmented, and/or incomplete (38). In various ways, GDR society, the narrator, and Christa T. herself all try to make her into an individual who responsibly serves the interests of society.

The experiment does not seem to have succeeded during her lifetime, which highlights again the tensions Mary Evans (among others) says women have faced upon their entry into public life. Paraphrasing Evans, we can say that "women in the twentieth century have been increasingly expected" to present "their own experiences as the record of the actions of autonomous individuals, and claim for themselves characters with the self-determination which had hitherto been largely the preserve of men" (78). Christa T. recognizes—at least for herself—that the self will not fit into such neat categories. Nonetheless, in society's audit of Christa T.'s performance along these lines, she is found to be deficient, which in turn creates the tension for which, one could argue, leukemia becomes the energy-sapping symbol.

Who Will Defend Katrin Lambert?

Drewitz's Katrin Lambert never withdraws to the private world of the family from her public efforts to be socially useful. In fact, she returns from the US to Germany after the war because she feels she is needed there (74). In her professional capacity as a social worker and her personal role as friend, wife, and mother, she devotes all of her attention to helping others. She preserves very little private space in which to meet her own needs. Indeed, her home—the space of the private self—becomes the site for public gatherings to discuss current social and political developments.

The narrator, on the other hand, has led a secluded, emotionally distant life, devoted to being a successful journalist.[14] Given how frequently she questions "what does that have to do with me," while she gets more and more involved in Katrin's story, one can assume that her primary motivator in life to this point has been the benefit she sees for herself in any particular course of action. As she goes about investigating Katrin's highly ambiguous death, she finds herself unexpectedly drawn into the needs of those people around Katrin who had both depended on her and exploited her willingness to help.[15]

Although she is in many ways a very different character from Christa T., Katrin, too, ultimately suffers from a self-chosen, but externally enforced, audit self. The structure of the novel itself reinforces this

idea, since here the reader really does have access only to what other people say about Katrin. In other words, the novel never gives the title character the opportunity to "speak herself" or to propose alternate readings of her behavior and motivations. Katrin Lambert represents essentially a collage of fragments packaged and mediated through the figure of the narrator. This might allow us to see the packaging process itself as equally central to the novel as Katrin's attempts to re-envision West German society's grasp of individual responsibility. Applying Stanley's notion of an audit self would then make possible a reading of Katrin's character through the way it functions in and is evaluated by society.

Self-sacrifice for others is generally not high on a capitalist society's list of profitable (and therefore desirable) public social roles. However, when it occurs, society is very eager to embrace it as quasi-exculpatory evidence of capitalism's ultimate humanistic superiority. An interesting side effect of this is that Katrin's acquaintances and colleagues often misread her as a communist because of her devotion to the public good. Occasionally, individuals from Katrin's personal and professional life acknowledge that their interactions with her were driven solely by their own needs, but such a recognition never prompts any one of them really to change the way they interact with the world. They all take advantage of her willingness to serve, but choose not to emulate her. The function of caregiver is thus exploited, but not socially elevated. Moreover, she is in the end evaluated as "weak." Her colleague at work considers her to be "too idealistic" (11), simply expecting too much from people. Her former foster parents try preventatively to ward off their own criticisms of Katrin by repeating several times "Katrin wasn't a bad person" (23, 32), while Falkenstein, her ex-husband, views her as very vulnerable (77).

Robby, one of Katrin's "cases" as a social worker, also recognizes the ways in which society expects us to be certain things, to serve certain social functions: "You all want to control me, make me useful, a beast of burden, socially acceptable..." (65). Robby, however, provides additionally an example of the ways in which people resist the imposition of an unaccepted audit self. His particular resistance to society's efforts finds expression in violence against those who have tried to help him. First he sets the group home in which he lives on fire, then he tries to rape Katrin the night before she dies. Katrin, too, ultimately rebels, but her frustrations—however she might have defined them—seek release in self-destructive behavior: her decision to go out on the ice is deliberately risky.

One could sum up Katrin's life philosophy as follows: "when someone is in trouble, one's own self doesn't count at all" (147). She

exemplifies the self-sacrifice of an unreflected ethics of care. Her untimely death, on the other hand, points to the problems inherent in early articulations of care ethics among feminists, and highlights some of the tensions that arise when definitions of self-worth are overly reliant on the satisfaction that comes from serving others. Because care ethics was a dominant model in feminist ethics early on and because Katrin Lambert to a great extent embodies both the ideals and potential pitfalls of an ethics based on care, it is worth indulging in a brief excursus on the response to care ethics among feminists to explore its relevance to Drewitz's *Who Will Defend Katrin Lambert?*

In her introduction to the volume *Feminist Ethics,* Claudia Card describes the earliest efforts in feminist moral theory as based largely on those experiences women felt previous moral theory had left out—namely, the experiences of women, children, and other social groups whose autonomy society restricts in a variety of ways and for a variety of reasons (3-34).[16] One of the prominent representatives of care ethics is Nell Noddings, whose book *Caring* followed feminists such as Carol Gilligan and laid out an ethics based on the principle of caring.

Along with many other feminist ethicists, Noddings feels that ethical theories have traditionally been rule-based, i.e., dicta based on abstract situations and then universalized to apply in any similar situation. She sees such ethical systems as representative of the "language of the father," within which the mother's voice is largely silenced.[17] She proposes instead an ethics based on caring, which is an act (single, continuous, or serial) carried out by the "one-caring" and received by the "cared-for." This is not the place for an extensive discussion of Noddings's work; rather, I wish to highlight only those aspects of her care ethics that apply to Drewitz's novel.

While Noddings suggests that caring must have both an agent and a recipient, the emphasis is almost exclusively on the one-caring. In fact, the moral worth of the "one-caring" is measured by the reception of care in the cared-for: "How good *I* can be is partly a function of how *you*—the other—receive and respond to me" (6). The only sense of reciprocity is, however, an acceptance of the caring by the cared-for. Thus, a sense of self-worth and social approbation for the one-caring depends almost entirely on external validation. Caring involves for Noddings not just an orientation toward the other, but an actual move away from self (16). She writes: "Our attention, our mental engrossment is on the cared-for, not on ourselves" (24). Although the reader learns actually relatively little about Katrin Lambert as an individual, her actions would seem to converge almost entirely with Noddings's notion of a person directed toward, or "engrossed" (to use Noddings's own terminology)

with the care of others. In the end, however, Katrin self-destructs. Drewitz's novel in essence, then, prefigures some of the concerns feminist critics of care ethics raised about theories of caring like Noddings's.

Feminists building on these early contributions quickly became suspicious of what seemed to them efforts to found a moral theory on the basis of supposed feminine characteristics. Thus, theorists writing after Gilligan and Noddings, for instance, insisted that making the mother-child relationship the basis of reflection on moral theory not only perpetuated the patriarchally sanctioned definition of woman as mother, but also tended to exclude from consideration relationships that do not conform to that model.[18] Some feminists attempt to revise the caring model in order to eliminate the essentialist tendencies they see in it. Others reject care as the fundamental guiding concept of ethics.

Sarah Hoagland, for example, argues for a care ethics, but divorced from the mother-child relationship. She finds such a care model too uni-directional to be useful for most human relationships (249). Hoagland also insists that the parent-child model is a "diminished caring relationship" because of the differing levels of understanding and participation between the parent and the child and because the ultimate goal in the parent-child relationship is to wean the child of dependence on the adult. The very transitory character of the relationship thus makes it difficult to apply beyond the parent-child dyad. Furthermore, the mother-child or parent-child relationship can tend toward justifying inequality in a relationship both because of the child's inability to care for itself as well as because we tend to value and stress the inequality of abilities between different individuals (250).

Katrin Lambert's approach to the people around her is to offer essentially unequivocal support. In the process, her own needs are suppressed by herself and ignored by those around her. Katrin's children, Knut and Monika, never manage to get beyond the uni-directional care model of mother-child. Only after her death do they even begin to realize that their mother might have needed them as much as they needed her. When considering her relationship to her own children, Monika regrets the distance that grew between Katrin and herself. She says, "Maybe she finally needed me, and I wasn't willing" (53). Knut, too, eventually considers that his mother was not there simply to respond to him, "And maybe she needed me in that moment" (173). The potentially uni-directional nature of care ethics in Katrin's case has left her drained and lonely.

Katrin's connection to the troubled Robby would seem to offer a perfect example of how inadequate and potentially harmful an over-reliance on care ethics can be.[19] Robby rebels against the efforts of those

around him—including Katrin—to mold him into a particular type of individual. Although already a young adult when Katrin meets him, he feels she treats him like a child at best, a servant at worst. The imbalance of their positions, which is one of Hoagland's criticisms of early models of care ethics, leads to a growing sense of disenfranchisement and resentment in Robby. Both Robby's decision to strike out at Katrin with physical force and Katrin's subsequent decision to risk her life on thin ice support the notion that Drewitz ultimately comes to reject Katrin's particular model of ethical responsibility. While Drewitz continues to explore the different relationship women have to the world around them, her subsequent novels reflect the understanding that one cannot adequately fulfill one's moral responsibilities while denying one's own needs. In a very real sense the novel questions the effort to export domestic models of behavior into the public sphere and challenges the benefits of such a caregiver model to self-development.

In fact, Katrin's self seems overly dependent on the way the people around her respond to her efforts to help. Gerhild Brüggemann Rogers has argued that Katrin's character becomes increasingly clear as the narrator moves through her interviews with Katrin's family, friends, and associates (38). I would argue, instead, that what becomes clearer in the course of the interviews is the way that an "audit self" can come to dominate an individual's self-understanding, and can thereby limit (perhaps even eliminate) the space an individual has for resistance or for self-production. Furthermore, this dynamic becomes intelligible in the late 1960s and 1970s when women became ever more important contributors to public life in Europe and the United States—precisely the moment at which Drewitz's Katrin Lambert and Wolf's Christa T. enter the public arena.

Narrators and Narrative Structure

Unlike Christa T. and Katrin Lambert, the narrators of both Drewitz's and Wolf's novels represent a potentially successful balancing act between an audit self and self-production. Wolf's narrator has found a social role for herself with which she seems to be comfortable. Evelyn Westerman Asher goes so far as to argue that "[t]he self-actualization...that is denied Christa T. in her own time is thus realized in her narrator, and by extension, the author, who would in her own life and work appear to be the true heir to both" (245). Of course, Wolf's narrator has also had the benefit of critical distance to the process of social surveillance and audit. She is, further, aware of the possible consequences when a society attempts to close off the venues of self-creation

in the name of an ideologically driven social program. Drewitz's narrator, positioned as she is at first outside of the network of relationships Katrin had developed, may be in a better position to resist the ever-increasing needs those around her want her to fill. On the one hand, she recognizes that the people from Katrin's life rely on her more and more, and she seems willing to be responsible to them. On the other, since she does not share Katrin's exclusive emphasis on others, she may have the necessary emotional distance to accept these new responsibilities without the potential for what in Katrin's case literally becomes self-sacrifice.

We must now examine how the larger differences in the social philosophies of East and West Germany necessitated a different relationship between the narrators of the two works and the objects of their reflections. The dominant social ideologies in East and West Germany corresponded both to the development of distinct "audit selves" and to the way the two narrators relate to the title characters. In the early years of the GDR, social philosophy required the submission of individual to collective needs. With the emphasis almost entirely on the collective good, the needs and desires of the individual were easily dwarfed. In order to flesh out the tension between the two, the narrator had to be a relatively close personal friend of the person whose life was being examined. Wolf's interest in the individual's place within such a state philosophy finds expression in the narrator's close personal relationship to Christa T. Furthermore, a character who struggles to pull together the fragments of her own life could not mold the material into a coherent portrait in the same way an outside observer could. While the narrator repeatedly thematizes her responsibilities to Christa T. to make sure that her portrayal of Christa's life is a fair representation of her friend's struggles, she is equally aware that the portrait she paints is her creation and serves her own purposes.

In contrast, Drewitz's narrator did not know Katrin Lambert personally well at all. Instead, it is her own sense of having not fulfilled her social responsibilities in the past that impels her to reconstruct the kind of person Katrin was and to compare Katrin's decisions with her own. In the process, she is gradually drawn into the vacuum that Katrin's death has left behind, redrawing the narrator's relationships of responsibility, without the narrator ever really understanding fully that this is happening.

West Germany's economic miracle fostered a highly individualist environment in which all were expected to look after their own future profit. In this framework, Katrin's choice to serve others represents a suspicious anomaly. However, in a society just beginning to question

again the scope of personal responsibility, her life needs both an outsider's perspective and the perspective of a skeptical reader in order to step out of the emotional dynamic inherent to Katrin's relationships. In fact, ultimately the narrator must come to bridge the gap between the entirely self-interested behavior of Katrin's friends and acquaintances and Katrin's own selfless care ethics. At the time Drewitz wrote this novel, she had begun to question an overemphasis on the word "I" to the disadvantage of "we." The topic returns in much of her later work as well. Katrin's self-sacrifice, however, cannot be the answer to the self-centeredness of others. An unreflected ethics of care can end up suicidal. In a sense, Drewitz's following novels will explore these tensions again, eventually reaching a less self-destructive understanding of social responsibility.

If we pursue the reading of these two characters as an illustration of the ways in which individuals both participate in and become subject to socially manipulated and collectively evaluated "audit selves," then it would make little sense for characters like Christa T. or Katrin Lambert to tell their own stories. The dynamic of social evaluation comes out most strongly in a narrative that pieces together the way individuals are assessed both by themselves and by those around them. Furthermore, the structure of the novels emphasizes that individuals seldom tell their own stories. In fact, one could argue that the individual is by necessity a collective storytelling project.

Conclusion

We have, of course, known for quite some time now that individuals are generally neither wholly autonomous nor thoroughly shaped by external forces. What intrigued me in the work of Steedman, Stanley, and Evans on autobiography theory was therefore not the insight that the self is also a product of historically specific social expectations, but rather the way they mapped out the audit process and its consequences not only for personal development, but also for the way social gender expectations have an impact on self-accounting and self-expression. In both novels, we can see an audit self in the making, the attending social surveillance tactics, and the tensions that result in the individual along the way. Furthermore, the process occurs in each novel within a very different social framework, which allows us to understand how various social systems produce diverse methods of (self-)auditing and surveillance. Despite the dissimilarities in the sociopolitical context, both versions of a female public self explored in these two works end up destroying the title character. Through the narrators and their somewhat

distanced perspectives on the life stories they are telling, both Wolf and Drewitz leave open the possibility for change, but the spectrum of choices and audit structures in the late 1960s and early 1970s left little room for much optimism.

Notes

[1] In Wolf's case the list includes most of her subsequent works, *Patterns of Childhood, Cassandra,* and *What Remains?* to name just a few. In Drewitz's oeuvre, the (self-)placement of individuals within history and their attempts to map their moral responsibilities on the basis of their sense of the individual's impact on history assume increasingly clear contours in *Yesterday Was Today* and *Ice on the Elbe*.

[2] A small sampling of the scholarly work will reveal that many critics have looked at *The Quest for Christa T.* as thematizing individual development and various aspects thereof. However, each scholar's approach differs and includes aspects of the novel that go beyond the construction of the self. Sabine Wilke, for instance, has seen in this novel numerous topics and approaches, which include drawing together a number of historiographical questions with the problems inherent in creating literary characters (*"Ausgraben und Erinnern"* 11) and exploring a utopian process of self-formation (*"Ausgraben und Erinnern"* 27). Helen Fehervary also sees the work in the context of fulfilling the "promise of subjective agency and historical realization" (163), but she also emphasizes Christa T. as a "composite of masks" with both an individual as well as a collective identity (168). Rainer Nägele asserts that *The Quest for Christa T.* destabilizes identity in the extreme (249). Graham Jackman, on the other hand, explores the way the novel lays out multiple layers of time and the individual's relationship to it (368, 372–73), and Myra Love argues that Wolf seeks in this text to destabilize "representational totalizations, including the self-representation of the authorial ego" (8).

[3] I have taken this term from Liz Stanley (40–60).

[4] This work has not yet been translated into English. Thus all of the translations are my own.

[5] I am not going to make the case here for a direct and conscious correlation between Wolf's *Christa T.* and Drewitz's *Lambert*. It is, however, interesting to note that the motif of "thin ice" occurs in *Christa T.* As a commentary on the scene in which one of Christa T.'s students destroys the bird eggs, Christa T. comments: "It's such a thin surface we walk on, so close to our feet the danger of dropping through into this bogland" (31). Wolf returns to this image later in the book as well (73).

[6] This is not to overlook the work that feminist theorists have done on autobiography before this. Feminist approaches to autobiography have arguably transformed the way scholars view autobiography and autobiographical material entirely and have opened up new venues for exploration—including those examined by the scholars on whom this article draws. For one account of how feminist scholarship changed the way others viewed autobiography, see Paul John Eakin's chapter "Relational Selves, Relational Lives: Autobiography and the Myth of Autonomy" (43-98). Sidonie Smith and Julia Watson provide a good overview of feminist scholarship on autobiography.

[7] Anna Kuhn has made this argument.

[8] These texts do not exhibit, then, the characteristics of autobiography that someone like Philippe Lejeune laid out in the early 1970s. Of course, Lejeune and others gradually changed their definition of autobiography and autobiographical material in response to the changing nature of the genre itself.

[9] See Eva Kolinsky's two works on women in Germany (*20th-Century* 84, 88-89, 112; and *Contemporary Germany* 37).

[10] For two secondary sources that read the work in a similar direction, see Sabine Wilke ("Between Female Dialogics" 243-44) and Evelyn Westermann Asher (244).

[11] Evelyn Westermann Asher's reading of the novel underscores the superiority and "moral incorruptibility" that the unexpected trumpet call demonstrates (236).

[12] Graham Jackman also emphasizes Christa T.'s commitment to participate fully in the new socialist society, hoping to "meet its norms and expectations" (364). See also Myra Love (91).

[13] I would take issue somewhat with Sabine Wilke's assertion ("*Ausgraben und Erinnern*" 33) that Wolf consciously avoids a portrayal of Christa T. as a model character, "vorbildhaft." What the narrator argues is that Christa T. can serve as a model in her very unwillingness to fit one of the prescribed social models society was then offering its citizens.

[14] See, for example, the comment the narrator makes as she prepares her apartment for dinner guests: "While I set the table it occurs to me how long it has been since I invited anyone to visit me" ("Als ich den Tisch richte, fällt mir ein, wie lange ich niemand mehr zu mir eingeladen habe" 104).

[15] Several of the characters from Katrin's circle of acquaintances begin to take the narrator's interest in their lives for granted, including Katrin's son Knut, Robby, and Vera von Sack (100, 123, 158, 165, 175).

[16] Card mentions particularly Joyce Trebilcot, Sara Ruddick, and, perhaps most influential, Carol Gilligan.

[17] "One is tempted to say that ethics has so far been guided by Logos, the masculine spirit, whereas the more natural and, perhaps, stronger approach would be through Eros" (Noddings 1).

[18] Michele Moody-Adams (particularly 207–08) and Sarah Lucia Hoagland (246–263) offer good examples of such critiques.

[19] Feminist ethicists have gone on to critique the kind of care ethics that people like Noddings have advocated from a variety of perspectives. For examples of such critiques, see, e.g., Michele Moody-Adams, who argues that many of the situations women face require a very different kind of response than caring (207–08). See also Laurie Schrage, who critiques an ethics based on care for being ultimately too reductive, for implicitly advocating a self-effacing posture for the caregiver, and for not being able to define adequately such issues as the limits of care (18–19, 21–22). From a public policy standpoint, Nancy D. Campbell also argues against the use of care ethics for public policy issues. Her concerns go again to issues of the boundaries of caring and to the question of "who" will be required to provide care—particularly given the gender role distribution prevalent in contemporary society (232–33).

Works Cited

Asher, Evelyn Westerman. "The Fragility of Self in Virginia Woolf's *To the Lighthouse* and Christa Wolf's *Nachdenken über Christa T.*" *Neohelicon* 19.1 (1992): 219–47.

Brüggeman Rogers, Gerhild. *Das Romanwerk von Ingeborg Drewitz*. New York: Peter Lang, 1989.

Campbell, Nancy D. "Recovering Public Policy: Beyond Self-Interest to a Situated Feminist Ethics." *Daring to Be Good: Essays in Feminist Ethico-Politics*. Eds. Bat-Ami Bar On and Ann Ferguson. New York: Routledge, 1998. 224–39.

Card, Claudia. "The Feistiness of Feminism." *Feminist Ethics*. Ed. Claudia Card. Lawrence, KS: U of Kansas P, 1991. 3–34.

———, ed. *Feminist Ethics*. Lawrence, KS: U of Kansas P, 1991.

Cosslett, Tess, Celia Lury, and Penny Summerfield, eds. *Feminism and Autobiography: Texts, Theories, Methods*. London: Routledge, 2000.

Drewitz, Ingeborg. *Eis auf der Elbe*. Düsseldorf: Claassen Verlag, 1982; Berlin: Goldmann Verlag, 1989.

———. *Gestern war heute: Hundert Jahre Gegenwart*. Düsseldorf: Claassen Verlag, 1978; Berlin: Goldmann Verlag, 1993.

———. *Wer verteidigt Katrin Lambert?* Stuttgart: Verlag Werner Gebühr, 1974.

Eakin, Paul John. *How Our Lives Become Stories: Making Selves.* Ithaca: Cornell UP, 1999.

Evans, Mary. "Extending Autobiography: A Discussion of Sylvia Plath's *The Bell Jar.*" *Feminism and Autobiography: Texts, Theories, Methods.* Ed. Tess Cosslett, et al. London: Routledge, 2000. 76–88.

Fehevary, Helen. "Christa Wolf's Prose: A Landscape of Masks." *Responses to Christa Wolf.* Ed. Marilyn Sibley Fries. Detroit: Wayne State UP, 1989. 162–85.

Fries, Marilyn Sibley, ed. *Responses to Christa Wolf: Critical Essays.* Detroit: Wayne State UP, 1989.

Gilligan, Carol. *In a Different Voice.* Cambridge, MA: Harvard UP, 1982.

Jackman, Graham. "'Wann, wenn nicht jetzt?' Conceptions of Time and History in Christa Wolf's *Was Bleibt* and *Nachdenken über Christa T.*" *German Life and Letters* 45.4 (Oct. 1992): 358–75.

Kolinsky, Eva. *Women in Contemporary Germany.* Oxford: Berg, 1989, 1993.

———. *Women in 20th-Century Germany.* Manchester: Manchester UP, 1995.

Kuhn, Anna. "The 'Failure' of Biography and the Triumph of Women's Writing: Bettina von Arnim's *Die Günderode* and Christa Wolf's *The Quest for Christa T.*" *Revealing Lives: Autobiography, Biography, and Gender.* Ed. Susan Groag Bell and Marilyn Yalom. Albany: SUNY, 1990. 13–28.

Lejeune, Philippe. *On Autobiography.* Ed. Paul John Eakin. Trans. Katherine Leary. Minneapolis: U of Minnesota P, 1989.

Love, Myra. *Christa Wolf: Literature and the Conscience of History.* New York: Peter Lang, 1991.

Moody-Adams, Michele. "Gender and the Complexity of Moral Voices." *Feminist Ethics.* Ed. Claudia Card. Lawrence, KS: U of Kansas P, 1991. 246–63.

Nägele, Rainer. "The Writing on the Wall, or Beyond the Dialectic of Subjectivity." *Responses to Christa Wolf.* Ed. Marilyn Sibley Fries. Detroit: Wayne State UP, 1989. 248–56.

Noddings, Nell. *Caring: A Feminine Approach to Ethics & Moral Education.* Berkeley: U of California P, 1984.

Ruddick, Sara. *Maternal Thinking: Towards a Politics of Peace.* Boston: Beacon Press, 1989.

Schrage, Laurie. *Moral Dilemmas of Feminism: Prostitution, Adultery, and Abortion.* New York: Routledge, 1994.

Smith, Sidonie, and Julia Watson, eds. *Women, Autobiography, Theory: A Reader.* Madison, WI: U of Wisconsin P, 1998.

Stanley, Liz. "From 'Self-Made Women' to 'Women's Made-Selves'? Audit Selves, Simulation and Surveillance in the Rise of Public Woman." *Feminism and Autobiography: Texts, Theories, Methods.* Ed. Tess Cosslett, et al. London: Routledge, 2000. 40–60.

Steedman, Carolyn. "Enforced Narratives: Stories of Another Self." *Feminism and Autobiography: Texts, Theories, Methods.* Ed. Tess Cosslett, et al. London: Routledge,2000. 25–39.

Trebilcot, Joyce. ed. *Mothering: Essays in Feminist Theory.* Totowa, NJ: Rowman & Allenheld, 1984, c1983.

Wilke, Sabine. *"Ausgraben und Erinnern": Zur Funktion von Geschichte, Subjekt und geschlechtlicher Identität in den Texten Christa Wolfs.* Würzburg: Königshausen und Neumann, 1993.

———. "Between Female Dialogics and Traces of Essentialism: Gender and Warfare in Christa Wolf's Major Writings." *Studies in Twentieth Century Literature* 17.2 (Summer 1993): 243–63.

Wolf, Christa. *Patterns of Childhood.* Trans. Ursule Molinaro and Hedwig Rappolt. New York: Farrar, Straus & Giroux, 1980, 1984.

———. *The Quest for Christa T.* Trans. Christopher Middleton. New York: Farrar, Straus & Giroux, 1970.

———. *What Remains and Other Stories.* Trans. Heike Schwarzbauer and Rick Takvorian. New York: Farrar, Straus & Giroux, 1993.

Pro-Porn Rhetoric and the Cinema of Monika Treut

Muriel Cormican

In this essay, I ferret out points of confluence between Treut's queer agenda and anti-porn feminism, arguing that the discourse on the films, unlike the films themselves, produces a simplistic figure of opposition, namely anti-porn feminism. This results in a fake and unproductive dichotomy whereby tolerant, pro-queer, fun-loving, pro-porn feminists protect the rights of the sexually oppressed against puritanical, anti-queer, militant, anti-porn feminists. Such a dichotomy undermines the important questions that Treut's films pose and that encourage us all, pro- and anti-porn feminists alike, to consider what our erotic options as women, lesbians, and/or feminists might be. (MC)

There is a wealth of cogent, sophisticated, and important secondary literature on the films of Monika Treut, ranging from Julia Knight's essays in the early 1990s to the most recent essay by Kathrin Bower in 2000. While early critics regularly grappled with the issue of pornography in Treut's films (Knight, Fox, Straayer), later critics seem all but silent on the topic (Bower, Flinn, Steffensen; Klotz and Mennel refer to it in passing), Gerd Gemünden's 1997 "How American Is It? The United States as Queer Utopia in the Cinema of Monika Treut" representing the only exception. Critics in general assume that Treut's films are not pornographic, and Treut herself, in an interview with Barbara Mennel, has explained that *Seduction: The Cruel Woman* disappointed audiences for precisely that reason ("Wanda's Whip" 153). There can be little doubt, however, that her films have something to do with pornography and the sex industry, and the pro-porn rhetoric in the discourse on the films emphasizes this connection. In this essay, I examine how pro-porn rhetoric is employed both in Treut's films and in the discourse on Treut's films and engage critically with a number of

assumptions that ghost through the discourse. I argue that *Virgin Machine,* in particular, but also *Seduction: The Cruel Woman* and *My Father Is Coming* suggest several points of commonality between Treut's filmic project and the project of anti-porn feminism: points of commonality that the discourse around those films, including statements by Treut herself, undermines and/or discounts. My fear is that anti-porn feminism has been treated overly reductively and has been unfairly simplified, such that an unnecessary, unhelpful, and false polarization occurs—anti-porn and hence anti-queer feminists versus Treut fans (coded pro-porn and hence pro-queer)—rendering both the films' and anti-porn feminists' positions on pornography, the pornographic gaze, queerness, and the sex industry less complex than they in fact are.[1] The pro-porn rhetoric that Treut draws on in her films to investigate women's erotic possibilities productively and to challenge feminist and queer theorists and activists on both sides of the pornography debate to heed each other as they continue thinking through problems they associate with the industry is employed in the discourse on those films in a manner that impedes rather than promotes dialogue between opposing camps.[2]

A comparison of how the relationship of women to porn is addressed in Treut's 1988 film *Virgin Machine* and how the same subject is broached in the secondary literature on that film can serve as a case in point. In *Virgin Machine,* the relationship of women to porn is explicitly addressed on only two occasions. On the first occasion, Dorothee is still in Hamburg and in the midst of what the images and diegetic sounds tell us is an extended period of crisis. She is surrounded by annoying noises, including the drip from her faucet, the water draining slowly and noisily out of her bathtub, a fly buzzing loudly overhead, and her boyfriend Heinz making a repeated and loud clicking noise with a toy. The noises are exaggerated to impress upon the viewer the extent to which they threaten the protagonist's sanity as she tries, in vain, to eliminate them. As a parallel, she is trying, in vain, to rid herself of Heinz. Suddenly, from a television set to which neither Dorothee nor Heinz is paying much attention, a woman's voice overpowers the annoying noises and announces: "No women have been allowed to be in positions of power to make porn for women. Our sexuality has been taken and stolen from us—we're not allowed to express it. We want women to forget this anti-porn stuff."[3] Not long thereafter, Dorothee embarks on her trip to San Francisco, happens upon a number of sex industry enclaves exclusive to women, and emerges from that long-term crisis. The noises disappear gradually until we are offered silence in both Dorothee's and the film's climax, the sex scene with Ramona.

Dorothee's gradual emergence from her crisis is marked not only by the sound bite that rings out in her Hamburg apartment from a pro-porn feminist, but also by what is essentially her own repetition of that sound bite much later in San Francisco as she peers out a window at a line of people entering a sex club:

> The sex industry is so wretched because so few women have any say in it. Susie Sexpert is absolutely right about that. The feminists should just get involved instead of rejecting the whole industry as filth. That way they could realize their fantasies. Love is one thing, fun another (Subtitles).

Dorothee finds satisfaction when she rejects her limited and limiting concept of romance and turns to a sex industry that sells whatever sexual fantasy one desires, including the fantasy of romance. She moves from an apparently monogamous heterosexual relationship in Hamburg in which she is the unwilling object of Heinz's desires, and in which desire is stagnant, to a series of lesbian sex-shows and performances in San Francisco where she becomes the arbiter of her own desires, and where desire is mobile and fluid.[4]

Were Treut to present only such favorable and liberating images of women's involvement in the sex industry and then draw on such images to infer that anti-porn feminism is unfounded or based on sexual trepidation and frigidity, she would be guilty of what Drucilla Cornell accuses many pro-porn advocates, namely, a "sentimentalization" of that industry. Cornell argues that "sentimentalization" occurs when one chooses to overlook the fact that the pornography industry "is anywhere from an eight to thirteen billion dollar industry and that in the mainstream of heterosexual pornography some women are both used and violated for profit on a daily basis" (554). Because Treut's queer agenda entails an effort to shock us out of our conventional comfort zones, she does underscore women's positive experiences within the sex industry. Susie Sexpert (*Virgin Machine*) and Annie Sprinkle (*My Father Is Coming*) are atypical, well-paid, celebrity sex-workers, the "women only" shows depicted in *Virgin Machine* are atypical sex shows, and a sex industry in which women (Wanda of *Seduction: The Cruel Woman,* Ramona of *Virgin Machine,* and Annie Sprinkle of *My Father Is Coming*) do not answer to male bosses interested primarily in making a profit, whether pimps or porn producers, is the exception rather than the rule. Despite this emphasis in her films, Treut manages to avoid the kind òf sentimentalization that Cornell describes by nodding to an aspect of sex work where all is not so rosy.

In "The Queer and Unqueer Spaces of Monika Treut's Films," Marcia Klotz draws our attention to the scene in which "Dorothee watches an emaciated white prostitute, carrying a bottle in a paper bag, look for business on a corner of the poverty-stricken Tenderloin District of San Francisco, as a number of thin, African-American men mill about around her" (72). She credits Treut here with an awareness that the queer havens in her film are anomalies and do not preclude the presence of "real" abuse in environments where women, and men too, perhaps, are less in control or not in control at all.[5] In what can be further interpreted as Treut's acknowledgment that a conflict of interests exists between the mainstream sex industry and women's attempts to redefine their roles within it, Marvin Moss, the self-declared "King of Porn in San Francisco," is forcibly excluded from the ladies-only strip show.[6] *Virgin Machine* indicates then that certain kinds of pornography, certain kinds of paid sexual activity, and certain branches of the sex industry facilitate woman's exploration of her sexuality and can be less repressive than traditional, monogamous, heterosexual relationships. It says that in those instances where women can create safe spaces in which they are in control of their performances and focused on their own pleasure as either performers or viewers—and in Treut's films such safe spaces are invariably identical with the queer havens that Klotz analyzes so thoroughly—sex work is not only not injurious to their dignity but empowering and enlightening. *Virgin Machine* modifies but nonetheless validates aspects of the feminist anti-porn campaign that sought and seeks not to eradicate all forms of sexual representation or sex work, but to prevent the subordination, oppression, and abuse of women in and through pornography and the sex industries.

A correlation between the anti-porn feminist campaign and Treut's queer agenda exists, and *Virgin Machine* reveals that correlation. The nuanced, non-polarizing approach that *Virgin Machine* takes to the subject of the sex industry and pornography is, however, generally absent in the discourse on it and Treut's other films. In discussing *Virgin Machine,* Julia Knight, Gerd Gemünden, and Monika Treut herself all invoke an anti-anti-porn rhetoric that threatens to alienate anti-porn feminists because it is reductive, polemical, and seems intent on setting up feminism, and in particular anti-porn feminism, as a straw woman to be knocked down. Rather than seeing *Virgin Machine* as a film whose humor, complexity, and queerness can appeal to anti-porn feminists, for example, Julia Knight argues forcefully that the film "flies in the face of the vociferous anti-pornography campaigns," and that to "anyone who shares Dworkin's views, *Virgin Machine*'s humorous approach to its subject matter is entirely inappropriate and unpalatable" ("Female

Misbehaviors" 182, 184). Knight's word choice ("flies in the face") implies an aggression toward anti-porn feminism that is absent in *Virgin Machine,* and her claim that its humor would offend anti-porn feminists stereotypes anti-porn feminists in a traditional vein, imputing to them an inability to laugh at their own politics and a lack of understanding for a queer agenda. In this instance, Knight's rhetoric simplifies both Treut's filmic treatment of the relationship between anti-porn and pro-porn feminists and pornography and the potential relationship between Treut's films and anti-porn feminists.

Even the reasoning that Gerd Gemünden invokes in his argument that *Virgin Machine* does not polarize anti-porn and pro-porn feminists betrays a similar antagonism toward anti-porn feminists in that he associates the anger in the pro-porn/anti-porn debate only with the anti-porn position. Reading the film as "a calculated provocation of the anti-porn movement," he credits it with deflating "some of the angry rhetoric that had polarized the opposing parties in this highly charged debate" (341). He invokes as evidence Treut's statement that hardboiled feminists, having seen it, could "not hold an anti-porn stance with regard to the film" (342). That he sees it as offering a corrective to anti-porn feminists only is evident from his explanation that the film critiques "the essentialist argument that pornography is harmful per se" and therefore makes "monolithic condemnations of the exploitation and reification of women" in pornography null and void (342). *Virgin Machine,* according to Gemünden, emphasizes a major shortcoming in anti-porn feminists' ideology. Like Knight, he assumes that the pro-porn position is not in need of further ideological scrutiny.

But Treut's statement that anti-porn feminists could not hold an anti-porn position with regard to the films is ambiguous, and there are other possible explanations for anti-porn feminists' positive response to *Virgin Machine.* If *Virgin Machine* is not porn, then it would be difficult to hold an anti-porn stance "with regard to the film." And if certain feminists do not see *Virgin Machine* as pornographic, it would be difficult then to read their enjoyment of the film as a sign of the effective deflation of anti-porn feminist anger. Furthermore, anti-porn feminists' arguments against pornography can be seen as "monolithic" only if one ignores their relatively specific understanding of pornography and accepts instead a definition of pornography as any representation of the sexually explicit.[7] Whereas anti-porn feminists generally believe in the possibility of disentangling "erotica," or non-violent, non-discriminating representations of sex and sexuality from pornography, pro-porn feminists do not, or at least fear that any attempt to differentiate would infringe on alternative representations of sexuality and sex, and thus

choose not to. It is not so much the case that anti-porn feminists are guilty of a monolithic condemnation of sexually explicit material as that pro-porn feminists are guilty of a monolithic acceptance of it. *Virgin Machine* provides a corrective for this shortcoming in pro-porn feminism, a shortcoming of which the critics seem unmindful: the film concedes in asides the legitimacy of an ideological position that criticizes pornography's and the sex industry's abuses. Indeed, Gemünden admits that it "would probably be an oversimplification to call Treut's position anti-anti-porn" (342). Perhaps the positive reception of the film on the part of feminists who Treut assumed would be hostile to her films has less to do with the reevaluation of their anti-porn position than with the fact that the film is neither what they would consider porn nor an uncompromising attack on anti-porn politics.

Beyond her films, Treut herself is equally guilty of oversimplifying feminism and anti-porn feminism and of invoking a discourse that is hostile toward anti-porn feminists. Defending pornography and the sex industry as a whole in interviews, she reduces anti-porn feminism to puritanism.[8] She tells Steve Fox of *Cineaste* that her first two films (*Seduction: The Cruel Woman* and *Virgin Machine*) were important for feminists "because at first they thought, 'Oh God, another porn movie,' but they couldn't help liking them both" (64). In "Female Misbehavior: The Cinema of Monika Treut," Knight relates Treut's remark invoked by Gemünden in his discussion of *Virgin Machine*: "Some really hard-boiled feminists came to see the film, ready to be angry; by the end, they were laughing and could not hold an anti-porn stance with regard to the film" (185). Both quotations expose Treut's underlying assumptions that feminism is essentially anti-porn feminism, that an anti-porn stance is one that condemns all sexually explicit material, and that film is a powerful medium capable of entirely altering viewers' perspectives on issues about which they feel strongly. The equation of feminism with anti-porn feminism is simply untenable, as is the reduction of the anti-porn position to the disavowal of all sexually explicit material. The third assumption is a common one in the critical reception of film and literature and demands further discussion here only because of how it is employed with a double standard within the pro-porn rhetoric in the discourse on Treut's films. While accusing anti-porn feminists of oversimplifying the relationship between images and the actions they might trigger, critics, including Treut herself, laud her films for achieving precisely what they claim violent pornographic images do not do: fundamentally affecting and even significantly altering viewers' attitudes and behaviors. I do not wish to argue here against an understanding of Treut's images as powerful and persuasive—they are. Rather, I seek to

underscore the contradiction inherent in accepting, on the one hand, that they are influential, and in completely rejecting, on the other hand, the anti-porn feminist logic that sees sexist, heterosexist, and racist pornographic representation as having a significant impact on its viewers and their behavior. If Treut's films can change viewers for the better, then by the same token, sexist, racist, homophobic, and heterosexist pornographic images can corrupt viewers.[9]

Unlike the discourse on them, Treut's films *Seduction: The Cruel Woman, Virgin Machine,* and *My Father Is Coming* present a thorough reflection on if and how viewing pornography or sex-shows might affect viewers. In *Virgin Machine,* Dorothee's tendency to look but not act is portrayed as a problem to be overcome. Until late in the film, she is depicted as the quintessential voyeur. Even her profession suggests that role: she observes and reports but, as a journalist, does not participate. On a boat trip in one of the opening scenes, Treut has her use binoculars, thus highlighting the disparity between what Dorothee sees and what she does. Rather than accept and participate in her immediate surroundings, she seeks satisfaction in that which is far off and in which she cannot directly participate. Even much later in San Francisco, this tendency persists: she climbs a building to observe movement in the street, again from an unusually distant perspective, as emphasized by the camera angle. Returning from one of her outings, she peers into a hotel room and watches a couple engaged in an S&M ritual, and, once alone in her own hotel room, she goes back and forth between watching television and looking out her window at the people milling about below. Dorothee always wants to see, and the more she sees of San Francisco's queer sexual subculture, the more willing she becomes to participate in it. Treut further emphasizes the "monkey see/monkey do" thematic by showing how even Dorothee, the observer who sought distance from what she observed, the observer so obsessed with romantic love, cannot help but join in the fun. Finally, she underscores the effect of images by tying Dorothee's final decision to become an active participant in commodified sex to her response to a television advertisement, the most commonly acknowledged means of using images to create and/or exploit needs and desires in viewers and to induce viewers to act on those desires and needs.

Treut broaches the connection between viewing and acting out again in *My Father Is Coming* (1991). Filmed in New York and primarily in English, *My Father Is Coming,* like *Virgin Machine,* explores the prospect of sexual liberation through sexual "deviance" and queerness and is performative, enacting in its relationship to the viewer that same relationship that it emphasizes in its plot between Vicky and the queer

or her father and the queer. Hans, an overweight and aging German, arrives in New York in traditional German costume with two gifts for his daughter who now lives there: German sausage and a Dustbuster. These gifts correspond to his view of Vicky as a happily married female heterosexual who, like all happily married female heterosexuals, spends her time cooking and cleaning. Vicky has substantiated her father's image of her by fabricating a straight life in her letters. The truth, however, is that she shares an apartment in a slum in New York with a gay roommate while attempting, with little success, to get on her feet as an actress. By the end of the film, Vicky's father has seen and discussed a masochistic act and a documentary about a transsexual, has been confronted by and has accepted his daughter's shifting sexual desires, and has been seduced by Annie Sprinkle, a porn-queen who rekindles his sexual desires. The film links Hans's exposure to, and eventual participation in, sexual performances to his increased tolerance for less conventional lifestyles. Vicky's attitude toward her own, and consequently her father's, sexuality also undergoes a change for the better in the course of the film because of an awakened interest in sexuality and sexual performances. After her father's arrival, she begins an affair with a female co-worker, befriends and becomes obsessively interested in a transsexual and the relationship of his sexuality and sexual desires to his identity, and she auditions for a role in a pornographic production. On the first evening of Hans's visit, Vicky's roommate, Ben, asks her what she thinks her father does in bed. She is repulsed by the suggestion of the older man's sexuality, answering, in her thick German accent, "Don't make me sick."[10] Yet at the end of her father's visit, together with Annie Sprinkle, his prostitute lover, she waves goodbye to Hans, indifferent to his flirtatious exchanges with Annie. Seeing has incited behavioral and attitudinal change for both father and daughter.

In *Seduction: The Cruel Woman* (1985), a film that investigates pleasure and desire in an S&M pleasure palace, Treut depicts a similar relationship between viewing and acting out. Justine, Wanda's American lover who arrives on a visit from the United States and is surprised by what she finds, requires but very brief exposure to Wanda's pleasure palace and its toys to change her initial horror at S&M rituals into a fascination that leads to participation.[11] And in the same way, a journalist in *Seduction* who comes merely to report on the pleasure palace, and even begins his interview with Wanda in a hostile tone, succumbs in the end to the pleasures of the place he intended only to observe.[12] While Treut's treatment of the journalist here suggests that, far from putting alien ideas in his head, Wanda's pleasure palace simply presents him with the opportunity to act out already established fantasies, an

alternative understanding of how pornography and the sex industry affect viewers is presented in the character of Dorothee (*Virgin Machine*). This naïve believer in romantic love, is, apparently, the recipient of alien ideas, and acts out newly inspired fantasies. The films offer a complex investigation of the pornographic gaze, one that neither universalizes the pornographic effect nor denies that a connection between viewing and acting out exists. They dwell, however, on the latter possibility: observing, seeing, and viewing can, and frequently do, entice one to participate in the sorts of acts one sees.

Since Treut seems convinced that viewing incites participation, it is odd that she so forcefully criticizes this element of the anti-porn feminist argument. It is also odd that she seems willing to accept pornographic representation and the sex industry as a whole as liberating when she herself is clearly working to change conventional pornographic representation. The changes brought about in the lives of Vicky, Vicky's father, Dorothee, and Justine cannot be seen as the result of exposure to pornography and sexually explicit scenarios per se, because the films deal with very specific kinds of pornography and sexually explicit material. The sexual deviance of Treut's films is much more complicated than simple participation in the sex industry, a kind of deviance, after all, that has long been sanctioned by the bourgeois establishment, that one might consider "straight" deviance. In these films, sexual deviance comes to mean intellectual and/or physical participation in queer subcultures. In juxtaposing a Germany of sexual repression and conventionality to an America of sexual liberation and "perversion" in both *Virgin Machine* and *My Father Is Coming,* Treut emphasizes the queer rather than the explicit or pornographic aspects of the images and performances she endorses. It is not the pornographic, but the queer nature of what Vicky and her father encounter that opens up new avenues of self-development.

Queerness, not pornography and the sex industry, becomes the catalyst for a more satisfying and less confined notion of self and of desire for Dorothee, Vicky, and Vicky's father. All three start out with the heterosexist assumptions that men desire women and women desire men, that there are, in short, a set of stable desire relations, but they stumble upon mismatches: women who desire women, women who want to be men but desire women, men who desire pain, women who, for their own and others' pleasure, enact male orgasm. While Treut's and the critics' anti-anti-porn discourse suggests that all pornography—including mainstream pornography that frequently reinscribes the traditional relations between sex, gender, and desire—prompts viewers to investigate their own sexuality, sensuality, and ultimately their identity, this

is not at all what the films suggest. They suggest that viewers are prompted to such investigations when confronted by representations and/or performances, explicit or otherwise, of unconventional relations between sex, gender, and desire, not by sex acts in and of themselves. In her films, then, Treut pits herself against the world of "straight" pornography just as much as anti-porn feminists do, but in her interviews, she relentlessly rails against anti-porn feminists while letting the "straight" pornography industry go unscathed.

The closest Treut comes to explicitly acknowledging what her films imply about the world of straight pornography and to revealing points of confluence with anti-porn feminism is to admit, in response to Steve Fox's question as to whether she buys "the argument that all women are hurt by the overwhelming preponderance of women in images of nudity or violence," that she is not happy with such images (64). She nevertheless goes on to set up a hierarchy of ways to fight for women's rights:

> Of course, I'm not really happy with all these images, but I think *it's the wrong way to fight for more female freedom*. It's much more important to work in other areas, like equal pay. Women are in really bad condition everyplace, and we should just get beyond *this puritanical, conservative stuff*. It's hard to draw the line *between porn and art, and most feminists don't really know about art* (64; emphasis added).[13]

This brief quotation contains three aggressive critiques of feminism and/or anti-porn feminism and evokes once more the polarization of anti- and pro-porn feminists that the films avoid. Treut's hierarchy of ways to fight for women's rights, a hierarchy in which anti-porn feminism becomes a "wrong way," is questionable. For those young girls and women who are sold into pornography and prostitution each year, and even for those women who work willingly in the industry but would like some basic employee rights, fighting for more and better pay for women in general is of dubious worth. Fighting against images of violence in pornography and the perpetration of acts of violence and exploitation against women in the making of pornography and in the sex industry need not, in any case, devalue or postpone the fight for better pay. Although intended to undermine the importance of a campaign that focuses on images or performances of sexual abuse, the logic behind the hierarchy cuts both ways: if the fight against negative and abusive images and so-called performances is secondary and of little real value relative to the fight for equal pay, then surely the same is true of the fight for positive and pleasurable images and performances.

Treut's dismissal of the anti-porn fight as "puritanical and conservative" is just as contentious. It is reductive and misleading. Since anti-porn feminists do not object to sex or to sexually explicit images in and of themselves, they cannot be called puritanical. Pornography and the sex industry have existed for a long time, and have always been tacitly supported by patriarchal ideology. Feminists' objection to them, then, for their use and abuse of women, cannot convincingly be termed conservative. Despite her admission that she, like anti-porn feminists, is not happy with the preponderance of images of violence against women, Treut refuses to see anti-porn feminism as an ideology with which she can at least partially sympathize. Neither she nor her critics explain how arguing for the continued existence of the patriarchal institutions of pornography and the sex industry is the opposite of conservative. In a rhetorical move designed to avoid rather than broach the real issues, they simply declare anti-porn feminism conservative and pro-porn feminism radically progressive. But, after all, there is nothing radical or particularly progressive about pornography, or about the notion that engaging in and watching others engage in sex is rebellious and liberating.[14]

Even today, pro-porn feminists must recognize that when they align themselves with the Hugh Heffners and Larry Flints of this world, they align themselves with men whose concern for women's rights is linked to nothing other than getting women, as Gloria Steinem says of the Sixties in the foreword to *The Vagina Monologues,* to replace the expected "no" to the demand for sex with a constant, eager "yes" (xiii). Drucilla Cornell underscores pornographers' lack of concern for women's rights in her essay "Pornography's Temptation": "The cynicism of a First Amendment organization sponsored and promoted by the pornography industry is only too evident. In their more honest moments, they readily admit that what is at stake for them in the pornography debate is their profitability and not the value of freedom" (554–55).[15] It remains unclear why Treut chooses to go to war with anti-porn feminism, or simply feminism in general, as is here the case, but seems reluctant to criticize predominantly heterosexist pornography producers and distributors who, in all likelihood, have little interest in her political and ethical agendas and who would almost certainly have little interest in, and refuse to distribute, her films.[16]

Gerd Gemünden and Barbara Mennel describe reactions to Annie Sprinkle's and Treut's work that indicate how such work, because of its queerness, has as much to fear from supporters and consumers of mainstream pornography as from anti-pornography feminists, if not more. Gemünden urges us to consider "Sprinkle's experience of being raided by the Cleveland vice squad when giving her performance 'Post-Post

Porn Modernist' but never being bothered when she performed live sex shows in that same city" (345). He interprets this inconsistency as follows: "The possibility of a queer sexuality, of being neither male nor female (or both), may well be the real issue at the core of the anti-pornography debate, and, not surprisingly, the gay and lesbian community has been the prime target of attack" (345). While Gemünden is absolutely right that queerness, and not sexual explicitness, appears to be the real target of the Cleveland vice squad, the association of the anti-pornography position with an anti-queer polemic, and of the Cleveland vice squad with the anti-pornography position is shaky. The conflicting responses to Sprinkle's shows could just as easily be the result of a heterosexist vice squad that is pro-porn but anti-queer. In other words, not all anti-porn supporters, particularly not anti-porn feminists, are anti-queer, as Gemünden's argument implies, and not all pro-porn advocates, particularly traditionalist and anti-feminist pro-porn advocates, are queer-friendly. Gemünden's anecdote can also be understood as a sign that mainstream pornography, that is, sex shows that target men and reenact (hetero-)sexist sex, is far more widely acceptable in our society than anything, explicit or not, that challenges established gender roles and prescribed sexual practices, and is thus much less likely to come under attack than even a feminist-queer non-pornographic performance.[17]

In a comparison of the German reception of Treut's *Seduction* with that of a couple of other films about sado-masochism, Mennel argues:

> More than simply the topic of sadomasochism itself, *Seduction*'s reappropriation and reversals of those gender and sexual positions inherent in the traditional models of masochism and sadism led to the film's negative reception and to the label "controversial." For example, the public response to *Seduction* contrasts with the West German box office successes of that time, Carlos Sauras' *Carmen* (1982) and Robert von Ackeren's *Woman in Flames* (1984). Both of these films address masochism and sadism explicitly, but advocate implicitly traditional gender politics (154).

Once again, Mennel's comparison and argument suggest that Treut has more to fear from advocates of pornography, from regular porn-viewers (a group that comes under no attack in the discourse) than she does from anti-pornography feminists (a group that is consistently undermined in the discourse). Indeed, Treut's own anecdotes about viewers who came looking for pornography and left the theater in anger because her films "don't deliver," and, conversely, feminist viewers who thoroughly enjoyed the same films seem to bear this out. Traditionalists and the religious right may reject all sexually explicit material. The focus of

anti-porn feminists, however, is neither the explicit nature of pornography nor alternative sexualities and lifestyles, but the manner in which pornography has tended to glamorize women's submission to men, to eroticize sexual violence against women, and to make men's pleasure paramount. Treut frequently takes potshots at feminism and constantly prods anti-porn feminists to reevaluate their position on pornography, to reflect on how it might be tied to a conservative element of the patriarchy, but only in her films does she encourage any comparable level of reflection from pro-porn feminists. Pro-porn rhetoric in the discourse on Treut's films tends to circumvent the analysis of the patriarchal structures that promote women's sex-work, but it contributes to that analysis in the films. If her films, as Gemünden argues, help shrink the schism separating pro- and anti-porn feminists, her own and others' defenses of the same films against what even her own stories about the films' reception suggest is an imagined enemy magnify it.

Because Treut's films constitute a positive intervention in the pornography debate within feminism and negotiate between feminist and queer models of sexuality, it is a pity that the discourse that has flourished around them repeatedly puts feminism and anti-porn feminism in a bad light. It is clearly very difficult to define pornography as a genre satisfactorily, and although one might well take issue with Dworkin and McKinnon's definition of harmful pornographic images, such objections demand argumentation and explanation. By simply denouncing anti-porn feminists and assuming that Treut fans cannot but feel the same, Treut and some of the critics get caught up in a level of rejection that Drucilla Cornell deems common in the pro- and anti-pornography debates, namely, projection and displacement. Cornell demonstrates at length the complexity of both pro- and anti-pornography positions, and calls for people on each side of the debate to be more tolerant of each other's viewpoints, to foster discussion and debate:

> When an idea or a reform programme is unattractive, so incompatible with one's sexual-political disposition that it has to be rejected, the rejection can be done either through argument or through displacement and projection. Both displacement and projection often can occur when no good counter argument comes to mind, either because there isn't one or because those who are offended by the idea are too invested in its disposal from the public realm that they are unable to debate it at all. Displacement and projection take all the anxiety and aggression a challenging idea or reform programme evokes and directs [sic] those effects not towards the idea or programme but to the person or people who propose it (12).

While Treut's films might be said to "argue," the discourse around them tends to "displace and project."

McKinnon and Dworkin and anti-porn feminists in general seem to say that there are problematic pornographic images of women that should be treated not as instances of free speech but as instances of real violence against women because they are images that first of all require violence against real women in their making, and, secondly, infringe on our human rights as women by contributing to a generally misogynist culture and by inciting viewers to engage in acts of real violence against real women. Treut, on the other hand, seems to say that while there are problematic pornographic images of women, they must be allowed to exist, because only if they exist can alternative images such as her own also exist. But whether Treut's films are pornographic at all is questionable. Thus, the tendency within the discourse to defend pornography as if one were defending Treut's actual works is baffling. Her films are intellectual investigations of pornography and of the potential for women's involvement in the production of sexually explicit images. True body-genre pornography does not seek to disappoint its viewers but aims to offer as much explicit sexual activity and thus arousal as possible.[18] Those who came to Treut's films looking for pornography accused her of not delivering the goods, and Julia Knight argues that Treut's most controversial act involves playing games with such viewers, offering them titles, video-sleeves, and posters that entice them with promises of what the films subsequently do not deliver ("Female Misbehavior" 184–85). The poster and video-sleeve cover for *Virgin Machine,* for example, show a picture of the naked upper bodies of two women involved in a sexual act, and the scene from which that picture is taken is the only scene in the film in which women have sex. Similarly, the poster and video-sleeve for *My Father Is Coming* show Annie Sprinkle's face and enormous breasts shadowing a prostrate man, suggesting a very explicit heterosexual sex act, but while there are more depictions of sex acts in *My Father Is Coming* than in *Virgin Machine,* there is still very little nudity or explicit sex of the sort that the poster and covers augur.

Treut's films imply many of the same questions that anti-porn feminists such as B. Ruby Rich, Diane Russell, McKinnon, and Dworkin ask: can there be a positive pornography or sex industry for women? If so, does it have to be self-reflexive? Does it have to situate itself consciously within, and acknowledge the misogynist tradition of, the genre? Does "feminist" pornography by its very nature require a critical mechanism? And if so, is there no equivalent to the traditional body-genre pornography for women? Does there have to be pornography as a pure body-genre for women because it exists for men? If a kind of

feminist pornography exists that is not self-reflexive, that does not question the misogynist tradition of the genre, that is not critical, Treut's films are not it. While her films are dependent on pornography, they are not identical with it. These questions, provoked by Treut's films, demonstrate that the relationship between those films and anti-porn feminism is more complicated than the discourse around them indicates. Rather than treat anti-porn feminism as a legitimate ideological position with which, as these questions indicate, she shares some ground, Treut and her supporters have repeatedly rejected anti-porn feminism by means of displacement and projection. Treut tells Steve Fox that "the worst thing we can do is buy the arguments of the censors. I find it a very bad sign when so-called feminists ally themselves with the religious right in these battles" (64). But anti-porn feminists have not allied themselves with the religious right at all. Instead Treut and others have chosen to depict them as people who have allied themselves with the religious right to make it easier to dismiss them and to ignore their arguments. The relationship between anti-porn and pro-porn feminists and between feminist and queer theorists does not have to be reduced to a fake dichotomy in which religious, anti-sex, puritanical, militant, politically correct feminists ("a bunch of sex cops out to handcuff the body politics' cock," Rich 405) infringe on woman's sexual freedom and the rights of the sexually oppressed, which are, however, staunchly protected by the irreverent, tolerant, pro-sex, fun-loving, post-feminist, pro-porn feminists. To set up such a dichotomy is to undermine the important questions that Treut's films pose and that encourage us all, pro- and anti-porn feminists, to consider what our erotic options, as women, lesbians, and/or feminists might be.

Notes

I would like to thank the anonymous reviewers for, and the editors of, the *Yearbook,* including Patricia Herminghouse, as well as my colleagues John Blair, Amy Cuomo, and Jennifer Manlowe, for their comments on drafts of this essay.

[1] It is a fairly common rhetorical move to label feminists who are not anti-pornography "pro-sex." In the discourse on Treut's films, for example, even Barbara Mennel and Chris Straayer, although not hostile to anti-porn feminism, use opposing categories such as anti-porn/pro-sex, suggesting the false polarization (if one is anti-porn, one is also anti-sex) of political and ethical positions. The discourse on Treut's films seems to reproduce a

problem that Biddy Martin examined in two essays published in 1994: "Sexualities without Genders and Other Queer Utopias" and "Extraordinary Homosexuals and the Fear of Being Ordinary." She worries about "the occasions when antifoundational celebrations of queerness rely on their own projections of fixity, constraint, or subjection onto a fixed ground, often onto feminism or the female body, in relation to which queer sexualities become figural, performative, playful, and fun" ("Sexualities" 104) and argues that it is time to stop "defining queerness as mobile and fluid in relation to what then gets construed as stagnant and ensnaring, and as associated with a maternal, anachronistic, and putatively puritanical feminism" ("Extraordinary Homosexuals" 101). In the interest of a more balanced designation of the two groups of feminists who, in the critical literature on pornography, are pitted against each other, I will refer to those who fight against the abuses of women in the making and viewing of pornography as anti-porn feminists, as they have always been called. But I refer to those who fight for an arena in which women can explore their sexuality uninhibitedly as pro-porn feminists rather than as sex-positive or anti-censorship feminists.

[2] What happens in the discourse on Treut's films illustrates Diane Price Herndl's warning about debates within feminism that lose their external point of reference. Drawing on David Carroll's critique of the Bakhtinian theory of carnival for its failure to take account of the controlled and institutionally legitimized nature of carnival as an outlet for the oppressed that thus dulls real revolt, she asks if contemporary feminists arguing against each other and undermining feminism are not merely representing an academic carnival: "In this climate, one must face the possibility at some point that the space which has been opened for feminist criticism may be merely a carnival provided by institutional authority—an event staged to allow feminists to drown out their own voices and thereby return to silence. The polyphony may well succeed in producing cacophony, with every sound getting lost among the other, competing sounds" (20).

[3] In many instances in Treut's films English is spoken. This is the case here: although the setting is Germany, the speaker on the television speaks English. Throughout this essay, quotations from the films are in English either because they were already in English in the film or because they have been reproduced verbatim from the subtitles for the films. When the latter is the case, I indicate it in parentheses after the quotation.

[4] "Stagnant" and "mobile and fluid" are terms borrowed from the Biddy Martin quotations in Note 1.

[5] Klotz notes the appearance here of African-American men in a film otherwise populated by whites and wonders "why the sad, coerced kind of sex is at home in a black neighborhood while the world of the erotic dance club is all white" (72). This is, of course, an interesting question, leaving

one to wonder whether Treut is commenting self-critically on her own failure to treat class and race in her investigation of pornography, queerness, and the sex industry, or whether she is simply suggesting that the abuses that do exist should not deter one from drawing what advantages one can out of the sex industry.

⁶ Compare Klotz (69).

⁷ It is clear that McKinnon and Dworkin went to some lengths to differentiate between so-called erotic images of women and what they consider harmful pornographic images. Here is their attempt to define degrading pornographic images of women: "(i) women are presented dehumanized as sexual objects, things, or commodities; or (ii) women are presented as sexual objects who enjoy pain or humiliation; or (iii) women are presented as sexual objects who experience sexual pleasure in being raped; or (iv) women are presented as sexual objects tied up or cut up or mutilated or bruised or physically hurt; or (v) women are presented in postures or positions of sexual submission, servility, or display; or (vi) women's body parts—including but not limited to, vaginas, breasts, or buttocks—are exhibited such that women are reduced to those parts; or (vii) women are presented as whores by nature; or (viii) women are presented as being penetrated by objects or animals; or (ix) women are presented in scenarios of degradation, injury, torture, shown as filthy or inferior, bleeding, bruised, or hurt in a context that makes these conditions sexual" (qtd. in Cornell 3-4).

⁸ One of the things that may account for the aggressive anti-anti-porn rhetoric in the discourse on Treut's films is the fact that her funding for *Seduction: The Cruel Woman* was cut by the West German government for reasons of obscenity, and the film was later almost banned by the Ontario Film Review Board for being "pornographic and injurious to the dignity of women" (qtd. in Knight 41). These public reactions to her first film definitely suggest, then, that her work could become the target of anti-pornography campaigns and could end up censored and that at least some segments of the population would see her films as pornography. Both Treut and her critics, then, must have seen a need to defend the films against what understandably became a monolithic anti-porn establishment.

⁹ Deciding what exactly constitutes corruption is obviously always a tenuous thing. Certainly, some would regard Treut's images as corrupting and call for their censorship. But despite the fact that some critics argue that Treut promotes absolute tolerance, this is thankfully not the case, as absolute tolerance taken to its logical conclusion means tolerating racism, sexism, Nazism. Treut has clearly negotiated a set of moral guidelines, and so does not appear to be against the notion of judgment per se, except in the case of pornography and the sex industry, that is. Making, or relying on others to make, judgments entails risk, but refusing to judge or to ask others

to judge entails no less a risk. Besides, if one argues that a film improves a viewer, then judgment of what constitutes improvement is already involved, and implies the ability to judge what constitutes its opposite, corruption.

[10] This feeling of distaste that Vicky experiences vis-à-vis her father's sexuality is also captured in the ambiguous use of the word "coming" in the film's title. Vicky uses the phrase "my father is coming" in shocked reaction to her father's looming visit at the beginning of the film. In retrospect, it can be seen to reveal her attitude toward his sexuality as well.

[11] Compare Knight (42).

[12] Similarly, in *Taboo Parlor,* when the two protagonists and the unsuspecting Victor, whom they have picked up eventually to kill, engage in heavy petting and sexual play in the bus, a number of commuters on the bus become involved, first by simply staring at the performance and then by joining in.

[13] Treut's dismissal of feminists as people "who don't really know about art" is obviously imprudent and needs little undermining. While one might argue with some validity that the anti-porn feminist position is naïve in its placement of representation and genre beyond historical change, even the most radical and best-known American anti-porn feminists, McKinnon and Dworkin, are discerning and discriminating about differences in representational forms in a manner that pro-porn feminists reject when they insist that in order for positive sexually explicit images to exist, the negative must be allowed to persist.

[14] See Carson Brown's "The New Sexual Deviant" in *Bitch* for a humorous and poignant discussion of how a woman's choice or desire to delay her involvement in sexual activity until the late teens and early twenties has become an indication that something is definitely wrong with her.

[15] In "Porn in the USA," an interview conducted by Anne McClintock with Candida Royalle, a woman who worked in the pornography industry for years as an actress before deciding to make her own woman-centered pornography, Royalle, despite her constant defense of pornography, emphasizes the abuse and exploitation of women that occur in the industry. She singles herself out as the only porn filmmaker who "has any real philosophical or political motive" and stresses how the working conditions on her set are of a much higher standard than otherwise within the sex industry: "People love working for me. In some cases, people take less money for working for me. They know that they are working for a woman who has been there, and who has a tremendous sense of compassion and respect for them, who cares about what she's doing. At the most, they'll have one sex scene a day and, with rare exceptions, will not work longer than an eight- to ten-hour

day. Other people may demand three sex scenes in a day and keep them there eighteen hours" (Royalle 548-49).

[16] Drucilla Cornell explains that the Adult Film Makers Association in the United States does not see a film as pornography unless it includes a "'cum' shot," that is, a close-up of the penis ejaculating ("Introduction" 5). She goes on to explain that their definition of pornographic film as film with a "cum shot" has led to the association's refusal to distribute much lesbian pornography because "they argued that lesbian 'pornographic' films do not have 'cum' shots because there is no filmed male ejaculation" (5). It is interesting, given these facts, that Julia Knight attacks anti-porn feminism for potentially making the distribution of Treut's films in England more difficult: "For the small number of independent distributors...sensitivity to the Dworkin argument can make Treut's films problematic, while memories of feminist pickets outside porn cinemas could make financial investment seem a risky venture" ("Female Misbehavior" 184). Why do larger pornography distributors not come in for the same critique?

[17] The general population's tolerance for the heterosexist sexually explicit is borne out by the television industry that beams vanilla sex into our homes on a daily basis in Hollywood films—material just as explicit as anything in Monika Treut's films, if not more explicit—but warns against "adult content" in shows such as *Queer as Folk* or *Ellen*.

[18] "Body genre" is a classification used by Carol Clover in "Her Body, Himself: Gender in the Slasher Film" to refer to films that privilege the sensational, the spectacle of the body and its excess of intense sensation. She includes horror films and pornography under this rubric.

Works Cited

Bower, Kathrin. "Outing Hybridity: Polymorphism, Identity, and Desire in Monika Treut's *Virgin Machine*." *The European Studies Journal* 17 (Spring 2000): 23-40.

Brown, Carson. "Legs Wide Shut: Mapping Virgin Territory." *Bitch: Feminist Response to Pop Culture* 13 (2001): 68-73.

Clover, Carol. "Her Body, Himself: Gender in the Slasher Film." *Representations* 20 (1987): 187-228.

Cornell, Drucilla. "Introduction." *Feminism and Pornography*. Ed. Drucilla Cornell. New York: Oxford UP, 2000. 1-15.

———. "Pornography's Temptation" *Feminism and Pornography*. Ed. Drucilla Cornell. New York: Oxford UP, 2000. 551-68.

Flinn, Caryl. "The Body in the (*Virgin*) Machine." *Arachne: An Interdisciplinary Journal of Language and Literature* 3.2 (1996): 48-66.

Fox, Steve. "Coming to America: An Interview with Monika Treut." *Cineaste* 19.1 (1993): 63–64.

Gemünden, Gerd. "How American Is It? The United States as Queer Utopia in the Cinema of Monika Treut." *A User's Guide to German Cultural Studies*. Ed. Scott Denham, Irene Kacandes, and Jonathan Petropoulos. Ann Arbor: U of Michigan P, 1997. 333–53.

Herndl, Diana Price. "The Dilemmas of a Feminine Dialogic." *Feminism, Bakhtin, and the Dialogic*. Ed. Dale M. Bauer and Susan Jaret McKinstry. Albany: State U of New York P, 1991. 7–24.

Klotz, Marcia. "The Queer and Unqueer Spaces of Monika Treut's Films." *Triangulated Visions: Women in Recent German Cinema*. Ed. Ingeborg Majer-O'Sickey and Ingeborg Von Zadow. Albany: State U of New York P, 1998. 65–77.

Knight, Julia. "The Meaning of Treut?" *Immortal, Invisible: Lesbians and the Moving Image*. Ed. Tamsin Wilton. New York: Routledge, 1993. 34–51.

———. "Female Misbehavior: The Cinema of Monika Treut." *Women and Film: A Sight and Sound Reader*. Ed. Pam Cook and Philip Dodd. Philadelphia: Temple UP, 1993. 180–85.

Martin, Biddy. "Extraordinary Homosexuals and the Fear of Being Ordinary." *Differences: A Journal of Feminist Cultural Studies* 6 (1994): 100–25.

———. "Sexualities without Gender and Other Queer Utopias." *Diacritics* 24 (1994): 104–21.

Mennel, Barbara. "Wanda's Whip: Recasting Masochism's Fantasy—Monika Treut's *Seduction: The Cruel Woman*." *Triangulated Visions: Women in Recent German Cinema*. Ed. Ingeborg Majer-O'Sickey and Ingeborg von Zadow. Albany: State U of New York P, 1998. 153–62.

———. "*My Father Is Coming*: Bodies and Sexualities in Three Films by Monika Treut." *Proceedings and Commentary: German Graduate Students Association Conference at New York University*. Ed. Patricia Doykos Duquette, Matthew Griffin, and Imke Lode. New York: n.p., 1994. 79–85.

Rich, B. Ruby. "Anti-Porn: Soft Issue, Hard World." *Issues in Feminist Film Criticism*. Ed. Patricia Erens. Bloomington: Indiana UP, 1990. 405–17.

Royalle, Candida. "Porn in the USA." *Feminism and Pornography*. Ed. Drucilla Cornell. New York: Oxford UP, 2000. 540–50.

Russell, Diane E.H. "Pornography and Rape: A Causal Model." *Feminism and Pornography*. Ed. Drucilla Cornell. New York: Oxford UP, 2000. 48–93.

Steffensen, Jyanni. "Epistemological Sadism: Queering the Phallus in Monica Treut's *Seduction.*" *Atlantis* 23.1 (1998): 137–45.

Straayer, Chris. "Lesbian Narratives and Queer Characters in Monika Treut's *Virgin Machine.*" *Journal of Film and Video* 45.2–3 (1993): 24–39.

Overcoming Boundaries: Feminist Doctorates and Women's Careers in Germanics 1980–2002

Patricia Herminghouse and David P. Benseler

On the basis of a bibliography of US doctoral dissertations in Germanics written by women since 1980, the authors examine developments in feminist research interests and post-dissertation experiences of women in obtaining jobs and publishing feminist research. While the increasing integration of feminist perspectives has served to open the field to intellectual horizons beyond the narrowly canonical, we perceive less progress in increasing the racial and ethnic diversity of its practitioners and improving opportunities for publication of feminist research. Given careful preparation for a difficult job market, feminist doctorates in German can be well positioned to bring needed transnational perspectives to the field of German studies. (PH and DB)

In an editorial postscript to *Women in German Yearbook 10* (1994) entitled "WIG 2000: Feminism and the Future of *Germanistik*," the editors offered an assessment of the first twenty years of Women in German and the first decade of the *Yearbook*. They concluded their remarks with a call for the transformation of knowledge in feminist terms. "Feminist criticism," they wrote,

> has always been more than merely a way to work with literature and culture; it has also been about the ways in which power has been used through the centuries to include and exclude certain groups.... The shared concerns of feminism and multiculturalism create an opportunity as well as a kind of moral imperative for change that can lead us beyond the borders of disciplines based in "national" literatures to a truly international and intercultural understanding of issues vital to us all (Clausen and Friedrichsmeyer 271).

Amidst a lot of recent talk of "feminization of the profession,"[1] some of it at times rather self-congratulatory and at others mournful, it can be instructive to look more closely at some developments in the profession over the past two decades, particularly the changes that have (or have not) been wrought in the doctoral training and post-PhD experience of women, especially feminists, in Germanics. The present project began as a study of the two decades from 1980 through 1999, but was extended to 2002 as new data, which may point to some changes in established patterns, became available. While the impulse behind our undertaking was to examine the impact of feminism on doctoral research and subsequent career experience, it quickly became apparent that this aspect could not be separated neatly from the broader question of women in the profession.

Since the 1970s, the number of women earning PhDs[2] in the field has exceeded that of men (see figure 1). Nonetheless, women appear to have generally fared more poorly than men in the job market. Since the doctorate is the key to entry into the profession, the foundation of what follows is an analysis of dissertations in Germanics since 1980. Of the more than 1200 dissertations written by women in this period, about one third could be classified as "feminist" and were looked at more closely in terms of content and approach. A bibliography of these dissertations is included at the end of this article. Further information was sought on the subsequent experiences of women PhDs in the job market and in their attempts to publish feminist research.

Background

The encounter of American feminism with *Germanistik* in the mid-1970s can be traced back to origins in challenges of the 1960s to the established order of things in society and in the academy (protests against the Vietnam war; civil rights activism; the belated addition, in 1968, of gender as a category in the Affirmative Action legislation of the 1960s; the post-Sputnik boom in enrollments in foreign-language programs). In a perverse way, the vigorous but failed campaign for an Equal Rights Amendment to the US Constitution itself also contributed to the political activation of women since the late 1960s, marking a decisive departure from the previous century, in which they were generally consigned to—at best—marginal roles in the profession. As Ellen Manning Nagy documented in her 1993 dissertation, published in 1997, "Women were not successfully integrated into the profession between 1850 and 1950, despite their prominence in pedagogy and their increasing numbers" (89). The toehold that some had gained in private colleges during those

100 years rarely involved them in the training of PhDs and, as Nagy's study makes clear, they were not professionally networked, either among themselves or with male colleagues, in a way that could lead to advancement and recognition for their work.

Extending Nagy's work on early women in the profession to the experiences of female Germanists among the scores of refugees from National-Socialist Europe, Gisela Hoecherl-Alden also documents how few of them managed to obtain and (after the war) keep an academic position. The professional integration of women who emigrated to the US after the end of the war, particularly those who completed their academic training in US graduate programs, proceeded somewhat more smoothly. Although they rarely rose to the levels of prestige attained by their male compatriots, Hoecherl-Alden points out the influence that a few of them have had in the profession.

Beginning in the 1960s, Germanists in many graduate programs were being prepared for the profession by a new immigrant generation of German-born and -trained faculty, most of them male, who had left the stifling atmosphere of the postwar West German universities in order to pursue career opportunities on this side of the Atlantic. This development had two important effects on their American graduate students. On the one hand, it reoriented the study of "things German" on American campuses much more toward German *Germanistik,* leading some women graduate students and young female faculty—just as the booming job market in the field began to collapse—to address their double disadvantage in the world of male *Germanistik.* By the mid-1970s, the rupture between their increasing encounters with feminist thought in the world outside the German department and their experience of institutional structures constraining their horizons in the profession began to express itself in indictments of ingrained practices and habits of mind that sustained women's exclusion from the realms of male academic privilege. The founding of Women in German in 1974 is the most obvious marker of this development.

On the other hand, the new émigrés were also opening up the intellectual horizons of US German departments to critical, indeed often Marxist, approaches that were much more socio-historically oriented than the formalist, culture-affirming paradigms that had generally prevailed in literature departments. Perhaps the socially conscious, philosophically critical approaches introduced by this more recent immigrant generation served to attract more politically aware students to the discipline than had been the case in previous decades, including those of the World War II era. This attraction was particularly apparent in the late 1960s and early 1970s as some of these émigré scholars—among

them Jost Hermand at the University of Wisconsin, Frank Hirschbach at the University of Minnesota, Peter Uwe Hohendahl at Washington University, and Frank Trommler at the University of Pennsylvania—began to broaden the literary horizons of the discipline beyond the canon of great German men to include the *terra incognita* of GDR literature. For not a small number of their students, including women who were soon to enter the profession, this encounter struck a chord with their political and intellectual discontents and strengthened their determination to transform the field through a combination of scholarly and political involvement. The sheer lack of knowledge about "the other Germany" was also an important incentive for engaging in interdisciplinary communication and cooperation that led beyond the isolation of what was then considered "mainstream" *Germanistik*. For many women, this political and cultural opening became the symbolic crack that enabled them to get a foot in the door of academe and, ultimately, to advance to the level where they became advisors to many of the PhDs whose dissertations were examined for this study.[3]

Methodology

This survey was based on a bibliography of dissertations completed from 1980 to 2002, derived by David Benseler from the annual listings he has compiled for *The Modern Language Journal* and *Die Unterrichtspraxis*.[4] Most of these entries have been verified with checks against *Dissertation Abstracts International* (*DAI*), library catalogs, and other sources. For this reason, we believe that the data we have been working with are more accurate than those published in each fall issue of *Monatshefte* or the statistical data compiled annually in either the *Digest of Education Statistics* or the *Survey of Earned Doctorates,* both of which have been used in many of the reports issued by the Modern Language Association.[5] Within the bibliography thus compiled, we focused on two categories: dissertations written by women (a total of 1,236), in order to ascertain proportions of female PhDs within the total number of doctorates in Germanics; and feminist dissertations (a total of 394, including 24 written by men). We define the term "feminist" very broadly to encompass all work in which gender was a central category of analysis, regardless of whether a dissertation had been written by a woman or a man. Because the number of male-authored dissertations, ranging from 0 to 3 dissertations per year (average 1 per year), was statistically too small to break out analytically into further categories, it has simply been subsumed into the category "feminist" (see table 1). It has also been possible to trace chronological patterns in research topics by cultural

period and approach,[6] by advisor, and by institution (see table 2). In addition, an informal inquiry to participants in the Women in German electronic discussion list[7] yielded considerable anecdotal information about the experiences of feminist scholars in pursuing dissertation topics, jobs, and opportunities for publication of their work. Some of these comments are quoted anonymously in this report, as are (partial) titles of dissertations chosen to illustrate particular trends.

Table 1: Female Doctorates and Feminist Dissertations

Calendar Year	Female Doctorates	Feminist Dissertations	% Feminist	Incl. Male
1980	54	12	22	1
1981	56	11	20	1
1982	51	13	25	0
1983	55	11	20	1
1984	48	13	27	0
1985	44	7	16	1
1986	52	11	21	0
1987	53	10	19	1
1988	57	15	26	1
1989	47	14	30	0
1990	59	11	19	0
1991	66	18	27	2
1992	71	24	34	0
1993	47	19	40	3
1994	60	22	37	1
1995	53	22	42	0
1996	53	26	49	1
1997	56	21	38	3
1998	76	42	55	3
1999	50	22	44	1
2000	54	21	39	1
2001	46	16	35	2
2002	28	14	50	1
1980–2002	1,236	394	32	24

Table 2: Female and Feminist Dissertations in Largest Doctoral Programs (1980–2002)

School	Female PhDs	Feminist PhDs	% Feminist
University of California, Berkeley	58	22	38
University of Wisconsin	47	23	49
University of Texas	45	12	27
Stanford University	44	12	27
University of Washington	42	11	26
Washington University	41	24	59
Ohio State University	39	16	41
University of California, Los Angeles	39	14	36
University of Minnesota	38	21	55
Cornell University	37	11	30
Indiana University	34	12	35
University of Illinois	33	11	33
Yale University	33	5	15
Princeton University	32	8	25
Rutgers University	31	10	32
Harvard University	31	4	13
University of Michigan	29	7	24
Georgetown University	28	7	25
New York University	27	7	26
University of Massachusetts	25	14	56
City University of New York	24	7	29
University of Maryland	23	10	43
University of Pennsylvania	23	6	26
Johns Hopkins University	21	3	14
University of North Carolina	20	5	25
University of Virginia	19	7	37
University of California, Davis	18	13	72
Pennsylvania State University	18	11	61
University of Cincinnati	17	7	41
University of California, Irvine	17	5	29
University of California, San Diego	17	4	24

For purposes of this survey, the term "feminist" was applied to, for example, studies or editions of texts of a single woman author, thematic studies of mother- or father-daughter relations, and examinations of the construction of identity, including masculinity, but not to studies of childhood, or something like a stylistic study of three poets, one of whom happened to be a woman, or a history of plays performed in a regional theater, one of which might have been by a woman. Despite the effort to avoid a restrictively "correct" definition of "feminist," this broad standard may nonetheless have inadvertently excluded some dissertations in which the feminist component was not readily evident in either the title or the *DAI* abstract. This possibility became clear in several replies to the WiG-L inquiry, in which respondents indicated that, although their dissertation might not *seem* feminist, it was definitely informed by the author's experience of academic feminism.

While some may argue, quite correctly, that feminist research was well underway by 1980, we chose the last two decades of the twentieth century (and the first years of the twenty-first, in which patterns seem to be changing) because it is in the 1980s that one can discern changes wrought by the tumultuous 1970s. That decade was marked by the transformative developments mentioned previously, which included the rise of both second-wave feminist activism and feminist theory in the US and, soon thereafter, in West Germany; the implementation of Affirmative Action for women; the introduction of the first courses to focus specifically on women writers;[8] and the founding of Women in German. Finally, by mid-decade the job market collapsed, due in large measure to the fact that post-Sputnik NDEA funding for foreign language education had dried up. Its corollary was a drop in the number of PhDs granted in foreign languages.

As figure 1 indicates, the annual number of doctorates granted in German since 1980–81 has fluctuated more or less between 60 and 90; the overall trend has been one of gradual increase. By contrast, the numbers from the four-year period 1977–78 through 1980–81 had plummeted from a high of 176 in 1972–73 to 106 in 1978–79. By the end of the 1970s, doctorates earned by women in German began to outnumber permanently those granted to men (*Digest of Education Statistics*). Furthermore, the increase in women earning doctoral degrees has been steeper than the overall trend in Germanics, especially compared to the trend for males, which has remained relatively level. This fact hardly means, however, that women have become the majority among faculty members in colleges and university departments, particularly those that award graduate degrees in German.[9] However much the marginalization of women in the profession had begun to change in the 1970s, the

patterns of exclusion documented by Nagy, Hoecherl-Alden, Joeres, Blackwell, and Teraoka have sometimes proved to be frustratingly persistent.

Whereas, as table 1 shows, the number of completed "feminist" dissertations fluctuated between 7 and 15 per annum during the 1980s (average 11.8), the numbers in the 1990s show a marked increase, ranging from 11 to 42 (average 22.7). Although it is too early to risk definitive statements about trends in the new century, statistics for 2000, 2001, and 2002 (21, 16, and 14, respectively) suggest that in both real and relative numbers the "feminist" trends of the 1980s and 1990s may be shifting.[10] Beyond the perceptible effect of bad news about the job market on the number of doctorates being granted, this apparent "decline" may also reflect the trend for topics such as multiculturalism, colonialism, and globalization, which originally emerged as new areas in the context of feminist German Studies, to be "mainstreamed" as critical issues in the discipline, without a central focus on questions of gender.

Feminist Dissertations over Two Decades

By the early 1980s, two approaches to literary topics comprised most feminist dissertation research. Interest at these early stages was most often focused on "images of women," whether as victims, heroines, or types ("the prostitute") in the works of "major" authors. Typical of these years are titles such as "The Woman as...," "The Heroine in...," "The Image of Women in...," "The Woman as Survivor in...." Despite the perspicacious 1975 caution by Ruth Angress [Klüger] against what would later be called "essentialism," titles and abstracts of dissertations in this vein reveal few doubts about what constitutes the category "woman," and often represent a variety of feminist criticism that Angress described as "general cries of outrage" (250). Early on, thematic and stylistic studies also gained in popularity: "The Theme of Adultery in...," "Prostitution in the Works of...," "The Treatment of...," "Emancipation in...."

The early 1980s were also marked by significant "archaeological" impulses: investigations of the work of women writers who were less known than the few, e.g., Annette von Droste-Hülshoff and Marie von Ebner-Eschenbach, who might have been included in graduate training of that era: Clara Zetkin, Else Lasker-Schüler, German-American women writers, Anna Luise Karsch, Regina Ullmann, Bettina von Arnim (four dissertations between 1982 and 1986), Malwida von Meysenbug, Louise von François (two dissertations, 1983 and 1985), Charlotte Birch-Pfeiffer, Christa Wolf, Anna Seghers. After an apparent lull, there

has been a renaissance of such life-and-works approaches in recent years, the fruit of improved access to the legacy of women in German-speaking cultures.[11]

Many of the topics of the 1980s reflect the limitations that constrained emerging feminist consciousness in its encounter with the canon of German literature and theory still being taught by a predominantly male senior faculty. In a 1991 MLA presentation, Ruth-Ellen B. Joeres described the situation with considerable impatience as *"Germanistik*'s tenuous acquaintance with feminism (not to mention American feminism's awareness of German feminist scholarship)" (251). She depicted the relationship of *Germanistik* and feminism, famously, as less a matter of "apples and oranges" than of "elephants and parsley," with deleterious effects on all sides (248). While traditionalists tended to confine their understanding of appropriate "theory" to what was published in German and resisted attempts to introduce "alien," i.e., French and American, theory, feminist Germanists became increasingly insistent in their critiques of a *Germanistik* that did not engage gender as a pertinent category of analysis. For almost a decade, however, there were few German studies with the impact of 1970s analyses by feminists such as Adrienne Rich, Josephine Donovan, Elaine Showalter, or Sandra Gilbert and Susan Gubar in American and British literature or French feminists such as Monique Wittig, Hélène Cixous, Luce Irigaray, and Julia Kristeva. Only very slowly does the impact of even the pioneering work done in the late 1970s by German feminists such as Silvia Bovenschen, Gabriele Dietze, Inge Stephan, and Sigrid Weigel make itself felt in the formulations of dissertations of the early 1980s.

In this period, however, feminist research was noticeably energized by the growing interest in GDR literature. Particularly exhilarating was the discovery of texts being produced at the immediate moment by writers such as Christa Wolf, Irmtraud Morgner, Sarah Kirsch, and Maxie Wander, who offered explorations of women's experience and pursuit of self-realization that were at once critical and self-reflective. Especially well received were the contributions to literary history and theory to be found, for example, in Wolf's essays on Bettina von Arnim and Karoline von Günderrode, Anna Seghers, and Ingeborg Bachmann, along with the many reflections on the process of writing and subjectivity embedded in both her literary texts and those of Morgner. This dimension was eagerly taken up by feminists who had become acutely aware of a theoretical deficit in their enterprise, especially the pursuit of a "feminist aesthetic." Already in 1981, there was a dissertation on Christa Wolf; Anna Seghers was the subject of two other studies in 1982 and 1983; Morgner in 1988 and 1990. Even in the years since reunification, East

German topics continue to rank among the most popular choices of feminist doctoral scholars.

Although the sort of topics and approaches that enjoyed popularity in the 1980s continue to be pursued through the 1990s, more sophisticated examinations of memory, history, and the contingencies of gender and identity have emerged. Women who, as graduate students, had sought to challenge the geographic and intellectual boundaries of *Germanistik* gradually became established in faculty positions that enabled them to influence curricular change and to function as dissertation advisors in at least some graduate departments. Whereas only a handful of women can be found among the dissertation advisors of the early 1980s, in most years since 1988, more feminist dissertations have been supervised by women than by men. Their influence is particularly evident in eighteenth- and nineteenth-century studies mentored by now senior scholars, including Barbara Becker-Cantarino, Susan Cocalis, Elke Frederiksen, Ruth-Ellen B. Joeres, and Lynne Tatlock. In comparison to many of the dissertations of the 1980s, which tended to focus on images of women or female victims and heroines in the texts of canonical authors, doctoral projects of recent years reflect more complex understandings of constructions of gender and the deployment of discourse in the making of meaning in culture and society. The change is evident already in title formulations such as "Depiction of Force and Loss of Self in...," ...Negotiating Social Discourses," "...Performances of Gender...," or "Writing Masculinities around 1800." The confluence of cultural studies and feminist approaches is especially apparent in the flourishing work of recent years on the medieval and early modern periods, with titles such as "The Misbegotten Male...," "The Topography of Gender in...," "Bodies at Court:...."

Increasingly in the 1990s, assumptions about terms such as "German" and "woman" are also modulated by recognition of the constitutive role of race, ethnicity, sexuality, class, and nationality. It would be impossible to list here all the dissertations that reflect this recently cultivated awareness, but a few will serve to illustrate this important development: "Gender, Ethnicity, and the Crisis of Representation...," "Race, Hybridity, and Identity in...," "Literature, Race, and Gender...," "Rewriting Women's Discourse across Cultures...," "Staging Ethnicity, Gender, and Nation...," "Staging Blackness: Race, Aesthetics, and the Black Female...," "Re-Reading and Rewriting Multiculturalism...," "German Women in Cameroon." While traditionalists might decry such work on constructions of identity and nation, multiculturalism, and colonialism as "faddish," we should keep in mind that

these are the sort of topics that equip their authors to enter the larger arena of discourse in cultural studies.

The attempt to classify dissertation topics was complicated by the welcome tendency of a much higher proportion of recent dissertations to be comparative in scope, frequently crossing national boundaries as well as those of period and genre. Such widening of the scope of "feminism" to include more general challenges to traditional, monolithic conceptions of cultural identity has tended to elide into the general area of Cultural Studies, a development that related to the 1990s tendency of some German programs to refashion themselves as departments of German Studies. But to date, few feminist dissertations—as is the case in much of what has been designated "German Studies"—display much evidence of in-depth engagement with the discourse of other disciplines. One notable exception to this assertion might be the growing number of dissertations on film, whose authors indeed need to learn the parlance and the methodology of Film Studies.

Women Confront the Job Market

Given the difficulty of compiling reliable data, it is problematic to risk comments on the gendered aspects of employment in Germanics. Allusions to the "feminization of the profession" aside, so much has changed—and continues to change—in the larger picture of academic employment that the certainties of a decade ago seem chimerical today. Despite the high proportion of women among recipients of the doctoral degree in our field, perusal of the "Personalia" listings of fall issues of *Monatshefte* reveals that there are still all-male departments and that some departments have yet to name their first female chairperson. Men continue to be hired into tenure-track positions at higher rates relative to the number of degree completions than women. Arlene Teraoka cautions against overly optimistic presumptions of "discipline-wide structural and attitudinal change" based on the fact that some women "are established as senior professors and department chairs, as deans and now even as provosts." These achievements, she points out, are those of a comparatively small number of women and must be weighed against the overall situation in the field. It is true, as she notes, that

> there are more women, in both prominence and number, in the field; and the profile of scholarship in German studies is more diverse, in the theories it adopts and in the materials it investigates, than ever before. Yet the disproportionate hiring of women PhDs in non-professorial positions, the virtual absence of minority faculty, and the continued dominance of native-German scholars all

speak to a troubling continuity rather than a change in the direction of democratization and openness.

As Teraoka's analysis of the annual departmental listings in *Monatshefte* shows, it is possible to argue for considerable progress on the basis of the tripling of the representation of women in tenured ranks, from 1 of 9 in 1971 to 1 of 3 in 1999. But she paints a dismal picture of the situation in non-professorial ranks: "In 1971, women earned 35 percent of PhDs and made up 42 percent of non-professorial faculty and 21 percent of faculty overall; in 1999, they earned 61 percent of doctoral degrees, held 75 percent of non-professorial positions, and comprised 43 percent of total faculty."

This negative assessment is borne out by several MLA surveys of PhD placement. A report on the proportion of PhDs from 1983–84 who had attained tenure-track employment showed that of the 80 PhDs (39 men, 41 women) surveyed in German, only 24 had tenure-track appointments, but of this group, 71% were men and 29% women ("PhD Survey"). Put in more crass terms, 44% of the male PhDs obtained tenure-track jobs, compared to 17% of the women. Of the 18 fields covered in that survey, German was second only to Italian in having the worst record in female employment. The 1991–92 survey did not report numbers in this fashion, but it is worth noting that, of the eight foreign-language areas surveyed, German had the highest proportion (64.9%) of doctorates earned by women. Of the major languages surveyed, however, German consistently had the lowest percentage of PhDs obtaining tenure-track positions (see Huber). Worse, as Teraoka's examination of data published in *Monatshefte* reveals, is the situation in the twenty largest PhD-producing departments, where the ratio of men to women hired as assistant professor (3:2) is inverse to the ratio of degrees granted to men versus women (2:3). It should not surprise us, then, to see that there is considerable variation among the number of feminist dissertations completed in the larger PhD programs (see table 2).

Likewise, in the last decade little progress has been made in addressing the pervasive "whiteness" of faculty, students, and curricula in German programs. Teraoka's analysis of minority representation and the recent report by Robert Fikes, Jr., which she cites extensively, show that the proportion of African-American, Asian-American, and Hispanic Germanists has remained at 2 percent or below for the two decades in our survey. Worse yet, she confirms that among minority students in language and literature finishing doctoral studies in the Big Ten (midwestern) universities and the University of Chicago between 1998 and

2000, *none* was in German, despite a national average of 13% minority representation in these fields.[12]

On a national basis, the *Survey of Earned Doctorates* for 1998 indicates that of the 41 men and 64 women earning doctorates in German in 1998, there were 2 American citizens or permanent residents of Asian origin, 1 "other Hispanic," and 2 of "unknown race" (NSF, NIH, et al., Appendix A; there is no information on the gender of these particular individuals). At the same time, the *Survey* reports, while the overall number of female doctoral recipients (all fields) doubled from 1988 to 1998, the number of African-American, Hispanic, Asian-American, and American-Indian PhDs increased two-, four-, five-, and eight-fold, respectively (NSF, NIH, et al., Appendix B). Thus, more than a decade after the American Association of Teachers of German addressed the striking underrepresentation of minority students and faculty in the field (see Peters; Schulz), Germanics remains as sorely lacking in ethnic and racial diversity as ever.

New PhDs are now confronted with structural changes in academic employment that severely circumscribe the opportunities open to them. With the end of mandatory retirement and increasingly stringent institutional budgeting practices, earlier predictions that a wave of retirements and an influx of students would open new employment opportunities have seldom materialized in forms other than non-tenure-track and part-time positions. In this respect, not enough has changed since 1985, when Jeannine Blackwell, writing just as her own series of temporary jobs was broken with an appointment to a tenure-track position, described not only the situation of temporary and adjunct faculty trying to hold their personal and intellectual lives together, but also the working conditions for those who assumed the role of "the young blood circulating through the moribund body of the German department" (276):

> Older men teach graduate courses and traditional advanced topics to small, predominantly female, groups of advanced students, while younger women and men teach business German, film, culture, beginning and intermediate courses, try to raise the enrollments by which their jobs are justified, and organize computer-assisted instruction (275).

What we have been able to discern about the employment patterns of women in our survey confirms that today initial placement in a tenure-track position is no longer the norm for new PhDs, especially women. Respondents to the inquiry posted on WiG-L as well as checks of successive annual Fall issues of *Monatshefte* ("Personalia") indicate a more typical trajectory that now can lead from one or two, sometimes three,

temporary positions to a tenure-track job. Tellingly, one respondent noted that she "had to do *only* [my emphasis, P.H.] one visiting assistant professor position before landing a job." By comparing annual department listings in *Monatshefte* with our bibliography of dissertations by women and feminists, it was also possible to detect another pattern among holders of temporary, adjunct, and part-time positions: many, particularly in the 1980s, were women who took jobs near their doctoral institution, often before completing the degree. Not a few managed to parlay this into long-term full-time, often tenure-track, employment. One such woman wrote, unapologetically, "A lot of personal reasons and practical questions of where in the life cycle I found myself played a substantial role in why I stayed where I was rather than trying to advance my career further by trying to garner a position at a research institution." To the extent that such a choice reflects a decision not to subject one's partner or family to wrenching separations or the exigencies of a job search process stretching over several years, it can be thought of as a different phenomenon than recent administrative moves to eliminate tenure lines or replace them with temporary or adjunct appointments.

To date it has not been possible to compile sufficient information to conclude whether having written a feminist dissertation is helpful (or detrimental) in a job market where the number of candidates and the number of positions available persist in an inverse relationship. On the one hand, there are some uncomfortable perceptions with which feminist job candidates still have to contend, but, on the other, they often appear to benefit from more supportive and lasting mentoring in the early stages of their professional lives. Individual experiences vary widely. One feminist PhD from the late 1990s, now in a tenure-track job, reported being discouraged by the senior member of her department, who "[told] me not to do feminist research because I wouldn't be able to find a job with such a profile." Another said, "At my interview, I was asked 'You're not a feminist are you?,' at which point I was glad my dissertation didn't *look* feminist." More confidently, a recently tenured feminist declared, "All in all, I'd say I belong to a generation for whom it's *selbstverständlich* [goes without saying] that gender studies is not only o.k., but will get you places." Her experience has clearly been different from that of a veteran of the 1980s, now tenured, who recalled, "When interviewing for jobs, which I did five years straight, the most common question was, 'Can you teach male authors?'"

Perhaps more typical is the experience of another younger scholar who said, "My employment was (unfortunately) not based on the fact that I specialized in feminist research." Her remark should remind us of

certain realities of the job market: departmental job listings are very unlikely to specify "feminist studies" as a desideratum in their job descriptions. Even when they move away from teaching in terms of conventional coverage of periods and genres, most programs still define positions on their faculty roster along these lines. In addition to filling "slots" thus described, they continue to look to new hires with "near-native" language proficiency and demonstrated teaching ability who can attract students by offering film, developing computer-based instruction, and working in interdisciplinary venues. In this, German programs are unlikely to differ from the behavior of 671 English departments that advertised openings in the MLA *Job Information List* in 1998–99 and 1999–2000: both in their initial screening of candidates and in the on-campus interview, departments that responded to a survey (55%) indicated that "potential for making a positive contribution to the institution as a whole" was of primary importance (Broughton and Conlogue 43–45). What might constitute such a "positive contribution" can, of course, sometimes derive from highly subjective perceptions of one's own turf.

Job applicants whose qualifications make them attractive to inter- and cross-disciplinary programs, such as film studies or gender studies, may well enjoy the advantage of extra support of their candidacy from faculty outside the hiring department. In what we have discerned so far about women's academic employment subsequent to the doctorate, it was instructive to learn that a number of them held full-time appointments outside the field of German: not only in Women's Studies or Comparative Literature, but also in English, Jewish Studies, Hebrew, French, Netherlandic Studies, Scandinavian, Slavic, and Spanish. Whether they came to graduate studies with the knowledge base that won them such positions or took courses outside the German department during their graduate studies, their career trajectories illustrate the wisdom of widening one's repertoire, at least to the point of being able to present oneself as capable of teaching as a generalist.

In an extremely negative appraisal of the job market for PhDs in German, Robert C. Holub drew on the resources of *Monatshefte* to compare the number of PhDs granted in German in 1986–1987 (79) with departmental listings of faculty in the 1990 DAAD-Monatshefte *Directory of German Studies*. On this basis, he ascertained that only 35.4% (28) of the 1986–1987 PhD cohort had obtained tenure-track or tenured positions by 1990. Allowing for the probability that a few more had "some kind of academic position somewhere," he nevertheless asserted that it is "unlikely that more than 50% of the PhDs from 1986–1987 will ever obtain a job that matches their training in graduate school"

(38). This is a particularly grim assessment in view of the fact that the job market actually peaked in 1988.

There is, however, a more optimistic way of looking at the current situation in contrast to 1984 when, we recall, only 17% of women with a doctorate in German had managed to land a tenure-track position. Our still insufficient data do seem to show that more recent female PhDs in German are surpassing the 1984 rates of job attainment, particularly if one allows for the newer pattern of several years in temporary positions. In fact, given the drop of about 33% of college enrollments in German over the course of the 1990s,[13] it is rather amazing that, according to the measure regularly utilized by the MLA, the number of all foreign-language position announcements in the October *Job Information List,* the number of jobs in German has not varied dramatically from its average share of 9.9% for most of the two decades covered in our survey. Drops in the number of both students and programs in German have still not been matched by proportionate drops in hiring; indeed until very recently the proportion of jobs in German has generally matched the overall pattern of jobs in foreign languages[14] (see figure 2).

Unsurprisingly, however, what can be learned about employment patterns for women PhDs suggests that the investment of the dissertation advisor in the development of students into professional peers plays a role that needs to be factored into the final assessment. The "generational compact" discussed by the editors of *Women in German Yearbook 11* entails the faculty member's responsibility not only to impart knowledge but to equip students "to teach language *and* literature *and* film *and* culture, to prepare materials for publication, to manage the stresses of conferences, and perhaps most importantly, to interview. In short, how to get a job and keep it" (Friedrichsmeyer and Herminghouse, "Generational Compact" 223). Certainly not all of the dissertation advisors whose students have had high rates of success in the job market have been members of WiG, with its long-standing commitment to the concerns of graduate students and junior members of the profession. It is, however, difficult to overlook their disproportional representation among the cohort of faculty whose students have generally found employment—just as there are other advisors whose students seem, by and large, to have fared very poorly in the search for an academic position.

Feminist Publishing

Publishing the dissertation does not seem to have been a priority for many scholars whose doctoral project might be described as "feminist." The majority of respondents to the inquiry posted on WiG-L reported

having published portions of the dissertation as articles or book chapters. A few recounted difficulties in trying to publish feminist research in traditional journals, but most seemed to have had positive experiences. For publication of the dissertation in book form, the picture was noticeably darker. A lucky few enjoyed the good luck of having their manuscript solicited by the editors of particular series, while others stressed gratitude for the interventions of senior scholars who opened doors into publishing houses for them.

As is the case across the discipline, a large proportion of feminist dissertations in German that are published as books have appeared in publishing houses with European roots, such as Peter Lang or Rodopi or some of the smaller German presses amenable to publishing monographs on German topics, even when written in English. But it is clear that the crisis in academic publishing recently addressed by the MLA[15] does impinge on the chances for publication of feminist dissertations. The remark by one respondent to the WiG list, "Most presses claim my topic is too narrow," best exemplifies the dilemma faced not only by feminists but by anyone seeking to place a manuscript for a highly specialized monograph. More than one respondent pointed to the past editor of a particular press who dismissed feminist theory as a passing fad or certain topics as "too trendy"—in contrast to other presses that have capitalized on recent developments by creating special rubrics in their list for such approaches as gender studies, cultural studies, and queer studies. In the current atmosphere, university press editors are often unwilling to take reader reports with any hints of reservations to their boards, as one disillusioned (male) respondent learned:

> In trying to place the revised manuscript as a book, the feminist argument produced one very negative reader report that killed my prospects at one press. I have since revised again to prevent that kind of reading (the gender analysis is still there) and am now looking to place the book manuscript.

In view of widespread expectations of a published book as a *sine qua non* for tenure, the number of people who reported having no intentions of revising the dissertation for publication in book form seems, at least initially, surprising. (Typical comments: "gone off in a different direction," "now more interested in other topics than dissertation research for my book project," "want to publish research relating to my teaching.") But to the extent that those who chose this course have come to recognize the current market preference for books of interest to broader audiences, their choices cannot be faulted. On the other hand,

it is also true that some scholars who did not write "feminist" dissertations have subsequently published significant feminist research.

Outlook

To date, the enormous drop in college German enrollments has not been matched proportionately by a decline in the number of PhDs granted in the field or, for that matter, the overall number of faculty positions. Indirectly, however, one can see its repercussions in the tenuring-in of many departments and the tendency to shift current hiring to non-tenurable ranks. Most recently, the Spring 2003 *MLA Newsletter,* announcing a decline averaging 20% in listings of positions in its October 2002 *Job Information List,* pointed out "how closely academic job opportunities have historically mirrored the national economy" and confirmed that "the recession has brought the recent improvement to an end" (Lawrence, et al. 6).

Bleak news indeed. Yet other "negative developments," such as the recent drop in the number of PhDs granted in the field, and particularly to women, suggest that some necessary adjustment in the ratio of candidates to jobs may be taking place as well. While this may spell difficulty for departments eager to recruit full cohorts of incoming doctoral students, it may also open brighter horizons for students who judiciously choose programs and, more crucially, dissertation advisors who are committed to preparing them for a successful future in their chosen profession. To the extent that this preparation, including the sort of dissertation they choose to write and the kinds of courses they are prepared to teach, enables doctoral candidates to break out of the institutional and intellectual confines of *Germanistik* into the broader spaces of interdisciplinary studies, to bring international perspectives in literary and cultural theory to bear on analyses of "things German," and to make our field more open to the world, one can in good conscience encourage those wishing to enter (and survive in) the field to pursue feminist research.

Notes

While both authors were very much involved in all aspects of this paper, Patricia Herminghouse is primarily responsible for the text, and David Benseler for the bibliographical compilation.

[1] The term seems to have first gained currency in Germanics following a 1994 *Unterrichtspraxis* article by Valters Nollendorfs.

[2] Throughout this essay, we use "PhD(s)" as an editorial convenience meaning "doctorate(s)." We chose "PhD" simply because more of them are awarded in any given year than are the DA or DML degrees.

[3] The connection between interest in GDR literature and the founding of Women in German in the early 1970s has most recently been discussed by Daley and by Friedrichsmeyer and Herminghouse ("Toward").

[4] See Benseler; Benseler and Moore. These sources offer reference to all previous compilations.

[5] Frequently, considerable differences appear among the statistics presented by each of these data-gathering organizations and it is not possible to reconcile them. At the most basic level, some collect data for the academic year, others for the calendar year. Some rely on information provided by individual departments; others on data submitted by graduate schools. In all cases, the accuracy of information provided depends on the expertise and carefulness of the persons providing it. Furthermore, discrepancies can arise when classifying dissertations on topics that are fundamentally "German," but granted by programs such as Comparative Literature, Linguistics, or Education.

[6] The following chronological divisions proved most practical for our purposes: Medieval, Early Modern, Eighteenth Century, Classicism and Romanticism, Vormärz and Realism, Fin de siècle/Naturalism/Expressionism, Twentieth Century general, Weimar, Third Reich and Exile Literature, Postwar Germany, GDR, Postwar Austrian and Swiss, Film, Postcolonial and Migrant Literature, Comparative Studies, and Pedagogy.

Approaches were categorized as follows: Influence Studies; Thematic and/or Stylistic Studies, including genre; Images of Women or Men; Reception Studies; Life-and-Works Approaches, including biography and editions; Constructions of "Identity"; Postcolonial and Multicultural Perspectives.

The total number of pedagogical dissertations (3) as well as those whose approach was classified as Influence Studies (6) or Reception Studies (8) turned out to be too small to suggest any trend over a period of two decades.

[7] WiG-L <women_in_german@uclink4.berkeley.edu>

[8] Already by fall 1978, *Monatshefte* was able to document how widespread the phenomenon of "women's literature" courses had become and who was teaching them in various institutions. Unfortunately, the special survey does not distinguish between graduate and undergraduate courses ("Women in German Literature").

[9] Well before concerns about the "feminization of the profession" began to be heard, some colleagues considered the recruitment of women a promising solution to the dwindling of enrollments in the mid-1970s. Addressing "The Future of German Studies" from his position as graduate dean at the University of Cincinnati, Guy Stern described a plan evolved by himself, Ruth Angress, and Helga Slessarev for the recruitment of post-college-age women to the study of German (in part by offering FLES classes for their children) as a potential way to revive dwindling enrollments in language classes, to which he added his own advocacy of eased accessibility to graduate education on a part-time or special basis (129). The plan was directed toward maintaining the viability of graduate and undergraduate programs in German, not necessarily with the concomitant goal of increasing the representation of women in academic ranks.

[10] Given what we have noted elsewhere in this article about the difficulties of obtaining consistent data, it may be premature to draw conclusions from the numbers reported for the most recent years.

[11] Although not specifically concerned with research at the dissertation level, Ruth-Ellen Boetcher Joeres addresses both the gains and deficits of recent feminist scholarship on nineteenth-century German literature ("Scattered Thoughts").

[12] Teraoka's analysis relies on data from the Committee on Institutional Cooperation (CIC) and the *Digest of Education Statistics*. She dismisses what she calls "Blut und Boden" explanations for the lack of minorities in German, pointing out that the CIC statistics show that minority students do not strictly follow ethnic or racial lines in their choice of graduate specialization.

[13] Brod and Welles offer statistics that show a loss of 56.1% in German enrollments in the years since they reached their high point in 1970. Whereas German comprised 13.7% of foreign-language enrollments in 1980, by 1998 it had dropped to 7.5%. Total graduate enrollments (not just PhDs granted) in German, like undergraduate enrollments, dropped 32% from 1990 to 1998.

[14] In a 1994 article in *Profession,* Robert C. Holub raises serious criticisms of the use of the *Job Information List* as a gauge of employment opportunities that actually materialize ("Professional Responsibility").

[15] The report of the MLA Ad Hoc Committee on the Future of Scholarly Publishing deals with the competing pressures on university presses, caught as they are between declining sales, especially to libraries that face escalating outlays for serial publications in scientific fields; the loss of institutional support; and higher production costs. And in a letter sent to members of the organization in May 2002, MLA President Stephen Greenblatt addressed the resultant "maddening double bind" confronting probationary

faculty members who are expected to publish at least one scholarly book if they wish to achieve tenure. In his letter, Greenblatt called upon departments and universities to rethink these expectations, concluding: "[D]epartments can no longer routinely expect that the task of scholarly evaluation will be undertaken by the readers for university presses and that a published book will be the essential stamp of a young scholar's authenticity and promise."

Works Cited

Angress, Ruth K. "German Studies: The Woman's Perspective." *German Studies in the United States: Assessment and Outlook*. Ed. Walter F.W. Lohnes and Valters Nollendorfs. *Monatshefte* Occasional Volumes 1. Madison: U of Wisconsin P, 1976. 247–51.

Benseler, David P. "U.S. Doctoral Degrees Related to the Teaching of German: 2001." *Die Unterrichtspraxis* 35.2 (Fall 2002): 181–84.

Benseler, David P., and Suzanne Moore. "Doctoral Degrees Granted in Foreign Languages in the United States: 2001." *Modern Language Journal* 86 (2002): 423–39. <www.blackwellpublishers.co.uk.mlj/>

Blackwell, Jeannine. "Turf Management or Why Is the Great Tradition Fading?" *Monatshefte* 77.3 (1985). 271–85.

Brod, Richard, and Elizabeth B. Welles. "Foreign Language Enrollment in United States Institutions of Higher Education, Fall 1998." <http://www.adfl.projects/index.htm>

Broughton, Walter, and William Conlogue. "What Search Committees Want." *Profession 2001*. Ed. Phyllis Franklin. New York: MLA, 2001. 39–51.

Clausen, Jeanette, and Sara Friedrichsmeyer. "WIG 2000: Feminism and the Future of *Germanistik*." *Women in German Yearbook 10*. Ed. Jeanette Clausen and Sara Friedrichsmeyer. Lincoln: U of Nebraska P, 1995. 267–72.

Daley, Margaretmary. "Feminist Professionalism: A Brief, Critical History of the Coalition of Women in German." *Teaching German in Twentieth-Century America*. Ed. David Benseler, Craig W. Nickisch, and Cora Lee Nollendorfs. *Monatshefte* Occasional Volumes 15. Madison: U of Wisconsin P, 2001. 98–107.

Digest of Education Statistics. Washington, DC: United States Department of Health, Education, and Welfare, Education Division, National Center for Education Statistics. Annual volumes 1980–2001.

Fikes, Robert, Jr. "African-Americans Who Teach German Language and Culture." *Journal of Blacks in Higher Education* (Winter 2000–2001): 108–13.

Friedrichsmeyer, Sara, and Patricia Herminghouse. "The Generational Compact: Graduate Students and Germanics." *Women in German Yearbook 11.* Ed. Sara Friedrichsmeyer and Patricia Herminghouse. Lincoln: U of Nebraska P, 1995. 223–27.

———. "Toward an American Germanics? Feminism as a Force for Change." *Teaching German in Twentieth-Century America.* Ed. David Benseler, Craig W. Nickisch, and Cora Lee Nollendorfs. *Monatshefte* Occasional Volumes 15. Madison: U of Wisconsin P, 2001. 89–97.

Hoecherl-Alden, Gisela. "Female Immigrant Intellectuals in Germanics: From Invisibility to 'Women in German.'" *Teaching German in Twentieth-Century America.* Ed. David Benseler, Craig W. Nickisch, and Cora Lee Nollendorfs. *Monatshefte* Occasional Volumes 15. Madison: U of Wisconsin P, 2001. 108–20.

Holub, Robert C. "Graduate Education in German: Past Experiences and Future Perspectives." *The Future of Germanistik in the USA.* Ed. John A. McCarthy and Katrin Schneider. Nashville: Dept. of Germanic and Slavic Langs., Vanderbilt U, 1996.

———. "Professional Responsibility: On Graduate Education and Hiring Practices." *Profession 94.* Ed. Phyllis Franklin. New York: MLA, 1994. 79–86.

Huber, Bettina. "The MLA's 1991–92 Survey of PhD Placement: The Latest Foreign Language Findings and Trends through Time." *ADFL Bulletin* 26.1 (Fall 1994): 34–48.

Joeres, Ruth-Ellen B. "'Language Is Also a Place of Struggle': The Language of Feminism and the Language of American *Germanistik.*" *Women in German Yearbook 8.* Ed. Jeanette Clausen and Sara Friedrichsmeyer. Lincoln: U of Nebraska P, 1993. 247–57.

———. "Scattered Thoughts on Current Feminist Literary Critical Work in Nineteenth-Century German Studies." *Women in German Yearbook 17.* Ed. Patricia Herminghouse and Susanne Zantop. Lincoln: U of Nebraska P, 2001. 217–44.

Lawrence, David, Natalia Lusin, and Elizabeth Welles. "Count of Positions in the October 2002 MLA *Job Information List.*" *MLA Newsletter* (Spring 2003): 6–7.

MLA Ad Hoc Committee on the Future of Scholarly Publishing. "The Future of Scholarly Publishing." *Profession 2002.* Ed. Phyllis Franklin. New York: MLA, 2002. 172–86.

MLA Committee on the Status of Women in the Profession. "Women in the Profession 2000." *Profession 2000.* Ed. Phyllis Franklin. New York: MLA, 2000. 191–217.

Nagy, Ellen Manning. *Women in Germanics 1850–1950.* New York: Peter Lang, 1997.

Nollendorfs, Valters. "Out of Germanistik: Thoughts on the Shape of Things to Come." *Die Unterrichtspraxis* 27.1 (Spring 1994): 1–10.

NSF/NIH/NEH/USED/USDA. *Survey of Earned Doctorates.* Prepublication Tables for the *Summary Report 1998, Doctorate Recipients from United States Universities.* Nov. 1999. Appendix A, B. <www.nsf.gov/sbe/srs/srs00404/start.htm>.

Peters, George F., et al. "Report and Recommendations of the AATG Committee for the Recruitment and Retention of Minorities in German." *Die Unterrichtspraxis* 26.1 (1993): 97–98.

"PhD Survey." *MLA Newsletter* (Summer 1986): 14–15.

Schulz, Renate A. "Profile of the Profession: Results of the 1992 AATG Membership Survey." *Die Unterrichtspraxis* 26.2 (1993): 226–52.

Stern, Guy. "The Future of German Studies: A Graduate Dean's Perspective." *German Studies in the United States: Assessment and Outlook.* Ed. Walter F.W. Lohnes and Valters Nollendorfs. *Monatshefte* Occasional Volumes 1. Madison: U of Wisconsin P, 1976. 247–51.

Teraoka, Arlene. "Democratization of the Profession: Women and Minorities in German, 1971 to the Present." *German Studies in the USA: A Historical Handbook.* Gen. Ed. Peter Uwe Hohendahl. New York: MLA, forthcoming.

Welles, Elizabeth B. "From the Editor." *ADFL Bulletin* 34.1 (Fall 2002): 1–6.

"Women in German Literature and Culture: A Special Survey." *Monatshefte* 70.3 (Fall 1978): 291–308.

Feminist Doctoral Dissertations in Germanics in US Universities: 1980–2002
(Advisors in Parentheses)

Abdullah, Mary C.G. "The Influence of Lou Andreas-Salomé and Her Writings on Rainer Maria Rilke between 1897 and 1905." Massachusetts, 1994 (Sigrid Bauschinger).

Abel, Brigetta M. "Identities in Flux: The Exile Novels of Adrienne Thomas, Irmgard Keun, and Anna Seghers." Minnesota, 1999 (Ruth-Ellen B. Joeres).

Abraham, Ruth A.D. "Mechthild of Magdeburg's 'Flowing Light of the Godhead': An Autobiographical Realization of Spiritual Poverty." Stanford, 1980 (Gerald Gillespie).

Ahrends, Maike. "Kaza Gecirmek: Having Accidents in Life-Identity Constructions between Cultures: The Prose Texts by Aysel Özakin, Renan Demirkan, and Emine Sevgi Özdamar." Michigan, 1999 (Julia Hell).

Allan, Lorelei. "Naturalists and the Woman Question: Images of Middle-Class *Emanzipierte* in German and Scandinavian Drama." Brown, 1982 (Frederick Love).

Allen, Julie D. "Determining Their Own Destiny: The Portrayal of Women's Emancipation in Lou Andreas-Salomé's *Fenitschka* and Arthur Schnitzler's *Frau Berta Garlan.*" U of Washington, 1996 (Sabine Wilke).

Ametsbichler, Elizabeth. "Society, Gender, Politics, and Turn-of-the-Century Theatre: Elsa Bernstein (Ps. Ernst Rosmer) and Arthur Schnitzler." Maryland, 1992 (Elke Frederiksen).

Anderson, Martina Sigrid. "Addressing Epistolary Subjects." Minnesota, 2000 (Ruth-Ellen B. Joeres).

Ankum, Katharina von. "The Reception of Christa Wolf's Works in the GDR and the FRG (1961–74)." Massachusetts, 1990 (Sara Lennox).

Archangeli, Melanie. "*Das Wochenblatt fürs schöne Geschlecht*: A Sociohistorical and Literary Analysis of an Eighteenth-Century Periodical for Women." Michigan, 1995 (Frederick Amrine).

Arons, Wendy. "Sophie Goes to the Theater: Performances of Gender and Identity in Eighteenth-Century German Women's Writing." California, San Diego, 1997 (Todd Kontje).

Atkinson, Ursula. "Befreiung aus den Fesseln der Vergangenheit: Ausgewählte Romane von Anja Lundholm." Rutgers, 1998 (Johanna Ratych).

Atterholt, Judy J. "Gender, Ethnicity, and the Crisis of Representation in Else Lasker-Schüler's Early Poetry and Prose." Stanford, 1993 (Russell Berman).

Aures, Inge E. "'Komm, sieh die Welt mit meinen Augen': Ehe/Paare im Exil: Ein Vergleich der weiblichen mit den männlichen Perspektiven in Exilautobiographien." Vanderbilt, 1997 (Helmut Pfanner).

Baackmann, Susanne. "'Erklär mir Liebe': Weibliche Schreibweisen von Liebe in der Gegenwartsliteratur." California, Berkeley, 1993 (Anton Kaes).

Baer, Hester. "Gender, Spectatorship, and Visual Culture in West Germany, 1945–62." Washington U, 2000 (Paul M. Lützeler).

Bäumer, Konstanze C. "*Goethes Briefwechsel mit einem Kinde*: Ein weiblicher Bildungsroman des 19. Jahrhunderts." California, Davis, 1983 (John Fetzer).

Bahrawy, Lisa de Servine. "An Exegesis of Selected Short Stories from Ingeborg Bachmann's *Das dreißigste Jahr* and *Simultan* from the Perspective of Austrian History." Harvard, 1987 (Gail Finney).

Baumgartner, Karin. "'She Passes Judgment as Would a Man': Political Discourse in the Novels of Caroline de la Motte Fouqué." Washington U, 1999 (Paul M. Lützeler).

Belgum, Kirsten. "Interior Meaning: Design of the Bourgeois Home in the Realist Novel." Wisconsin, 1989 (Jost Hermand).

Bennett, Timothy A. "The Symbolic Figure of the 'Renaissance Woman' in Cultural Context: Selected Italian Novellas of Paul Heyse, Isolde Kurz, and Heinrich Mann." Johns Hopkins, 1985 (Lieselotte Kurth and William McClain).

Benthin, Karin. "Malvida von Meysenbug: Eine Untersuchung zur Selbst- und Weltdarstellung in den *Memoiren einer Idealistin*." State U of New York, Stony Brook, 1983 (Barbara Elling).

Benz, Beate C. "Mädchen, Mütter, Machtweiber: Untersuchungen zum Frauenbild im Drama des Sturm und Drang." Rutgers, 1985 (John Fitzell).

Berwald, Olaf. "Visuelle Gewalt und Selbstverlust bei Günderrode, Hölderlin und Fichte." North Carolina, 2000 (Alice Kuzniar).

Bilsky, Lisa. "Adrienne Thomas, Gertrud Isolani, and Gabriele Tergit: German-Jewish Women Writers and the Experience of Exile." Wisconsin, 1994 (Jost Hermand).

Blackwell, Jeannine. "*Bildungsroman mit Dame*: The Heroine in the German 'Bildungsroman' from 1770 to 1900." Indiana, 1982 (Henry Remak).

Blickle, Peter. "Die Kunst der scheinbaren Kunstlosigkeit: Maria Beigs Texte der achtziger Jahre und ihre Rezeption." Michigan, 1994 (Marilyn Fries).

Bode, Gerlind E. "Where Are Shakespeare's Sisters Today? A Comparative Study of Contemporary American and German Women Dramatists." Maryland, 1984 (John Fuegi).

Böhler-Dietrich, Annette. "Theaterentwürfe deutschsprachiger Autorinnen im 20. Jahrhundert." Virginia, 2000 (Renate Voris).

Bohler, Lisette. "Der Mythos der Weiblichkeit im Werke Max Frischs." California, Los Angeles, 1995 (Hans Wagener).

Borella, Sara S. "Voicing the Difference: Contemporary Swiss Women Writers." Brandeis, 1993 (Jane Hale).

Borisoff, Deborah J. "Changing Aspects in Twentieth-Century Faustian Works: The Woman as Illuminator and Liberator of the Isolated Hero." New York U, 1981 (Doris Guilloton).

Bos, Pascale. "Writing against Objectification: German Jewish Identity in the Works of Grete Weil and Ruth Klüger." Minnesota, 1998 (Jack Zipes).

Bothe, Britta. "Love and Work in Irmtraud Morgner's Salman Novels." California, Los Angeles, 1995 (Ehrhard Bahr).

Bower, Kathrin M. "In the Name of the (M)other? Articulating an Ethics of Memory in the Post-Holocaust Poetry of Nelly Sachs and Rose Ausländer." Wisconsin, 1994 (Nancy Kaiser).

Braddock, Katherine L. "Questioning the Authority in History: The Father Biographies in a Postmodern Context." Washington U, 1991 (Paul M. Lützeler).

Braker, Regina. "Bertha von Suttner's *Die Waffen nieder!*: Moral Literature in the Tradition of Harriet Beecher Stowe's *Uncle Tom's Cabin*." Ohio State, 1991 (Charles Hoffmann).

Bramkamp, Agatha C. "Marie von Ebner-Eschenbach and Her Critics." Cornell, 1984 (Inta Ezergailis).

Brantly, Susan C. "The Life and Writings of Laura Marholm." Yale, 1987 (George Schoolfield).

Braunbeck, Helga G. "Autorschaft und Subjektgenese: Christa Wolfs *Kein Ort. Nirgends*." California, Santa Barbara, 1990 (Laurence Rickels).

Brauner, Sigrid M. "Frightened Shrews and Fearless Wives: The Concept of the Witch in Early Modern German Texts (1487–1560)." California, Berkeley, 1989 (Elaine Tennant).

Braunsdorf, Lynn. "Self-Actualization in Representative Works of Marie von Ebner-Eschenbach." Pennsylvania, 1992 (Horst Daemmrich).

Brewer, Cindy Patey. "Reading Narrative Relief in Novels by Sophie Mereau, Friederike Helene Unger, and Johanna Schopenhauer." Utah, 1998 (Martha Helfer).

Brunner, Edda S. "Sprache, Ideologie und Praxis in Kleists *Marquise von O...*: Spannungsmomente und gesellschaftliche Machtverhältnisse." California, Berkeley, 1990 (Bluma Goldstein).

Bubser-Wildner, Siegrun T. "'Der Traum nach vorwärts': Utopie als funktionaler Prozess in Irmtraud Morgners Roman *Leben und Abenteuer der Trobadora Beatriz*." Iowa, 1996 (Wolfgang Ertl).

Burns, Sigrid A. "Frauen zwischen Natur-Magie und Emanzipation." Washington U, 1984 (Egon Schwarz).

Cannon, Sue S. "The Medicine of Hildegard of Bingen: Her Twelfth-Century Series and Their Twentieth-Century Appeal as a Form of Alternative Medicine." California, Los Angeles, 1993 (Donald J. Ward).

Caprio, Temby M. "Women's Film Culture in the Federal Republic of Germany: Female Spectators, Politics and Pleasure from the Fifties to the Nineties." Chicago, 1999 (Katherine Trumpener).

Carr, Richard. "The Mythology of Fundamental Social Transformation: Christa Wolf's *Medea* (1996) in the Tradition of Her *Kassandra* (1983)." Virginia, 2001 (Lorna Martens).

Carstens, Belinda. "Prostitution in the Works of Ödön von Horváth." North Carolina, 1980 (Siegfried Mews).

Carter, Alicia L. *"Fremde Pflanzen:* The Gendered Gardens of Adalbert Stifter and Theodor Fontane." Ohio State, 2002 (Barbara Becker-Cantarino).

Chew, Jane S. "The Theme of Adultery in the Novels of Theodor Fontane." Pennsylvania State, 1980 (Manfred Keune).

Christensen, Kirsten M. "In the Beguine Was the Word: Mysticism and Catholic Reformation in the Devotional Literature of Maria van Hout (†1547)." Texas, 1998 (David Price).

Condray, Kathleen. "'Das Gehirn unsrer lieben Schwestern': Women Writers of the Journal *Jugend* from 1919 to 1940." Illinois, 2001 (Karl-Heinz Schoeps).

Cormican, Muriel. "Sex, Sexuality, and Gender: Cultural Critique in the Fictional Works of Lou Andreas-Salomé." Indiana, 1999 (William Rasch).

Cox, Judith H. "The Female Adolescent in East German Literature." Texas, 1986 (Hans-Bernhard Moeller).

Cullens, Christine. "'Female Difficulties': Novels by English and German Women, 1755-1814." Stanford, 1989 (Bliss Carnochan).

Dabak, Shabangi. "Images of the Orient in the Travel Writings of Ida Pfeiffer and Ida Hahn-Hahn." Michigan State, 1999 (George Peters).

Davis, Emily. "The Bride as Symbol: Mechthild von Magdeburg and the Logic of Mysticism." Washington U, 2002 (James Poag).

Deiulio, Laura C. "The Promise and the Body: Marriage in German Literature around 1800." Princeton, 2000 (Stanley Corngold).

Della Rossa, Denise M. "'Was sollen unsre Töchter lesen?': Literature and Literary Criticism in the German Women's Periodical Press, 1848-1919." Wisconsin, 2002 (James Steakley).

Denman, Mariatte C. "Staging the Nation: Representations of Nationhood and Gender in Plays, Images and Film in Postwar West Germany (1945-49)." California, Davis, 1978 (Anna Kuhn).

Dernedde, Renate. "Muttergestalten und Mutter-Tochter-Beziehungen in deutschsprachiger Prosa." New York U, 1992 (Margaret Herzfeld-Sander).

Devinney, Margaret. "Text and Community: A Consideration of the Legends of Gertrud von Le Fort." Pennsylvania, 1986 (Frank Trommler).

Diakun, Gertrud. "Märtyrertum und Selbstmord: Frauengestalten in Lohensteins Trauerspielen." State U of New York, Buffalo, 1983 (Erika Metzger).

Dillmann, Gabriele. "What Cannot Be Remembered Cannot Be Left Behind: A Self-Psychological Interpretation of Ingeborg Bachmann's Work." California, Los Angeles, 2000 (Janet R. Hadda).

Dillon, Ernestine. "'Adelige, Bürgerliche, Wirtin, Bäuerin, Wirtschafterin, Magd, Aussenseiterin, Waldfee...': Frauen in ausgewählten Prosawerken von Peter Rossegger." Indiana, 1998 (Giles Hoyt).

Dolan, Judith A. "Performing Theory on Designing Men: The Subversive Role of the Woman-Director-Designer." Stanford, 1996 (Carl Weber).

Drescher, Barbara. "The Vanishing Female Protagonists in the Weimar, Exile, and Postwar Fiction of Irmgard Keun, Dinah Nelken, and Ruth Lanshoff-Yorck." Minnesota, 2001 (Arlene Teraoka).

Drossel-Brown, Cordula. "Zeit und Zeitwahrnehmung in der deutschsprachigen Lyrik der 50er Jahre: Marie Luise Kaschnitz, Ingeborg Bachmann, Christine Lavant." Vanderbilt, 1992 (Hans Schulz).

Duffaut, Rhonda R. "Beyond Definition: Language, Games, Gender, and Nationality in Ingeborg Bachmann's Prose." California, Irvine, 1997 (John Smith).

Dundzila, Audrius V. "Maiden, Mother, Crone: Goddesses from Prehistory to European Mythology and Their Reemergence in German, Lithuanian, and Latvian Romantic Dramas." Wisconsin, 1991 (Reinhold Grimm).

Duplantier, Rebecca. "Amazon Figures in German Literature: The Theme and Variations in the Nineteenth and Twentieth Centuries." Ohio State, 1992 (Mark Roche).

Eggert, Doris M. "(Gem)einsame Standpunkte: Androgynie in der Literatur mit Schwerpunkt auf deutschsprachigen Veröffentlichungen von Frauen nach 1945." Rutgers, 1999 (Hildburg Herbst).

Eidecker, Martina E. "Von der sozialistischen Utopie zur Verlustanzeige: Irmtraud Morgners verzweifelt-lustvolle Suche nach Sinn." California, Los Angeles, 1995 (Kathleen Komar).

Eldh, Åsa. "The Mother in the Work and Life of Peter Weiss." Brandeis, 1988 (Eberhard Frey).

Emonds, Friederike B. "Gattung und Geschlecht: Inszenierung des weiblichen in Dramen deutschsprachiger Theaterschriftstellerinnen." California, Davis, 1994 (Gail Finney).

Evans, Catherine A. "Charlotte Birch-Pfeiffer: Dramatist." Cornell, 1982 (Inta Ezergailis).

Felden-Archibald, Tamara. "Reiseliteratur von Vormärzlerinnen: Zur literarischen Repräsentation der Geschlechterrollenerfahrung." Maryland, 1990 (Elke Frederiksen).

Fields, Hanna S. "Mythologie und Dialektik in Ilse Aichinger's *Die grössere Hoffnung*." Texas, 1991 (Hans-Bernhard Moeller).

Foell, Kristie. "Blind Reflections: Gender in Elias Canetti's *Die Blendung*." California, Berkeley, 1992 (Winfried Kudszus).

Foley-Beining, Kathleen. "Physicality and Women's Eucharistic Devotion in Catharina Regina von Greiffenberg's *Andächtige Betrachtungen*: 'Von Marien Schwanger-Gehen' and the 'Abendmahls-Andachten.'" California, Los Angeles, 1992 (Hans Wagener and Kathleen Komar).

Fox, Thomas C. "Louise von François: Between *Frauenzimmer* and *A Room of One's Own*." Yale, 1983 (Jeffrey Sammons).

Frame, Lynn-Marie H. "Forming and Reforming the New Woman in Weimar Germany." California, Berkeley, 1997 (Anton Kaes).

Francis-Stack, Aine M. "The Portrayal of the Child and Childhood in Selected Works of Marie Luise Kaschnitz." Kansas, 2000 (Leonie Marx).

Frantz, Barbara F. "Gertrud Kolmar's Prose Stories about Inferiority, Violence, Social Impotence, Maternal Bonds, and the Boundaries of the Self." California, Santa Barbara, 1995 (Ursula Mahlendorf).

Fraunhofer, Hedwig. "Postpaternalism and the Fear of the Feminine: The Economic and the Erotic in Strindberg, Brecht, Giraudoux, and Sartre." Oregon, 1995 (Linda King).

French, Loreley. "Bettina von Arnim and the Development of Epistolary Aesthetics by German Women: An Analysis of Theory and Practice." California, Los Angeles, 1986 (Wolfgang Nehring).

French, Shelley S. "The Narrator's Portrayal of the Women in Goethe's *Wilhelm Meisters Lehrjahre*." Illinois, 1992 (Harry Haile).

Führich, Angelika. "Aufbruch der geopferten Heldinnen: Zum Frauenbild im Drama der Weimarer Republik." Pennsylvania, 1989 (Frank Trommler).

Fullard, Katja C. "Maria Magdalena, Mutter und Medusa: Das Bild der Frauen in den Werken von Dieter Wellershoff." Florida, 1996 (Keith Bullivant).

Gaettens, Marie-Luise. "Recalling Fascism: A Critique of Patriarchy in Contemporary German Women's Literature." Texas, 1986 (Barbara Becker-Cantarino).

Ganeva, Mila. "A Forgotten History of Modernity: Fashion in German Literature, the Illustrated Press, and Photography, 1918–33." Chicago, 2000 (Katherine Trumpener).

Gaus, Linda. "*Zuo nutz und heylsamer ler*: Representations of Women in Early Modern German Satire." California, Berkeley, 1995 (Elaine Tennant).

Gehlker, Marion. "Blurring Gender Boundaries: Desire, the Body and Writing in Ingeborg Bachmann's *Simultan* Cycle." New York U, 1998 (Bernd Hüppauf).

Geiger, Gerlinde M. "Die befreite Psyche: Emanzipationsansätze im Frühwerk Ida Hahn-Hahns, 1838–1848." Massachusetts, 1984 (Susan Cocalis).

Gelbin, Catherine S. "The Indelible Seal: Race, Hybridity, and Identity in Elisabeth Langgaesser's Writings." Cornell, 1997 (Sander Gilman).

Gerstenberger, Katharina. "Writing Herself into the Center: Centrality and Marginality in the Autobiographical Writings of Nahida Lazarus, Adelheid Popp, and Unica Zuern." Cornell, 1993 (Peter Uwe Hohendahl).

Gerstle, Dorrit. "Das Frauenbild bei Heinrich Böll." City U of New York, 1984 (Martin Anderle).

Gill, Gudrun. "Die Utopie Hoffnung bei Luise Rinser: Eine sozio-psychologische Studie." Southern California, 1988 (Cornelius Schnauber).

Girtler, Rosalinde. "Feministische Gesellschaftskritik in Friederike Roths Dramen." Ohio State, 1995 (Dagmar Lorenz).

Gjestvang, Ingrid L. "Machtworte: Geschlechterverhältnisse und Kommunikation in dramatischen Texten (Lenz, Hauptmann, Bernstein, Streeruwitz)." Wisconsin, 1998 (Klaus Berghahn).

Gluck, Jolan. "Betty Paoli: Die Dichterin als Spiegel ihres Jahrhunderts." City U of New York, 1988 (Allen McCormick).

Gokhale, Vibha. "Looking Beyond the Traditional Images of Women in Theresa Huber's Short Prose Narratives." Michigan State, 1992 (Karin Wurst).

Goldschen, Anna. "Bettine von Arnim's Child Persona and Female Development in Her Fairy Tale Novel *Das Leben der Hochgräfin Gritta von Rattenzuhausbeiuns*." California, Santa Barbara, 1986 (Ursula Mahlendorf).

Gölz, Sabine. "*Legenda Femina*: Die verschwindende Poetik der Ingeborg Bachmann." Cornell, 1987 (Sander Gilman).

Gonglewski, Margaret R. "A Discourse-Analytic Investigation of Deixis in Anna Seghers' *Der Ausflug der toten Mädchen*: Oscillating Place, Time, and Person." Georgetown, 1995 (Heidi Byrnes).

Good, Charles F. "Domination, Dependence, Denial and Despair: The Father-Daughter Relationship in Dramas by Grillparzer, Hebbel, and Hauptmann." Purdue, 1990 (Christiane Keck).

Goozé, Marjanne E. "Bettina von Arnim, the Writer." California, Berkeley, 1984 (Winfried Kudszus).

Gordon, Terri J. "The Aesthetics of the *Demi-Nu*: Modernist Representations of the Dancer in Paris and Berlin from the *Fin de Siècle* to the Nazi Period." Columbia, 2000 (Andreas Huyssen).

Gorla, Gudrun. "Marie von Ebner-Eschenbach: 100 Jahre später. Eine Analyse aus der Sicht des ausgehenden 20. Jahrhunderts mit Berücksichtigung der Mutterfigur, der Ideologie des Matriarchats und formaler Aspekte." Rutgers, 1997 (Erna Neuse).

Gracanin, Maja. "'Über allen Menschen und Dingen lag...ein Hauch von Zwiespältigkeit': Dualism and Division in the Novels of Marlen Haushofer." Cincinnati, 2001 (Jerry Glenn).

Granger, Christine. "A Student of Standard German Two Hundred Years Ago: Sophie von Laroche and Wieland's Edition of Her Last Work." State U of New York, Stony Brook, 1992 (Barbara Elling).

Green, Anne M. "The Women in the Novellas of Clemens Brentano." Illinois, 1994 (James McGlathery).

Grießhaber-Weninger, Christl. "Literatur, Rasse und Geschlecht: Eine Studie zum Diskurs um die Jahrhundertwende." Washington U, 1998 (Lynne Tatlock).

Grollman, Stephanie. "Das Bild des 'Anderen' in den Tagebüchern und Reiseberichten Luise Rinsers." Iowa, 1998 (Wolfgang Ertl).

Grothe, Anja. "The Re-Inscription of Female Antiquity by Contemporary Russian and German Women Authors." City U of New York, 2000 (Amy Mandelker).

Grove, Vickie. "The Burden of Exemplaries: Three Eighteenth-Century Heroines." Princeton, 1982 (Stanley Corngold).

Guenther, Christina E. "Sexual and Textual Politics Reconsidered: Kleist's *Amphitryon* and *Marquise von O* vs. their Adaptations in the 1960s." Wisconsin, 1990 (Jost Hermand).

Gulielmetti, Angela. "Berthold Auerbach and the German Nation: Educating the Male Citizen." Washington U, 1999 (Robert Weninger).

Hanssen, Paula J. "Elisabeth Hauptmann: Brecht's Silent Collaborator." Illinois, 1993 (Karl-Heinz Schoeps).

Harnisch, Antje. "Geschlecht, Sexualität und Familie: Untersuchungen zum Realismus Gottfried Kellers, Wilhelm Raabes und Theodor Fontanes." Wisconsin 1992 (Klaus Berghahn).

Harris, Judith. "Modes of Domination: The Social Dimension of Ingeborg Bachmann's Fiction." California, Berkeley, 1983 (Andrew Jaszi).

Harrison, Mette I. "Irony, Utopia, and Beyond: A Critique of Bourgeois Gender Polarity in Two Late Eighteenth-Century *Bildungsromane*." Princeton, 1995 (Eric Santner and Sylvia Schmitz-Burgard).

Harwell, Xenia S. "Images of the Female Adolescent in Exile in Select Works of Russian and German Women Writers." Tennessee, 1997 (Carolyn Hodges).

Hayworth, Amy J. "An Ecofeminist Perspective: Ecology and Feminism in the Works of Reinig, Maron, Morgner, and Wolf." Illinois, 2000 (Karl-Heinz Schoeps).

Heckner, Elke. "Unruly Bodies: *Geschlecht* in Kleist, Hegel, Freud, and Brecht." Johns Hopkins, 2000 (Rainer Nägele).

Hedgepeth, Sonja M. "'Everywhere I Search for a Homeland': Exile in the Works of Else Lasker-Schüler." Pennsylvania State, 1991 (Ernst Schürer).

Hedstrom, Elke. "Margarethe Susanne von Kuntsch (1651–1717): Leben und Werk." Kansas, 1987 (Helmut Huelsbergen).

Heinemann, Marlene E. "Women Prose Writers of the Nazi Holocaust." Indiana, 1981 (Henry Remak).

Heinigk, Penelope. "The Other Side of the Tracks: Representations of Gender in Early Railroad Turmoil." Oregon, 2001 (Karla Schultz).

Heinrichsdorff, Amelie. "Nur eine Frau? Kritische Untersuchungen zur literaturwissenschaftlichen Vernachlässigung der Exilschriftstellerinnen in Los Angeles: Ruth Berlau, Marta Feuchtwanger, Gina Kaus und Victoria Wolff." California, Los Angeles, 1998 (Ehrhard Bahr).

Hell, Julia. "Crisis Strategies: Family Narratives, Gender, and the Literary Representation of German History." Wisconsin, 1989 (Klaus Berghahn).

Hempel, Nele. "Marlene Streeruwitz: Eine kritische Einführung in das dramatische Werk unter besonderer Berücksichtigung von Gewalt und Humor." Massachusetts, 1998 (Susan Cocalis).

Henderson, Heike H. "Re-Reading and Re-Writing Multiculturalism: Turkish Women Writers in Germany." California, Davis, 1997 (Anna Kuhn).

Henschel, Rebecca A. "The National Socialist Past in Women's Novels of the 1970s and 1980s." North Carolina, 1998 (David Pike).

Herrmann, Anne. "Towards a Female Dialogic: Virginia Woolf and Christa Wolf." Yale, 1983 (Peter Brooks and Ingeborg Glier).

Herrmann, Karin U. "Frau—Körper—Natur: Ein Diskurs wider die Natürlichkeit." U of Washington, 1993 (Sabine Wilke).

Hock, Lisabeth M. "Replicas of a Female Prometheus: The Textual Personae of Bettina von Arnim." Washington U, 1998 (Lynne Tatlock).

Hoffmann, Pamela E. "Ingeborg Drewitz: Die Bedeutung ihrer sozialpädagogischen und literaturtheoretischen Essays mit Ausblick auf ihre Romanproduktion." New York U, 1988 (Margaret Herzfeld-Sander).

Holmgren, Janet B. "'*Die Horen* haben jetzo wie es scheint ihr weibliches Zeitalter...': The Women Writers in Schiller's *Horen*—Louise Brachmann, Friederike Brun, Amalie von Imhoff, Sophie Mereau, Elisa von der Recke, and Caroline von Wolzogen." California, Irvine, 2000 (Meredith Lee).

Hoober, Gudrun. "The Dual Nature of Victimization: A Study of Four Women in Gerhart Hauptmann's *Rose Bernd* and Theodor Fontane's *Effi Briest*." Oregon, 1996 (Elke Liebs).

Howells, Christa V. "Heimat und Exil: Ihre Dynamik im Werk von Hilde Spiel." Rice, 1994 (Michael Winkler).

Huener, Rachael A. "*Reklamemarken* in Wilhelmine Germany: Consuming Fictions." Minnesota, 2001 (Gerhard Weiss).

Hunt, Irmgard E. "Mütter und Muttermythos in Günter Grass' Roman *Der Butt*." U of Washington, 1982 (Linda Hill).

Hutchison, Catherine. "The Narrator's Tale: Christa Wolf and the Reader in the Text." Michigan, 1994 (Anne Herrmann).

Hyner, Bernadette. "Exploring I's: Reflection and the Self in Works by Sophie von La Roche and Elisa von der Recke." Vanderbilt, 2001 (John McCarthy).

Iman-Loch, Lynda M. "Barbara Frischmuth's 'Sternweiser Trilogy' and the Co-Creation of New Social Models." Nebraska, 1999 (Robert Shirer).

Ingham, Marion F. "The Goddess Freyja and Other Female Figures in Germanic Mythology and Folklore." Cornell, 1985 (Alan Berger).

Jackson, Laura M. "Negotiating Identity: Mother-Daughter Relationships in Novels by Jutta Heinrich, Elfriede Jelinek, Waltraud Anna Mitgutsch, and Helga Novak." U of Washington, 1996 (Sabine Wilke).

Jaeger, Dagmar. "Theater im Medienzeitalter: Das postdramatische Theater von Elfriede Jelinek und Heiner Müller." Massachusetts, 2001 (Sara Lennox).

Jankowsky, Karen H. "Unsinn/Anderer Sinn/Neuer Sinn: Zur Bewegung im Denken von Christa Wolfs *Kassandra* über den Krieg und die 'Heldengesellschaft.'" Washington U, 1986 (Paul M. Lützeler).

Janzon, Anjouli E. "Contested Historiography: Women Writers of Spain and the Former German Democratic Republic." California, Berkeley, 1998 (Dru Dougherty).

Jarvis, Shawn C. "Literary Legerdemain and the 'Märchen' Tradition of Nineteenth Century German Women Writers." Minnesota, 1990 (Ruth-Ellen B. Joeres).

Jeep, Lynda H. "Feminist Intertextuality: Fiction by Contemporary Argentine and German Women Writers." Chicago, 1994 (Clayton Koelb).

Jernigan, Harriett V. "The Descending March of Humanity: Masochism and the Modernist Imaginary." Stanford, 1998 (Russell Berman).

Jirku, Brigitte E. "Von Frauen verfaßter Roman des 18. Jahrhunderts: Ich-Erzählerin und Erzählstruktur." Wisconsin, 1990 (Klaus Berghahn).

Johnson, Christa C. "Engendering Space: Architectures of Sexual Difference in Early Twentieth-Century Germany." Stanford, 1997 (Russell Berman).

Justis, Diana L. "The Feminine in Heine's Life and Oeuvre: Self and Other." Cornell, 1993 (Peter Uwe Hohendahl).

Kaleyias, George P. "Reflections of History: The Stories of Anna Seghers in Weimar Germany and in Exile, 1924–1947." Maryland, 1981 (Peter Beicken).

Kallin, Britta. "Staging Ethnicity, Gender, and Nation: German-Language Drama by Female Playwrights (1990–96)." Cincinnati, 2000 (Sara Friedrichsmeyer).

Kassouf, Susan M. "Writing Masculinities around 1800." Cornell, 1996 (Carolyn A. Martin).

Kautz, Elizabeth A. "The Fruits of Her Labor: Working Women and Popular Culture in the Weimar Republic." Minnesota, 1997 (Richard McCormick).

Kepple, Amy. "Imaging the Body in Contemporary Women's Poetry: Helga Novak, Ursula Krechel, Carolyn Forché, Nikki Giovanni." Ohio State, 1991 (Helen Fehervary).

Keyek-Fransen, Deborah. "The Fantastic GDR: Four Narratives by Christa Wolf." Michigan, 1996 (Marilyn Sibley-Fries and Hermann Weiss).

Kingsbury, Alice V. "The Writings of Christa Wolf: From Objective to Subjective Authenticity." Michigan State, 1981 (Thomas Falk).

Kirby, William B. "'Dein und mein Gedächtnis ein Weltall': A Metahistorical Avenue into Marie-Thérèse Kerschbaumer's Literary World of Women." Massachusetts, 1998 (Sigrid Bauschinger).

Klages, Norgard. "Childhood Memories in Women's Autobiographical Writings of the 1970s and 1980s." North Carolina, 1992 (Alice Kuzniar and Siegfried Mews).

Klei, Mary W. "Clara Viebig's Eifel Works, 1897–1925: Evaluation of Her View of Society with Consideration of her Place in the Female Tradition." Cincinnati, 1989 (Helga Slessarev).

Klotz, Marcia. "White Women and the Dark Continent: Gender and Sexuality in German Colonial Discourse from the Sentimental Novel to the Fascist Film." Stanford, 1995 (Russell Berman).

Komm, Katrin G. "Gender, Nation, and the Modern: Hedwig Dohm and Elizabeth von Arnim in Germany around 1900." Maryland, 1999 (Elke Frederiksen).

Kord, Susanne. "Ein Blick hinter die Kulissen: Deutschsprachige Dramatikerinnen im 18. und 19. Jahrhundert." Massachusetts, 1990 (Susan Cocalis).

Koré, Cléa E. "Decadence and the Feminine: The Case of Leopold von Sacher-Masoch." Stanford, 1983 (Gerald Gillespie).

Kosta, Barbara K. "Personal Histories: Autobiography and Female Identity in Contemporary German Literature and Film." California, Berkeley, 1989 (Anton Kaes).

Krause-Soriano, Sigrun. "Weibliche Tugend und männlicher Mut: Auseinandersetzung mit zeitgenössischen Normen im Leben und Werk Johanna Schopenhauers." Rutgers, 1999 (Hildburg Herbst).

Kreide, Caroline. "Lou Andreas-Salomé: Feministin oder Antifeministin? Eine Standortbestimmung zur wilhelminischen Frauenbewegung." California, Berkeley, 1992 (Robert Holub).

Krick, Kirsten A. "History in Fiction: Ingeborg Bachmann and the Folktale Tradition." California, Santa Barbara, 1996 (Torborg Lundell).

Krimmer, Elisabeth. "Offiziere und Amazonen: Frauen in Männerkleidung in der deutschen Literatur um 1800." Massachusetts, 1998 (Susan Cocalis).

Krol, Monika. "Women Writers and Social Change in the Former GDR after the *Wende*: Gabriele Stötzer, Christa Wolf and Sarah Kirsch." California, Los Angeles, 1996 (Ehrhard Bahr).

Kuechelmann, Nancy. "Narrative Perspective and Thematic Issue in Selected Short Prose Works of Marie von Ebner-Eschenbach." Rutgers, 1994 (Joanna Ratych).

Kuehnel, Irmeli S. "Reinhard Fuchs: A Gendered Reading." Maryland, 1995 (Gabriele Strauch).

Kuhn, Elisabeth D. "Gender and Authority: Classroom Diplomacy in Frankfurt and Berkeley." California, Berkeley, 1989 (Robin Lakoff).

LaBahn, Kathleen J. "Anna Seghers' Exile Literature: The Mexican Years (1941–1947)." Washington U, 1983 (Paul M. Lützeler).

Labovitz, Esther K. "The Female 'Bildungsroman' in the Twentieth Century, A Comparative Study: Dorothy Richardson, Simone de Beauvoir, Doris Lessing, Christa Wolf." New York U, 1982 (Margaret Herzfeld-Sander).

Lamb-Faffelberger, Margarete B. "Elfriede Jelinek und Valie Export: Rezeption der feministischen Avantgarde Österreichs im deutschsprachigen Feuilleton." Rice, 1991 (Margret Eifler).

Larson-Thorisch, Alexa. "Was It Rape? Sexual Violence and the Construction of Gender in Legal-Medical and Literary Discourse (1770–1810)." Wisconsin, 1994 (Jost Hermand and Nancy Kaiser).

Lashgari, Mahafarid. "Schiller's Gender Theory in His Classical Discourse." California, Los Angeles, 1995 (Ehrhard Bahr).

Lassahn, Elke H.R. "Bodies at Court: Experiencing the Body in the Context of *Minne* and Chivalry in Wolfram von Eschenbach's *Parzival*." Pennsylvania State, 1998 (Francis Gentry).

Lefko, Stefana. "Female Pioneers and Social Mothers: Novels by Female Authors in the Weimar Republic and the Construction of the New Woman." Massachusetts, 1998 (Susan Cocalis).

Lenckos, Frauke E. "The Marvelous and the Sublime: The Aesthetics of Nineteenth-Century German and British Women Poets, Annette von Droste-Hülshoff and Christina Rossetti." Michigan, 1997 (Martha Vicinus).

Libbon, Stephanie. "Frank Wedekind's Fantasy World: A Theater of Sexuality." Ohio State, 2000 (Barbara Becker-Cantarino).

Loentz, Elizabeth. "Negotiating Identity: Bertha Pappenheim (Anna O.) as German-Jewish Feminist, Social Worker, Activist, and Author." Ohio State, 1999 (Dagmar Lorenz).

Lohmeyer, Enno. "Marie von Ebner-Eschenbach als Sozialreformerin." Kansas, 2001 (Leonie Marx).

Love, Myra N. "'Das Spiel mit offenen Möglichkeiten': Subjectivity and the Thematization of Writing in the Works of Christa Wolf." California, Berkeley, 1983 (Bluma Goldstein).

Luscher, Jean A. "The Rhetoric of Female Confession: An Investigation of Female Religious Self-Expression in Selected German Confessional Autobiographies and *Bekenntnisse,* 1698–1806." Indiana, 1997 (Ferdinand Piedmont).

Mabee, Barbara. "Geschichtsbewußtsein und Erinnerungsspuren in der Lyrik von Sarah Kirsch: Eine Analyse ihrer Bildersprache." Ohio State, 1988 (Hugo Bekker).

MacLeod, Catriona. "Fictions of Androgyny in the German *Bildungsroman*." Harvard, 1992 (Dorrit Cohn).

Madhyastha, Rosemarie S. "Die Frau als Bildungsobjekt in den deutschen und englischen moralischen Wochenschriften des 18. Jahrhunderts." City U of New York, 1984 (Allen McCormick).

Madigan, Kathleen M. "Forever Yours: The Subgenre of the Letter from the Dead to the Living, with Thematic Analyses of the Works of Elizabeth Singer Rowe and Meta Klopstock." North Carolina, 1988 (Christoph Schweitzer).

Madler, Jennifer L. "The Literary Response of German-Language Authors to Selma Lagerlöf." Illinois, 1998 (Rochelle Wright).

Maier-Katkin, Birgit E. "Complicity, Defiance, and Indifference: Women and Everyday Life in Hitler's Germany as Reflected in Selected Exile

Works of Anna Seghers and Irmgard Keun." Pennsylvania State, 1998 (Ernst Schürer).

Mareske, Irina. "'...als wolle sie aus sich selbst heraus': Die Darstellung weiblicher Körperlichkeit in Pose, Bewegung, und Raum im fiktionalen (Früh)Werk Ricarda Huchs und Lou Andreas-Salomés." California, Davis, 1998 (Anna Kuhn).

Marshall, Catherine C. "Men and Women, Goddesses and Mortals: A Thematic Study of Ilse Langner's Mythological Dramas." Cincinnati, 1995 (Jerry Glenn).

Marshall, Jennifer C. "The Beloved Sacrifice: Violence and the Construction of Intergender Social Alliances in Nineteenth-Century German Prose." Yale, 1997 (Jeffrey Sammons).

Martin, Carolyn A. "The Death of 'God,' the Limits of 'Man,' and the Meanings of 'Woman': The Work and the Legends of Lou Andreas-Salomé." Wisconsin, 1985 (Jost Hermand).

Martin, Elaine A. "Uncommon Women and the Common Experience: Fiction of Four Contemporary French and German Women Writers." Indiana, 1982 (Henry Remak).

Martin, Judith. "German Women Writers Read Madame de Staël: Cultural and Sexual Politics in the German Novel from Romanticism to the *Vormärz*." Washington U, 1999 (Lynne Tatlock).

Martin, Lucinda. "Women's Religious Speech and Activism in German Pietism." Texas, 2002 (Katherine Arens).

Martinez-Rico, Ingrid M. "In Search of the Romantic Female Voice: Annette von Droste-Hülshoff and Rosalia De Castro." Pennsylvania State, 1994 (Raymond Fleming).

Maurer-Haas, Andrea. "Women Role Models in Plays of Austrian Women Dramatists from the French Revolution to the First World War." Connecticut, 1998 (Gerhard Austin).

McCarthy, Margaret. "Bodies, Beautiful Souls, and *Bildung*: Reconstructing the First-Person Singular 'I' in German Women's Autobiographical Texts (Ingeborg Bachmann, Jutta Bruckner, Anne Duden)." Rochester, 1996 (Patricia Herminghouse).

McCombs, Nancy. "Earth Spirit, Victim, or Whore? The Figure of the Prostitute in German Literature, 1880–1925." California, San Diego, 1982 (James Lyon).

McGlashan, Ann. "Creating Women: The Female Artist in *Fin-de-Siècle* Germany and Austria." Indiana, 1996 (Marc Weiner).

McInerney, Magdalen B. "Flames Fed from Within: Medieval Women and Mystical Writing." California, Berkeley, 1994 (Carolyn Dinshaw).

McIsaac, Peter. "Open to the Public: The Creation of the Museum and the the Construction of Gender in Nineteenth-Century German Literature and Culture." Harvard, 1996 (Beatrice Hanssen).

McLary, Laura A. "The Fragmented Body and the Repression of Memory: The Recurrence of the Incest Story in the Works of Georg Trakl." Massachusetts, 1996 (Susan Cocalis).

Meister, Peter W. "The Healing Female in Hartmann's *Eric, Iwein,* and *Der arme Heinrich,* Wolfram's *Parzival,* and Gottfried's *Tristan.*" Virginia, 1988 (William McDonald).

Mennel, Barbara C. "Seduction, Sacrifice, and Submission: Masochism in Postwar German Film and Literature." Cornell, 1998 (David Bathrick).

Mercer, Julie A. "Paul Zech: Exoticism, Gender, and Social Criticism in His Writing." Texas, 1997 (Katherine Arens).

Metz, Joseph R. "Gendered States: On the Borders of Gender, Nation, and Identity in Stifter and Rilke." Harvard, 1999 (Judith Ryan).

Meyer, Imke. "Jenseits der Spiegel kein Land: Ich-Fiktionen und Identitäts-Illusionen in Texten von Franz Kafka und Ingeborg Bachmann." U of Washington, 1993 (Jens Rieckmann).

Meyer, Marsha E. "Marieluise Fleisser: Her Life and Work." Wisconsin, 1983 (Reinhold Grimm).

Michael, Nancy. "Elektra and Her Sisters: Male Representation of Female Characters in Viennese High Culture, 1900–05." Wisconsin, 1991 (Jost Hermand).

Mikoltchak, Maria. "A Comparative Analysis of *Madame Bovary, Anna Karenina,* and *Effi Briest*: A Feminist Approach." South Carolina, 2000 (Wiebke Strehl).

Millet, Kitty J. "To Survive Outside the Law: An Analysis of Holocaust Women Survivors' Testimonies." Minnesota, 1996 (Ronald Sousa).

Mittman, Elizabeth. "Encounters with the Institution: Woman and *Wissenschaft* in GDR Literature." Minnesota, 1992 (Ruth-Ellen B. Joeres).

Mittnik, Kay L. "Rosa Mayreder and a Case of 'Austrian Fate': The Effects of Repressed Humanism and Delayed Enlightenment on Women's Writing and Feminist Thought in *fin-de-siècle* Vienna." Rice, 1990 (Susan Clark).

Moeller, Aleidine K. "The Woman as Survivor: The Development of the Female Figure in Heinrich Böll's Fiction." Nebraska, 1980 (Mark Cory).

Möller-Sahling, Folke-Christine. "'Wie schön und unendlich schöner malt die Ferne Dich': Der Liebesdiskurs im Briefwechsel um 1800." Ohio State, 2002 (Barbara Becker-Cantarino).

Moffit, Gisela B. "Daughter-Father Relationships in the Father Memoirs of German-Speaking Women Writers of the 1970s." Michigan State, 1991 (Patricia Paulsell).

Morris, Katherine S. "Early Medieval Witchcraft: Characteristics of the Feminine Witch Figure." Texas, 1985 (Edgar Polomé).

Morris, Leslie. "'Ich suche ein unschuldiges Land': Reading History in the Poetry of Ingeborg Bachmann." Massachusetts, 1992 (Sigrid Bauschinger).

Morris-Keitel, Helen G. "Identity in Transition: The Image of Working-Class Women in Social Prose of the *Vormärz* (1840–1848)." Wisconsin, 1991 (Jost Hermand).

Morrison, Susan S. "Discursive Violence: Women with Authority in Old English, Middle English, Middle High German and Early New High German Texts." Brown, 1991 (Michel-André Bossy).

Mueller, Isolde M. "Norms vs. Narrative: The Impossibility of Representing Femininity in Late Eighteenth-Century German Literature." Minnesota, 1996 (Ruth-Ellen B. Joeres).

Mullens, Margaret. "Body and Soul: Deafness and Identity in Ruth Schaumann's Autobiographical Novel *Das Arsenal*." Maryland, 2001 (Elke Frederiksen).

Multer, Lioba. "Bachmann and Bohemianism: A Critical Bilingual Edition of Selected Poems by Ingeborg Bachmann Introduced by a Critical Essay." Ohio State, 1989 (Dagmar Lorenz).

Nagy, Ellen M. "A History of Women in Germanics, 1850–1950." Ohio State, 1993 (David Benseler and Charles Hoffmann).

Nenno, Nancy. "Masquerade: Woman, Nature, Modernity." California, Berkeley, 1996 (Anthony Kaes).

Neville, David O. "The Chalice of the Flesh: The Soteriology of the Body in Mechthild von Magdeburg's *Das fliessende Licht der Gottheit*." Washington U, 2002 (James Poag).

Newman, Gail M. "The Visible Soul of Poetry: Women and the Poet in Novalis' *Heinrich von Ofterdingen*." Minnesota, 1986 (Jochen Schulte-Sasse).

Niers, Werner G. "Frauen schreiben im Exil: Zum Werk der nach Amerika emigrierten Lyrikerinnen Margarete Kollisch, Ilse Blumenthal-Weiss, Vera Lachmann." Rutgers, 1987 (Maria Wagner).

Norris, Sigrid G. "A Theoretical Framework for Multimodal Discourse Analysis Presented via the Analysis of Identity Construction of Two Women Living in Germany." Georgetown, 2002 (Ron Scollon).

Norton, Sydney J. "Modernity in Motion: The Performance Art of Mary Wigman and Valeska Gert in the Weimar Republic." Minnesota, 1998 (Richard McCormick).

Novak, Simone. "The Return of the Medea: Bridging Dichotomies in Contemporary German Culture." California, Davis, 1998 (Anna Kuhn).

Obermeier, Karin C. "Private Matters Made Public: Love and the Sexualized Body in Karoline von Günderrode's Texts." Massachusetts, 1995 (Susan Cocalis).

O'Brien, Mary-Elizabeth. "Fantasy and Reality in Irmtraud Morgner's Salman Novels: A Discursive Analysis of *Leben der Trobadora* and *Amanda*." California, Los Angeles, 1988 (Ehrhard Bahr).

Ogden-Wolgemuth, Linda. "Visions of Women in the Life and Works of Sigmund von Birken." Pennsylvania, 1998 (Karl F. Otto, Jr.).

Oosterhoff, Jenneke A. "'Die Männer sind infam, solange sie Männer sind': Die Konstruktion der Männlichkeit in den Werken Arthur Schnitzlers." Washington U, 1998 (Lynne Tatlock).

Ortega, Stephanie D. "The Model for a Participant Reading of Contemporary Autobiographical Literature: Object-Relations in Christa Wolf's *Kindheitsmuster*." Texas, 1989 (Barbara Becker-Cantarino and A. Leslie Willson).

Ortquist-Ahrens, Leslie. "Opening Pandora's Box: America and American Women in Films from the Weimar Republic." Indiana, 1999 (James Naremore).

Osselmann, Dawn-Leigh H. "Misogyny in Heine and Baudelaire and Its Link with Romantic Pessimism." Pennsylvania State, 1994 (William Crisman).

Ostrem, Francine M. "Maternal Inscriptions: Jelinek, Kafka, Sacher-Masoch." California, Berkeley, 1991 (Winfried Kudszus).

Ozer, Irma. "The Treatment of the Maladjusted Protagonist in the Fiction of Ingeborg Bachmann and Christa Wolf." New York U, 1986 (Margaret Herzfeld-Sander).

Parkin, Nora L. "'Geschlecht und Transgression': The Theology of Sin and Salvation in Thuring von Ringoltingen's *Melusine*." Washington U, 1993 (James Poag and Gerhild Williams).

Pierce, Nancy J.F. "Woman's Place in German Turn-of-the-Century Drama: The Function of Female Figures in Selected Dramas by Gerhart Hauptmann, Frank Wedekind, Ricarda Huch, and Elsa Bernstein." California, Irvine, 1988 (Helmut Schneider).

Pietsch, Hildegard. "Anspielung, Zitat und Montage in Irmtraud Morgners *Amanda: Ein Hexenroman*." Washington U, 1990 (Paul M. Lützeler).

Plate, Liedeke. "Visions and Re-Visions: Female Authorship and the Act of Rewriting." Indiana, 1995 (Matei Calinescu).

Poeter, Elisabeth. "'Der Frauen Wissenschaft ist der Mann': Phantasie und Wirklichkeit weiblicher Bildung." California, Berkeley, 1991 (Hinrich Seeba).

Pohl, Rosa-Marie. "Cold-Blooded Tales of Women with Tails in the Works of Johannes Praetorius (1630–80)." Pennsylvania, 1996 (Karl Otto, Jr.).

Pohle, Bettina. "Woman as Icon: Representations of Femininity around 1900 in German Literature and Culture." California, Berkeley, 1994 (Anton Kaes).

Pollack, Beatrix M. "Ilse Blumenthal-Weiss' Werke: Kommentar, Edition, Einführung." Maryland, 1994 (Elke Frederiksen).

Poor, Sara. "Medieval Incarnations of Self: Subjectivity and Authority in the Writings of Mechthild von Magdeburg." Duke, 1994 (Ann Marie Rasmussen).

Powell, Morgan. "The Mirror and the Woman: Instruction for Religious Women and the Emergence of Vernacular Poetics, 1120–1250." Princeton, 1997 (Michael Curschmann).

Prandi, Julie. "Spirited Women Heroes of the *Goethezeit*: Women Protagonists in the Dramas of Goethe, Schiller, and Kleist." California, Berkeley, 1980 (Bluma Goldstein).

Prigan, Carol L. "Redeeming History in the Story: Narrative Strategies in the Novels of Anna Seghers and Nadine Gordimer." Ohio State, 1992 (Helen Fehervary).

Pritchett, Rinske van Stipriaan. "The Art of Comedy in Nineteenth-Century Germany: Charlotte Birch-Pfeiffer (1800–68)." Maryland, 1989 (Elke Frederiksen).

Prutti, Brigitte. "Bild und Körper: Modi weiblicher Präsenz in Lessings Dramen *Emilia Galotti* und *Minna von Barnhelm*." California, Irvine, 1995 (Helmut Schneider).

Raihala, Lorelle M. "A Treacherous Haven: Heinrich von Kleist's Representation of Marriage, Family, and Gender Relations." Washington U, 1998 (Paul M. Lützeler).

Rainwater van Suntum, Lisa. "The Rosa Myth: A Feminist Reading of Rosa Luxemburg in Twentieth-Century German Culture." Wisconsin, 2002 (Jost Hermand).

Ramanathan, Geetha R. "Gender and Madness in Five Modern Plays." Illinois, 1988 (Herbert Knust).

Rao, Shanta. "The Political Aesthetic of Elfriede Jelinek's Early Plays." Massachusetts, 1997 (Susan Cocalis).

Redmann, Jennifer. "Imagining Selves: Gender and Identity in the Work of Else Lasker-Schüler." Wisconsin, 1996 (Nancy Kaiser and Klaus Berghahn).

Reeves, Eva. "Purloined Letters: Detecting Gender in Poe, Lacan, Derrida, and Max Frisch's *Mein Name sei Gantenbein*." Cornell, 2001 (Geoffrey Waite).

Rejda, Sybille. "Das Opfer emanzipiert sich: Die Tochter im deutschen Roman des 19. und 20. Jahrhunderts." Nebraska, 1984 (Mark Cory and Bruce Erlich).

Remmler, Karen L. "Walter Benjamin's *Eingedenken* and the Structure of Remembrance in Ingeborg Bachmann's *Todesarten*." Washington U, 1989 (Paul M. Lützeler).

Reutershan, Joan B. "Clara Zetkins Ausnahmeposition in der Literaturpolitik der deutschen Sozialdemokratie in der Epoche der II. Internationale." New York U, 1980 (Volkmar Sander).

Rhine, Marjorie E. "Inscriptions and Incisions: Writing and the Body in the Works of Franz Kafka and Yukio Mishima." Wisconsin, 1992 (Keith Cohen).

Richards, Ruthann. "The Image of Women in Selected Moral Weeklies of the Early English and German Enlightenment (1709–1745)." Cincinnati, 1984 (Helga Slessarev).

Rieger, Sylvia H. "Janusbilder: Der Diskurs um Frauen und Juden in der bürgerlichen Öffentlichkeit des deutschen Kaiserreichs." Washington, 2000 (Richard Gray).

Riehl, Ester. "'Die fähige Hausfrau erhält den Staat': Family, Nation, and State in Nineteenth-Century German and Austrian Literature." Ohio State, 1997 (Dagmar Lorenz).

Risko, Agnes J. "'Gott zu Ehren, dem Neben-Christen zum Nutz': Anna Elisabeth Horenburg's *Manual for Midwives* (1700)." Ohio State, 1998 (Barbara Becker-Cantarino).

Ritmeester, Hubertina A. "Rilke and the Motherhood Debate: A Feminist Perspective on the Young Rilke." Washington U, 1987 (Egon Schwarz).

Ritter, Lieselotte T. "Das Potential der Frau bei Heinrich von Kleist." Michigan State, 1981 (Raimund Belgardt).

Roetzel, Lisa. "Constructing Masculine Identity: The Function of Women and Family in Eighteenth-Century German Literature." Minnesota, 1992 (Jochen Schulte-Sasse).

Rogers, Gerhild B. "Recurring Themes and Narrative Perspective in the Novels of Ingeborg Drewitz." Texas, 1985 (Barbara Becker-Cantarino).

Romann, Marita. "Alternative Fictions: German Women Writers and the Discourse on Femininity around 1800." California, San Diego, 1996 (Todd Kontje).

Rose, Ferrel. "Marie von Ebner-Eschenbach's 'Künstler(in)Novellen.'" Yale, 1991 (Ingeborg Glier and George Schoolfield).

Rossbacher, Brigitte. "Gender, Science, Technology: The 'Dialectic of Enlightenment' in GDR Women's Literature." California, Davis, 1992 (Anna Kuhn).

Rowe, Marianne L. "A Typology of Women Characters in the German Naturalist Novel." Rice, 1981 (Michael Winkler).

Royer, Berit C.R. "Sophie Albrecht (1757–1840) im Kreis der Schriftstellerinnen um 1800: Eine literatur- und kulturwissenschaftliche Werk-Monographie." California, Davis 1999 (Gail Finney).

Rusch-Feja, Diann D. "The Portrayal of the Maturation Process of Girl Figures in Selected Tales of the Brothers Grimm." State U of New York, Buffalo, 1986 (Erika Metzger).

Russi, Roger. "Dialogues with Epic Figures: Christa Wolf's *Kassandra*, Monique Wittig's *Les Guérillères,* and Marion Zimmer Bradley's *The Firebrand.*" North Carolina, 1993 (Alice Kuzniar).

Russo, Eva-Maria. "'Auf keinen Teufel gefasst': The Discourse of Seduction and Rape in Eighteenth-Century German Literature." California, Los Angeles, 2000 (Ehrhard Bahr).

Scheck, Irene E. "Die Isolation der Frau in der zeitgenössischen deutschen Prosa." Oregon, 1982 (Wolfgang Leppmann).

Scheffer, Julia. "'Die Sprache aus dem Bett reissen': Feminist Satire in the Works of Elfriede Jelinek and Isolde Schaad." Washington, 2001 (Sabine Wilke).

Schell, Renee M. "The Power to Look: Gender and Identity Politics in Selected Works of Heinrich von Kleist." Stanford, 1998 (Russell Berman).

Schenberg, Cora. "'Mittendurch die Leute': Sarah Kirsch and the Play of Boundaries." Virginia, 2003 (Lorna Martens).

Schestokat, Karin U. "German Women in Cameroon: Travelogues from Colonial Times." Southern California, 1995 (Dagmar Barnouw).

Schleimer, Gloria. "Protected Self-Revelation: A Study of the Works of Four Nineteenth-Century Women Poets: Marceline Desbordes-Valmore, Annette von Droste-Hülshoff, Elizabeth Barrett-Browning, and Emily Brontë." California, Irvine, 1981 (Renée Hubert).

Schleissner, Margaret R. "Pseudo-Albertus Magnus: *Secreta Mulerium Cum Commento, Deutsch*: Critical Text and Commentary." Princeton, 1988 (Michael Curschmann).

Schlipphacke, Heidi M. "The Daughter's Symptom: Female Masochism in Literary Works by G.E. Lessing, Sophie von La Roche, Ingeborg Bachmann, and Elfriede Jelinek." U of Washington, 1999 (Richard Gray).

Schmitz-Burgard, Sylvia. "Vorschriften: Geschlechterdiskurs im europäischen Roman des 18. Jahrhunderts (Richardson, Rousseau, Goethe)." Virginia, 1991 (Renate Voris).

Schneider, Georgia F. "Portraits of Women in Selected Novels by Gabriele Reuter." Syracuse, 1982 (Dennis McCort and Gerd Schneider).

Schneider, Ursula A. "*Ars amandi*: A Thematic Inquiry of Sexual and Erotic Exceptions in the Early Tales of Thomas Mann and in the Works of Marguerite Duras." City U of New York, 1992 (Allen McCormick).

Schönfeldt, Christiane. "Dialektik und Utopie: Die Prostituierte im deutschen Expressionismus." Pennsylvania State, 1994 (Ernst Schürer).

Scholz, Myra J.H. "A Merchant's Wife on Knight's Adventure: Permutations of a Medieval Tale in German, Dutch and English Chapbooks around 1500." Indiana, 1993 (William Shetter and Herman Pleij).

Schueller, Jeanne M. "The Effects of Two Types of Strategic Training on Foreign Language Reading Comprehension: An Analysis by Gender and Proficiency." Wisconsin, 1999 (Monika Chavez).

Schwab, Gisela. "Die weibliche Dreifaltigkeit: Untersuchungen zum Frauenbild im Prosawerk Heinrich Bölls." Rutgers, 1987 (Joanna Ratych).

Serfozo, Barbara. "Warring Narratives: The Diaries and Memoirs of Lore Walb, Ursula von Kardorff, and Margret Bovari."Georgetown, 2002 (Friederike Eigler).

Shafi, Monika M.H. "Utopian Visions in the Literature of German Women Authors." Maryland, 1986 (Elke Frederiksen).

Shea, Kerry A. "The Misbegotten Male: Of Castration, Vivisection, and Other Perils of the Medieval Romance Heroine." Cornell, 1988 (Winthrop Wetherbee).

Shouse-Luxem, Leslie. "Infanticide, Illegitimacy, and Abortion in Modern German Literature." Rice, 1998 (Michael Winkler).

Singer, Heidi M. "Leben und Zeit der Dichterin A.L. Karsch." City U of New York, 1983 (Allen McCormick).

Singer, Sandra. "Resistance and Agency of the Female Subject in the Fiction of Hedwig Dohm, Isolde Kurz, and Helene Böhlau." Wisconsin, 1993 (Nancy Kaiser).

Siwak, Ewa. "Rewriting Women's Discourse across Cultures: Reception and Translation of Ingeborg Bachmann's Prose in Poland and in the United States." Texas, 1998 (Kirsten Belgum).

Skidmore, James M. "History with a Mission: Ricarda Huch's Historiography during the Weimar Republic." Princeton, 1993 (Theodore J. Ziolkowski).

Smith, Christa M. "'Paläontologe werden': Politics, Narrative, and the Construction of Female Subjectivity in the German Novel of the 1970s." Princeton, 1995 (Michael Jennings).

Smith, Sabine M. "Sexual Violence in German Culture: Rereading and Rewriting the Tradition." California, Davis, 1996 (Anna Kuhn).

Sokolsky, Jane E. "Rosa Mayreder: The Theory in Her Fiction." Washington U, 1997 (Paul M. Lützeler).

Sopcak, Lorna J. "The Appropriation and Critique of the Romance Novel, Film, and Fashion in Irmgard Keun's Weimar Prose: Humor, Intertextuality, and Popular Discourse." Minnesota, 1999 (Ruth-Ellen B. Joeres).

Sotiropoulos, Carol. "Frictions, Fictions, and Forms: Woman's Coming of Age in Eighteenth-Century Educational Discourses." Connecticut, 2001 (Margaret Higonnet).

Spalding, Almut M. G. "Elise Reimarus (1735–1805), the Muse of Hamburg: A Woman of the German Enlightenment." Illinois, 2000 (Mara Wade).

Steinhagen, Virginia I. "Educating Rita and Her 'Sisters': The Female *Bildungsroman* in the German Democratic Republic." Minnesota, 1996 (Ruth-Ellen B. Joeres).

Steinwand, Jonathan M. "Mnemonic Images: The Gender of Modernity in Schiller, Friedrich Schlegel, Hölderlin, and Bettine Brentano-von Arnim." State U of New York, Binghamton, 1993 (Dennis J. Schmidt).

Stephens, Don S. "Regina Ullmann: Biography, Literary Reception, Interpretation." Texas, 1980 (Christopher Middleton).

Sterba, Wendy E. "The Representation of the Prostitute in Contemporary German and English Language Film." Rice, 1989 (Margaret Eifler).

Sterling-Hellenbrand, Alexandra C. "The Topography of Gender in Middle High German Arthurian Romance." Pennsylvania State, 1995 (Francis Gentry).

Steyer, Brigitte. "Traumadarstellung und deren Implikationen in Ingeborg Bachmanns *'Todesarten'-Projekt*." California, Los Angeles, 2000 (Kathleen R. Komar).

Stocky, Mary B. "The Radio Plays of Elisabeth Langgässer: A Historical, Biographical Approach." State U of New York, Buffalo, 1987 (Peter Heller).

Stricker, Terri L. "A Comparative Study of *Femme-Fatale* Imagery and Its Significance in Selected *Fin-de-Siècle* Art and Literature." Arkansas, 2000 (Brian Wilkie).

Striedter, Anna K. "Women Writers and the Epistolary Novel: Gender, Genre, and Ideology in Eighteenth-Century Fiction." California, San Diego, 1993 (Winifred Woodhull).

Stuecher, Dorothea D. "Double Jeopardy: German-American Women Writers in the Nineteenth Century." Minnesota, 1981 (Ruth-Ellen B. Joeres).

Sturges, Beate. "Die Frau im Werk und Leben Lessings." Wayne State, 1984 (Guy Stern).

Suess, Walter. "Mythos-Geschichte-Utopie: Historische Untersuchung der Werke Anna Seghers und Christa Wolfs." California, Davis, 1991 (Anna Kuhn).

Suhr, Geertje P. "Die Wandlungen des Frauenbildes in der Lyrik Heinrich Heines." Illinois, Chicago, 1980 (Lee Jennings).

Sull, Young-Suk. "Die Lyrik Else Lasker-Schülers: Stilelemente und Themenkreise." George Washington, 1980 (Klaus Thoenelt).

Sutherland, Wendy. "Staging Blackness: Race, Aesthetics, and the Black Female in Two Eighteenth-Century German Dramas: Ernst Lorenz Rathlef's *Die Mohrinn zu Hamburg* (1775) and Karl Friedrich Wilhelm Ziegler's *Die Mohrinn* (1801)." Pennsylvania, 2002 (Liliane Weissberg).

Sy-Quia, Hilary A.C. "The Body Politic in a Contested Present: Christa Wolf and the Making of History." California, Berkeley, 2000 (Robert Holub).

Szalay, Eva L. "Negotiating Constructions of Femininity, Subjective Agency, and Resistance in Selected Fiction by Kaschnitz, Bachmann, and Wolf." Georgetown, 1998 (Friederike Eigler).

Tannert, Mary. "Auguste Groner's Mystery and Detective Fiction." Tennessee, 1992 (Henry Kratz).

Tasaka, Wakaba. "The Quasi Father-Daughter Relationship as an Established Literary Theme." Pennsylvania State, 1996 (Gerhard Strasser).

Tate, Laura A. "Women's Emancipation and the German Ideal of *Bildung* in the Life and Writings of Helene Lange." Wisconsin, 1999 (Nancy Kaiser).

Tekavec, Valerie. "'God's Little Rascal': A Feminist Theological View of Else Lasker-Schüler's Prose." City U of New York, 1998 (Tamara S. Evans).

Templeman, Susan M. "Theodor Fontane and François Mauriac: A Portrait of Female Characters in Conflict." Purdue, 1991 (Christiane Keck).

ter Horst, Eleanor. "From Hermaphrodite to Amazon: The Transformation of Gender Paradigms in Lessing, Goethe, and Kleist." Michigan, 1996 (Frederick Amrine).

Thiel, Anne. "Verhinderte Traditionen: Märchen deutscher Autorinnen vor den Brüdern Grimm." Georgetown, 2001 (Susanne Kord).

Thornton, Heidimarie L. H. "The Situation of Women in Gerhart Hauptmann's Early Naturalist Works." Vanderbilt, 1981 (Dieter Sevin).

Thorsen, Kristine. "Divine Geometry: Elisabeth Langgässer's Lyric Cycles." Northwestern, 1988 (Kathy Harms).

Thorson, Helga M. "Re-Negotiating Borders: Responses of German and Austrian Middle-Class Women Writers to the Medical Discourses on

Sex, Gender, and Sexuality at the Turn of the Century." Minnesota, 1996 (Ruth-Ellen B. Joeres).

Toegel, Edith M. "Emily Dickinson and Annette von Droste-Hülshoff: Poets as Women." U of Washington, 1980 (Diana I. Behler).

Tragnitz, Jutta R. "Sidonia Hedwig Zäunemann: The Satirist and Her Struggle for Recognition." Illinois, 1999 (Marian R. Sperberg-McQueen).

Tubach, Sally P. "Female Homoeroticism in German Literature." California, Berkeley, 1980 (Winfried Kudszus).

Vallaster-Safriet, Elfe. "Hilde Domin: Untersuchungen zum lyrischen Werk." Cincinnati, 1987 (Jerry Glenn).

Van Ornam, Vanessa J. "'Werde Weib, Sophie!': Negotiating Social Discourses: Nineteenth-Century Constructions of Femininity in the Work of Fanny Lewald." Washington U, 1998 (Lynne Tatlock).

Vansant, Jacqueline. "Feminism and Austrian Women Writers in the Second Republic." Texas, 1986 (Barbara Becker-Cantarino).

Van Vliet, JoAnn. "Apocalypse and the Poetics of Collection: Ingeborg Bachmann's *Die gestundete Zeit*." Virginia 2001 (Beth Bjorklund).

Vedder-Schults, Nancy. "Motherhood for the Fatherland: The Portrayal of Women in Nazi Propaganda." Wisconsin, 1982 (Jost Hermand).

Vogele, Yvonne A. "The Reluctant Witches in Benedikte Naubert's *Neue Volksmärchen der Deutschen* (1789–92)." U of Washington, 1998 (Diana Behler).

Volz, Sabrina R. "Women and Sacrifice in Eighteenth-Century German Drama: Lessing's *Emilia Galotti,* Goethe's *Stella,* and Schiller's *Räuber.*" Pennsylvania State, 1998 (Markus Winkler).

von Bechtolsheim, Barbara. "Die Brüder Grimm neu schreiben: Zeitgenössische Märchengedichte amerikanischer Autorinnen." Stanford, 1987 (David Wellbery).

von der Emde, Silke. "Entering History: Feminist Dialogues in Irmtraud Morgner's *Leben und Abenteur der Trobadora Beatriz nach Zeugnissen ihrer Spielfrau Laura*." Indiana, 1994 (Ingeborg Hoesterey).

von Hammerstein, Katharina. "Freiheit—Liebe—Weiblichkeit: Tricolore der sozialen und individuellen Selbstbestimmung in den Werken von Sophie Mereau Brentano." California, Los Angeles, 1991 (Wolfgang Nehring).

von Held, Kristina. "Evas Erbe: Mythenrevision und weibliche Schöpfung in der Lyrik Rose Ausländers." Massachusetts, 1997 (Susan Cocalis).

von Hoene, Linda. "Fascism and Female Melancholia: The Lure of Fascism for the Female Subject in Psychoanalytic Theory, German Literature, and Film." California, Berkeley, 2002 (Robert Holub).

von Mering, Sabine. "Women's Tragedy: From Gottsched to Günderrode." California, Davis, 1998 (Gail Finney).

Voss, Christine. "Projektionsraum Mythos bei Christa Wolf: Von der *Kassandra* zur *Medea*: Eine literarische Analyse der feministisch-mythographischen Konzepte in diesen Werken." Rutgers, 1998 (Frederick Lubich).

Wager, Jans B. "*Femmes fatales* and *Femmes attrapées*: Women and Representation in the Weimar Street Film and Film *Noir*." California, Davis, 1997 (Seth Schein).

Wagner, Francis F. "The *Humilitas* Tradition and Mechthild von Magdeburg's *Das fliessende Licht der Gottheit*." Washington U, 1997 (James Poag).

Waldstein, Edith. "Bettina von Arnim and the Literary Salon: Women's Participation in the Cultural Life of Early Nineteenth-Century Germany." Washington U, 1982 (Paul M. Lützeler).

Walker-Moskop, Ruth M. "Health and Cosmic Continuity in Hildegard of Bingen." Texas, 1984 (Edgar Polomé).

Walshe, Maire J. "The Life and Works of Wilhelmine von Hillern, 1836–1916." State U of New York, Buffalo, 1988 (Michael Metzger).

Ward, Jennifer K. "The Films of Margarethe von Trotta and Their Reviews: A Feminist Critical Analysis." Vanderbilt, 1992 (Helmut Pfanner).

Ward, Sean. "Madame Palatine's Princely Conversations: Four Essays in the Sociology of Knowledge." Stanford, 1998 (Hans Gumbrecht).

Weber, Ulrike. "Christa Wolf and the Memory of the Future: Gender, Socialism, Resistance." Northwestern, 1994 (Christine Froula).

Webster, Marilyn W. "Mechthild von Magdeburg's Vocabulary of the Senses." Massachusetts, 1996 (James Cathey).

Weigert, Astrid. "Schriftstellerinnen als Ästhetikerinnen: Genre und Geschlecht in Romantik und Naturalismus am Beispiel von Dorothea Schlegel und Elsa Bernstein." Georgetown, 1999 (Susanne Kord).

Weinberger, Gabriele. "Aesthetics and Politics of Fascism: West German Women Filmmakers in the 1970s." Ohio State, 1988 (Dagmar Lorenz).

Weingant, Liselotte. "Das Bild des Mannes im Frauenroman der siebziger Jahre." Illinois, 1981 (Walter Höllerer).

Westerfield, Leigh. "Bonds of Communion as Sources of Power: Women Writers and Resistance in France and Germany, 1939–45." Indiana, 1989 (Matei Calinescu and Breon Mitchell).

White, Christina. "Gender and the German Autumn: The Representation of Terrorism and the Female Terrorist in Social Discourse, Literature, and Film." Minnesota, 2001 (Arlene Teraoka and Richard McCormick).

Wideburg, Laura A. "Kriemhild: Demon-Hero-Woman." U of Washington, 1993 (Stephen Jaeger).

Wierschke, Annette. "Schreiben als Selbstbehauptung: Kulturkonflikt und Identität in den Werken von Aysel Özakin, Alev Tekinay und Ermine Sevgi Özdamar." Minnesota, 1994 (Arlene Teraoka).

Wild, Christopher J. "*Repraesentatio immaculata*: Zur Theatralisierung des jungfräulichen Körpers im deutschen Drama des 17. und 18. Jahrhunderts." Johns Hopkins, 1998 (David E. Wellbery).

Wilkinson, Eileen. "Reception as Representation: The Multiple Mirrors of Anna Seghers' Works." Texas, 1992 (Janet Swaffar).

Winkle, Sally A. "Women as Developed in Sophie van La Roche's *Geschichte des Fräuleins von Sternheim* and Goethe's *Die Leiden des jungen Werthers*." Wisconsin, 1984 (Max Baeumer).

Wittmann, Judith Jean. "A Semantic Study of Five Words for 'Girl' and 'Woman' from Wulfila through Luther." Colorado, 1982 (Robert T. Firestone).

Worley, Linda K. "Louise von François: A Re-Interpretation of Her Life and Her 'Odd-Woman' Fiction." Cincinnati, 1985 (Helga Slessarev).

Wotschke, Jean. "From the Home Fires to the Battlefield: The Mother as Representative, Victim, and Critic of Wilhelminian Society in Expressionist Drama." Pennsylvania State, 1994 (Ernst Schürer).

Wylie-Ernst, Elizabeth. "Frau Holle and the Recreation of Myth." Pittsburgh, 1996 (D. L. Ashliman).

Younger, Charlotte K. "Goethe's Symbols of Poetic Creativity: The Interlocking of the Masculine and the Feminine in *Faust II*." Virginia, 1984 (Benjamin Bennett).

Zak, Nancy. "The Portrayal of the Heroine in Chrétien de Troy's *Erec et Enide,* Gottfried von Strassburg's *Tristan,* and *Flamenca*." California, Berkeley, 1981 (Joseph Duggan).

Zimmermann, Inge M. "Der Mensch im Spiegel des Tierbildes: Untersuchungen zum Werk Else Lasker-Schülers." Kansas, 1980 (Warren Maurer).

Zinggeler, Margrit V. "Literary Freedom and Social Constraints in the Works of Swiss Writer Gertrud Leutenegger." Minnesota, 1993 (Leonard L. Duroche).

Zinn, Gesa. "Film, Fiction, and Feminism: Politics in Helke Sander's Cinematic and Literary Texts: Representation of Gender, Subjectivity, Humor, and Music." Minnesota, 1995 (Richard McCormick).

ABOUT THE CONTRIBUTORS

Elizabeth R. Baer is Professor of English at Gustavus Adolphus College, where she holds the Florence and Raymond Sponberg Chair of Ethics. She also serves as a Visiting Professor at the University of Minnesota where she teaches a course entitled "Women and the Holocaust: Gender, Memory and Representation." She was the recipient of a Fulbright Award in the summer of 2000 to study the history of Jews in Germany. She is the editor of *Shadows on My Heart: The Civil War Diary of Lucy Buck* (1997). Her new book, *Experience and Expression: Women, the Holocaust and the Third Reich* (2003), is an anthology of essays on gender and the Holocaust, coedited with Myrna Goldenberg. In 2000, Elizabeth Baer was awarded the Virginia Hamilton Prize for the Best Essay on Multicultural Children's Literature for an article on children's literature about the Holocaust. She is also the coeditor, with her daughter, Hester Baer, of Nanda Herbermann's *The Blessed Abyss: Inmate #6582 in Ravensbrück Concentration Camp for Women* (2000).

Hester Baer is Assistant Professor of German and Film and Video Studies at the University of Oklahoma. She received her PhD in German, with a graduate certificate in Women's Studies, from Washington University in 2000. Her research interests focus on gender and popular culture in postwar and post-unification Germany. She has articles published or forthcoming on the gendering of popular and avant-garde filmmaking practices in Herbert Veseley's *Das Brot der frühen Jahre*; on sound in Rolf Thiele's *Das Mädchen Rosemarie*; on the 1950s women's magazine *Film und Frau*; and on memory, national identity, and global cinematic practice in Alfonso Cuarón's *Y Tu Mamá También*. She is currently completing a book manuscript about female spectators and West German cinema in the 1950s. She is also the translator and coeditor, with her mother, Elizabeth Baer, of Nanda Herbermann's *The Blessed Abyss: Inmate #6582 in Ravensbrück Concentration Camp for Women* (2000).

Karyn Ball is Assistant Professor of English specializing in critical and literary theory at the University of Alberta in Edmonton. She edited a

special issue of *Cultural Critique* on trauma and its cultural aftereffects (Fall 2000). An article "Wanted, Dead or Distracted: On *Ressentiment* in History, Philosophy, and Everyday Life" appeared in the fall 2002 issue of *Cultural Critique* and her essay "Ex/propriating Survivor Experience, or Auschwitz 'after' Lyotard" has been published in *Witness and Memory: The Discourse of Trauma* (2003).

Angelika Bammer is Associate Professor in the Program of Culture, History, and Theory in The Graduate Institute of the Liberal Arts at Emory University. She is the author of *Partial Visions: Feminism and Utopianism in the 1970s* (1991) and editor of *Displacements: Cultural Identities in Question* (1994) and the special issue of *New Formations: A Journal of Culture/Theory/Politics* on "The Question of 'Home'" (1992). She has published essays on the history of medicine, feminist theory, the politics of memory, and contemporary literature.

David P. Benseler is Emile B. de Sauzé Professor of Modern Languages and Literatures at Case Western Reserve University. His numerous publications are primarily in bibliography, the history of the profession, and methods. He is co-compiler and coeditor of *A Comprehensive Index to* The Modern Language Journal *1916-1996*; coeditor of *Teaching German in Twentieth-Century America; The Dynamics of Language Program Direction*; and of *Teaching German in America: Prolegomena to a History*. He edited *The Modern Language Journal* from 1980 to 1993 and the *Annual Bibliography* of the American Council on the Teaching of Foreign Languages from 1973 to 1979.

Pascale Bos is Assistant Professor in the Department of Germanic Studies and Affiliated Faculty in the Comparative Literature, Women's Studies, and Jewish Studies Programs at the University of Texas at Austin. She has published articles on German and Dutch Jewish literature and culture, gender and the Holocaust, and second-generation Holocaust literature. She recently finished her first book-length study, *Survivor Authors Seeking Address: Grete Weil, Ruth Klüger, and the Problematic Jewish "Return" to German(y)*.

Muriel Cormican received her PhD in German Literature from Indiana University, Bloomington in 1999 and is currently Assistant Professor of German at the University of West Georgia. She has published articles on Lou Andreas-Salomé and recent German film and is currently completing a book on the negotiation of identity in the fictional works of Lou Andreas-Salomé.

Lisa Disch is Associate Professor of Political Science at the University of Minnesota, where she teaches courses in contemporary political theory. She is the author of *Hannah Arendt and the Limits of Philosophy* (1994) and *The Tyranny of the Two-Party System* (2002).

Mila Ganeva is Assistant Professor of German at Miami University in Ohio. Her research focuses on visual culture in Germany in the period 1900-1945 as well as on Berlin in literature and film. She has published on Ernst Jünger's photography books, on Berlin film in the 1990s, and on fashion photography. She is currently working on a book manuscript, *A Forgotten History of Modernity: Fashion in the Literature, Illustrated Press and Photography of the Weimar Republic.*

Marjorie Gelus is Professor of German in, and Chair of, the Department of Foreign Languages at California State University, Sacramento. She has taught almost everything, but her research centers on work of the *Goethezeit,* especially on the works of Heinrich von Kleist, which she has subjected to increasingly eccentric feminist interrogation over the decades. She has been active in Women in German for the past thirteen years, and now, in her dotage, is enjoying a new-found extroversion in odd roles in that beloved institution of the annual Women in German Conference, the closing cabaret.

Patricia Herminghouse is Karl F. and Bertha A. Fuchs Professor emerita of German Studies at the University of Rochester. She has written widely on nineteenth- and twentieth-century German literature, the social contexts of women's writing, and German émigrés in nineteenth-century America. Editor of the textbook anthology *Frauen im Mittelpunkt* and a volume of translated writings by Ingeborg Bachmann and Christa Wolf, she also coedited two volumes on GDR literature and, more recently, *Gender and Germanness: Cultural Constructions of Nation* (1998) as well as an anthology of *German Feminist Writings* from the seventeenth century to the present. She coedited the *Women in German Yearbook* from 1995 to 2002.

Ruth-Ellen Boetcher Joeres is Professor of German and Women's Studies in the Department of German, Scandinavian, and Dutch at the University of Minnesota. Her research has focused on the social and literary history of German women from the eighteenth to twentieth centuries, on feminist theorizing, and increasingly on the role of personal narratives and the personal in academic writing. Her most recent book is *Respectability and Deviance: Nineteenth-Century German*

Women Writers and the Ambiguity of Representation. She is presently at work on a volume of autobiographical and theoretical essays exploring the interrelationships between developments in the fields of German Studies and feminist inquiry.

Irene Kacandes is Associate Professor of German Studies and Comparative Literature at Dartmouth College. She is the author of *Talk Fiction: Literature and the Talk Explosion* (2001), coeditor of *A User's Guide to German Cultural Studies* (1997), and coeditor of *Teaching the Representation of the Holocaust* (forthcoming in the MLA Options for Teaching Series). Her rereadings of Kolmar's *A Jewish Mother* are part of ongoing research into trauma and the relationship of literature and history.

Michelle Mattson received her PhD from Stanford University in 1991 and is currently Associate Professor of German at Iowa State University. Her research has covered such diverse topics as post-war women's literature, feminist research on autobiography, feminist ethics, political representation in German television, questions of immigration and diversity in Germany today, issues of political subjectivity, and contemporary German drama. She is currently writing a book entitled "Politics, History, and Feminism: German Women Authors Writing through Political and Historical Experience."

Leslie Morris is Associate Professor of German and Director of the Center for Jewish Studies at the University of Minnesota, Twin Cities. She is the author of a book on history and memory in Ingeborg Bachmann's poetry, and coeditor, with Karen Remmler, of *Contemporary Jewish Writing in Germany* (2002). She has also coedited, with Jack Zipes, *Unlikely History: The Changing German-Jewish Symbiosis* (2002). She has written articles on the poetics of exile, diaspora, translation, and the border, and on artistic and theoretical approaches to memory and the Holocaust. She is currently working on a book on elegy and postmemory in German, American, and French poetry.

Jill Suzanne Smith is Visiting Assistant Professor of German at Union College in Schenectady, NY. A PhD candidate in Germanic Studies at Indiana University, Bloomington, she recently finished her dissertation on literary and cultural discourses on prostitution in Berlin, 1880–1930. Her research interests include gender studies, discourses on female and Jewish sexuality, German colonial and postcolonial history and literature, and nineteenth- and twentieth-century German Jewish studies.

NOTICE TO CONTRIBUTORS

The *Women in German Yearbook* is a refereed journal. Its publication is supported by the Coalition of Women in German. Contributions to the *Women in German Yearbook* are welcome at any time. The editors are interested in feminist approaches to all aspects of German literary, cultural, and language studies, including pedagogy, as well as in topics that involve the study of gender in different contexts: for example, work on colonialism and postcolonial theory, performance and performance theory, film and film theory, or on the contemporary cultural and political scene in German-speaking countries.

While the *Yearbook* accepts manuscripts for anonymous review in either English or German, binding commitment to publish will be contingent on submission of a final manuscript in English. The editors prefer that manuscripts not exceed 25 pages (typed, double-spaced), including notes. Please prepare manuscripts for anonymous review and follow the sixth edition (2003) of the *MLA Handbook* (separate notes from works cited). Send one paper copy of the manuscript (no e-mail attachments, please) to each editor:

Ruth-Ellen Boetcher Joeres
Department of German,
 Scandinavian, and Dutch
205 Folwell Hall
University of Minnesota
Minneapolis, MN 55455-0124

Phone: 612-625-9034
Fax: 612-624-8297
E-mail: joere001@tc.umn.edu

Marjorie Gelus
Department of Foreign
 Languages
6000 J Street
California State University
Sacramento, CA 95819-6087

Phone: 916-278-5510
Fax: 916-278-5502
E-mail: gelus@csus.edu

For membership/subscription information, contact Vibs Peterson, (Studies of Culture and Society, Howard Hall, Drake University, Des Moines, IA 50311; e-mail: vibs.petersen@drake.edu).